Midwestern Women

D0010480

MIDWESTERN HISTORY AND CULTURE

General Editors

James H. Madison and Thomas J. Schlereth

MIDWESTERN WOMEN

Work, Community, and Leadership
at the Crossroads

Edited by
Lucy Eldersveld Murphy and
Wendy Hamand Venet

Indiana University Press
Bloomington and Indianapolis

© 1997 by Indiana University Press
All rights reserved

No part of this book may be reproduced or utilized in any
form or by any means, electronic or mechanical, including
photocopying and recording, or by any information storage
and retrieval system, without permission in writing from the
publisher. The Association of American University Presses'
Resolution on Permissions constitutes the only exception to
this prohibition.

The paper used in this publication meets the minimum
requirements of American National Standard for
Information Sciences—Permanence of Paper for Printed
Library Materials, ANSI Z39.48-1984.

Manufactured in the United States of America

Library of Congress Cataloging-in-Publication Data

Midwestern women : work, community, and leadership at the crossroads /
edited by Lucy Eldersveld Murphy and Wendy Hamand Venet.
p. cm. — (Midwestern history and culture)
Includes bibliographical references and index.
ISBN 0-253-33307-5 (cloth : alk. paper). — ISBN 0-253-21133-6
(pbk. : alk. paper)
1. Women—Middle West—History. I. Murphy, Lucy Eldersveld,
date. II. Venet, Wendy Hamand.
HQ1438.M53M53 1997
305.4'0977—dc21 97-4073

I 2 3 4 5 02 01 00 99 98 97

For our mothers:
Martha T. Hamand
and
Molly Wilson Magee

Contents

Foreword

SEVERAL YEARS AGO I received a shocking compliment. While in Washington, D.C., on business I arranged to have lunch with a former graduate student whom I had not seen for years. She politely inquired about my recent move to Indiana, then stated, "But you don't *look* like a dowdy midwesterner."

It is this stereotype of the Midwest as drab—and therefore unworthy of much notice—that editors Lucy Eldersveld Murphy and Wendy Hamand Venet confront in this probing, analytical volume. Murphy and Venet clearly believe the Midwest is remarkable. They maintain that the Midwest—and its women—played, and continue to play, a significant role in the nation's history.

How has the Midwest gotten such a dreary image? After all, modern Americans also refer to the Midwest as the "heartland" of the United States. Can a region be both things—downright mediocre *and* the essential core of the nation? Apparently so, for many people like to think of a "heart" as solid, sturdy, and basically obscure. But a heart also supplies crucial services; it keeps the extremities of New York and California alive.

Besides such contradictory interpretations, the Midwest as a region is a relatively recent concept. The term came into use well after the Civil War, probably during the 1880s. Few people have ever bothered to define it. When I lived in Iowa, my colleagues asked if I was going back East, meaning Ohio. When I was on the East Coast, others referred to Iowa as the West, or even the Far West.

Neither did the Midwest ever have an exciting symbol. The farm constituted the region's defining emblem. Even today, images of cows—both serious and comic—flood Wisconsin gift shops. Images of pigs dominate in Iowa, while "Amber Waves of Grain" adorn Indiana license plates. No stormy-browed colonial Puritans, licentious cotton planters, or wild westerners here. No wonder Americans think of the Midwest as solid—even cute and charming—yet still a bit monotonous.

Similar biases appeared among scholars who not only studied New England, the South, and the West, but formed such scholarly organizations as the Southern Historical Association and the Western History Association (whose area of interest subsumed at least part of the Midwest). Even the

Mississippi Valley Historical Association quickly became the Organization of American Historians.

Given such dismissive attitudes, it is little wonder that midwestern women have received less than their fair share of scholarly coverage. In addition, early women's history suffered from "New England bias," that is, the belief that what happened in New England virtually defined the rest of the nation. After all, it might be argued, New Englanders who migrated westward carried place names, such architectural features as widow's walks, and cultural values with them. Although this line of reasoning has some validity, it denies the effect of such regions as the Midwest on the development of peoples and cultures.

Taken together, the Midwest's image problem and the New England bias have hampered scholarship on midwestern women. Fortunately, Murphy and Venet have taken the initiative to offer this volume as proof to the contrary. The chapters in it clearly benefit from other less restrictive aspects of nearly three decades of women's history scholarship. For example, various contributors understand—and explore—the overlapping of public and personal in women's lives, the concept of municipal housekeeping, the importance of women's voluntary organizations, and women's roles in building communities. Perhaps more important, the essays reflect concern with midwestern women of color, an awareness slow and sometimes painful in coming among women's historians.

The essays also allow agrarian women, ranging from Native American to Anglo, to assume their full importance. Building on the pioneering work of such scholars as Mary W. M. Hargreaves, Joan M. Jensen, and Nancy Grey Osterud, several of the authors in this volume demonstrate the significance of women's efforts to the agrarian base of the United States.

Yet others analyze women's work, women's place in families, and women's agency. The latter concept, also a recent achievement of women's historians, reveals the extent of women's power. Following the innovative work of such scholars as Vicki Ruiz and Carol Devens, contemporary-era women's historians have become more encompassing than simply discussing victimization, exploitation, and cultural dissolution. Rather, they pursue an understanding of the ways in which women exercised agency and resisted oppression. By picking and choosing, taking what suited them and rejecting what appeared to threaten their position, status, or culture, women exercised an agency no less forceful for its subtlety.

Thus, this volume stands in line with some of the best traditions and scholarship of women's history. It also offers many of its own ideas: that midwestern women were significant; that their history must be retrieved; that they exercised agency; and that they played a decisive part in midwestern history. Too, by stressing the lives of individuals and the work of clubs, or-

ganizations, and institutions, it denies the idea that history is created by such forces as economics, war, or famine. Here, individual women and women in groups are the actors on the historical stage.

An additional contribution is notable progress toward a comparative history of women in the various regions of the United States. It is impossible to determine just what is different about women of a particular region unless they can be compared with women in other regions of the country. To do that, scholars must reconstitute and evaluate the history of women in each of the regions.

Currently, there is no agreement on the ways and extent that regional women were different or similar. As early as 1977, historian D'Ann Campbell used multivariate statistical techniques to determine that "a western regional effect" existed on women's attitudes. The values of the young western women she sampled contrasted noticeably with those of northeastern and southern women. More recently, others similarly discovered what they termed "a distinctive pattern" and a strong environmental influence. At the same time, however, historian Karen Anderson speculated that western women are much like those in other parts of the country, that "western women have not differed substantially from women elsewhere in the nation in their labor force status, political rights and roles, or family roles and status."[1]

One way historians of women can attack this essentialist-versus-nonessentialist issue is by establishing the details and experiences of women's lives in the various regions. This is exactly where the present volume excels. Not only does it retrieve midwestern women's history and restore it to the historical record, but it demonstrates these women's diversity, will, and impact.

As a result, this volume looks like anything but dowdy midwestern history. Instead, it is a treasure trove of new information and exciting ideas. In confronting the stereotype of the Midwest and midwestern women, it gives the terms new meanings, ones that are rich, full, and inspiring.

Glenda Riley
Alexander M. Bracken Professor of History
Ball State University
Muncie, Indiana

Note

1. D'Ann Campbell, "Was the West Different? Values and Attitudes of Young Women in 1943," *Pacific Historical Review* 47, no. 3 (August 1977): 453–63; and Karen Anderson, "Western Women: The Twentieth-Century Experience," in Gerald D. Nash and Richard W. Etulain, eds., *The Twentieth-Century West: Historical Interpretations* (Albuquerque: University of New Mexico Press, 1989): 114.

Acknowledgments

T HIS PROJECT BEGAN when the two of us met at a Berkshire Conference six years ago, and found that we shared an interest in midwestern women's history and a sense of frustration about the lack of scholarly attention being paid to it. Several months later, each of us received a letter from Jim Madison calling our attention to the Indiana University Press series on midwestern history that he coedits with Tom Schlereth. Madison and Schlereth were actively seeking manuscripts that considered gender as a category in scholarship on the Midwest. We wrote a proposal for a volume of essays about midwestern women's history and met with Jim and with Joan Catapano of Indiana University Press. Both supported our proposal with enthusiasm from the beginning. We owe a debt of gratitude to Joan, Jim, and Tom for their encouragement and their careful reading and editing of the manuscript in every phase of the project.

All of the selections in this volume are original. In looking for authors to invite, we scoured journals, dissertations, and conference programs, and tried to find essayists who could cover a range of topics, time periods, states, and cultures. Several scholars referred us to researchers they knew, including Kathleen Neils Conzen, Darlene Clark Hine, John Jentz, Jacqueline Peterson, Mike Fraga, Helen Tanner, Wendy Gamber, and Jim Madison. We are especially grateful to them for acquainting us with the work of many fine scholars of the Midwest.

In preparing the bibliography, we placed notices in historical newsletters asking for citations. A number of scholars shared information with us and offered encouragement at the same time. We thank them for their assistance in developing a bibliographic resource we hope will be helpful to researchers.

The authors and editors of this volume comprise a group of women almost as diverse as those we write about. We represent different races, ethnicities, and ages. We live in the Midwest, the South, the West, New England, and Europe. During the years we have collectively worked on this book, we have made a number of life changes. Two of us have completed dissertations, three have had babies, one attended a child's wedding, two have welcomed grandchildren, and five have changed jobs. But we all share a commitment to midwestern women's history, and we have all worked hard researching, writing, and editing this book. Above all, we hope to draw at-

tention to the importance of midwestern women's history, and to encourage others to study it. We hope this collection will prove to be a useful resource.

 Wendy Hamand Venet Lucy Eldersveld Murphy
 *Atlanta, Georgia* *Warrenville, Illinois*

Midwestern Women

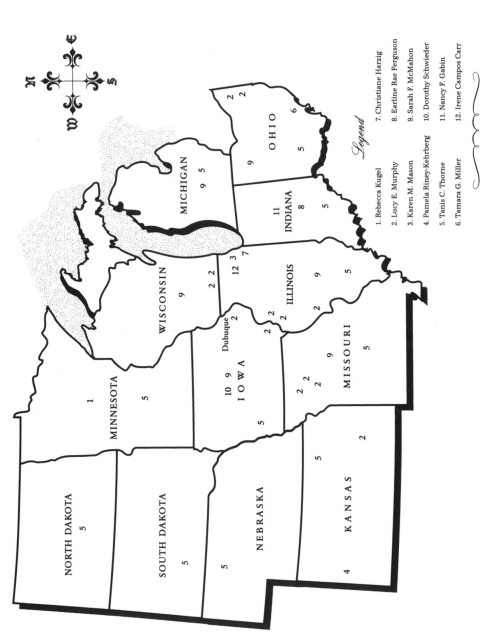

Figure 1. Places in the Midwest Mentioned in This Volume, by Author

Terry Sheahan 1996

Legend

1. Rebecca Kugel
2. Lucy E. Murphy
3. Karen M. Mason
4. Pamela Riney-Kehrberg
5. Tanis C. Thorne
6. Tamara G. Miller
7. Christiane Harzig
8. Earline Rae Ferguson
9. Sarah F. McMahon
10. Dorothy Schwieder
11. Nancy F. Gabin
12. Irene Campos Carr

Introduction

The Strange Career of Madame Dubuque
and Midwestern Women's History

WENDY HAMAND VENET AND
LUCY ELDERSVELD MURPHY

ON AN OCTOBER day in 1897, several men climbed to the top of a bluff overlooking the Mississippi River and began to dig. They were intent on celebrating the history of their community, and had decided to erect a monument to the man they considered its founding father. Julien Dubuque, a white French Canadian who had arrived in 1788 and, with the permission and cooperation of the local Mesquakie community, had engaged in lead mining, fur and lead trading, and farming, had died in 1810. The monument the men envisioned would stand on the location of Dubuque's grave. As they dug, however, they encountered not just the remains of their founding father, but of two other people as well, all buried together. Experts identified the two extra skeletons as those of an Indian man and an Indian woman. According to local oral tradition, the Native man was Dubuque's best friend, the chief of the Mesquakie village a stone's throw away from this bluff, and the woman was Dubuque's wife, the chief's daughter.[1]

These two Native skeletons did not fit into the plans for the Dubuque historical monument, so while Dubuque's remains were reinterred and a twenty-eight-foot limestone tower was erected over the grave, the Mesquakie bones were put on display in town: the man's were wired together and hung up as a curiosity, the woman's skull was put on a shelf, and the rest of her was tossed into a bushel basket and left in the basement of the local museum. In the most literal sense, these two people and their history were marginalized in a way they had never been in life, the woman believed to be Madame Dubuque even more so than her father. (In 1973, the "chief" was reburied, but not his daughter.)

The way Americans look at history has changed dramatically during

the century since this revealing event. In the last two and a half decades especially, increasing numbers of historians have turned their attention to the heretofore marginalized people of America's past, developing research tools and approaches to help in understanding the experiences of non-elites, people of color, and women. Women's history has developed an exceptional degree of sophistication and popularity; (the triennial Berkshire Conference on the History of Women has become the second largest historical gathering in the United States, exceeded in attendance only by the annual meeting of the American Historical Association). During the same quarter century, scholars of the South and Southwest Borderlands pioneered approaches to studies of slavery, ethnic minorities, and race relations. The "new southern" and the "new western" history provide examples of exciting social, economic, and multicultural history, within the context of regionally defined identities. At the intersections of these scholarly trends, the experiences of southern and western women, women of color, and Euro-Americans are beginning to find central places in the writings of revisionist scholars, achieving a balance too often lacking in earlier historiography. For the Northeast, urban, labor, and rural historiography has also focused on women in exciting ways.

Midwestern history has lagged behind, both in terms of published primary sources and regionally defined interpretive works. One striking example of this problem is revealed by an advertisement for a Readex microfilm series entitled "American Women's Diaries." The series is divided into three sections: "New England Women," "Southern Women," and "Western Women," without explanation or apology for the exclusion of a midwestern component. There *have* been a few notable studies in recent years that consider gender and are self-consciously midwestern, such as studies by Glenda Riley and John Mack Faragher, but the Midwest is worthy of a great deal more creative historical thinking.[2] The research tools and approaches of women's history have much to offer those who agree on the need to provide midwestern history with a fresh approach and a new conceptual cohesiveness.

In our view, the challenges facing historians, then, are to reconsider the Midwest as an area with particular regional experiences, to integrate women more fully into midwestern history, and to develop more thoroughly concepts of the midwestern "female experience." We think this requires rethinking the old questions and asking new ones.

Scholars attempting to reinvigorate midwestern history encounter a number of difficulties. One is an identity crisis. The average midwesterner knows in her heart that she is a prototypical American (after all, most of the anchorwomen and -men on the national television news speak with the same heartland accent). However, many intellectuals—especially those from elite East or West Coast colleges—consider midwesterners to be simply those less-

than-elegant cousins, and even many midwesterners see themselves this way. Coastal Americans too often have a sense of the Midwest as an unsophisti- cated version of the Northeast, with little to differentiate it other than its chronic inability to achieve eastern standards of finesse.

In the absence of studies that characterize midwestern women's experi- ences, scholars have had to generalize based on studies of other regions. For example, in her path-breaking 1977 work *The Bonds of Womanhood*, Nancy Cott tentatively implied that New England's norms were also midwestern, arguing that "New England had the most influential regional culture in the country's early history. . . . New Englanders . . . contributed to the making of a nation (the Northern part of it, at least) in their image. . . . " Historians of southern women have already questioned the universality of "the New England model";[3] it is time that scholars of midwestern women did the same. As our bibliography shows, there is a substantial body of research on women that has yet to be synthesized and that holds the promise of challenging our assumptions and raising new questions.

There was a time when residents of the northern central states knew where they were: the West. The western Great Lakes states were part of "the Old Northwest." The University of Michigan fight song proclaims its ath- letes to be the "champions of the West." But western history has been am- bivalent about including us in its family. Sometimes, western historians define their purview as "the trans-Mississippi West," clearly leaving Wisconsin, Il- linois, Ohio, Michigan, and Indiana beyond the pale.

Another problem is that the Midwest is geographically diverse, encom- passing woodland, prairie, and plains regions; defining the Midwest's boun- daries is no easy task. Both the prairies and the Great Plains have good claims for inclusion, although residents of these flat subregions do not always con- sider each other midwesterners. The upper Mississippi Valley and drainage seems to constitute a sensible geographic entity, as does the western Great Lakes region. But what about the border with Canada?

Canadians are quick to tell U.S. scholars that we consistently ignore our northern neighbor, and few would argue with this assessment. The Canadian border is a political boundary, and we may ask ourselves whether, for some historical topics, such as social and economic histories, it is a conceptual bar- rier to improved understanding. Reconsidering the importance of politically drawn demarcations may invigorate midwestern scholarship.

Scholars of the Southwest have long considered the border with Mexico to have been significant throughout the region's history. Books such as Adelaida del Castillo's collection of essays, *Between Borders*, examine issues of gender, race, culture, and colonization in path-breaking ways.[4] Students of the midwestern experience may do well to take cues from this Southwest- ern Borderlands scholarship, and consider the extent to which the Midwest

has been affected by its borderland location. Only a few scholars looking at gender, such as Carol Devens in *Countering Colonization* have crossed borders in their research.[5]

It may well be that one's definition of the Midwest will vary according to era and topic. For example, the eighteenth-century areas of French trade and settlement constitute a rational unit of focus as Richard White's book *The Middle Ground* demonstrates. Lewis Atherton's *Main Street on the Middle Border* (1954) centers on *towns* in the Midwest. Like Atherton, we begin our book with a general definition of the Midwest as the region comprising the present states of Ohio, Michigan, Indiana, Illinois, Wisconsin, Minnesota, Iowa, Missouri, Kansas, Nebraska, and the Dakotas.[6] We asked our contributors to set forth their own definitions if those definitions differed from ours.

Among the Midwest's most important defining features are its distinctive landscapes, abundant and varied natural resources, and central location. The western Great Lakes and upper Mississippi River systems have made this a region of crossroads for thousands of years; nineteenth-century canal and rail systems, and twentieth-century roads and air routes, increased both the Midwest's relatively easy access to the outside and its good internal communication. Because these systems have made this a region frequently traveled by people from far afield seeking to use the region's resources, the Midwest has always been culturally diverse, since before the arrival of Europeans and up to the present time. Sometimes groups have formed homogeneous colonies, making the Midwest "an ethnic and cultural checkerboard," in the words of Andrew R. L. Cayton and Peter S. Onuf.[7] On other occasions, people from various backgrounds have intermarried and/or created multicultural communities. While native-born people had to adjust to newcomers, immigrants adapted to new ecosystems, power structures, economic realities, and existing cultures. Some came and did not stay.

Peggy Pascoe suggests that Western History could benefit from scholarly focus on "Women at the Cultural Crossroads," advice that may apply at least as well to midwestern history.[8]

When we look at the Midwest as a crossroads region, women and issues of gender emerge. As migrants faced the challenge of adapting to a new environment, their cultural norms met those of other groups, were challenged, sometimes clashed, and often shifted as all groups made adjustments. As opportunities arose for work both within the home and in the marketplace, women challenged traditional gender roles. Their new environment, economic situation, and social position offered opportunities for community building and leadership roles. Those outside the established power structure developed ways to wield influence. For these reasons, we have subtitled this book "Work, Community, and Leadership at the Crossroads."

Although approaches in historical research may have become more sophisticated during the last twenty-five years or so, midwestern scholars are still facing the same problems and are often falling into the same patterns that worked to marginalize so many midwestern people. The example of Madame Dubuque, her bones and her historiography, may serve to illuminate some of the pitfalls of midwestern historical scholarship.

Most obviously, when the focus has been on white men—as when the remains of Julien Dubuque were celebrated with a monument—the memories of others have been diminished. This throws the whole picture out of balance, obscures a great deal, and often forces artificial constructs onto historical subjects.

This tendency to celebrate Julien Dubuque as Iowa's "first white permanent settler" was a precursor to the tendency of historians of the Midwest writing during the middle to late twentieth century to believe that the region's history really started with the arrival of white "American settlers," or when the United States gained hegemony over the region, as if the centuries of Native, French, Spanish, and British experiences here never happened. For example, R. Carlyle Buley's *The Old Northwest* begins in 1815, and Cayton and Onuf's *The Midwest and the Nation* begins with the Northwest Ordinance of 1787.[9] Many state histories could also be cited here. Curiously, earlier historians acknowledged the long experience of midwestern people, historians such as Louise Phelps Kellogg, Reuben Gold Thwaites, and Walter Prescott Webb. (Even Frederick Jackson Turner wrote his dissertation on "The Character and Influence of the Indian Trade in Wisconsin.")[10] This is not to say that recent monographs have ignored indigenous and colonial midwestern history altogether, but that this early period constitutes a blind spot for nearly everyone except the Indian and French colonial specialists. General works and works emphasizing women's experiences have tended to begin with and focus on the "pioneers."[11] Thus, in spite of some comprehensive local historiography, it has been easy to overlook the degree to which Julien Dubuque lived and worked with his Mesquakie neighbors, friends, and relatives, who perhaps ought also to be considered founders of the area.[12]

The booster mentality that seeks more to champion a local hero than to explore a region's past distorts and dehumanizes even its subject, often mythologizing him. In the case of Julien Dubuque, this meant at least one early biographer robbed him of his wife. Because no church marriage records could be found, reports by contemporaries that he had married a Mesquakie woman were discounted by local history buffs, who refused to believe that the Founding Father had married outside his faith and his race.[13]

Letters to Julien Dubuque have since surfaced, however, clearly sending regards to "Madame Dubuc"; and in her memoir, *Halfbreed*, Maria Campbell traces her ancestry to Monsieur Dubuque.[14] Although these records do

prove the existence of Madame Dubuque (and the remains interred with Monsieur Dubuque may have belonged to her), precious little information is available about her. Even her name is not surely known: the bones assumed to have been hers were marked "Potosa," but this may be just a variation on the generic mining community name Potosi found in South America and Mexico, of which there were several imitators in the Midwest by the 1890s.

Typically, government and business documents have revealed frustratingly little about women's activities before the Civil War. Lack of regard for women's role meant that, except in rare cases, only a family's male head appears in records related to government and business. Historians seeking information about women of the early national and antebellum periods found federal census records difficult because, prior to 1850, names were given only for heads of households. Popular during the 1970s, nominal linkage studies based on these censuses, such as Don Harrison Doyle's *The Social Order of a Frontier Community*, were for this reason skewed toward men.[15]

Letters, diaries, travel accounts, and memoirs have proven to be much better sources of information about women, in general, as scholars such as Marilyn Ferris Motz, author of *True Sisterhood: Michigan Women and Their Kin, 1820–1920*, and Glenda Riley, author of *The Female Frontier* and *Frontierswomen: The Iowa Experience*, have demonstrated.[16] Yet these types of sources reveal the most about educated white women, who wrote and saved them. Madame Dubuque apparently left no documents in her own hand. For her, as for many other women, especially women of color, researchers must piece together from disparate sources clues to the outlines of their past. This presents a challenge to historians to find new sources, fresh approaches to old sources, and new research methods in the quest both for women's history and for a "new midwestern history."

The present volume is an effort to face these challenges. Clearly there is a need to begin to define and explore the nature of midwestern women's experiences through time. As difficult as this proposition may be, our book is an attempt to promote the process. By providing a vehicle for current scholarship by both new and established scholars, we hope to invite research and analysis of this long-neglected topic. We also hope to demonstrate some of the ways in which midwestern women's experiences were like those of other American women and ways in which they were distinctive. Because this field of study is so recent, it is a challenging proposition and one that cannot be treated authoritatively for some time.

One of our goals has been to reveal the diversity of midwestern women's experiences by including chapters covering four centuries of history; women of Native American, European, African, and Mexican background; and women representing urban, rural, and frontier perspectives. Of course we do not intend this volume as a catchall. Clearly it is beyond the scope of a

single book to come close to capturing the ethnic, racial, cultural, economic, and political diversity of midwestern women's past. Moreover, in selecting original work for inclusion in this volume, we found that, while there is significant scholarly interest in many topics involving midwestern women, others await study. For example, we were delighted to find so many historians undertaking research involving the Midwest's largest city, Chicago, but disappointed that we could not find a similar degree of interest in Detroit and Cleveland. We were excited by the number of scholars studying the Progressive Era, but dismayed by the relative dearth of material on women in the colonial, early national, and post–World War II periods.

We asked each of the contributors to this volume to consider carefully the question of midwestern distinctiveness. It was a challenging proposition—some told us, nearly impossible—given the relative lack of secondary work on most of the topics included here. We hope that both the text and the bibliography will promote the process of integration of gender analysis into the broader story of the Midwest, and of midwestern women's experiences into the field of women's history.

The contributors to this volume have taken a variety of approaches. Each of the first four chapters explores facets of midwestern women's history by examining the life and career of an individual and suggesting what her life reveals about women in a broader context. This approach is invaluable when exploring a topic about which little has been published. Two of these subjects, Susie Bonga Wright and Mary McDowell, were community leaders who left varied documentary records. The others, milliner Emily Austin and farm wife Martha Friesen, lived obscure lives that would never have come to the attention of historians were it not for a single record each left, Emily's privately published autobiography and Martha's unpublished diary.

The other eight chapters explore collective topics. All the contributors use a variety of sources, including letters, diaries, newspapers, censuses, artifacts, and oral history.

A number of themes emerge in this book. A pervasive one is women's leadership, the ways in which women adapted to their new environment and defined and redefined their gender roles. An earlier generation of historians assumed that women had no power and played no political role, and that the public and private spheres were mutually exclusive. More recent scholarship has caused a reappraisal of this long-held belief. The chapters by Tanis C. Thorne and Rebecca Kugel demonstrate that public and private worlds overlapped as Native American women promoted community welfare through personal and group activities and, in the process, sometimes gained power and influence for themselves. They organized political meetings and served as diplomats. As Kugel and Thorne make clear, even the women's marriages must be seen as both public and private, both personal and political.

The chapters by Christiane Harzig and Earline Rae Ferguson reveal ways that late nineteenth- and early twentieth-century German-American immigrant women in Chicago and black women in Indianapolis gained influence through clubs and by organizing on the community level. Some voluntary organizations that were originally defined within the traditional female sphere of literary societies evolved into improvement societies to help those in need. At the same time, women activists gained experience as leaders, organizers, financiers, and public figures.

By the time of the Progressive Era, black and white women had spent decades organizing without access to the formal machinery of power, but some women had begun to channel their activism toward the elective process. They worked to achieve female suffrage and elect candidates sympathetic to their concerns. Women used a variety of strategies, including what Karen Mason describes as "municipal housekeeping," to seek power by employing rhetoric harkening to the traditional female domestic role. Once they won the vote, some women participated in local, state, and national protests to eliminate inequality.

Another strong theme in this book is women's role as community builders. Native American women helped to extend communities by exogamy, the custom of outmarriage, according to Thorne's study of the fur trade era. This practice was believed to be an important and honorable obligation of women. Native-born and immigrant white women contributed to community building by settling frontier areas, as Tamara G. Miller reveals. Miller addresses the importance of women's kinship ties in community formation.

In settled areas, voluntary organizations were a major force for community cohesiveness. The clubs and benevolent organizations founded and supported by immigrant European women, and native-born white and black women, all demonstrate the role women have played in creating a sense of community by helping the disadvantaged, the elderly, and the sick. Equally important is the role their work has played in giving them outlets from domesticity, providing them with a sense of purpose outside of the family setting, affording them recreation, and relieving loneliness.

Midwestern women have been involved in community building through religious activities. Rebecca Kugel's research identifies Ojibwe women's role in Episcopalian philanthropic efforts, demonstrating the ways that these women preserved and promoted their Native culture within the context of a traditional Euro-American religious body. Earline Rae Ferguson's study of black Indianapolis Progressives similarly shows how Baptist and Methodist women were inspired by a feminist theology to create organizations such as the Sisters of Charity in response to community needs.

In contrast to the chapters on community building, Pamela Riney-Kehrberg's work reminds us of the shortcomings of community. Her bio-

graphical approach to rural life in twentieth-century Kansas reveals themes of isolation, depression, and despair and the failure of family, church, or state to alleviate it.

The book also considers the extent to which midwestern women have struggled to control and define their work, their working environments, and the terms of their labors. The contributors examine, too, the intersections of women's work, communities, and families. *work*

The quality of their work has been important to midwestern women, as a source of both self-esteem and the respect of others. Sarah F. McMahon's article on pioneer food preparation argues that women's high standards and the ability to meet them rewarded rural women's efforts in settled areas, but frontier challenges often undermined those efforts, with negative results for the balance of domestic power. Lucy Eldersveld Murphy's biographical study of nineteenth-century milliner Emily Austin suggests the centrality of skill and hard work to artisan women, as a source of pride and as a means of achieving independence. Austin valued both skill and work quality as extremely important in her life. Like frontier cooks who labored to produce palatable, varied, and appealing meals, and small-town craftswomen whose careful efforts created beautiful bonnets and dresses, twentieth-century farm women worked through Home Economics Extension programs to gain new skills and improve their production, according to Dorothy Schwieder's research. Along the way, many gained not only knowledge and self-confidence, but also leadership skills, unlike their male counterparts.

Skill acquisition and leadership also converge in Kugel's study of Ojibwe women adapting their work roles as part of a late nineteenth-century Episcopalian mission. Although they adopted "white" house styles, domestic organization, and production methods as part of a larger strategy of community preservation, these Native women did not accept dictates of subordination to male authority. In fact, they antagonized white male church leaders by injecting women's traditional political leadership into the new church-sponsored sewing circles. At a similar junction of work and women's organizations, Ferguson demonstrates that in Indianapolis, African American clubwomen's service to their community included developing nurses' training programs with the expectation that graduates would fulfill not only their professional obligations but certain social obligations as well, assuming leadership roles.

While many women sought to define or control their work, other factors influenced their opportunities for employment. Nancy F. Gabin's article explores World War II–era dialogues regarding gender divisions of labor, revealing the variety of responses and the complexities of job definition issues. In the Midwest as in the rest of the nation, World War II proved to be a watershed, bringing unprecedented numbers of women into the work force

and creating issues of gender hierarchy now long neglected by historians. Five decades later, in another factory setting, Irene Campos Carr found that midwestern Mexican women negotiated control of their labor and work environment by adapting "expert" organization, by insisting upon being treated with dignity, and by developing a community of workers.

It will be years before historians of women can make conclusive judgments about midwestern distinctiveness. This volume, however, supports three generalizations:

1. Historically, the Midwest has been a region of continuous migration. The contributors to this volume have traced the contact between Native American women and Euro-Americans in the eighteenth and nineteenth centuries, the westward advancement of eastern Americans and the migrations of Europeans directly to the Midwest, the infusion of African Americans from the South in the nineteenth and twentieth centuries, and the twentieth-century arrival of Mexicans in large numbers. All groups have 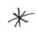 been drawn by the Midwest's abundant natural resources and economic opportunities. In most instances, kinship has been a major force in female migration patterns.

2. From the precontact period onward, at least up until the twentieth century's burgeoning global economy, the Midwest has been a crossroads of trade. Subsequently, it represents a mixture of traits from East and West; even the name "Midwest" suggests its transitional nature. Midwestern distinctiveness, then, is grounded in the concept that the area is an amalgam of regional attributes.

3. The Midwest may be characterized as a place where many cultures meet. Migrants have brought their values and cultures with them, and adapted them to conditions as varied as unsettled households, family breakup, poor health, ecological variety, neighboring cultures, and community needs. The arrival of migrants has altered and enriched the communities they have joined or the regions they have settled. Their arrival has often led to suspicion and even conflict, including religious controversy and long struggles over access to political power. For some midwestern women, barriers to acceptance and equality continue, based on ethnic, racial, religious, and cultural discrimination.

This volume further suggests five features that characterized *midwestern women's* experiences:

1. During the colonial and fur trade eras, many European and Euro-American men like Julien Dubuque migrated to the Midwest without female kin. Large numbers of Native American women married these immigrants, in part to help establish alliances between their communities and the Europeans. The children of the biracial couples, often called Métis people, frequently acted as mediators between Indian and white groups. Rebecca Kugel

and Tanis C. Thorne discuss the effect of diplomatic considerations on some Indian women's marriages.

2. In some situations, women's religious affiliations maintained or increased women's leadership capabilities and their opportunities for political and social influence. Kugel shows that Ojibwe women leaders could adapt the efforts and teachings of Episcopalian missionaries to facilitate their community's revitalization. Ferguson argues that believing "God gave woman a mind" encouraged black clubwomen in their efforts to meet community challenges, such as a desperate need for health care for black people.

3. Many midwestern women suffered from isolation and what they considered unsettled conditions. During several different periods, women in certain areas experienced not only loneliness, but also heavy workloads caused in part by lack of access to tools and other products, or people to assist with their labors. In the early stages of migration, particularly with those who did not migrate in groups, Sarah F. McMahon demonstrates, pioneer wives struggled to feed their families in trying circumstances, often without the appreciation of their families. The efforts of women in families that migrated several times, however, were more often acknowledged than those pioneering for the first time.

In rural areas, isolation often continued after an initial period of settlement—sometimes becoming worse if members of groups who migrated together scattered. Dorothy Schwieder explains that in rural prairie regions, isolation decreased by the 1920s due in part to improvements in transportation, but farm women in the Plains and far northern sections of the Midwest continued to be cut off from regular contact with others into the 1950s. Farm women in Iowa, Schwieder found, often turned to Home Economics Extension activities for social outlets, education, and opportunities that could make their work at home more efficient and successful. Pamela Riney-Kehrberg's biographical study of one Kansas woman's experiences with grief, however, demonstrates that many farm women continued to suffer from loneliness and the burdens of heavy workloads during the mid-twentieth century.

4. Midwestern women's efforts were crucial in community building. Tamara Miller demonstrates that their efforts in creating and maintaining kinship networks held settlements together in their early stages. Furthermore, where institutions were needed, such as schools and hospitals, women's organizations were often instrumental in creating and staffing them. During the Progressive era, leaders such as Mary McDowell legitimated these civic activities as "municipal housekeeping," Karen M. Mason finds. Ferguson demonstrates that African American women created hospitals and nurses' training programs when racism barred blacks from white-controlled establishments. Harzig's study also reveals the contributions of German-

American women activists in community development. In a sense, new communities and the absence of services in growing cities provided outlets for women's civic efforts and opportunities for women to exercise leadership as they made meaningful contributions assisting their neighbors. Even in work environments, Campos Carr demonstrates, women continued to create communities that sustained them as they coped with stressful jobs in an adopted country.

5. Work patterns have varied considerably for women in the Midwest. As in other regions, Native American women of the fur trade era created a relatively gender-balanced economy, while Euro-American women have struggled throughout their history with issues of gender hierarchy, even during and after World War II. In the nineteenth-century Midwest, which was much less industrialized and urbanized than the Northeast, Murphy shows that fewer women worked outside their homes than in other regions. There were fewer industrial and agricultural wage earners, though small craft shops and retail establishments were abundant. However, because of the concentration of heavy industry here by the mid-twentieth century, Gabin demonstrates, the World War II experience had a particularly strong effect on women workers and ideas about gender hierarchy in the workplace. In recent years, work in new industries such as electronics manufacturing continues to be gendered, as Campos Carr's study reveals.

As of this writing, the supposed remains of Madame Dubuque are in the custody of the State of Iowa, after having been carefully examined by an archaeologist. Representatives of the office of the Iowa state archeologist have been consulting with Mesquakie leaders to determine the most appropriate location for her reburial. It is indeed time to get midwestern women's bones and our histories out of our basements. It is time to return this woman to the dignity of a quiet resting place. It is also time to rethink the monuments and anonymity of midwestern—and women's—history.

Notes

1. Richard Herrmann, *Julien Dubuque, His Life and Adventures* (Dubuque: Times-Journal, 1922), 65–67; Thomas Ryder, "Seek Proper Reburial for Bones of Fox Indian Chief," *Des Moines Register* 17 September 1972; Ryder, "Dubuque's Chief Peosta Reburied on River Bluff," *Des Moines Register* 13 May 1973; Jack Brimeyer, "Seek Final Resting Place for Peosta," Dubuque *Telegraph-Herald* 18 Sep-

tember 1972; Brimeyer, "Consider the Friendship," Dubuque *Telegraph-Herald*, 13 May 1973.

2. Glenda Riley, *The Female Frontier: A Comparative View of Women on the Prairie and the Plains* (Lawrence: University Press of Kansas, 1988); John Mack Faragher, *Sugar Creek: Life on the Illinois Prairie* (New Haven, CT: Yale University Press, 1986).

3. Nancy F. Cott, *The Bonds of Womanhood: "Woman's Sphere" in New England, 1780–1835* (New Haven, CT: Yale University Press, 1977), 10; see Elizabeth Fox-Genovese, *Within the Plantation Household: Black and White Women of the Old South* (Chapel Hill: University of North Carolina Press, 1988).

4. Adelaida R. Del Castillo, ed., *Between Borders: Essays on Mexicana/Chicana History.* (Encino, CA: Floricanto Press, 1990).

5. Carol Devens, *Countering Colonization: Native American Women and Great Lakes Missions, 1630–1900* (Berkeley: University of California Press, 1992).

6. Richard White, *The Middle Ground: Indians, Empires, and Republics in the Great Lakes Region, 1650–1815* (New York: Cambridge University Press, 1991); Lewis Atherton, *Main Street on the Middle Border* (Bloomington: Indiana University Press, 1954, 1984).

7. Andrew R. L. Cayton and Peter S. Onuf, *The Midwest and the Nation: Rethinking the History of an American Region* (Bloomington: Indiana University Press, 1990), 27.

8. Peggy Pascoe, "Western Women at the Cultural Crossroads," in Patricia Nelson Limerick, Clyde A. Milner II, and Charles E. Rankin, eds., *Trails: Toward a New Western History* (Lawrence: University Press of Kansas, 1991), 40–58.

9. R. Carlyle Buley, *The Old Northwest*, 2 vols. (Indianapolis: Indiana Historical Society, 1950); Cayton and Onuf, *The Midwest and the Nation.*

10. For example: Louise Phelps Kellogg, *The French Regime in Wisconsin and the Northwest* (New York: Cooper Square Publications, 1925); Kellogg, *The British Regime in Wisconsin and the Northwest* (Madison: State Historical Society of Wisconsin, 1935); Walter Prescott Webb, *The Great Plains* (Boston: Ginn, 1931); Frederick Jackson Turner, "The Character and Influence of the Indian Trade in Wisconsin" (Ph.D. diss., Johns Hopkins University, 1891; rept., Norman: University of Oklahoma Press, 1977). For a detailed bibliography of Thwaites's many works, see Frederick Jackson Turner, *Reuben Gold Thwaites, A Memorial Address* (Madison: State Historical Society of Wisconsin, 1914), 63–94.

11. Julie Roy Jeffrey, *Frontier Women: The Trans-Mississippi West, 1840–1880* (New York: Hill and Wang, 1979); Sandra L. Myres, *Westering Women and the Frontier Experience; 1800–1915* (Albuquerque: University of New Mexico Press, 1982); Riley, *The Female Frontier*; Riley, *Frontierswomen: The Iowa Experience* (Ames: Iowa State University Press, 1981).

12. Thomas Auge, "The Life and Times of Julien Dubuque," *Palimpsest* 57 (January–February 1976): 2–13; William E. Wilkie, *Dubuque on the Mississippi, 1788–1988* (Dubuque: Loras College Press, 1987).

13. For example, M. M. Ham, "Who Was Peosta?" *Annals of Iowa*, 3rd. series, 2 (July 1896): 470–72.

14. F. Lesueur to J. Dubuc, 30 March 1809; N. Boilvin to Julien Dubuc, 22 May 1809; Missouri Historical Society, copies in the collection of Loras College,

Dubuque; Auge, "Julien Dubuque"; Maria Campbell, *Halfbreed* (Toronto: McClelland and Stewart Ltd., 1973), 18.

15. Don Harrison Doyle, *The Social Order of a Frontier Community: Jacksonville, Illinois, 1825–70* (Urbana: University of Illinois Press, 1978).

16. Marilyn Ferris Motz, *True Sisterhood: Michigan Women and Their Kin, 1820–1920* (Albany: State University of New York Press, 1983); Riley, *The Female Frontier*; Riley, *Frontierswomen*.

I.

Four Lives

1

Leadership within the Women's Community

Susie Bonga Wright of the Leech Lake Ojibwe

REBECCA KUGEL

HISTORICALLY, THE LIVES of Native American women have been misunderstood by the dominant society.[1] They have been characterized as oppressed and powerless drudges (the "squaw" stereotype) or as exotic and compliant helpers of the male European colonizers (the "princess" stereotype). In recent years, numerous scholars, both Native and non-Native, have issued calls to move beyond this inadequate polarization and reexamine the lives and work of Native women.[2]

Perhaps no realm of female activity is less accessible than leadership. There is great irony in this, for Europeans and, later, Euro-Americans, were struck by Native women's political presence and participation. Along the eastern coast of North America, the earliest English colonizers encountered women in positions of leadership. John Smith made note of the "Queene of Appamatuck" in his first communications; the Puritans likewise observed that the leader of the Massachusetts confederacy, on whose lands they had established their colony, was a woman, the "squa-sachim of Puckanokick." In the eighteenth century, John Adair, an English trader in the Southeast, disparagingly described the Cherokees as "under petticoat government," and long before Adair's complaint that Cherokee women exercised too much political power, both English and French colonists had come to recognize and respect the political influence of Iroquois women. In addition, and of particular interest to this study, there exists in the early nineteenth century a remarkable portrayal of Netnokwa, a female political leader in a multi-ethnic Ojibwe-Odawa community.[3]

Yet the Europeans and Euro-Americans who were so keenly aware of Native women's influence and participation in public councils rarely re-

17

corded—and presumably, were rarely aware of—other forms of female po-
litical activity that took place away from council meetings. In part this is due
to the fact that the interests of Europeans and Euro-Americans, revolving
largely around trade relations, diplomacy, and military affairs, were issues
concluded in the council meeting forum. They had little reason to look else-
where, to other social groups or social settings. From this situation numer-
ous questions arise concerning Native women's political participation. For
instance, were Native women's political expressions confined only to the
public councils? Were certain women recognized as leaders among women,
within kinship groups such as clans or extended families? How were such
female leaders selected and what were their responsibilities? And of course,
how did Native women's political activity vary between tribal groups?

This chapter examines, within a specific tribal setting, a form of female
political activity outside the realm of the public council. Given the scanty
documentary record respecting women's activities, this work can provide
only a partial glimpse, and raises questions it cannot answer. Yet in revealing,
however imperfectly, the political activities of Native women from a particu-
lar tribal background, the Minnesota Ojibwe, at a particular point in time,
the last quarter of the nineteenth century, it suggests much about the range
of political activity in which Native women engaged, and, perhaps more im-
portant, the goals their political actions were meant to achieve.

Susie Bonga Wright, from the Minnesota Ojibwe community of Leech
Lake, emerges from a small selection of documents in the 1870s and 1880s
as a leader and spokeswoman for an important female constituency within
her community. Bonga Wright's actions offer a view into the functioning of
a distinct women's community, but they also allow an examination of the
ways in which women's leadership was challenged and channeled by the
growing dominance of Euro-American society. While only sketchily por-
trayed in the documents, her personal life reveals additional information that
illuminates her leadership role, both in its traditional and innovative dimen-
sions. Further, her life, as a person of mixed African and Ojibwe ancestry,
the daughter of an influential fur trader, also lends itself to an examination
of the changing intersections of race, class and gender.[4]

Like other midwestern Indians, the Ojibwe understood gender relations
as complementary. Men and women were social halves that made up a whole.
To Ojibwe minds, this was clearly demonstrated economically on a daily ba-
sis—male hunters provided the meat portion of the family's diet and female
farmers contributed the products of the earth: grains, vegetables, and fruits.
An obvious component of Ojibwe gender complementarity was the signifi-
cant sex-segregation of male and female work. This is not to say that men
and women worked in isolation from each other, for this was not ordinarily
the case. Indeed, men and women often worked in physical proximity to one

another, but on gender-specific aspects of a task. What gendered work roles do indicate is that the Ojibwe perceived women and men as having differing areas of expertise and interest.[5]

Not surprisingly, given the gender-segregated organization of much of Ojibwe life, women and men formed separate political councils. One Ojibwe community made this division explicit in 1882, identifying "two persons as our leaders[,] one for the men & the other for the women." These two political bodies met together to create community policy, with the leader of the women's council presenting female opinion "to the men at their Meeting." While only the female leader, or *ogimakwe*, spoke, in keeping with Ojibwe political protocol, all other interested women could and did attend these joint meetings.[6] Ojibwe women also operated independently as a political entity. Assuming that Euro-Americans also divided political activity along gender lines, they worked to establish connections with organizations they understood to be Euro-American women's councils. In 1878, for instance, three prominent Ojibwe women wrote the wife and daughter of the Indian agent, emphasizing the "very pleasant feelings [that] have existed between us."[7]

Ojibwe women also addressed issues within their communities. In the 1820s, for example, a visitor observed that when the Leech Lake community had obtained alcohol and a general village revel was taking place, it was "the usual practice" for the women to confiscate all weapons and police the community while the men drank, preventing the intoxicated from injuring themselves or others. Such female drinking patrols existed in Ojibwe communities until at least the 1870s.[8]

Yet the most ubiquitous circumstance under which Ojibwe women organized themselves involved coordinating and directing their daily and seasonal work, much of which was performed in groups. The work of farming, gathering wild foods, and processing all foodstuffs; the construction of housing; and the manufacture of clothing, bedding, domestic containers, and utensils; not to mention child care, required women to organize and lead their activities. One female leader, Susanna Roy, discussed her work coordinating the labor of other women, organizing "the women [to] work making things."[9]

This most mundane level of activity may well have been the most important, however. The daily environment of a work group provided an obvious forum for political debate, and indeed, in the work group setting, Ojibwe women discussed issues and formulated their opinions. As late as the 1890s, missionary worker Pauline Colby observed that the work groups remained the arena for Ojibwe women "to discuss all affairs of interest to them." Echoing descriptions of more formal council meetings, Colby noted the egalitarian nature of these political discussions. Any woman might "rise

and make an address," to the others, Colby noted, and all opinions were given "respectful attention." Susie Bonga Wright's career likewise demonstrates the significance of the work group for female leaders. While she participated in the multiple layers of female political activity, "speaking for" her supporters in a variety of contexts and regularly communicating with interested Euro-American women, the work group remained a central focus of much of her political activity.[10]

Born around 1850, Susie Bonga grew to young adulthood during some of the most difficult times the Ojibwe had known. Pressured by the growing physical and economic dominance of the United States during the 1850s and 1860s, the Minnesota Ojibwe had ceded most of their lands in the Treaty of 1855. The results had been calamitous. The reduced and fragmented land base could not sustain the older hunting/gathering and trapping economy, and the Ojibwe slid rapidly into poverty. Economic and social decline were accompanied by bitter political divisions, as Ojibwe communities split over strategies for dealing with the growing American presence. Unable to sustain themselves from the land, the Ojibwe found themselves increasingly dependent on cash payments from the U.S. government. This dependence, they learned to their dismay, made them increasingly vulnerable to additional American demands, both for more land cessions and for the dramatic cultural changes Euro-Americans called "civilization."[11]

American policy respecting Native Americans in the middle to late nineteenth century involved the near-complete transformation of Native people. Federal government policymakers and well-meaning Euro-American reformers envisioned a two-pronged program simultaneously involving conversion to Christianity and the adoption of an idealized variant of American agrarianism, a cluster of cultural attributes that Euro-Americans called "civilization." The Ojibwe (indeed, all Native Americans) were to embrace private property, especially with respect to landholding, and accept a market economy with gender roles for men as wage-earning farmers and women as housekeepers who did not earn wages for their societally undervalued housework. Political matters were to be decided by a majority of the adult males. Ojibwe children were to attend schools where the civilized values would be sternly inculcated. On more visible and daily levels, the Ojibwe were to adopt the housing, clothing, foods, and language of Euro-Americans.[12]

In the face of this onslaught, the Ojibwe, including the people of Susie Bonga's village of Leech Lake, sought to preserve what they regarded as their cultural core. Daily manifestations of Euro-American culture such as housing and clothing styles did not concern them deeply. Indeed, as the Ojibwe had been involved in the fur trade since the 1600s, they had already adopted many items of Old World material culture. What the Leech Lakers struggled hard to preserve were a series of intangibles, valued and distinctive

cultural attributes, ways of thinking and behaving, that were sharply at odds with Euro-American cultural norms and expectations. They sought to continue their political decision-making process along aboriginal lines, basing decisions on unanimity rather than majority rule, and including both women and men as political participants. They further struggled to maintain an economic system based on egalitarian redistribution of resources contributed by both sexes rather than the private accumulation of wealth controlled by men. Beginning in the 1850s, gaining widespread support by the 1870s, sizeable numbers of Ojibwe sought to turn the "civilization" program into a weapon they might wield in their own defense. Hard-pressed to find means of self-support now that the resources of their former land base were denied them, the Ojibwe were particularly interested in the possibilities that increased reliance on agriculture seemed to promise.

At the same time, the Ojibwe also sought to cultivate ties with those groups of Euro-Americans heavily involved in administering the government's programs. Prominent in creating and administering the federal Indian policy were several Christian denominations and a host of religiously inspired individuals, a policy innovation begun during the presidency of Ulysses S. Grant. Deeply concerned about injustices toward Native peoples, determined to eliminate the near-legendary fraud and corruption of the Indian Office, such well-connected "friends of the Indian" could be mobilized in defense of Native interests.

Toward this end, important political leaders, their family members and influential supporters on several Ojibwe reservations formally converted to Episcopalianism, the denomination that had maintained a presence in Ojibwe country during the midcentury decades. At Leech Lake, in July of 1880, the sister of the premier village leader, Flat Mouth, led an initial group of thirty-nine converts from notable families. Prominent among them were the Bongas, with ten family members, including Susie, converting.[13]

If the decades of Susie Bonga's youth had been difficult, the late 1870s and early 1880s were exciting times. Their adaptive revitalization strategy, the Ojibwe believed, was succeeding. They were learning a range of valued skills, from literacy in English to the mechanical knowledge to operate farming equipment. Conflicts with their Euro-American Episcopal friends, who decidedly did not envision an enduring Ojibwe cultural or political existence, had yet to arise. Instead, the two groups could focus on the obvious overlap in their goals. Euro-American and Ojibwe threw themselves into the work of constructing churches and organizing congregations. More compelling, from the Ojibwe perspective, were the simultaneous efforts to create the infrastructure they would need to become subsistence farmers. Land had to be cleared, plowed, and planted in Euro-American fashion with draft cattle and farm machinery; barns, outbuildings, and farmhouses had to be built;

and the Ojibwe had to learn to equip and maintain these possessions, on which their new lifestyle was to be based.

The Episcopalians, like other denominations, advocated conventional Euro-American gender roles for Native peoples, and focused most of their time and energy on transforming the lives of Ojibwe men. They paid far less attention to Ojibwe women. Indeed, efforts to transform women's roles were often understood only within the larger context of altering male work. The Episcopalian head missionary, Joseph A. Gilfillan, a Euro-American, argued that as long as Ojibwe women continued their traditional subsistence pursuits (including agriculture), men would never accept their proper role of family provider. Once women were made into "housekeepers," however, Ojibwe men would be forced to adopt the corresponding male work of farming. Also suggestive of Episcopal priorities was the fact that they supported no female missionaries, who might reasonably be expected to focus their attention primarily upon Ojibwe women, for the first forty years of mission work.[14]

Nor were the wives of male missionaries to involve themselves in active prosletyzing. Joseph Gilfillan made clear his feelings on the work proper for the sexes. Having determined that he and his wife could not both perform missionary work and maintain a household, he advocated a conventional and biblically sanctioned division of labor. Her husband, Harriet Cook Gilfillan recollected, "agreed with the Apostles that 'it is not meet for us to leave the word of God and serve tables.'" Rather than split the household work, "he took the 'Word' and she the 'tables.'" The Gilfillans regularly invited "for supper" "all the good Christian Indians . . . and their wives," with the goal of showing them "a Christian home." Prominently in evidence within that home were the proper male and female spheres. If Native men were to become yeomen farmers, Native women were being offered a familiar vision of female domesticity; they were to become Victorian True Women.[15]

Ojibwe women as well as men discovered that, in seeking to adapt the Euro-American civilization program to their own ends, they needed to learn a daunting range of new skills and work roles. Susie Bonga Wright and her contemporaries began living in log or frame houses equipped with heavy furnishings in place of their mothers' easily cleaned and easily transported bark *wigwams*. They ceased to manufacture basic household items such as storage containers, dishes, and other cooking and eating utensils from forest resources, relying instead on more-fragile crockery that had to be carefully cleaned and maintained. They began cooking on woodstoves instead of open-pit fires, and they had to learn to process and prepare a range of new foodstuffs. As the Ojibwe began wearing Euro-American-style dress, women sought to learn to construct, clean, and maintain clothing and bedding made of wool and cotton instead of tanned animal skins. Ojibwe women evidently

pursued knowledge of their half of the new agrarian lifestyle with an enthusiasm that initially gratified the Euro-American missionaries.[16]

It is in this environment of creative cultural adaptation that Susie Bonga Wright's leadership can be observed within the several arenas that constituted the female community. Deeply committed to the Ojibwe-directed program of social adaptation, Bonga Wright exemplified personally many of the qualities Ojibwe women sought to acquire. She had learned to maintain a household in such model fashion that she was judged "a very good housekeeper" by no less an authority than the patriarchal Joseph Gilfillan. She also had "considerable" Euro-American-style "learning," so that she spoke English "pretty well" and could converse knowledgeably on polite subjects. While the local Euro-American populace praised Bonga Wright as "a very rare girl" for conforming to their image of feminine domesticity, the Ojibwe esteemed her personal characteristics that accorded with their own, long-standing leadership ideals. Her "good sense" and "wisdom" were qualities the Ojibwe expected of their leaders, and the fact that her words and actions were "regulated by the greatest prudence" was far more important in Ojibwe eyes than her "zeal in the cause of religion," which impressed Euro-Americans.[17]

At the same time that the Ojibwe valued the traditional leadership qualities Susie Bonga Wright displayed, there was no doubt that Euro-American approbation enhanced her leadership standing in the classic Métis role as bicultural mediator or broker. Because of her housekeeping skills and good reputation, the Indian agent had hired her for one of the few secure, responsible jobs available to Native women, "the position of Matron of the Indian [boarding] school" at Leech Lake, and locally, "the white people think there is no person like Susie." Bonga Wright built on such expressions of esteem to forge important ties, both to members of the local Euro-American elite and in the wider network of religiously oriented Indian reformers.[18]

Such a brokering role was not without its own unique difficulties, however. Euro-Americans assumed Bonga Wright's wholehearted commitment to their policy of eventual Ojibwe social and cultural absorption into the larger Euroamerican society. The Ojibwe, in stark contrast, trusted Bonga Wright as a broker because she shared their goals of preserving their cultural core and revivifying their communities. Bonga Wright's reputation and social skills gave her an avenue to exploit on Ojibwe behalf, and many of her actions contained "coded" messages, revealing her continued commitment to Ojibwe goals despite her apparent support for Euro-American policies. The unequal power relations between Ojibwe and Americans dictated that such actions had to be subtle, and Susie Bonga Wright excelled at performing actions open to dual interpretation. In one representative instance, she and other Leech Lake women sent beaded moccasins to Bishop Whipple's wife,

Cornelia. From an Ojibwe perspective, the act reiterated an alliance, the giving of gifts symbolizing the ties renewed between two female communities. Euro-Americans viewed such acts in quite a different light, understanding "articles of Indian manufacture" as a "faint expression" of Christianized Indians' gratitude toward their Euro-American benefactors.[19]

While Susie Bonga Wright's public acts and persona were important in demonstrating her leadership capabilities, the critical arena in which she exercised leadership was that core unit of the female community, the work group. Ojibwe women who supported the revitalization effort continued to perform much of their work in groups, as Ojibwe women had historically done, and the work group remained the forum in which they discussed community issues and formulated their opinions. Within this aboriginal political context, Leech Lake women also emphasized their continued commitment to the traditional Ojibwe political goal of consensual, unanimous decision making. "We are all agreed in all we say and do," wrote Bonga Wright and four other influential women in 1882, signifying unanimity by their action of affixing all their names to the letter as well as by their words.[20]

If the Episcopal-inspired adaptations were to succeed, the female work groups would have been a critical component in their success. First and foremost, if Ojibwe women were going to support the proposed innovations, that support would be created, then mobilized, within the work groups. Bonga Wright clearly understood this. She spent much time discussing the proposed adaptive strategy, "getting the Indian women into her room," and "explaining . . . to them" what the adaptations entailed, carefully building the unanimous consent the Ojibwe recognized as constituting a legitimate political decision.[21]

In addition, much of the knowledge of the new domestic skills would have been imparted in the work group setting. Bonga Wright herself noted this, observing that the women "bring sewing in which they need help" to the Episcopalians' women's meetings. The enthusiasm with which Ojibwe women from Leech Lake and other communities attended these women's meetings "to learn knitting sewing cutting &c," also indicates their interest in acquiring the needed new domestic skills.[22]

Less obviously but just as critically, Susie Bonga Wright's activities also reflect the ways the Ojibwe sought to turn the Euro-American civilization program to their own advantage. One of the most public and visible portions of her work, organizing sewing bees and prayer meetings among the Leech Lake women, reveals a distinctive female variant of that process, one all the more fascinating because, superficially, the activities she organized seemed to conform so closely to the ideal of domesticity that Euro-Americans sought to impose on Native women.

In the early 1880s, Bonga Wright and other Leech Lake Episcopal

women had "begun the good work" of organizing a sewing circle. Bonga Wright assured Bishop Whipple that meetings always opened with prayer, and that the women "do not seek *earthly* reward." The Episcopal hierarchy approved heartily, and encouraged all Ojibwe converts to commence such women's meetings. Not only did sewing circles allow Ojibwe women to perfect their new skills of housewifery, the meetings also engaged them in appropriately female charitable work.[23]

Beneath the surface of Susie Bonga Wright's pious remarks, however, lies another, more significant layer of meaning. At the same time they sought to learn the new skills, Bonga Wright and the other Episcopal women reaffirmed their commitment to the traditional Ojibwe redistributive economy. The new-style Anglo-American clothing and bedding made at the sewing bees was "*carefully* given to the needy." The women sought to reinforce community solidarity and avoid partisanship. "We have tried," they wrote, "To be *impartial*."[24]

In addition to their commitment to group solidarity and the traditional economy, the Episcopal Ojibwe women stressed other desired forms of behavior. They reserved their highest praise for one of their number because "she never for an instant had an angry mind to any one." This anonymous woman won community approbation for her efforts to insure group harmony. "[I]f any of them were at enmity between themselves there was she standing in the midst trying to bring them together again." At the same time admirable behavior was praised, reprehensible acts were roundly condemned. Selfishness, viewed with especial antipathy in Ojibwe culture, was vigorously denounced. Bonga Wright's contemporary, Susanna Roy, was excoriated in 1879 when she behaved selfishly. Women complained that Roy had "taken one whole piece of the print [cloth]" for herself when "she ought to have given it to the most needy poor."[25]

Further evidence that the women of Susie Bonga Wright's sewing circle were continuing an older form of Ojibwe female political activity comes from their involvement in larger community issues. The women "boldly spoke" their opinions on community issues, working to insure continued Ojibwe commitment to the values of group solidarity and egalitarian distribution of resources within the new framework of "civilization." They continued their more overt political activities, too, regularly attending and speaking at community councils where the men frequently noted that "the women are heer [sic] to hear what we say." This was not at all to the liking of head missionary Gilfillan, who blasted female political activity as "an injurry [*sic*] to the cause of [the] mission."[26]

Gilfillan's opposition to continuing female political activity reveals much about Euro-American expectations for Ojibwe converts. The Ojibwe had a different perspective, though, which is revealed in the writings of Cana-

dian-born, Ojibwe-Odawa missionary, John Johnson Enmegahbowh. It was his interpretation of gender roles, not Gilfillan's, that the converted Ojibwe supported. Where Gilfillan insisted on separate spheres and female subordination, Enmegahbowh emphasized women's integral importance to community rejuvenation. He urged that Ojibwe women "not keep silence" regarding community concerns. In his writings, he described women as emotionally strong and physically courageous, as more unflinchingly committed to community well-being than men, and as stalwart partners whose example inspired their mates. The women's meetings, he felt, were "doing much good." Quite clearly, the "procivilization" Ojibwe expected female political activity to remain much as it had always been, centered in the work groups and female political councils, and staunchly supportive of community-defined goals.[27]

During these same decades, as the Ojibwe anticipated certain outcomes from their adaptive strategy, they were frequently and jarringly reminded that they now inhabited a world largely not of their own making. In an ironic twist, Susie Bonga Wright found herself and her leadership credibility profoundly challenged *not* from the female world of her supporters, but from men, both Euro-American and Ojibwe. The very nature of the challenge mounted against Bonga Wright indicated how much had been altered. This male intervention in a domain that had always belonged to women also involved a series of issues that had no precedents in Ojibwe society. To her apparent consternation, the critique of Susie Bonga Wright's leadership capabilities was centrally involved in an unfolding Ojibwe dialogue concerning "race."

For the first time in the 1870s and 1880s, the Ojibwe were forced to confront Euro-American notions of "race." The Ojibwe had intermarried for two centuries with the peoples of the Old World, majoritively with Europeans but with the occasional African as well. By the nineteenth century, the Ojibwe population possessed a wide range of physical characteristics. The Ojibwe understood people to belong to a variety of ethnic and national backgrounds, and identified individuals accordingly as French, British, American, Ojibwe, Menominee, Odawa, Dakota, and so forth. Skin color and phenotype were not, however, determining factors in assigning an ethnic identity. Cultural characteristics—the clothing one wore, one's religion, perhaps most important, one's economic pursuits—were a wiser guide, to Ojibwe minds. Thus the Ojibwe had long considered the literate, multilingual, fur-trading, Christian, Afro-Ojibwe Bonga family to be French. Susie's grandfather, Pierre Bonga, of full African ancestry, was a fur trader whose mother tongue was French; his half-Ojibwe son, George, a longtime trader at Leech Lake, had been educated in Montreal and spoke French in addition to Ojibwe and English. Their "race," as Euro-Americans conceptualized that term, was a

point of interest to the Ojibwe, but it was not grounds for assigning them an identity. The African American population of Minnesota remained quite small in the nineteenth century, and the Bongas apparently did not consider themselves part of an African American community. Susie Bonga Wright's generation evidently understood themselves to be Ojibwe. According to her sister, Nancy Bonga Taylor, "we call one another as Indians." When Euro-Americans attempted to impose their conceptions of "race," the result for the Bongas was bewildering and painful.[28]

The dialogue involving "race" commenced when young Charles T. Wright, recently widowed son of Wabanakwad, the respected "head chief" at White Earth Reservation, and himself one of the influential Ojibwe Episcopal deacons, consulted Joseph Gilfillan concerning "the propriety of . . . marrying Miss Susie Bonga." The Episcopal church hierarchy approved of the match, with Gilfillan characterizing her as "wise, chaste and [a] good religious young woman." For Charles Wright, however, there was a major "sticking point": Susie Bonga's African ancestry. While Gilfillan assured his superiors that Susie Bonga "shows the negro blood but little," her family was well known in Ojibwe country and her ancestry was equally well known. Charles Wright had "heard that white people look down on . . . those of negro blood," and this information concerned him. The Episcopal Ojibwe expected him to succeed his father to a preeminent leadership position, and Wright worried about his effectiveness as a leader if an injudicious marriage left him open to "the ridicule of his companions."[29]

The few documents detailing the courtship of Charles Wright and Susie Bonga illuminate striking differences of perception between the men who contemplated the "fitness" of the marriage. Susie Bonga's "race," newly defined, was a central issue, of course, but its significance was very differently understood by Ojibwe and Euro-American men. Gender roles and gender role adaptation were also weighted differently. Taken together, the discussions of "race" and gender also highlight the nature of the challenge to Susie Bonga's leadership, revealing how external to her sources of power and legitimacy it was. Significantly, the people *not* heard from in the nearly two-year period that the marriage was under consideration were Ojibwe women. Without a doubt, they had opinions on the subject, but their voices evidently did not find their way into the documentary record. On that final level, the power differential between men and women in Euro-American society is also revealed, reminding the Ojibwe that while men and women were both affected by the considerable intrusive power of Euro-American society, they were not affected in the same ways nor in equal measure.

For the Episcopalian hierarchy and head missionary Gilfillan, any issues raised by Charles Wright's proposed marriage had to be considered in the context of the overall success of the Episcopal mission endeavor. Central to

Episcopal plans for continued success was a program of grooming young Ojibwe men for the clergy. Commencing their careers as deacons, these carefully selected young men were to form a cadre of dedicated proselytizers who would expand the mission work begun by the earlier generation. In their personal lives, the deacons and their wives were to serve as shining examplars of all the attributes of the Euro-American "civilization" policy. For Gilfillan, upon whose shoulders fell the actual work of fulfilling these expectations, creating exemplary family lives for the deacons was tremendously problematic, commencing with the difficulty of finding "suitable" wives.[30]

Two concerns, both reflective of differing Euro-American and Ojibwe female gender roles, loomed particularly large. First, it was extremely difficult to find "among the Indian girls of marriageable age" young women "known to be pure." Although the Episcopalians struggled mightily to instill Euro-American sexual mores, the Ojibwe of the 1870s and 1880s still regarded premarital sexual activity as normal and natural for young people. In the second place was the problem of finding young women sufficiently knowledgeable about Euro-American housekeeping to be able to maintain what the Episcopalians deemed an appropriate household. The Episcopalians especially wished the deacons and their wives to exemplify the new "civilized" lifestyle with respect to such visible behaviors as dress, eating meals seated at a table at regularly appointed hours, and living in appropriately furnished and neatly kept-up Euro-American-style houses. The work of maintaining these domestic examples, of course, fell to the deacon's wives. Very few young Ojibwe women in the 1870s and 1880s could meet both these criteria. That Susie Bonga could made her a very likely spouse for an Ojibwe deacon, in the minds of the Euro-Americans. Since her African ancestry did not "show" in her physical appearance, Gilfillan felt her "blood" was not "an insuperable bar" to the marriage. Her piety, "spotless character," and qualifications as a good housekeeper far outweighed her mixed "racial" background.[31]

Reflecting Euro-American society's understanding that class was predicated on race, Gilfillan dismissed Charles Wright's concerns about Susie Bonga's African ancestry. As an Indian, Wright could never achieve social equality with Euro-Americans regardless of his professional and educational attainments, and so it little mattered if his wife had "[N]egro blood." That Wright had such concerns, Gilfillan believed, stemmed from unfortunate class pretentions; he considered himself "gentry." What Wright needed, in Gilfillan's estimation, was to focus more on his mission work and less on his presumed high social status. Although women's housework was undervalued in Euro-American society, it was centrally important for creating the lifestyle the missionaries wanted the Ojibwe to adopt, and thus became for them the defining characteristic of what constituted a good missionary's wife. For

Charles Wright, a pious Ojibwe woman skilled in housekeeping "would advance his work far more than any [other] wife he could find[,] Indian or white."[32]

Charles Wright, of course, understood the situation very differently. "[B]eing the son of the Head Chief and expecting to succeed" his father, Wright viewed himself first and foremost as a *political* leader. Not only his father but his grandfather had been a prominent political leader, and the Ojibwe were willing to grant Wright a leadership role if he proved himself capable. Retaining political control of their own communities was a crucial component in the Ojibwe's revitalization effort. While the Euro-American Episcopalians viewed the Ojibwe deacons as the next generation of fervent proselytizers, the Ojibwe understood these young men as a sophisticated new generation of civil leaders, whose ability to speak, read, and write English would enable them to articulate Ojibwe concerns and defend Ojibwe interests effectively. The deacons revealed their priorities when they complained that their English-language training was insufficient. It was not enough that they "could read the Ojibway Book." What they sought, they reminded Bishop Whipple, was to "understand English." Charles Wright deliberately linked his roles as Ojibwe political leader and Christian preacher in his correspondence, signing himself "Charles T. Wright, Son of Chief White Cloud."[33]

Given Charles Wright's commitment to the revitalization effort, and the central role he expected to play in it, political considerations weighed heavily in his choice of a mate (although, as an *ogima's* son with political aspirations of his own, they would have been important in more aboriginal times as well). Ojibwe politics were kinship-based, and the Ojibwe expected that the female relatives of a male political leader would assume positions of leadership among women. Three of Susie Bonga's contemporaries demonstrated that this pattern still operated in the 1870s and 1880s. At her own community, Ruth Flat Mouth, the sister of the premier civil leader, was prominent within the women's community. At White Earth, Susanna Roy was the daughter of one civil leader and sister to another; Oge zhe yashik, also from White Earth, was the wife of "the chief." An *ogima's* wife, if she demonstrated the requisite abilities, could become an important figure in the female political community. In Charles Wright's thinking, a "suitable" wife would be able to galvanize the women's community in support of the revitalization strategy. In her life and actions, she would uphold the cultural attributes the significant adaptations were meant to protect and enhance. By the 1880s, it was no longer enough to consider Susie Bonga's qualifications in the traditional leadership arenas. All too aware of Euro-American racial attitudes, Charles Wright had to wonder if Susie Bonga's African ancestry would prevent other Ojibwe, newly sensitized to the significance of "[N]egro blood,"

from taking her seriously as an *ogimakwe*. And would his own standing as a
leader be jeopardized if he married a woman with African ancestry?[34]

As he contemplated how the Ojibwe would view his marriage to Susie
Bonga, Charles Wright must also have considered the reaction of Euro-
Americans. In spite of his innocent remark about "whites looking down
upon negroes but not at all on Indians," Wright could not have been blind
to the anti-Indian racism of the local Euro-American population. Discrimi-
nation and prejudice against Ojibwe ran the range from small daily humili-
ations to occasional lynchings and murders.[35] As leaders of a new generation
of Ojibwe, the Episcopal deacons self-consciously presented themselves to
Euro-Americans as "civilized" and "Americanized." Their claims to political
autonomy and just treatment were grounded in the assumption that by ac-
cepting "civilization" and Christianity, they had removed any differences
between themselves and Euro-Americans. If the Ojibwe cast their lot with
African Americans, even persons such as Susie Bonga whose African ancestry
did not "show" and who had no ties to an African American community,
did they risk becoming identified with that most despised of American "ra-
cial" minorities? Much about their daily lives already bore a disquieting re-
semblance to the treatment accorded African Americans. To avoid being per-
manently relegated to the lowest and most oppressed racial status, many
Ojibwe people sought to distance themselves from African Americans. In
such a setting, the African American ancestry of some Ojibwe became, sud-
denly, enormously problematic.[36]

Susie Bonga herself was tremendously upset by the controversy her pro-
posed marriage caused, informing Charles Wright "it would be a death-blow
to her" if the marriage did not occur. The Episcopalians understood this
remark in their own cultural terms, as the normal female reaction to a broken
engagement, and Gilfillan "heartily wish[ed]" that, "for the sake of the poor
girl," the marriage would go forward. Yet neither Susie Bonga's words nor
her actions support such an interpretation of Victorian distress. She publicly
expressed herself as having "set her mind on marrying Charles Wright," and
she remained "determined to have him" in spite of the controversy. It is also
highly significant that Susie Bonga was financially independent. With a (rela-
tively speaking) well-paying job as Matron at the Leech Lake boarding
school, plus some money of her own, probably from her recently deceased
father's estate, Bonga did not need to marry for economic security, and in-
deed, had not. In her late twenties at the time of Charles' initial proposal,
Susie was not considered a particularly young woman, either by Ojibwe or
Euro-American standards of the day. Given her own solid commitment to
the Ojibwe-directed adaptations of the 1870s and 1880s, it seems likely Susie
Bonga had not married previously because she had not found a young man
who met *her* standards.[37]

As she considered the marriage proposal of a prospective tribal leader, Susie Bonga, the daughter of a politically prominent family, must have anticipated that her leadership talents and qualities would be closely scrutinized. She probably also assumed, with some confidence, that she would acquit herself well. Her abilities included her success as a broker mediating with Euro-Americans plus her leadership within the women's work groups at Leech Lake. She was deeply disconcerted when discussion focused instead on her "racial" background, newly and negatively defined. Suddenly, in 1880, a racial category that had scarcely existed in previous years mattered more than her firm commitment to Ojibwe community rejuvenation and her impressive personal adaptations in pursuit of that goal. Seen in this light, her remark to Charles Wright that "it would be a death-blow to her" if they did not marry takes on a far more tragic meaning than the conventional interpretation of a broken heart that the Euro-American Episcopalians assigned to it.[38]

Susie Bonga and Charles Wright did eventually marry two years later, but only "after great toil & trouble," over the vexing issue of her African ancestry. Ironically, once the marriage occurred, the "racial" issue seems to have died down; and Susie Bonga Wright's leadership abilities were seemingly unaffected. As Charles Wright's wife, she commenced her sewing circle and it was during these years, the early 1880s, that the Episcopal women were most active in community rebuilding work. By the 1890s, as Bonga Wright reached her forties and achieved the greater status the Ojibwe accorded a mature adult with children, she seems to have solidified a position of even greater respect in both the Ojibwe and Euro-American communities. Yet it is perhaps a reflection of the earlier controversy that, by the 1890s, Bonga Wright did not use her Euro-American name. Instead, she was known to Euro-Americans, including missionaries who saw her daily, either by her Ojibwe name, Chimokomanikwe, or as "Mrs Nashotah," the latter being an anglicization of Charles Wright's Ojibwe name, Nijode. Perhaps her own Euro-American name, especially her surname, Bonga, was too much a reminder of the uncertain racial status accorded her family in the Euro-American world of the late nineteenth century, and as such, better quietly dispensed with.[39]

Susie Bonga Wright's life is by no means completely revealed in the documentary record. Nevertheless, those aspects of her life that do emerge offer important insights into the lives and experiences of Native women. Ojibwe women participated in the political decision-making process of their communities, and continued to have a voice in internal tribal affairs at a time when Euro-Americans granted them no place in the political structures they sought to impose on Native people. Equally striking is the important role Ojibwe women played in their communities' efforts to retain their cultural

integrity and some semblance of autonomy in the face of Euro-American domination.

On a second level, Susie Bonga Wright's experiences, in particular her political activities, also provide insights into the experiences of midwestern Native women other than the Ojibwe. The Ojibwe were not unique among midwestern Native Americans in their efforts to control their interactions with Euro-Americans and to direct the processes of cultural change. Across the Midwest, Native peoples engaged in creative dialogue with representatives of Euro-American (and, in earlier periods, European) cultures. Religious issues, in particular making sense of Christianity, were major concerns of long standing. The work of Carol Devens notwithstanding, the process was more complex than simple acceptance by men and rejection by women. In *The Middle Ground*, Richard White reveals the complexities of midwestern Native people's perceptions and utilizations of Christian religious teachings. In one instance, he notes, Illinois women in the 1690s embraced Catholic teachings, especially worship of the Virgin Mary, to assert a set of regenerated community norms in a time of "warfare, direct cultural challenge by Jesuits, population decline and . . . widespread violence against women." In many respects, then, the efforts of Susie Bonga Wright and her contemporaries to use Christianity creatively as a weapon in their own defense had a long history in the Midwest. The actions of the Illinois women, nearly two hundred years prior to Susie Bonga Wright's own efforts, underscore as well the enduring importance of female political action in midwestern Native communities.[40]

A second aspect of Susie Bonga Wright's life, her changing "racial" status, speaks poignantly to issues of cultural contact that scholars of the Midwest are only beginning to examine. In Chapter 6 of the present volume, Tamara G. Miller observes that, in the early nineteenth century, the Midwest was characterized by considerable ethnic and cultural diversity. This observation can certainly be extended to the region's Native American population, which comprised dozens of independent political and cultural entities. The fur trade–based Métis society that spanned the region was composite by its very nature. As Americans, people whose political allegiance was to the United States (however varied their own regional or ethnic background), came to dominate the region, however, they sought to impose, among other things, their understandings of "race" on the disparate populations they encountered.

Euro-Americans explicitly rejected the *cultural* categorization of persons that had marked Native and Métis societies. Instead, they attempted to assign racial statuses on the basis of biological "facts." Such physical characteristics as skin color, hair color and texture, and eye color became particularly important indicators of "race." Most significantly, Euro-American "ra-

cial" categories were exclusive; they rejected intermediary statuses. One could be "Indian" or "white"; one could not be both. Thus the bicultural and bi-"racial" Métis found no place for themselves within the Euro-American system of racial classification. The Bongas, along with other "mixed-blooded" families, struggled to understand the new categorizations and the new "racial" identities open to (or denied) them. Because their non-Native ancestry was African rather than European, the Bonga family faced unique challenges to their sense of ethnic identity. Susie Bonga Wright's bewildered pain at the controversy over her marriage underscores the human cost involved in the Euro-American effort to redefine "race."[41]

The complexities of race and ethnic identity in the Midwest are by no means resolved by this examination of the life of Susie Bonga Wright. Just as Bonga Wright's political activities provide only a glimpse into Native women's political participation, so, too, her struggles to comprehend Euro-American conceptions of "race" underscore how much remains to be done on this topic. Continuing scholarly examination of differing cultural conceptions of "race" promises to expand further our understanding of cultural diversity among all the populations of that allegedly most homogenous of regions, the Midwest.

Notes

1. The author would like to thank the Research Committee of the Academic Senate of the University of California, Riverside, for their support of this research; thanks also to Lucy Eldersveld Murphy, an editor of great patience, optimism, and unending good humor.

2. Recent treatments exploring new dimensions in Native women's lives include Clara Sue Kidwell, "Indian Women as Cultural Mediators," *Ethnohistory* 39 (Spring 1992): 97–107; Sylvia Van Kirk, "Toward a Feminist Perspective in Native History," in William Cowan, ed., *Papers of the 18th Algonquian Conference* (Ottawa: Carleton University Press, 1987); see also Rayna Green, "The Pocahontas Perplex: The Image of Indian Women in American Culture," *Massachusetts Review* 16 (1975): 698–714.

3. Smith and Winslow quoted in Robert S. Grumet, "Sunksquaws, Shamans, and Tradeswomen: Middle Atlantic Coastal Algonkian Women during the 17th and 18th Centuries," in Mona Etienne and Eleanor Leacock, eds. *Women and Colonization: Anthropological Perspectives* (New York: Praeger Publishers, 1980), 43–62, 49, 50. Adair quoted in Theda Perdue, "The Traditional Status of Cherokee Women," *Furman Studies* 5 (1980): 19–25, 20. On Iroquois women: Diane Rothenberg, "The

Mothers of the Nation: Seneca Resistance to Quaker Intervention," in Etienne and Leacock, op. cit., 63–87; Judith K. Brown, "Economic Organization and the Position of Women among the Iroquois," *Ethnohistory* 17 (1970): 151–67; Cara B. Richards, "Matriarchy or Mistake: The Role of Iroquois Women through Time," in Verne F. Ray, ed., *Cultural Stability and Cultural Change*, Proceedings of the 1957 Annual Meeting of the American Ethnological Society (Seattle: University of Washington Press, 1957), 36–45; and Anthony F. C. Wallace, *The Death and Rebirth of the Seneca* (New York: Alfred A. Knopf, 1970 [originally published 1955]). For Netnokwa, *The Falcon: A Narrative of the Captivity and Adventures of John Tanner* (New York and London: Penguin Books, 1994 [originally published 1830]). Anthropologists special-izing in the study of Algonkian peoples including the Ojibwe observe that Net-nokwa was not unique in her role as an important and respected female political leader; rather, the scarce documentary record has obscured the lives of other female political leaders. James McClurken, personal communication.

4. Kenneth Wiggins Porter, "Relations between Negroes and Indians within the Present Limits of the United States," *Journal of Negro History* 17 (July 1932): 287–367; and Porter, "Negroes and the Fur Trade," *Minnesota History* 15 (December 1934): 421–33.

5. Priscilla K. Buffalohead, "Farmers, Warriors, Traders: A Fresh Look at Ojib-way Women," *Minnesota History* 48 (Summer 1983): 236–44. Ruth Landes's ethno-graphic classic, *The Ojibwa Woman* (New York: W. W. Norton & Company, 1971 [originally published 1938]), unfortunately contains no examination of women's po-litical activities.

6. Wa ge ji ge zhik, Oge zhe ya shik, and George B. Johnson to Henry B. Whipple, July 28, 1882, Henry Benjamin Whipple Papers (hereafter Whipple Papers), Box 15, Minnesota Historical Society (hereafter MHS); Susanna Roy to Whipple, April 13, 1882, Whipple Papers, Box 16, MHS. For the word *ogimakwe*, translated as "a female chief," see Bishop Frederic Baraga, *A Dictionary of the Ojibway Language* (Montreal: Beauchemin and Valois, 1878), pt. 2, 317.

7. Mrs. J. J. Enmegahbowh, Mrs. E. W. Minogeshig and Mrs. Anna Negaun to Mrs. and Miss Stowe, March 6,1878, Lewis Stowe Papers, Box 1, MHS.

8. Giacomo C. Beltrami, *A Pilgrimage in Europe and America, Leading to the Discovery of the Source of the Mississippi and Bloody River; with a Description of the Whole Course of the Former, and of the Ohio*, 2 vols. (London: Hunt and Clarke, 1828), II, 448. See untitled newspaper article from the St. Anthony's Falls *Democrat*, Feb-ruary 11, 1870, in Works Projects Administration, Minnesota Writers Project Annals, Subject Files, Box 170, "Nationality Groups—Indians, 1870–77" (hereafter WPA Pa-pers), MHS (women confiscating weapons); William Whipple Warren, "History of the Ojibways, Based upon Traditions and Oral Statements." Minnesota Historical Society *Collections* 5 (1885): 3–394, 301; and Jedediah D. Stevens Diary, Jedediah Dwight Stevens Papers, MHS (Ojibwe efforts to monitor drinking behavior).

9. Susanna Roy to Whipple, April 13, 1882, Whipple Papers, Box 16, MHS. In addition to Landes, *The Ojibwa Woman*, op. cit., 124–77, anthropological descrip-tions of women's work include Frances Densmore, *Chippewa Customs* (St. Paul: Min-nesota Historical Society Press, 1979 [originally published 1929]), 119–28 and passim.; and Sister M. Inez Hilger, *Chippewa Child Life and Its Cultural Background*, Smith-sonian Institution Bureau of American Ethnology Bulletin 146 (Washington: Gov-ernment Printing Office, 1951), 52, 55, 115–16, 129–30, 137–38, 141, 147, 156, 170–71.

Mid-nineteenth-century ethnographic accounts discussing women's work are J. G. Kohl, *Kitchi-Gami: Life Among the Lake Superior Ojibway* (St. Paul: Minnesota Historical Society Press, 1985 [originally published 1860]), 3–11, 29, 29–31, 46–47, 315–16, 412–14; and Warren, "History of the Ojibways," 186, 264–66, 337–38.

10. Pauline Colby, "Reminiscences," 1894– c. 1908, pp. 49, 65, MHS.

11. For Ojibwe socioeconomic decline and the political divisions thus engendered, see Rebecca Kugel, "'To Go About on The Earth,' An Ethnohistory of the Minnesota Ojibwe, 1830–1900," (Ph.D. diss., University of California, Los Angeles, 1986); especially chapters 4 and 5.

12. For American Indian policy during the second half of the nineteenth century, see Francis P. Prucha, *American Indian Policy in Crisis: Christian Reformers and the Indian, 1865–1900* (Norman: University of Oklahoma Press, 1976).

13. "Leech Lake Confirmations," July 23, 1880, Whipple Papers, Box 38, MHS.

14. Joseph A. Gilfillan to Whipple, February 15, 1876, Whipple Papers, Box 11, MHS.

15. "Home Life," by Harriet Cook Gilfillan, n.d. [c. 1880s], Joseph A. Gilfillan Papers, Box 1, MHS; Gilfillan to Whipple, October 25, 1878, Whipple Papers, Box 13, MHS. For the True Womanhood ideal, see Barbara Welter, "The Cult of True Womanhood, 1820–1860," *American Quarterly* 18 (1966): 151–74.

16. See Colby, "Reminiscences," p. 56, for the new knowledge and considerable physical labor involved in maintaining a Euro-American-style household.

17. Gilfillan to Whipple, May 20, 1880, Whipple Papers, Box 14, MHS.

18. Gilfillan to Whipple, May 20, 1880, Whipple Papers, Box 14, MHS. Colby "Reminiscences," pp. 82, 83, 93–94, and 103, for Bonga Wright's role as bicultural intermediary.

19. Gilfillan to Whipple, December 3, 1875, Whipple Papers, Box 11; Gilfillan to Whipple, June 10, 1887, Whipple Papers, Box 19, MHS.

20. Susie B[onga] Wright, Mrs. Kate Reese, Mrs. Elizabeth [blank in ms], Mrs. Maggie Selkirk, Miss Ruth [Flatmouth] to Whipple, September 22,1882, Whipple Papers, Box 16, MHS.

21. Gilfillan to Whipple, May 20, 1880, Whipple Papers, Box 14, MHS.

22. Susie B[onga] Wright, Mrs. Kate Reese, et al. to Whipple, September 22, 1882, Whipple Papers, Box 16, MHS; Gilfillan to Whipple, December 3, 1875, Whipple Papers, Box 11, MHS.

23. Susie B[onga] Wright, Mrs. Kate Reese, et al. to Whipple, September 22, 1882, Whipple Papers, Box 16, MHS.

24. Susie B[onga] Wright, Mrs. Kate Reese, et al. to Whipple, March 11, 1883, Whipple Papers, Box 16, MHS.

25. Madjigishick to Whipple, January 5, 1887, Whipple Papers, Box 18, MHS; Mrs. C. Johnson to Whipple, August 15, 1879, Whipple Papers, Box 14, MHS. See A. Irving Hallowell, "Ojibwa Ontology, Behavior and World View," in Dennis Tedlock and Barbara Tedlock, eds., *Teachings from the American Earth: Indian Religion and Philosophy* (New York: Liveright, 1975), 141–78, for the opprobrium attached to selfishness and greed.

26. John Johnson Enmegahbowh to Whipple, January 18, 1880, Whipple Papers, Box 14, MHS; "Committee of Ma ji gi zhik's Band" to Whipple, August 14, 1881, Whipple Papers, Box 15, MHS; Enmegahbowh to Whipple, September 23, 1878, Whipple Papers, Box 13, MHS.

27. Enmegahbowh to Whipple, January 18, 1880, Whipple Papers, Box 14; Enmegahbowh to Whipple, September 23, 1878, Whipple Papers, Box 13, MHS. For positive characterizations of women, see Enmegahbowh, "The Death of Chief Tuttle," in *The Church and the Indians*, January 13, 1874, Whipple Papers, Box 10; Enmegahbowh to Whipple, March 7, 1876, and May, 1894, Whipple Papers, Boxes 11 and 22, MHS.

28. Testimony of Nancy [Bonga] Taylor, March 3, 1914, Ransom Judd Powell Papers, Box 6, MHS.

29. Gilfillan to Whipple, May 20, 1880, Whipple Papers, Box 14, MHS.

30. Pamphlet, "The Indian Deacons at White Earth," December 5, 1888, Gilfillan Papers, Box 1, MHS; Gilfillan to Whipple, November 13, 1876, and October 10, 1878, Whipple Papers, Boxes 12 and 13, MHS (expectations for deacons).

31. Gilfillan to Whipple, May 20,1880, Whipple Papers, Box 14, MHS; Gilfillan to Whipple, November 5, 1877, Whipple Papers, Box 12, MHS; Gilfillan to Whipple, May 20, 1880, Whipple Papers, Box 14, MHS. Gilfillan to Whipple, January 17, 1874, and July 24, 1879, Whipple Papers, Boxes 10 and 13, MHS (traditional Ojibwe sexual mores); Gilfillan to Whipple, May 20, 1880, and December 3, 1875, Whipple Papers, Boxes 14 and 11, MHS (expectations for deacons' wives).

32. Gilfillan to Whipple, May 20, 1880, Whipple Papers, Box 14, MHS; Gilfillan to Whipple, November 21, 1882, Whipple Papers, Box 16, MHS; Gilfillan to Whipple, May 20, 1880, Whipple Papers, Box 14, MHS.

33. Gilfillan to Gilbert, March 10, 1892, Fred Smith to Whipple, June 27, 1878, and Charles T. Wright to Whipple, June 25, 1892, Whipple Papers, Boxes 22, 13, and 22, MHS. Of the eight original deacons, seven were the sons of political leaders or their close supporters. See pamphlet, "The Indian Deacons at White Earth," December 5, 1888, Gilfillan Papers, Box 1, MHS.

34. Gilfillan to Whipple, May 20, 1880, Whipple Papers, Box 14, MHS. See: Susie B[onga] Wright, Mrs. Kate Reese, et al. to Whipple, September 22, 1882, Whipple Papers, Box 16, MHS (Ruth Flatmouth); E. Steele Peake, "Reminiscences," c. 1856, Protestant Episcopal Church Diocese of Minnesota Papers (hereafter PEC Papers), Box 46, volume 44, MHS (Susanna Roy); Gilfillan to Whipple, September 12, 1881, Whipple Papers, Box 15, MHS (Oge zhe ya shik).

35. Gilfillan to Whipple, May 20,1880, Whipple Papers, Box 14, MHS. For the range of abuses the Ojibwe suffered, see Peake to Whipple, July 8, 1884, Whipple Papers, Box 17, MHS (Ojibwe men called "boys"); William H. Williams to Edward P. Smith, August 16, 1873, RG 75 M234 Roll 160: 635–36 (Ojibwe cheated by merchants); Enmegahbowh to Whipple, May 15, 1872, Whipple Papers, Box 9, MHS (Ojibwe fired on by Euro-American settlers); "Minnesota Justice—White and Red," newspaper article from the St. Paul *Pioneer*, December 10, 1872, RG 75 M234 Roll 160: 585 (Ojibwe murdered in cold blood by Euro-Americans); "Lynch Law in Brainerd," newspaper clipping from the Brainerd *Tribune*, July 27, 1872, in WPA Papers, Box 170, MHS (lynchings).

36. See James H. Merrell, "The Racial Education of the Catawba Indians," *Journal of Southern History* 50 (August 1984), 363–84, for another Native people's efforts to comprehend Euro-American definitions of "race."

37. Gilfillan to Whipple, May 20, 1880, Whipple Papers, Box 14, MHS. See "Confirmations, Leech Lake," July 23, 1880, Whipple Papers, Box 38, MHS (Susie Bonga's age); Albion Barnard to Edward P. Smith, January 7, 1875, National Archives

Microfilm Publications, Record Group 75, Microcopy 234, Roll 162: 28 (George Bonga's death); James Bonga to Whipple, July 7, 1877, and Sela G. Wright to Whipple, July 7, 1877, Whipple Papers, Box 12, MHS (provisions of George Bonga's will).

38. Gilfillan to Whipple, May 20, 1880, Whipple Papers, Box 14, MHS.

39. Gilfillan to Whipple, January 16, 1882, Whipple Papers, Box 15, MHS; Colby, "Reminiscences," 82–83, where Bonga Wright is referred to as "Gemokomaniqua," Colby's rendering of Chimokomanikwe; 93–94, 98, 103, where she is referred to as "Mrs. Nashotah."

40. Richard White, *The Middle Ground: Indians, Empires, and Republics in the Great Lakes Region, 1650–1815* (Cambridge, MA: Cambridge University Press, 1991), 67; Carol Devens, *Countering Colonization: Native American Women and Great Lakes Missions, 1630–1900* (Berkeley: University of California Press, 1992).

41. Jacqueline Peterson, "Prelude to Red River; A Social Portrait of the Great Lakes Metis," *Ethnohistory* 25 (Winter 1978): 41–67; Melissa L. Meyer, *The White Earth Tragedy: Ethnicity and Dispossession at a Minnesota Anishinaabe Reservation, 1889–1920* (Lincoln: University of Nebraska Press, 1994); also Tanis Chapman Thorne, "People of the River: Mixed-Blood Families on the Lower Missouri," (Ph.D. diss., University of California, Los Angeles, 1987).

2

Journeywoman Milliner

Emily Austin, Migration, and Women's Work in the Nineteenth-Century Midwest

LUCY ELDERSVELD MURPHY

W E ARE TOLD that the women of America have much leisure time," a Norwegian immigrant wrote home from Iowa in 1862, "but I haven't yet met any woman who thought so!"[1] As she had discovered, nineteenth-century midwestern women—even middle-class "ladies"—worked hard. In fact, one of the most distinctive features of women's experiences in the nineteenth-century Midwest was their work. By comparison with other regions, particularly the South and Northeast, midwestern women's work differed in its scope and limits. Midwestern women's work was affected by family and life cycle stages, by access to kin, by local economies, and by community values, culture, and wealth. Women's efforts ranged from work within the family, to self-employment, to wage work; from changing diapers, to selling homemade butter or maple sugar, to taking boarders, shopkeeping, or teaching school; and even to volunteer work in community service.

Some of the work patterns may be seen in statistics gathered by census takers. For example, the 1870 federal population census reveals certain regional variations in women's occupations. (See Table 1.) As compared with women in the Northeast and South, a smaller percentage of females age ten and over were categorized as "gainfully employed" in the Midwest. Relatively large percentages of these midwestern workers were domestic servants and teachers, and fewer were in industrial or agricultural wage work.

Statistics for the southern states reveal, by contrast, the effect of an overwhelmingly agricultural economy, the legacy of slavery and cultural acceptance of agricultural wage work for women. Cultural values as well as educational and skill opportunities in the South are also evident in the small numbers of teachers and workers in garment and fashion trades.

The Northeast was notable for its large numbers of industrial workers. About one-third of New England women counted as working were in non-

sewing industrial occupations, huge numbers of them as cotton mill opera-
tives. In the larger northeastern cities, clothing and bonnet production had
by 1870 been organized on a large scale, employing many women workers at
notoriously low wages.[2] Relatively small percentages of female wage earners
were teachers or servants, and almost none were agricultural workers.

In the 1870s, most of the Midwest was still not industrialized, a fact with
important implications for women and their work. In the towns, women
worked in small family craft shops and retail stores, sometimes as proprietors
in their own right. Clothing and bonnets were generally produced locally,
within families or in small shops. Wage work was available for educated
daughters as teachers, and for the uneducated as household workers, but
there were few industrial jobs.[3] Data for the West appear similar, except for
California's large number of workers in service occupations.

Unfortunately, the picture of women's work provided by the 1870 federal
population census—or any census—is quite limited. It reveals merely a count
of workers at a moment in time. It sees only some workers, some of those
who were paid in cash, overlooking both labor within the family economy
and production for sale or barter on a small scale, such as the socks knitted
or boarders taken in. Census takers often missed seasonal and part-time work
and self-employment, and they often assumed without asking that women
were not "gainfully employed." When a census taker knocked on a door, he
and the respondent had to identify a person's primary occupational identity:
predictably when there were several to choose from, the term "keeps house"
generally ranked first. Of course, "keeps house" and its many variations did
not appear on the occupational tables of the census compendiums, because
it was not considered "gainful employment."[4]

Even so, occupational data miss the many nuances of women's work.
More difficult to find than numbers of workers are the seasonal rhythms,
the importance of stages in the life cycle and family formation, the signifi-
cance of access to kin. What was the range of experiences possible within
one life? How important was the accessibility of skill? What effect could a
local community have on a woman's work? What effect did migration have
on the midwestern female worker, and to what extent might she use it as an
adaptive strategy? How could work both affect and reflect a woman's iden-
tity and values?

An unusual document that sheds light on these issues, the autobiography
of Emily Austin, was published in 1882 in Madison, Wisconsin. Although
many midwestern women left memoirs, this one stands out because, unlike
others, it records the experiences of an artisan woman, a frequent migrant,
who experienced aspects of small-town life in the Midwest usually obscured
in the historical record.[5]

Emily had been married four times, so she had gone by five surnames.

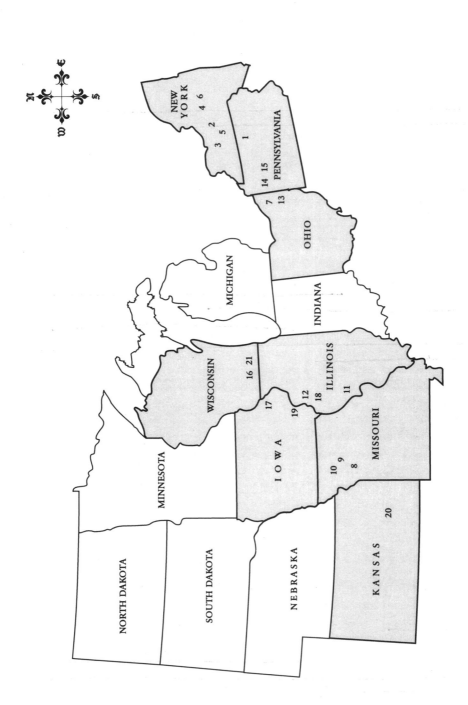

Figure 2. The Migration of Emily Austin, 1813–1901

Terry Sheahan 1996

Emily Austin Chronology

Location	Approximate Date	Special Event
1. Tioga County, Pa.	1813	Emily Coburn born
2. Unadilla River, N.Y.	1818	
3. Greene Twp., Chenango County, N.Y.	1821	
4. Guilford, N.Y.	1823	
5. Sanford, N.Y.	1827	1829 joined Presbyterian Church
	1830	June 1830, baptized a
6. Guilford, N.Y.		Mormon
7. Kirtland, Ohio	1830	
8. Jackson County, Mo.	1831	1833 married Clark Slade
9. Clay County, Mo.	1834	1834 Helen born
		1836 Elizabeth born
10. Far West, Caldwell County, Mo.	1836	1838 William born
11. Pittsfield, Ill.	1839	1840 Sarah Frances born
		1842 Clark, Jr., born
		1842 Clark, Sr., died
12. Nauvoo, Ill.	1841	
13. Wayne, Ohio	1843	
14. Espyville, Pa.	1847	1847 joined Methodist Church
15. Meadville, Pa.	1850	
16. Madison, Wisc.	1851	1852 married James B. Finch
17. Bellevue, Iowa	1853	
18. Nauvoo, Ill.	1859	Early 1860s married James H. Ward
19. Fort Madison, Iowa	1871	1871 Emily and James separated
20. Burlingame, Kans.	1872	1873 James Ward died
21. Madison, Wisc.	1874	1877 married Philander Austin
		1882 published book
		1901 Emily died

Table 1 Women's Work in 1870, in Selected States and Occupational Categories

State	Number of Women Workers	Workers as a Percentage of All Women	Servants	Teachers	Other Professional and Personal Service Providers*	Agricultural Wage Workers	Milliners, Dressmakers	Seamstresses and Tailoresses	Industrial Workers, Not Sewing
Ill.	63,283	7 %	66 %	9 %	8 %	2 %	8 %	5 %	2 %
Iowa	23,126	6 %	64 %	19 %	3 %	2 %	10 %	2 %	**
Maine	28,441	12 %	38 %	1 %	15 %	**	8 %	8 %	29 %
Mass.	128,301	21 %	34 %	5 %	4 %	**	6 %	10 %	39 %
N.Y.	257,039	15 %	54 %	6 %	7 %	**	10 %	9 %	12 %
Va.	75,201	16 %	61 %	2 %	8 %	22 %	1 %	3 %	3 %
Miss.	86,501	30 %	15 %	**	8 %	76 %	**	**	**
Tex.	28,595	10 %	37 %	2 %	9 %	49 %	**	2 %	**
Calif.	13,780	9 %	56 %	8 %	15 %	2 %	10 %	6 %	2 %
Ore.	683	3 %	53 %	20 %	10 %	2 %	10 %	2 %	2 %

*includes boardinghouse keeper, hairdresser, hotel worker, waitress, laborer (unspecified), laundress, nurse, physician, music teacher, and 60 other occupations.
**less than 2 percent.
Source: *Ninth Census of the U.S. 1870* 1:686–94.

Wisconsin was merely one of eight states and Madison one of eighteen communities in which she had lived during her sixty-nine years, since she had moved, on the average, two or three times each decade. She had embraced three different faiths: Presbyterian, Mormon, and Methodist. She had borne five children, and, widowed, failed in her struggle to support them, placing them in foster homes. As they came of age she watched them scatter south and west and then followed. She had been poor most of her life, sometimes even hungry, but had several times achieved for a few years a measure of what she considered success. Although she had been a wife, widow, migrant, church member, and mother, in her seventieth year Emily Austin identified herself first and foremost as a hardworking milliner. Emily worked at millinery—the making, trimming, repairing, and reconstructing of bonnets—in ten different places between about 1828 and 1873. This identity was a source of pride for her, because of its links to craft traditions and to women's culture, both of which were highly valued in the villages of the late nineteenth-century Midwest. Even more important, she valued this identity as a source of independence.

Emily wrote her autobiography at the urging of "disinterested persons" because she had been among the earliest converts to the Mormon religion, and had been a member of that church for about twelve years.[6] The book is entitled *Mormonism; or, Life among the Mormons.* Clearly aimed at an audience hungry for literature critical of the Latter-day Saints, it conforms to many of the conventions of anti-Mormon literature such as discussion of plural marriage and the Danites fringe group.[7] But beneath the "exposé" of Mormon life (which Emily actually recorded fairly accurately) is a proudly told story of one tough woman's travails. Fortunately, Emily either could not or would not separate her experiences with the Mormons from her entire life story, even though she spent only about a dozen years "among the Mormons."

In many ways, the book flows like an old woman's spoken stories, skipping over long periods of time, wandering off the subject to cite scripture or give advice, then suddenly returning, occasionally backing up to give some forgotten exposition. But writing didn't come easily to Emily. "Feeling my incapability of doing literary work, I hope to be generously pardoned for all mistakes, both in form and in language, of this little history," Emily wrote in her preface.[8] The many flaws in her prose—including malapropisms, poor punctuation, awkward phrasing, and confusing organization—suggest that Emily's manuscript was not edited, a circumstance appreciated by the historian listening for the subject's original voice. Although Emily mentioned the names of communities, only a few dates and people's names appear in the book: these details had to be pieced together from outside sources such as census and marriage records.

fluidity

Much can be learned from this book about the ways in which skill, gender, location, health, economy, and kin intersected to influence individual welfare in the nineteenth century. Emily's experiences also reveal the fluidity of social class, wealth, occupation, and family roles in the Midwest. In addition, they demonstrate a great deal about the family, especially its fragility.

As an overview, Emily's life can be seen in four phases: childhood, young adulthood, a period of widowhood with young children, and a phase from midlife on.

Phase I, 1813–1830: Childhood

By the time Emily Coburn was born January 30, 1813, in Tioga County, Pennsylvania, migration had become a family tradition. Her paternal grandparents had migrated from Massachusetts to Connecticut, and Emily's uncles located in Vermont, Pennsylvania, Wisconsin, and New York. Her mother, Rose Linda Lyon, descended from Indian traders, farmers, and millers, while Emily's father, Amariah Coburn, came from a family of innkeepers, artisans, and farmers.[9]

Emily's parents changed occupations and residences every three or four years, generally staying in and around Chenango County, New York, after Emily's fifth birthday. Her father most enjoyed the not-very-lucrative occupation of a singing teacher, although he and Rose Linda also tried farming and hotel keeping. When he left his wife and seven children for three years to seek his fortune in Canada, Emily recalled, her mother "hired a lady in the house to learn us to braid straw," to help support the family in a common form of home manufacture. The braided straw would be exchanged for credit at the local general store. Rose Linda also sent a son to apprentice as a tanner with an uncle, but times must have been very hard with Amariah gone because she had to give up two daughters for adoption. Emily's brother-in-law would later record with considerable understatement that Amariah's absences "threw a heavy burden upon the mother in rearing her family."[10]

At about age 13, Emily was sent to apprentice at millinery to her brother's wife, and she spent two or three years learning to make, clean, repair, and trim bonnets—skills that would be extremely important to her, particularly later in life.[11]

When in June of 1830, Emily, her sister Sally, and Sally's husband Newel Knight became three of the earliest followers of the Mormon Prophet, Joseph Smith, it created an uproar not only in the Coburn family but also generally in two communities, to the extent that Smith was jailed and tensions nearly erupted into riots. Soon the three joined the Mormon migration westward.[12] This was the first time Emily herself made the decision to migrate; following examples set by her parents and grandparents, she would

make similar decisions every three or four years for most of the rest of her life.

Phase II, 1830–1843: Young Adulthood, The Mormon Years

Beginning in 1830, Emily, Sally, and the Knight family were part of the Mormon migrations to Kirtland, Ohio, and to Missouri, where, in 1833 at age twenty, Emily married Clark Slade, the cousin of Sally's husband. For about six years Emily and Clark attempted to farm.

After the Latter-day Saints were chased out of three counties in Missouri by intolerant neighbors, the family fled to Pittsfield, Illinois in 1839. Clark and Emily had exhausted their resources.[13] Their efforts at tenant farming near Pittsfield met with little success. There Emily worked at millinery as her husband was dying of "consumption." By 1842, she was a twenty-nine-year-old widow with five children between the ages of nine years and six months, and she moved to Nauvoo to be near Clark's relatives, who took two of Emily's girls into their homes for several years.

Nauvoo, the central Mormon settlement, was at this time the largest city in Illinois, with a population of between 10,000 and 16,000. Emily taught a small elementary school in her house, until she became disillusioned with the Latter-day Saints in about 1843 over the issue of plural marriage, and migrated back east, three years before the Mormon exodus to Salt Lake.[14]

Phase III, 1843–1851: Widowhood

The third phase of Emily's life, during which she was a young widow struggling to support her five children, was characterized by disappointment and failure. During this eight-year period, she migrated to be near her friends and brothers in northeastern Ohio and northwestern Pennsylvania. Typical of her preference for small towns, Emily lived in Wayne, Ohio, and Espyville and Meadville, Pennsylvania. Although she worked at millinery and nursing in an attempt to keep her children together, and she dreamed of having "a snug little home," ill health and poverty made Emily place her children in foster homes and live as a boarder. "There is no torture so cruel as for a mother to be separated from her children; however hard this may be, many a mother has been under the necessity of enduring this thorn in her side during her natural life," Emily commented in retrospect.[15] Like her mother, who had been forced to give up two daughters, Emily's maternal success was thwarted by poverty.

Phase IV, 1851–?: Wife and Proprietor

In about 1851, Emily entered a period during which she spent much of her time as a millinery proprietor, experiencing some success in midwestern towns: in Madison, Wisconsin; in the Mississippi River towns of Bellevue and Fort Madison, Iowa, and of Nauvoo, Illinois; and (as an assistant) in the east Kansas town of Burlingame. She lived with or near her adult children for about half of these years, although she supported herself.

Emily married at least three more times: in 1852 (at age thirty-nine) to James B. Finch in Madison, in the early 1860s (at about age fifty) to James H. Ward in Nauvoo, and in 1877 (at age sixty-three) to Philander Austin in Madison. (Only the marriage to Ward was recalled in Emily's memoir.)[16] After the 1882 publication of her book, her whereabouts are difficult to trace, although according to one source, she died in 1901 in an unknown place.[17]

Emily's experiences reveal a great deal about the nineteenth-century midwestern family, migration, work, and the ways they intersected. Migration was a dominant theme of the nineteenth-century midwestern experience. Throughout the century, scholars have found, no more than 40 percent to 60 percent of Americans stayed in one community for a decade, and even fewer persisted in areas of recent white settlement.[18] Emily was one of those "floating" migrants about whom the authors of community studies can only wring their hands and make statements of despair, such as John Mack Faragher's remark, "the private histories of the mobile majority are largely lost to us."[19] Emily's book, however, provides a rare opportunity for studying the experiences and mobility of one of those people who never persisted from one decennial census to the next.

Many of the northeasterners migrating to the Midwest were refugees from a society in economic and social flux. Among them were the Mormons, whose leader Joseph Smith revived the communal ideal. According to Whitney Cross, Smith "resurrected the strong sense of social obligation. . . . Born Yankees troubled by the problems of security in a more individualistic society found this doctrine pleasing."[20] Like other migrants to the Midwest, the Mormons included large numbers of energetic, lower-class people "of an entrepreneurial spirit."[21]

Migration *to* the Midwest might mean leaving for a less complex economy or for an ideal vision of community, but what about migration *within* the Midwest? For women in particular, this intraregional migration is hard to decipher. Emily's case shows us how complex the process of—and motivations for—migration could be.[22]

Emily moved, on the average, every three or four years. Her mobility seems to have been part of a family pattern of grouping and regrouping, a form of chain migration. When she joined the Mormon church, it was not only an act of religious faith, but an act of affiliation with her older sister in preference to her parents. After her husband's death, she moved repeatedly to be near her siblings and mother, and later her adult children, who were themselves migrating within the Midwest. On two or three occasions, she moved to be near friends.

But Emily's migrations can be seen not only as moving to be near kin or friends, but also as leaving behind bad economic, family, and marital situations. Most men in the eighteenth and nineteenth centuries had independence as their primary goal; so, too, did Emily. Although she moved often to be near relatives, she kept working, and apparently maintained separate residences most of the time. As long as she was healthy, she avoided dependence on children or siblings, and moved away from them when she could not get millinery work nearby.[23] Clearly, work opportunity was another factor influencing Emily's decisions to move.

There is some evidence to suggest that Emily's second and third marriages failed and that two of her moves may have been responses to these situations.[24] Emily seems to have regretted her second marriage, in 1852 at age thirty-nine to James Finch. She did not mention him in her memoir, so he remains a mysterious figure. She used his surname for a short time after moving to Bellevue, but appeared in the next census using her first husband's surname. According to her book, Emily separated from her third husband, James Ward, "for reasons which I shall not name at present," and then he died.[25] Emily published her book under her fourth husband's surname, as Emily M. Austin, but never mentioned him either. According to the marriage records of Madison's First Methodist Church, Emily Ward married Philander Austin, a teamster, in 1877 when she was sixty-three. We may hope that she was happier with this match than with Finch and Ward, who apparently inspired at least two of her migrations.[26]

The nineteenth-century family was fragile. Migration certainly helped to fragment it, even when family members traveled with kin. Emily and her siblings, children, and even mother and uncles scattered across the Midwest, making their company and their assistance much less accessible. Death, of course, changed families in several ways. The gendered nature of work was a major factor in this change. If a mother died, her children might be dispersed to those who could do the "women's work" of child care. For example, when Emily's sister Sally died, Emily raised Sally's two-year-old son until Newel remarried, since Newel evidently did not feel he could care for a small child by himself.[27]

If a man died, those who depended on him could be left without sup-

port because, unless they had substantial resources, special skill, and good health, women's work was unlikely to be well rewarded. A husband's death could be devastating to a family. Clark Slade's death, around 1842, left Emily with five small children and few resources. "My pretended friends soon came in possession of what my husband left for me and his little children," she recalled.[28] She had a difficult time keeping track of the children. The baby was "so dangerously ill that it could not be left a moment," so "I could not pay much attention to the other little ones, and they were feeling at full liberty to go where and when they pleased."[29] Soon, she was swindled out of her "last cow."[30]

She tried to support her children working at millinery, teaching, and nursing, but within a few years, Emily had to place all of her children in foster homes, although "the thought of being separated from my family," Emily wrote, "almost destroyed my reason."[31] Four of Emily's five children appear with their foster families in the 1850 federal census. Emily had found places for them with artisan and farm families apparently needing teenage help of the appropriate gender. A look at these families suggests that families in certain life cycle stages—either when a couple was elderly or had small children but lacked teenagers or young adults—were more likely than others to welcome extra children.

The oldest, Helen (Nellie) Slade, was sixteen years old in 1850 and living in Andover, Ohio. She had been taken in by a couple who were, like her parents, from New York. Like Helen's mother, her foster father was an artisan, in this case a blacksmith. This couple had seven children, five of them under age nine. No doubt Helen was expected to help take care of the children and household.

Four doors down lived Helen's twelve-year-old brother, William, an only child staying with an elderly couple, the husband a chairmaker, another artisan. This may have been something of an apprenticeship, although William attended school, according to the census, the only one of the Slade children to be enrolled that year. Certainly a healthy preteen could be a great help to an older couple.[32]

Betsey and Sarah, ages fourteen and eleven, had each been placed with a farm family, one in eastern Ohio and the other nearby in western Pennsylvania. Both families had only adult sons, whose time would probably have been taken up with male sex-typed farm work. The Slade girls must have been welcomed as helpers to the sixty-three- and sixty-four-year-old farm wives.[33]

Emily's brother and uncle were nearby in western Pennsylvania but were evidently unable or unwilling to take in any of her children. Brother Esick Coburn lived with his second wife, Phebe, and five children ages two through fourteen on Phebe's parents' farm. Next door were Uncle Harvey

and Aunt Mariah and their two adult daughters.[34] Were their resources completely tied up with no need for youthful help? One of Emily's brothers did take her in for several weeks when she was severely ill with rheumatic fever. Soon, in about 1851, she recalled, "I received a letter from my mother, who then resided in Wisconsin, requesting me to come to her; that she could cure me, she thought."[35] Although three sisters lived near her mother, Emily's children had evidently not been invited along, nor probably could she have afforded to pay their traveling costs, so she left them behind.[36] It is clear that there were limits on the assistance one could expect from her extended family. This may help to explain why Emily chose to remarry three times.

transition?

In many ways, Emily was typical of thousands of women workers. In 1870, over 165,000 women in the U.S. were self-employed, more than half of them running millinery and dressmaking shops. By 1880, nearly 300,000 women were counted by the U.S. Census Bureau as milliners, dressmakers, and seamstresses (including proprietors and employees), a probable underestimate. For centuries, millinery and dressmaking had been among a very limited number of crafts to which women could formally apprentice.[37]

Small-town millinery shops in the mid-nineteenth-century Midwest were women's social centers, the female equivalent of the legendary general store or barber shop. Milliners sold bonnets they had "put together after the latest Parisian fashions or to order," as they advertised. They made and decorated new hats of straw or cloth, and refinished old ones, bleaching, cleaning, stiffening, pressing, shaping, and trimming them anew, tasks requiring a high degree of skill. Milliners also sold fancy goods, which included fabric, ribbons, buttons, gloves, corsets, and similar items. There were two busy seasons per year, and proprietors generally made two annual buying trips to St. Louis, Chicago, or New York, preparing for their "grand openings" in March and August. They would be busy until early July or January, after which business slacked off for two or three months.[38]

Emily's book clearly reveals the effect of artisan traditions on her life. Scholars studying male artisans have not tied these traditions to women's experiences. The age-old male craft hierarchy of master, journeyman, and apprentice was replicated in thousands of millinery shops like Emily's, each run by a "mistress" or "proprietor," with the help of paid skilled "assistants" and apprentices. Traditional artisan values of independence, pride in skill and in high quality work, modest personal ambition, and industriousness are evident throughout the autobiography.[39]

It was by chance that Emily entered the millinery trade in the first place. After her older brother, Esick Lyon Coburn, had completed his apprenticeship as a tanner to an uncle, he met and married Hannah Jewel, a young

milliner from Philadelphia, in 1826. Emily recalled that after their wedding and honeymoon, the couple "quietly settled down in a snug little home of their own, each one resuming his or her accustomed avocation" in Sandford, New York.[40] This passage reveals that in the Mid-Atlantic region, this couple, at least, did not expect an artisan bride to abandon her craft to be supported by her husband. Soon afterward, thirteen-year-old Emily was drafted into the millinery trade. She wrote,

> At this time I was desired to go and assist my brother's wife; she wanted me as an apprentice girl, as she was running a large millinery establishment; and eventually I was one among a number of girls, learning the millinery, with a proprietor at the head.[41]

In the tradition of colonial crafts and like her older brother, Emily entered an apprenticeship to a relative, and moved to Sandford in the neighboring county to live with the family of the mistress, her sister-in-law.

After about three years with Esick and Hannah, Emily completed her training. At roughly the same time, during the enthusiasm of the Second Great Awakening, she joined the Presbyterian Church of Sandford. Her memoir recalled,

> I now had, at an early age, learned a trade; and choosing not to eat the bread of idleness, and furthermore to let independence be my aim, and ever look upon avarice as my worst foe, I felt determined to start out in the right path in pursuing the journey of life. To emulate the example of the good Samaritan effectually, one must be in possession of an independence.[42]

Later in life, when she was a millinery proprietor in the Midwest, Emily not only taught her daughters, but took other women as apprentices and taught them craft skills, taking them into her home as well, continuing the traditions of artisan organization. For example, around 1855, she was running a shop in Bellevue, Iowa, with some success, and recalled that "applications to take apprentice girls were not in the least uncommon, and this afforded me a chance to take my choice."[43]

Because customers required that each bonnet be different from every other, the milliner had to be flexible and had to do without labor-saving devices. "My pressing was accomplished by hand," Emily explained, "as it would not answer the purpose to press so many different shapes with a pressing machine, which was not adequate for this purpose. . . ."[44] This maintained craft traditions and inhibited mass production.

In the East, in places like western New York, where Emily grew up; Philadelphia, where Hannah Jewel received her training; and New England, out of which Emily's ancestors had migrated, craft traditions were being chal-

lenged by industrial capitalism and mass production. But except in the largest eastern cities, women's millinery and dressmaking concerns across the country remained small in the mid-nineteenth century. In 1870, for example, according to the Census Bureau's Statistics of Manufactures, the average millinery shop in the United States employed 4.3 hands. (The largest establishments were in New York, Massachusetts, and Pennsylvania, employing on the average 7.7, 6.3, and 5.4 hands, respectively. Elsewhere, the average number of hands employed was 2, 3, or 4.)[45] In large midwestern cities such as Chicago, men like Marshall Field began mass producing women's garments after 1860, but in the small towns, millinery shops remained vital institutions of women's culture and craft production into the twentieth century.[46]

Emily hoped to be able to make a living in each community she joined. In most towns, this proved to be difficult for her, but in the 1850s and 1860s, her memoir indicates that she was able to achieve success for a few years in two communities: Bellevue, Iowa, and Nauvoo, Illinois. Several factors influenced Emily's success as an artisan and determined her ability to "make a good living." They can be divided into two categories: characteristics of the *communities* in which she worked, and *personal* variables. It is likely that other artisans in the Midwest, particularly women in crafts producing women's garments, were similarly affected by these factors.

Emily moved to Bellevue, Iowa, in 1853 to be with her married daughter Nellie and three other children. She recalled,

> After my arrival there, and finding there was no milliner in the place, I commenced work, determined on making it a success. . . . My work increased, and I may well say the prospect looked promising. I now found myself with a large run of custom, and had reason to fancy that my work was appreciated by all. This was a great satisfaction indeed. . . . I filled up my store; my income increased far beyond my expectations and continued good for a number of years.[47]

In this shop Emily took apprentices and hired "assistants."[48]

Why was Emily able to achieve success in this town when she had to struggle to support herself in other communities? Her memoir suggests several community-related factors that could contribute to a milliner's success.

First of all, the women of Bellevue were clearly style-conscious, and were willing to pay for fashionable garments. Demand was evidently vigorous; as Emily remembered, "[It was] all I could do attending to orders and the many wants which were proclaimed in my ears every hour in the day."[49]

Second, the lack of competition may have been a factor in Emily's Bellevue success, for she mentioned that "there was no milliner in the place."[50] Across the Midwest, milliners and dressmakers were much scarcer than in the Northeast. Relative to the female population, their potential cus-

tomers, there were about half as many milliners and dressmakers in 1870 in
Iowa and Illinois, for example, as in Massachusetts or New Jersey.[51]

Third, the ladies of Bellevue were apparently able to pay well for Emily's
goods and services. She stated that "money was plenty, and all business in a
flourishing condition. . . . "[52] Bellevue, a Mississippi River town, was in the
midst of a rapidly growing farm region with ready market access for its ag-
ricultural products.[53]

As midwestern agricultural communities began to feel the benefits of
participation in the market economy, fashionable women's garments came to
symbolize female self-definition as well as ties to idealized "civilization." Pos-
session of stylish bonnets and clothing signified participation in women's
culture. This gave milliners high status.[54]

If milliners like Emily depended, in part, on the health of the local econ-
omy for their success, an economic depression could be devastating. Emily
was still in Bellevue when the Panic of 1857 hit; in spite of her recent success,
her own familiarity with poverty made her acutely aware of the Panic's effect
on working people. She wrote,

> all business was suspended; almost every person who was depending on
> day labor for their support carried with them a sad countenance. . . .
> [T]here was but little demand for the production of manufacturers. . . .
> [T]he winters were long and severe, and it seemed impossible for poor
> people to subsist upon the small pittance they received for a day's labor. If
> even they were so lucky as to obtain a day's work, how gratefully the sum
> of fifty cents a day was received by the poor laborer.[55]

Eventually Bellevue's economic depression of the late 1850s was too much
for Emily, and she prepared to move on again, explaining, "I depend on
working at my trade for a living, and if I can't get that to do, what can I
do?"[56]

Thus, a milliner could thrive in a community that was, like Bellevue in
the mid-1850s, affluent and peopled with fashion-conscious consumers. It also
helped if there was little or no competition. Communities lacking these
qualities, on the other hand, offered poor prospects for a milliner.[57]

There were other factors determining a milliner's success that were less
related to her community, but more likely to be affected by her *personal* cir-
cumstances. Emily's experiences in Nauvoo, Illinois, during the 1860s illus-
trate the importance of personal factors such as marital status, children, life
cycle, health, and energy.

Emily moved to Nauvoo from Bellevue around 1860, and about a year
later married James Ward, whom she describes as a retired merchant and
homeowner.[58] She wrote, "Now I had a home; but finding that my husbands
means, or income, was not as I had anticipated, I in a short time began my

accustomed occupation, the millinery business."[59] Although Nauvoo had been in decline since the 1846 Mormon exodus, Emily built up a good business during the early 1860s. At the same time, Nauvoo was experiencing a moderate economic recovery, as grape culture proved to be adaptable to local conditions, and winemaking flourished.[60] "It was now plain to me," Emily reasoned, "that the matter of dress was considered expedient, although it had been suggested to me differently at the commencement."[61] Emily's business success resulted from a combination of local economic health and consumer interest, but also from hard work and family support.

While Emily implied that it was not her expectation to work after marrying Ward, married businesswomen were not at all uncommon in Illinois in the middle decades of the nineteenth century. About half of self-employed women in Illinois during this period were wives, according to one study.[62] Emily herself had done millinery work around 1840 in Pittsfield, while married to Clark Slade, and probably also in the early 1850s in Madison, Wisconsin, while married to James Finch. For women like Emily, marriage may have meant access to capital and credit.

It could also mean access to family assistance. By 1860, Emily no longer had children too young to help out, needing support and attention. But her children had married and established families demanding *their* energy and resources, so Emily could not count on their help.[63]

By marrying James Ward, Emily gained family support. Although he was retired, James owned not only a "beautiful residence," but also another piece of property that may have produced income, served as a shop, or provided collateral for credit.[64] In addition, it seems his reputation attracted customers. She explained, "My husband being well acquainted in that vicinity, assisted me in obtaining work, and I soon had a full supply. . . . "[65]

James also had two daughters, Laura and Lilly, who were twelve and nine years old in 1861. Emily recalled, "they were very good to me, which made me love them, although they were not my own."[66] Furthermore, Emily clearly felt that her housework and other domestic duties had to be kept up, and her stepdaughters were able to take care of these chores. "The two little girls were adequate, for most of the work about the house, and this was a great relief," she recalled.[67] Unfortunately, none of Emily's Nauvoo family members was skilled with a needle, so she had to limit her business. She explained, "My commendation depended upon the neatness of the work; also, having no assistance all was done by my own hands."[68] Men could provide support and customers; teens and preteens who could sew or do housework could also be a great help.

Besides the availability of family support, an artisan's success depended on her ability and willingness to work hard. Health and strength are cited throughout Emily's book as issues of constant concern, directly influencing

her welfare.[69] Emily's industriousness held special meaning for her. "Idleness" is a term used with derision throughout her autobiography, and she clearly considered it a vice. For example, when she was unemployed, she related, "My ambition . . . was not that of being idle," and she stressed how hard she worked.[70]

We can see, in her description of her third husband, a contrast with her own values and experience, and there is in it a certain sense of her own superiority. She wrote, "My husband was aged and knew but little about managing with want or necessity. He never had labored for his living. As his father was wealthy and gave him a good start in the wholesale and retail merchandise, he was not prepared for toil, fatigue, hard labor or want."[71] Emily had certainly labored for her living, and was all too familiar with want and necessity. It is interesting that she did not consider merchandising activity to be "labor" or "toil."

Her autobiography ends with advice to the reader, including several pages of quotations about industriousness and work. Her last remark on the subject is given without quotation marks or attribution: "Work, constant, honest, well directed work; that is the royal road to permanent distinction, to lasting success; and there is no man, however moderate his mental endowments may be, who may not by faithful work, give the world something which it never would have had without him."[72] Although the subject of this passage is masculine, there should be no doubt that Emily applied it to herself.

Regarding women, Emily wrote, "from our birth to our death we are the slaves of prejudice and of circumstance."[73] Her craft skills and artisan values were the only weapons she had to combat that type of slavery. "[T]he only way which was sure," she explained, "I could count on myself if all others failed. There was one thing I felt sure of, and that was a living, if no more; that was by hard work at the straw millinery."[74]

Emily was neither a "republican mother," measuring her worth by the citizen children she raised, as in Linda Kerber's study, nor was she a "true woman," as defined by Barbara Welter.[75] Although her autobiography was pious, she was much more active and independent than submissive or domestic. Like other midwestern women, she considered herself a "lady" but certainly not a lady of leisure.

Was she typical? She typified artisan values that scholars have previously considered masculine. Her work patterns of self-employment alternating with a variety of other jobs such as teaching and nursing seem to have been the norm for midwestern women. Certainly, her frequent migration was very common for this region; it was one of several survival strategies available to women, which included not only changing communities to be with kin or friends, but also changing work, and marrying. The fluidity of wealth, oc-

cupation, family roles, and location that Emily experienced were <u>probably</u> ?
much more common than scholars have realized in the nineteenth-century
Midwest. But Emily's skill, her training and artisan values, put her among the
elite of women workers and these were the source of her pride and identity.

Notes

The author would like to thank Alfred F. Young, Wendy Hamand Venet, M. Theresa
Sheahan, Allan Kulikoff, Wendy Gamber, Thomas Dublin, Ileen DeVault, Mary
Fredrickson, Barbara Posadas, and Dean May for advice and encouragement on this
project. Earlier versions of this research were presented to the Illinois History Sym-
posium, 1990, and the Organization of American Historians Annual Meeting, 1993.
This chapter is dedicated to Alfred F. Young.

1. Gro Svendsen, *Frontier Mother, The Letters of Gro Svendsen*, translated and
edited by Pauline Farseth and Theodore C. Blegen (Northfield, MI: Norwegian-
American Historical Assn., 1950), p. 28.

2. Of all paid women workers in Maine in 1870, 21.6 percent were cotton mill
operatives; in Massachusetts that year, the figure was 17.7 percent. Ninth Census of
the U.S. I: 686–94. Wendy Gamber, "A Precarious Independence: Milliners and Dress-
makers in Boston, 1860–1890," *Journal of Women's History* 4, no. 1 (Spring 1992): 60–
88; Virginia Penny, *Employments of Women: A Cyclopaedia of Woman's Work* (Boston:
Walker, Wise & Co., 1863).

3. On self-employed women, see Lucy Eldersveld Murphy, "Business Ladies:
Midwestern Women and Enterprise, 1850–1880," *Journal of Women's History* 3, no. 1
(Spring 1991): 65–89; Murphy, "Her Own Boss: Businesswomen and Separate Spheres
in the Midwest, 1850–1880," *Illinois Historical Journal* 80 (Autumn 1987): 155–76.

4. See Glenda Riley, "'Not Gainfully Employed': Women on the Iowa Fron-
tier, 1833–1870," *Pacific Historical Review* 49 (May 1986): 237–64.

5. Emily M. Austin, *Mormonism; or, Life among the Mormons* (Madison, WI:
M. J. Cantwell, 1882; reprint, facsimile, New York: AMS, 1971). The author will be
referred to by her first name throughout this chapter because she went by so many
different surnames.

6. Ibid., p. 3.

7. Conventions of anti-Mormon literature are discussed in Leonard J. Arring-
ton and Jon Haupt, "Intolerable Zion: The Image of Mormonism in Nineteenth
Century American Literature," *Western Humanities Review* 22 (Summer 1968): 243–
60.

8. Austin, *Mormonism* p. 3.

9. Austin, *Mormonism*, pp. 5, 78.; Robert B. Miller and A. B. Lyon, eds., *Lyon
Memorial: New York Families Descended from the Immigrant Thomas Lyon, of Rye*
(Detroit: Press of William Graham, 1907), cited in State Historical Society of Wis-
consin, Emily M. Austin file; Katie Mills letters, 5 February 1962 and 27 April 1964,

in the collection of Chenango County Historian, Norwich, NY. Letter, James L. Kimball, Jr., Research Librarian, Historical Department, the Church of Jesus Christ of Latter-Day Saints to Lucy E. Murphy, 26 October 1992.

10. Austin, *Mormonism*, pp. 10–11, 17. Newel Knight journal quoted in letter of 18 November 1958 from Thelma Thomas, in the collection of State Historical Society of Wisconsin, Emily M. Austin file. Eventually, Rose Linda had at least eleven children in all: nine survived her, and at least two predeceased her. Ibid., pp. 25, 83; Dane County, Wisconsin, Circuit Court, Register in Probate, R. L. Coburn will, Microfilm Box 73, 1 November 1852. (Emily inherited fifty cents from her mother.) On strawbraiding, see Thomas Dublin, "Women and Outwork in a Nineteenth-Century New England Town: Fitzwilliam, New Hampshire, 1830–1850," in Steven Hahn and Jonathan Prude, eds., *The Countryside in the Age of Capitalist Transformation* (Chapel Hill: University of North Carolina Press, 1985), 51–69.

11. Austin, *Mormonism*, p. 50.

12. Ibid., pp. 31–46, 57–58; Larry C. Porter, "A Study of the Church of Jesus Christ of Latter-Day Saints in the States of New York and Pennsylvania, 1816–1831," Ph.D. dissertation, Brigham Young University, 1971, pp. 198–204; "Records of Early Church Families," *Utah Genealogical and Historical Magazine* 26 (July 1935): 108–110, 147, 148.

13. Austin, *Mormonism*, p. 92.

14. Austin, Mormonism, pp. 58–106; Porter, "A Study of the Church," pp. 213–17.

15. Austin, *Mormonism*, pp. 106–66, quotation is on p. 161.

16. Ibid., p. 199; Federal Population Census, Hancock County, Illinois, 1860, p. 543, and 1870, p. 234; Dane County Wisconsin Register of Deeds, Marriage Records v. 6 p. 59, #3; p. 75, June 1852. Philander Austin was a teamster born in Truxton, New York. Madison, Wisconsin, First Methodist Church Marriage Records, 5 January 1877.

17. Letter, James L. Kimball, Jr., Research Librarian, Historical Department, the Church of Jesus Christ of Latter-Day Saints to Lucy E. Murphy, 26 October 1992.

18. This research is summarized in Stephan Thernstrom, *The Other Bostonians: Poverty and Progress in the American Metropolis, 1880–1970* (Cambridge, MA: Harvard University Press, 1973), pp. 224–31.

19. John Mack Faragher, *Sugar Creek: Life on the Illinois Prairie* (New Haven, CT: Yale University Press, 1986) p. 60.

20. Whitney R. Cross, *The Burned-Over District: The Social and Intellectual History of Enthusiastic Religion in Western New York, 1800–1850* (Ithaca, NY: Cornell University Press, 1950), p. 145.

21. Leonard J. Arrington and Davis Bitton, *The Mormon Experience: A History of the Latter-Day Saints* (New York: Vintage Books, 1980), pp. 37–38.

22. Emily's migrations could never have been reconstructed without the aid of this book, and the research of Mormon historians such as Larry Porter. Even with the book, this proved to be extremely difficult, since she gave virtually no dates in the book and did not mention two of her four marriages.

23. She did expect her son William to take care of her in old age, however. Austin, *Mormonism*, p. 203.

24. Emily separated from her third husband; Austin, *Mormonism*, pp. 213, 221, 237; Emily used the name Finch in 1856 in Bellevue (Iowa State Census, Bellevue, p.

396, State Historical Society of Iowa), but in 1860 she went back to using the name of her *first* husband, Slade. Federal Population Census, Hancock County, Illinois, 1860, p. 546. Neither death nor divorce records could be located for James B. Finch in Madison or Bellevue.

25. Dane County, Wisconsin, Register of Deeds, Marriage Records, v. 6, p. 59, #3; Austin, *Mormonism*, pp. 221, 237.

26. First Methodist Church Marriage Records, 5 January 1877.

27. Austin, *Mormonism*, pp. 84–85; Marilyn Ferris Motz, *True Sisterhood: Michigan Women and Their Kin, 1820–1920* (Albany: State University of New York Press, 1983), discusses kin as a resource in times of distress.

28. Austin, *Mormonism*, p. 102.

29. Ibid., p. 103.

30. Ibid., pp. 107–108.

31. Ibid. p. 157. At first, just two of the children were placed with her late husband's relatives, who remained members of the Mormon church after Emily had quit. When these in-laws wanted to move to Salt Lake, Emily brought the girls to Ohio.

32. U.S. Census, 1850, Andover, Ashtabula County, Ohio, pp. 174a, 175.

33. U.S. Census, 1850, Plymouth, Ashtabula County, Ohio, p. 264; North Shenango, Crawford County, Pennsylvania, p. 463a. According to this census, Emily lived alone in Meadville. Her youngest, Clark Jr., was not found in the 1850 census. Meadville, Crawford County, Pennsylvania, p. 142.

34. U.S. Census, manuscript, 1850, Randolph Township, Crawford County, Pennsylvania, p. 293.

35. Ibid., p. 165.

36. Ibid., p. 168.

37. Ninth Census of the United States, I: 686–694; III: 412, 426, 459; Tenth Census of the United States, I: 796. (The number of milliners, dressmakers, and seamstresses in 1880 was listed at 281,928.) Murphy, "Business Ladies;" Murphy, "Her Own Boss."

38. Census takers often worked during the summer slack period, which is why milliners were undercounted in the censuses. For discussion of millinery work, see Murphy, "Her Own Boss," and Christie Daily, "A Woman's Concern: Millinery in Central Iowa, 1870–1880," *Journal of the West* 21 (April 1982): 26–32.

39. Alfred F. Young, "George Robert Twelves Hewes (1742–1840): A Boston Shoemaker and the Memory of the American Revolution," *William and Mary Quarterly* 3rd. series, 38 (October 1981): 561–623; Sean Wilentz, *Chants Democratic: New York City and the Rise of the American Working Class, 1788–1850* (New York: Oxford University Press, 1986); Bruce Laurie, *Artisans into Workers: Labor in Nineteenth-Century America* (New York: Hill and Wang, 1989).

40. Austin, *Mormonism*, p. 29; Katie Mills Letter, 27 April 1964, on Coburn-Jewell wedding sets it at 10 October 1826.

41. Austin, *Mormonism*, p. 30.

42. Ibid., p. 31.

43. Ibid., p. 178. Apprentices apparently paid for their training. Ibid., p. 223.

44. Ibid., p. 189.

45. Ninth Census of the United States, III: 459. Dressmaking establishments averaged 6.3 hands; ibid., p. 426. Paul E. Johnson, *A Shopkeeper's Millennium: Society*

and Revivals in Rochester, New York, 1815–1837 (New York: Hill and Wang, 1978); Herbert Gutman, *Work, Culture and Society in Industrializing America* (New York: Random House, 1966); Wilentz, *Chants Democratic.*

46. U.S. Census, Industry, Illinois, 1860 and 1870 (Field's enterprise is enumerated in 1870 Chicago, p. 3); interview with Edmund G. Love, Michigan writer, columnist, and octogenarian, author of *The Situation in Flushing* (Berrien Springs, MI.: Hardscrabble Books, 1980), June 1984.

47. Austin, *Mormonism*, pp. 177–78. Nellie's husband was probably Jacob Sells, a miller in 1856. Iowa State Census, Jackson County, Bellevue, p. 414.

48. She also hired a black woman who may have been Jane Ferrell, 18 years old in 1856, listed as a servant not living with Emily at the time of the census. Iowa State Census, 1856, Jackson County, p. 410; Austin, *Mormonism*, pp. 188–90.

49. Ibid., pp. 177–78.

50. The failure of a second millinery shop may have been due in part to Emily's competition, although she attributes it to the owners' lack of financial expertise. Ibid., pp. 179–80.

51. Murphy, "Business Ladies," p. 82. From Table 6, "Potential Customers per Milliner/Dressmaker, 1870" (females age ten and over): Iowa, 163; Illinois, 183; Massachusetts, 80; New Jersey, 92.

52. Austin, *Mormonism*, p. 177.

53. J. D. B. DeBow, U.S. Census Bureau, *Compendium of the Seventh Census* (1850), pp. 230–35; *Census Returns, State of Iowa for 1856* (Iowa City: Crum & Boye, 1857), pp. 176–87.

54. Daily, "A Woman's Concern"; Murphy, "Business Ladies."

55. Austin, *Mormonism*, p. 188.

56. Ibid., p. 194. Evidently she did not consider letting her adult children support her. They may have been suffering financially, too. A decade later, when Emily moved to Burlingame, Kansas, to be with another married daughter, she worked as a millinery journeywoman, or "assistant." But the economic depression ensuing from a severe plague of locusts forced her to move once more. Ibid., pp. 233–36.

57. Less affluent communities did not offer the milliner promising prospects. In the late 1850s, when Emily migrated for a second time to Nauvoo, the town was still reeling from the economic devastation caused by the 1846 Mormon exodus to Salt Lake. During her early months there, Austin remembered, "all I had to encourage me was, I knew I could do almost any kind of work, and at a small price in this place, as people here were not in fact able to pay much for work." Ibid., p. 198. Likewise, one couldn't get one's hopes up too high in Espyville, Pennsylvania, around 1847, for as Emily discovered, "In a small village work must be done cheaply, and consequently a great deal of work must be done for a little money." Ibid., p. 164.

58. Emily moved to Nauvoo at this time, although she had no kin or close friends left there, because she hoped to reclaim a town lot she had owned in 1843 (an effort which proved to be futile). Ibid., p. 199. Emily must have seen a marriage proposal by Ward as an offer of security, or a chance to achieve her dream of "a snug little home."

According to the 1860 Federal Population Census for Hancock County, p. 543, James Ward was a sixty-one-year-old laborer, born in Ireland, with a combined wealth of $600. He had migrated from Middletown, Ohio, where the census found him in

1850 (Butler County, p. 435) as a hotel landlord with $3,500 worth of real estate. Either Emily was misinformed about her husband's background (which seems likely), or confused him with her second husband (about whom little is known), or embroidered the truth for the sake of the book. Most other details of the book, where they can be verified, do check out. The main problem with the book is the amount of information left out, such as dates, people's names, and the facts of her second and fourth marriages.

59. Austin, *Mormonism*, pp. 199–200.

60. John C. W. Bailey, *Illinois State Gazetteer and Business Directory for the Years 1864–65* (Chicago: Bailey, 1864), pp. 478–79.

61. Austin, *Mormonism*, p. 200.

62. Murphy, "Business Ladies."

63. Emily appears in the 1860 census living alone with only $25 worth of property to her name; this is apparently the period, before she married Ward, during which she "persevered for a number of months, having not enough to eat to be in the least degree half comfortable." Austin, *Mormonism*, p. 198; Federal Population Census, Hancock County, Illinois, 1860, p. 546.

64. Hancock County Collectors Books, 1860, 1863, Illinois Regional Archive Depository, Western Illinois University, Macomb, Illinois.

65. Austin, *Mormonism*, pp. 207–208.

66. Ibid., p. 200; Federal Population Census, Hancock County, Illinois, 1860, p. 543.

67. Austin, *Mormonism*, p. 208.

68. Ibid., p. 200. Earlier, in Espyville, Pennsylvania, and in Bellevue, when her own daughters Nellie and Elizabeth were teenagers, they had helped with millinery and other sewing work. Ibid., p. 164; Iowa State Census, Bellevue, 1856, State Historical Society of Iowa. Whether there were no skilled workers available to be hired in Nauvoo, or whether Emily could not afford to hire any, is unclear.

69. In Nauvoo, Emily remembered, "my health or strength were not equal to the accomplishing of so much hard labor, yet . . . it would be humiliating to surrender for the want of strength to accomplish and complete all in a respectable manner. . . . " Austin, *Mormonism*, pp. 199–200. Over the years, she had suffered from what may have been recurrent rheumatism, doubly frustrating for preventing her from working hard.

70. Austin, *Mormonism*, p. 198.

71. Ibid., p. 204.

72. Ibid., p. 245.

73. Ibid., p. 58.

74. Ibid., p. 222.

75. Linda Kerber, *Women of the Republic; Intellect & Ideology in Revolutionary America* (New York: W. W. Norton, 1980); Barbara Welter, "The Cult of True Womanhood: 1820–1860," *American Quarterly* 18 (1966): 151–74.

3

Mary McDowell and Municipal Housekeeping

Women's Political Activism in Chicago, 1890–1920

KAREN M. MASON

> There are times when Mary McDowell dons cap and gown to march in
> the convocation procession of the University of Chicago, for she is a member
> of the faculty. And there are other times when she takes to her bed, piles
> pillows behind her back and revels in the luxurious delights of trimming hats.
> If she were a man she might be a captain of industry or a "boss"
> politician; if she were not the head resident of the University settlement
> it is almost certain she would be a fashionable milliner, and it is a
> large round guess which she would rather be.
>
> —*American Magazine*, January 1911

MARY MCDOWELL (1854–1936) was a settlement house worker, labor organizer, and member and leader of numerous reform organizations and women's clubs. She was active in the Woman's Christian Temperance Union in the 1880s, worked briefly at Hull House in the 1890s, and from 1894 until 1929 was head resident of the University of Chicago Settlement in Chicago's stockyards district. She helped found the Women's Trade Union League in 1903, ran for county commissioner in 1916, and from 1923 to 1927 held the post of commissioner of public welfare for the city of Chicago.[1]

Despite this impressive record of public activism, McDowell's admirers and biographers continually described her in terms that called to mind women's domestic roles. Either she was a "maiden aunt" to the city of Chicago or she was a "municipal housekeeper" sweeping up the city. In 1938, three years after McDowell's death, a book of essays was published in her honor. Entitled *Mary McDowell and Municipal Housekeeping*, the book contains ar-

ticles by McDowell and people who had known her describing various phases of her life and work. In the introduction the editor, Caroline Hill, bemoans the fact that the city's "housekeeping" was being left to politicians and labor bosses, who were not doing an adequate job of keeping the city clean. Like many of her contemporaries, Hill believed that women had a uniquely feminine role to play in city government as "municipal housekeepers." In this instance, the term referred to keeping the actual physical city clean, but it was often used metaphorically to describe efforts to rid city hall of corruption, or more generally to refer to women's civic activism.[2]

Mary McDowell used the term herself to describe the role she and other women played in city government. She "repeatedly said that women must come to regard their city as their home, and must apply to it the standards of the home, dismissing incompetent public servants by their votes as they would discharge incompetent domestic help. The home must not end with the front doorstep."[3] In similar fashion, Jane Addams likened the work of city government to that of homemakers: "A city is in many respects a great business corporation, but in other respects it is enlarged housekeeping. . . . [M]ay we not say that city housekeeping has failed partly because women, the traditional housekeepers, have not been consulted as to its multiform activities?"[4]

The use of gendered language to describe women's reform activities was, in fact, not unusual in this period, and the use of the municipal housekeeping metaphor in particular became increasingly common in the first two decades of the twentieth century. "Municipal housekeeping" as used by Progressive Era women referred to the application of women's domestic skills to the larger environment outside the home, whether in cleaning up the physical city to make it a more healthy place to live or in ridding politics of corruption. Historians have generalized the term to encompass a wide array of reform activities undertaken by clubwomen and settlement workers beginning in the 1890s, ranging from civic improvement projects to the provision of social services neglected by government.

Mary McDowell is an interesting case study in municipal housekeeping, in part because of the varied activities in which she engaged, but more importantly because she recognized and articulated the political nature of these supposedly "domestic" activities. As such she helps to illuminate the changes that were occurring in the definition and practice of politics in this period.

This chapter focuses on just three of the many forms of political action McDowell undertook in the years between 1890 and 1920: her organization of neighborhood women's clubs to promote various reforms, her fight for a garbage disposal system in Chicago, and her participation in electoral politics once women were granted the vote in Illinois. An examination of these reform efforts and the language with which she described them illustrates the

signif of region!

ways in which women's activism in the Progressive Era took them increasingly into the public arena and at the same time politicized the domestic arena.

Throughout her years at the University of Chicago Settlement, McDowell's political activism focused primarily on the local and state levels, with occasional forays into national politics. Her political activism on the local level was geared toward cleaning up the stockyards district in which the University of Chicago Settlement was located and making it a healthier and more pleasant place to live, and on organizing the workers and other neighborhood residents so that they would demand improvements in their living and working conditions. McDowell's political activism on the state level focused on two issues, women's suffrage and protective labor legislation, while her ventures into the national political arena included lobbying Congress to pass a bill authorizing an investigation of women's working conditions.

By the time Mary McDowell became head resident of the University of Chicago Settlement in 1894, she already had experience in organized reform efforts by women. Her first venture into reform came in the Woman's Christian Temperance Union (WCTU). In 1887 she was appointed organizer for the Young Woman's Christian Temperance Union and began traveling the country in this position. After a short stint with the WCTU, McDowell entered the Chicago Kindergarten College. When she completed the course, she was employed briefly as a tutor by a family in New York. She returned to Chicago in 1890 and went to live at Hull House, where she taught kindergarten and helped organize the Hull House women's club. When the University of Chicago decided to establish a settlement house, Jane Addams recommended that Mary McDowell be appointed head resident. McDowell accepted the position and in 1894 moved into the University of Chicago Settlement in the Back of the Yards district.[5]

For a number of reasons, settlement houses were an apt setting for women who sought an expanded political role. First, by living and working in a homelike setting, settlement workers replicated certain features of the domestic sphere. As such, they did not appear to be flouting traditional female roles. The settlement house movement, then, redefined womanhood "by the extension, rather than the rejection of the female sphere," to quote Estelle Freedman. In this female sphere women had a unique identity and could "create their own forms of personal, social, and political relationships."

As a result, settlement houses, women's clubs, and other separate female institutions were an effective strategy by which women gained leverage in the larger society. As Kathryn Kish Sklar has argued, settlement houses served not only as surrogate families for unmarried women but also as political resources, giving women a base from which to promote reform. Meet-

ings of labor unions and various social reform organizations were held at Hull House, enabling the women of Hull House to make contacts with men who held political clout in Chicago. This strengthened their position when they campaigned for social reform in the political arena, and sharpened their political organizing skills.[6]

Although the University of Chicago Settlement was not the mecca for reformers that Hull House was, it nonetheless was a political resource for McDowell; she was able to organize the residents of the neighborhood for political actions, which provided her with a base of power, however tenuous. Certainly the settlement allowed her to form her own brand of political alliances, as she organized neighborhood residents to work for improvements in living conditions and a stronger political voice.

McDowell would later state that when she moved Back of the Yards "the political conditions were primitive and the people unawakened and overpowered by a political brutality centered in [the alderman]," who coerced voters to support him. McDowell attempted to educate the residents about their political rights and awaken their civic consciousness through settlement activities so that they would work to improve the neighborhood, which was a dumping ground for the city's garbage and industrial waste. The aim of the settlement was explicitly political: "To initiate movements for city wide reforms in co-operation with city organizations to prove to the community their civic needs and then help to supply those needs."[7]

In an effort to take political control away from the ward boss, who she believed exploited the people, and claim it for the people, Mary McDowell organized a variety of clubs at the settlement to appeal to different groups within the neighborhood. As a member of the WCTU and other women's organizations, McDowell had learned of the power of association: political power could be wielded even by disfranchised groups through lobbying, petition campaigns, and the creation of public opinion. McDowell spent her first years at the settlement working with children and organizing clubs for women and men modeled on the civic organizations with which she was familiar. A civic club of young men of voting age discussed "civic and social questions" under the leadership of the male settlement residents. Another group, the Neighborhood Guild, was McDowell's ideal of what a democratic political organization should be: composed of both men and women, it served as a "bureau of complaints" for the neighborhood, bringing problems to the attention of the health department and creating a body of public opinion that city hall could not ignore. In contrast to the women's groups McDowell organized, however, the guild was short-lived, perhaps because it had not originated among the people.[8]

McDowell had greater success with the Settlement Woman's Club, a literary and social gathering of young mothers who soon began tackling

the problems of the neighborhood and taking their concerns to city hall. McDowell's work with the Settlement Woman's Club, more than any other activity in which she was involved in the 1890s, reveals the way in which she organized women and taught them to behave politically and at the same time politicized women's domestic tasks. The Settlement Woman's Club began as an organization of mothers concerned with the needs of their children. When mothers brought their children to the kindergarten at the settlement, McDowell invited them to stay for a cup of coffee. On January 3, 1896, a group of these mothers organized the University of Chicago Settlement Woman's Club, the object of which was "to associate women of different nationalities and different creeds together in a fellowship that helps each woman to be a better mother, sister, neighbor and citizen." As in most of the settlement's activities, McDowell's presence was strongly felt. She guided the club's activities with a firm hand and was elected president of the club year after year, despite occasional challenges from other nominees.[9]

The Settlement Woman's Club helped organize the varied activities of the settlement and was a means of disseminating information in the neighborhood. The club sponsored lectures and entertainments to raise money for a library and a cooking school, was in charge of the library, procured trees for a school located in the neighborhood, arranged for a garden for the settlement, and took the neighborhood children on picnics. Meetings of other settlement clubs, such as the men's club and the Neighborhood Guild, were announced at women's club meetings, so that women would tell husbands and neighbors about them. Information was given out on a variety of topics, from "scientific cooking" and the dangers of impure food, to the best type of garbage box to be used. The club undertook practical projects such as cleaning up the neighborhood, paid for the expense of "Miss Wilson's reports on unclean alleys," and ran the public baths once they were built.[10]

McDowell also used the club to educate women about electoral politics, particularly legislation that affected women and children, and to garner support for various local causes she favored, primarily in the area of education. She urged members to attend a meeting protesting the closing of a local high school, for instance. The club gradually developed into an organization of women working to solve problems in the neighborhood. Although a large part of each meeting was devoted to the reading of poems, discussion of literature, or listening to talks by members on a variety of subjects, from travel to history, the club undertook various civic reforms as well.

The first effort at civic improvement was a petition circulated in the neighborhood requesting that a bathhouse be built Back of the Yards. Although McDowell was often the initiator of these civic improvement projects, she credited a Bohemian woman with the idea of a bathhouse. McDowell accompanied the club members to city hall when they presented

the petition, and through this and other projects taught the women how city government functioned and how they could make it work for them. When the mayor or city council granted some of their requests, McDowell berated the women for bowing down to the politicians in gratitude, explaining that it was the duty of city government to provide services for its citizens; McDowell wanted the women to behave as citizens with a right to city services, rather than as supplicants or as submissive women.[11]

Besides petitioning their alderman for a bathhouse, the members started a neighborhood clean-up campaign, the scope of which ranged from organizing children to pick up trash, seeing that garbage inspectors were appointed, getting a local factory to stop using a vacant lot as a holding tank for polluted water, and trying to get city government to come up with a new method of garbage disposal that would keep Back of the Yards from being used as a dumping ground for the city's refuse. Many of these projects fell within women's realm of duties; but these housekeeping tasks were politicized in that women were taking responsibility not only for their own homes, but for their neighborhoods, and ultimately for the city as a whole.

In 1899, as the club embarked on its third year, McDowell described its work at the annual meeting of the Illinois Federation of Women's Clubs. Her speech indicates that, well before she used the municipal housekeeping metaphor, she was using gendered language to describe the political activism of women. She stated that the first year had been devoted to the study of "women's work and women's organizations, her [sic] social, political and industrial place in the world" and that this study had awakened in the members "a sense of the organic unity of womankind" and a social conscience. "After a year of receiving impressions," McDowell wrote, "the Club began to express itself in efforts for the Community. A social conscience was awakened." McDowell recognized that not all women could or would become involved in women's clubs. She argued that there was a certain "class of women with social instinct" who had a "dawning consciousness of what democracy means." These women have "a stirring within, a longing to enter into a broader life, to know what women in other localities know"; they want to be part of the "onward movement of womankind." She believed that the settlement could help channel this feeling and make these women a social force. In order to become part of this force for social change, however, "a woman must see herself as one with Womankind, then one with Humanity." Once a woman recognized herself as part of this larger sisterhood, she could become "mother to the community."

McDowell thus spoke about politics in female terms. She believed that the goal of women's clubs was to help women to see themselves in relation to the community, rather than as isolated individuals. She wanted to awaken in her neighbors a civic consciousness, a recognition of their responsibility

to their community. The object of the Settlement Woman's Club, in fact—
"to associate women of different nationalities and different creeds together
in a fellowship that helps each woman to be a better mother, sister, neighbor
and citizen"—illustrates McDowell's belief that there was an intimate con-
nection between the home and the community, and perhaps even a natural
progression for women from private to public life. McDowell hoped to imbue
in these women an understanding of "the relation of each mother, herself,
her child, and her family, to the universal family of life—to the social com-
munity."[12]

Although McDowell was offering women a broader role, she continued
to use gendered language in her description of that role, defining women's
public roles as mothering. As Anne Firor Scott has pointed out, it is impos-
sible to know whether women had internalized traditional beliefs about
women's roles, thus explaining the use of gendered language to describe
their activities, or whether they used phrases like municipal housekeeping as
strategies—to head off opposition to their actions.[13] Maureen Flanagan ar-
gues that women extended their experiences in the home into the municipal
arena through their civic reform programs, trying to bring about the best
good for all, as they did in the home. The reason they were able to behave
politically was because they described their activities as municipal housekeep-
ing, a phrase that evoked women's traditional role in the home, and as such
did not threaten those in power.[14]

McDowell used this language when speaking to groups of middle-class
women and the immigrant women of her neighborhood alike. She also used
it when addressing men, whether the voting public or state legislators. Her
use of this language, then, does not seem to have been simply a strategy.
Whereas phrases such as "municipal housekeeping" and "cleaning up the
city" were widely used in the Progressive Era, this idea of being a mother
to the community had a much deeper meaning for McDowell. McDowell
invested great meaning in motherhood, but in some ways viewed biological
motherhood as less important than what might be called social motherhood.
Recognizing the importance society placed on women's maternal role—and
the opprobrium directed at women who did not marry—McDowell fash-
ioned a political role for women that had motherhood as its foundation and
yet was accessible to unmarried women. McDowell strove to create a mater-
nal role for single women that was as highly valued by society as was bio-
logical motherhood.

Paula Baker has argued that by the end of the nineteenth century wom-
en's sphere had expanded to encompass any place that women and children
were and that motherhood had become a profession the duty of which was
to watch over all of society, not simply the family. This vision of the home
"encouraged a sense of community and responsibility toward all women,

and it furnished a basis for political action."[15] McDowell's use of maternal rhetoric suggests that she was attempting to promote a broader vision of women's sphere; she wished to convince the women of her neighborhood that they should view the entire community as their home.

McDowell's reform efforts in the 1890s centered on the neighborhood, but her efforts to clean up the Back of the Yards neighborhood soon took her into the realm of municipal politics. She realized that she was dealing with a citywide problem that could not be solved by residents' attempts to keep the streets and alleys clean. The issue of garbage collection and disposal became a primary focus of McDowell's political activism after 1900, to such an extent that she became known as "The Garbage Lady." Her efforts started with the organized women of the settlement. The Settlement Woman's Club organized children in the neighborhood into clubs charged with the responsibility of cleaning up the streets. The women checked to see that garbage bins were emptied, and secured the appointment of a female sanitation inspector. McDowell herself lobbied city hall to develop a plan for waste disposal.

McDowell described her fight for a citywide system of garbage disposal as a response to the "exploitation of people ignorant of their rights." After putting up with bad odors, gases, smoke, an open cesspool, and "Bubbly Creek" (a creek into which the city's sewage flowed) for many years, a Bohemian woman finally became so outraged at the dumping of garbage near her house that she went to McDowell in 1905 and asked her to accompany a group of women to city hall to demand that the city stop the dumping. The women were shunted from office to office at city hall, but finally ended up speaking to the Commissioner of Public Works, a young man who told McDowell the women would have to create public opinion in order to force the finance committee to make an appropriation for the matter.

So McDowell began to tell the story to civic groups, churches, and anyone who would listen, believing that she was the only one of the group of women who "could speak to the motley public of Chicago" because of her class background, settlement experience, and connections with members of various civic organizations. "At first," she wrote, "I fancy I was more or less emotional with a personal feeling of righteous indignation finding expression in my words. . . . " Gradually, she became more knowledgeable about sanitary, scientific methods of waste disposal, making herself the expert she believed should advise the city on the matter.

Securing a garbage disposal system for Chicago became her cause célèbre. She headed the city waste committee of the Woman's City Club and, her expenses paid by a club member, toured Europe and the United States to study various methods of waste disposal. Upon her return she reported not only to the Woman's City Club, but also to the all-male City Club.

McDowell and the Woman's City Club favored incineration of garbage be-
cause it would create a healthier environment in the city; furthermore, they
urged the city to take responsibility in this area through municipal owner-
ship and operation of garbage and waste facilities. The Woman's City Club
was at least partially successful; the city purchased the waste reduction plant
in 1914.[16]

Why did McDowell devote so much of her attention to the issue of
garbage collection? First, because she believed that neglect of this problem
by the city had such adverse consequences, in particular, an extremely high
rate of infant mortality Back of the Yards. But perhaps more important, sani-
tation was symbolically a female concern; women were responsible for house-
keeping in the domestic sphere, so why not in the city at large? Through her
campaign for a cleaner city and a better system of sanitation, McDowell
brought women's traditional concerns into the political arena, thus expand-
ing women's sphere and at the same time creating a role for women in civic
affairs.

McDowell also fought for a broader political role for women through
her advocacy of women's suffrage. She belonged to suffrage organizations
and lobbied for municipal suffrage at the state capitol in Springfield. In her
fight for suffrage McDowell continued to focus on women's maternal role.
She described the week when both the ten-hour-day bill and municipal suf-
frage were being debated at the state legislature as "woman's day at the capi-
tal," with "the strongest advocates for . . . all . . . questions relating to the
rights of motherkind" gathered in Springfield.[17] Perhaps McDowell believed
that the male legislators would be more likely to pass a suffrage bill if the
appeal were couched in terms of traditional female roles. But this reference
to motherhood and women's maternal role was a continuing thread in the
speeches she gave throughout her career and thus seems not to have been
merely a strategy.

After women won municipal suffrage in Illinois in 1913, McDowell be-
came active in electoral politics. She had been a member of the Woman's
City Club since its founding, but in the winter of 1914 she organized the
29th Ward Woman's Civic League and campaigned for the aldermanic can-
didate it endorsed. The purpose of the league was to articulate the desires
of women voters and make them known to the candidates. In 1916 McDow-
ell and Harriet Vittum, head resident of Northwestern Settlement, ran for
the Cook County board of commissioners. In one campaign leaflet addressed
to "men of all parties," the two emphasized that the reason they should be
elected was because the county board had jurisdiction over the institutions
through which the poor, sick, and delinquent were cared for and that their
experience and training as settlement workers (and Vittum's training as a
nurse) gave them the qualifications to understand the problem and wisely
appropriate the funds for these institutions.[18]

Although their campaign literature did not explicitly state that McDowell and Vittum were better suited for the job because they were women, it focused on aspects of the office that were considered to be women's special province. McDowell stressed that women voters had different interests from those of men. She said that women voters especially "wanted to make human service the paramount work of the County Board." Her goal was to strengthen the welfare department and welfare work of the county by adding foreign-speaking workers to the staffs of county institutions, encouraging the construction of branch hospitals in industrial and manufacturing districts, the building of a new county jail, and like projects.[19]

Going a step further, McDowell argued that women had a special talent for such positions. She contended that "woman's experience as housekeeper and care-taker in the home is a contribution much needed on the County Board. Women always had to care for the sick, the feeble, the aged, and the children. The food—its purchase and its preparation is one of the principle [*sic*] departments of all the County institutions and needs the housekeeping instinct and experiences to keep it hygienic as well as economical."[20] Newspaper articles also focused on the supposed talents and skills of their sex. The *Chicago Tribune* pictured the two women with soap, mop, and pail cleaning up the city and called McDowell and Vittum "the Gold Dust Twins." The reference was to Gold Dust Cleaning Powder, which was sold in a package picturing two black servants with the phrase "Let the twins do the work." McDowell and Vittum would clean up the city both literally and metaphorically, getting rid of trash and political corruption.

At a time when women had not yet received full political rights and even the rights they had were being challenged, it perhaps made sense to focus on the differences between women and men, showing why women in particular were needed in the political arena. Maureen Flanagan has argued that

> [u]sing a term such as "municipal housekeeping" enabled women to become involved in every facet of urban affairs without arousing opposition from those who believed woman's only place was in the home. Moreover, by depicting the city as the larger home, the women were asserting their right to involve themselves in every decision made by the Chicago city government, even to restructure that government.

Certainly women were perceived as less threatening when they portrayed themselves in traditionally female terms. But doing so did not guarantee their success; McDowell and Vittum lost the election, perhaps because, at the last minute, women were denied the right to vote in the election.[21]

The example of Mary McDowell illustrates how women in the Progressive Era politicized the domestic by making the traditional concerns of

women the basis for political action. These "municipal housekeepers" both broadened the definition of the political and encouraged political participation by women. McDowell urged women Back of the Yards to take advantage of the few political rights they had in the late nineteenth century, such as voting for state university trustees, and she helped women gain other rights. She freely crossed the borders between public and private, stepping into the political arena when she went to city hall to talk to aldermen, attend city council meetings, or take complaints to the city health department. She ran for office three years after women were granted municipal suffrage in Illinois and later held a political appointment as commissioner of the city's department of welfare.

Across the country, women engaged in similar activities under the rubric of municipal housekeeping; the municipal housekeeping phenomenon was not unique to Chicago, nor even to the Midwest. Chicago women were, nonetheless, in the forefront of women's political activism in the Progressive Era. They helped set the agenda for reform and devised means of bringing about their goals, not only on the local level, but at the state and national levels as well. An activist environment at Hull House and at the University of Chicago, together with a strong trade union movement, encouraged the growth of politically active women's organizations in the city.

But even before the establishment of Hull House in 1889, Chicago women had formed associations in order to address urban problems. The Chicago Woman's Club, founded in 1876, became a prototype for reform-oriented women's clubs throughout the nation. The department form of organization that originated with the Chicago Woman's Club was copied by women's clubs in other regions. The Chicago Woman's Club interested itself in a wide range of causes, from juvenile protection and education to women's suffrage, and exerted considerable influence on civic affairs. In the first decade of the twentieth century, Jane Addams headed a federation of one hundred women's clubs that supported inclusion of a municipal suffrage plank in the Chicago charter.[22]

In addition to these prominent citywide organizations, there were many neighborhood-based clubs, as well as associations formed around particular issues. These organizations inspired countless women to become politically active and provided them with a vehicle for influencing the shape of the city around them. The organization of the General Federation of Women's Clubs in 1890 helped to spread ideas and programs such as those of the Chicago Woman's Club to other states and regions of the country.

Elsewhere in the Midwest, such organizing for civic reform was also occurring. An Iowa Federation of Women's Clubs was founded in 1893 and by 1895 was already taking on "village improvements," a rural version of municipal housekeeping. In that year, an Iowa woman who was also active in

the General Federation of Women's Clubs asked Iowa women to consider, "Where is that 'away' to which your town throws its tin cans and rubbish?" According to the Iowa Federation's historian, "'Village Improvement' began as a housewifely dislike for the unsightliness of tin cans and trash heaps, but quickly encompassed all sanitation, beautification, and protection for a town or city." The Iowa Federation quickly moved on to advocating other reforms, ranging from child labor legislation to raising the age of consent.[23]

In Waukesha, Wisconsin, four women's clubs launched a campaign for municipal improvement in 1896 that included starting a public library along with the general goals of "civic betterment and public welfare." Milwaukee women worked to secure appointive positions for women at the municipal level and to elect women to school board seats. Elsewhere in the state, clubwomen worked for prison reform, endorsed vocational education, and agitated for a variety of other reforms.[24]

But such activities were not distinctively midwestern. Anne Firor Scott's survey of women's voluntary associations demonstrates that women in towns and cities across the United States joined together to promote civic improvements, and called their undertakings "municipal housekeeping." In Massachusetts, for example, the Mothers Club of Cambridge, organized in 1878 around issues of child raising and household management, had by the 1890s shifted its focus to social reform, discussing the eight-hour day, tenements, and nursing; becoming involved in a local settlement house; and establishing a vacation school for children that was later taken over by the local government.[25]

In Alabama, white clubwomen, who formed the Alabama Federation of Women's Clubs in 1895, were especially concerned with reconciling club life with domestic responsibilities, and fearful of being associated with advocates of suffrage and other women's rights. (The Alabama Federation of Women's Clubs did not endorse suffrage until 1918.) Nonetheless, Alabama clubwomen established kindergartens, attacked child labor and illiteracy, and sought the right to serve on school boards, among other reforms.[26]

Across the country in New Mexico, civic improvement projects were undertaken at the local level beginning in the 1890s, well before the 1911 organization of the New Mexico Federation of Women's Clubs. "Social housekeeping" emerged somewhat later in New Mexico, as clubwomen in the 1920s took responsibility for health and welfare services that were later taken over by state and local government.[27]

Admittedly, the activities that constituted "municipal housekeeping" emerged at different times and included varied activities from place to place. And while the municipal housekeeping phenomenon sprang up across the country, its forms varied according to local needs and temperaments. In large urban centers like Chicago, the forms it took were influenced by the needs

and involvement of immigrants, workers, and various ethnic, racial, and cultural groups. Part of Mary McDowell's municipal housekeeping, for example, included organizing workers into unions so that they could demand a living wage and better working conditions, thus promoting family and health.

Likewise, the ethnically diverse population of New Mexico spawned various forms of voluntarism, not all of which could be termed municipal housekeeping. The voluntarism of Hispanic and Indian women in New Mexico "was less formal because it was built into family, community, and religious structures." And while African American clubwomen tackled social welfare and civic improvement issues much as white clubwomen had done, their voluntarism was distinguished from that of white clubwomen by its focus on self-help and racial solidarity, and its desire to refute the widely held belief that African American women were sexually promiscuous. And, in fact, the club movement held special significance for African American women: it was "a vehicle for their recognition as a distinct social and political force in the black community."[28]

The activism of Mary McDowell and other municipal housekeepers helped politicize domestic labor, first, by making women's domestic skills the basis for their roles in the community and, second, by forcing municipal, state, and federal government to take responsibility for what had traditionally been the concerns of women, such as sanitation and health. Municipal housekeepers believed that there were certain tasks that should properly be carried out by women because of their relation to traditional female roles and women's resulting expertise in these areas. Caring for the sick and aged and taking responsibility for sanitation, for example, should fall to women because they had long performed these nurturing and housekeeping roles in the home.

McDowell envisioned herself as an agent of change in society, acting both within and outside the arena of electoral politics to improve the conditions of life for immigrants and workers in her neighborhood. She brought women—immigrant, working-class, and middle-class—into the political arena and encouraged them to act politically. In so doing, she challenged power relations in the city, by attempting to give disfranchised and otherwise silenced groups a means of voicing their demands and gaining a greater measure of control over their lives.

By the same token, McDowell argued that women would have a positive effect on politics. She often spoke of the human interest represented by women in politics, believing that women would represent "human needs" as opposed to, say, the business interests of manufacturers. A politics thus humanized through women's influence would be particularly responsive to the needs of women and children.

Yet she did not limit women's sphere of action to domestic concerns, nor did she perceive that sphere as geographically distinct. It could not be equated simply with the private realm. Women's purview was all of society, according to McDowell. McDowell blurred the boundaries between public and private, saying that women should consider the city their home. By encouraging women to political action—both inside and outside the electoral arena—McDowell gave women a voice in their governance and greater control over the structures that ruled their lives. She believed women should make use of the political rights they had and she worked to further women's rights by advocating suffrage and organizing the women of her neighborhood.

McDowell and other municipal housekeepers helped to create a broader political role for women, but their gendered language indicated a persistent division of the world into male and female realms. Their emphasis on women's maternal role reinforced traditional views that women's social roles were biologically determined. Thus, even though McDowell frequently crossed the boundaries between private space (home) and public space (such as city hall and the state legislature), her use of gendered language helped perpetuate the belief that women were different from—and thus not equal to—men.

As Nancy Cott has noted, women continued their tradition of exercising political influence through voluntary organizations outside the electoral and legislative arena even after enfranchisement in 1920.[29] Voluntarism allowed women to pursue political goals in the public realm while appearing to maintain traditional gender roles. The use of gendered language to describe women's activism, however, proved a double-edged sword: while making women's political involvement more palatable to men and women alike, it also reinforced the view that women were essentially different from men.

Notes

1. Louise C. Wade, "Mary Eliza McDowell," in *Notable American Women, 1607–1950: A Biographical Dictionary*, vol. II (G–O), ed. Edward T. James, Janet Wilson James, Paul S. Boyer (Cambridge, MA: The Belknap Press of Harvard University Press, 1971), 462–64.

2. In an article written upon McDowell's retirement from the post of Commissioner of Public Welfare, journalist Carroll Binder described her as a "kindly and optimistic 'aunt' of her wards" and a "beaming, white-haired bespectacled lady of 74 whom one would want as one's own grandmother if she weren't dedicated to the

whole community." Carroll Binder, "What Mary McDowell Thinks After Fifty Years of Service," *Chicago Daily News* (April 27, 1927). William Hard characterized McDowell as one of Chicago's five maiden aunts. William Hard, "Chicago's Five Maiden Aunts: The Women Who Boss Chicago Very Much to Its Advantage," *American Magazine* 62 (September 1906): 480–89. Caroline M. Hill, comp., *Mary McDowell and Municipal Housekeeping: A Symposium* (Chicago: [1938]).

3. Hill, "Compiler's Preface," *Mary McDowell*, vi.

4. Jane Addams, "Women and Public Housekeeping" (New York, National Woman Suffrage Publishing Co., Inc., 1910?), History of Women Microfilm (New Haven, CT: Research Publications, Inc., 1977).

5. Howard E. Wilson, *Mary McDowell, Neighbor* (Chicago: University of Chicago Press, 1928), 16–24; Wade, "Mary Eliza McDowell," 462–64; Binder, "What Mary McDowell Thinks"; Mary McDowell, "How the Living Faith of One Social Worker Grew," *Survey Graphic* 60 (April 1928): 42–43; *The Union Signal*, March 24, 1887, p. 8 (Temperance and Prohibition Papers, Microfilm Edition, Series U, Roll 4).

6. Estelle Freedman, "Separatism as Strategy: Female Institution Building and American Feminism, 1870–1930," *Feminist Studies* 5 (Fall 1979): 518, 514. Kathryn Kish Sklar, "Hull House in the 1890s: A Community of Women Reformers," *Signs* 10 (Summer 1985): 658–77.

7. McDowell as well as her neighbors received a political education during her years in the stockyards district. When the residents of the neighborhood complained about garbage dumps, garbage wagons, and a poorly maintained tenement house in the neighborhood, it turned out that all three were owned by the alderman. Mary McDowell, "Civic Experiences–1914," 1–4, Mary McDowell papers, folder 19, Chicago Historical Society (CHS).

8. McDowell, "Civic Experiences—1914," 2–3.

9. University Settlement Woman's Club, minutes, 1896–1922, McDowell Papers, box 4, CHS.

10. University Settlement Woman's Club, minutes, 1896–97, McDowell Papers, box 4, CHS.

11. University Settlement Woman's Club, minutes, 1896–97, McDowell Papers, box 4, CHS. The secretary recorded, "Pres[ident] said we need not feel ashamed to ask for anything that was for the good of the Community, that the Mayor and Aldermen were our servants and when we ask for any thing we must not [bow?] down to them and be so thankful for what we get." University Settlement Woman's Club, minutes, October 28, 1897, McDowell Papers, box 4, CHS.

12. "Report of the University of Chicago Settlement Woman's Club to the State Federation of Women's Clubs," 1899?, McDowell Papers, box 4, CHS.

13. Anne Firor Scott, *Natural Allies: Women's Associations in American History* (Urbana: University of Illinois Press, 1991), 82.

14. Maureen A. Flanagan, "Gender and Urban Political Reform: The City Club and the Woman's City Club of Chicago in the Progressive Era," *The American Historical Review* 95 (October 1990): 1032–50.

15. Paula Baker, "The Domestication of Politics: Women and American Political Society, 1780–1920," *American Historical Review* 89 (1984), 631–32. Rheta Childe Dorr asserted in 1910, "Woman's place is Home . . . But Home is not contained within the four walls of an individual house. Home is the community. The city full of people is the Family. The public school is the real Nursery. And badly do the

Home and Family need their mother." Rheta Childe Dorr, *What Eighty Million Women Want* (Boston, 1919; reprint edition, New York, 1971), 327, quoted in Baker, "Domestication," 631–32.

16. Mary McDowell, "City Waste," 3, in Hill, *Mary McDowell*; Flanagan, "Gender and Urban Political Reform," 1038–39.

17. Mary McDowell, "The Girls' Bill: A Human Proposition," *The Survey* (July 3, 1909): 511–12.

18. Wilson, *Mary McDowell*, 188–89; McDowell, "Civic Experiences—1914," 17–18; Letter "To the thoughtful voters—men and women—of the 29th Ward" from the 29th Ward Woman's Civic League, March 1914, Mary McDowell Papers, box 3, folder 19, CHS. "Some Reasons Why Men of All Parties Should Vote for Mary E. McDowell and Harriet E. Vittum for County Board Commissioners," 1916?, Woman's City Club of Chicago Records, box 1, folder 1, CHS.

19. "Some Reasons Why Men"; Mary McDowell, "Civic Experiences," 1, Mary McDowell Papers, box 3, folder 19, CHS.

20. McDowell, "Civic Experiences," 1.

21. Wilson, *Mary McDowell*, 189; Flanagan, "Gender and Urban Political Reform," 1048–50.

22. Adade Mitchell Wheeler with Marlene Stein Wortman, *The Roads They Made: Women in Illinois History* (Chicago: Charles H. Kerr Publishing Company, 1977), 63–64; Scott, *Natural Allies*, 118; Marlene Stein Wortman, "Domesticating the Nineteenth-Century American City," in *Prospects: An Annual of American Cultural Studies*, vol. 3, ed. Jack Salzman (New York: Burt Franklin and Company, Inc., 1977), 548.

23. Hazel P. Buffum, "Iowa Federation of Women's Clubs," *The Palimpsest* 34 (May 1953), 212–27.

24. Genevieve G. McBride, *On Wisconsin Women: Working for their Rights from Settlement to Suffrage* (Madison: University of Wisconsin Press, 1993), 152–57.

25. Scott, *Natural Allies*, 122–27.

26. Mary Martha Thomas, *The New Woman in Alabama: Social Reforms and Suffrage, 1890–1920* (Tuscaloosa: University of Alabama Press, 1992), 41–68.

27. Sandra Schackel, *Social Housekeepers: Women Shaping Public Policy in New Mexico, 1920–1940* (Albuquerque: University of New Mexico Press, 1992), 1–11, 87–110.

28. Schackel, *Social Housekeepers*, 96–97; Thomas, *The New Woman*, 69–91. Schackel's analysis of the distinctiveness of African American women's clubs builds on that of Lynda F. Dickson, "The Early Club Movement among Black Women in Denver, 1890–1925" (Ph.D. dissertation, University of Colorado, 1982).

29. Nancy Cott, *The Grounding of Modern Feminism* (New Haven, CT: Yale University Press, 1987), ch. 3.

4

The Limits of Community

Martha Friesen of Hamilton County, Kansas

PAMELA RINEY-KEHRBERG

B Y THE MIDDLE years of the twentieth century, most Americans assumed that the frontier had passed, and that the extreme isolation farm families had faced during the settlement of the rural heartland was only a distant memory. In the far western reaches of Kansas, however, many farming families still lived in virtually the same sort of isolation that existed in the late nineteenth century. In the rural districts of Hamilton County, Kansas, the opportunity for the creation of female communities varied widely over time. Ironically, in Lamont Township the best prospects for this were present in the early days of the twentieth century, when the area was briefly inhabited by a community of Russian Mennonite farmers. Time and depopulation eroded the ability of local women to create communities of interest, challenging the strength and resourcefulness of the remaining residents. Such was the case of Martha Schmidt Friesen, an early settler who lived most of her life in this remote corner of rural Kansas.

Martha Schmidt Friesen, who kept a diary from 1936 until her death in 1955, experienced this change in community fortunes in Hamilton County, Kansas.[1] She was born in 1884 on a central Kansas farm, but she lived her adult life with her husband, George, on a large farm roughly ten miles south of Kendall, in the southeastern corner of Hamilton County. Their township was sparsely settled, miles from a town of any size. The radio and the automobile were their connections to the world beyond their farm. On May 21, 1941, the family's only surviving son, Will, died in Oregon as a result of injuries sustained in a sawmill accident. That event plunged the family into a period of intense grief and mourning, the course of which was deeply affected by the lack of a coherent community in their rural, western Kansas location.

Before proceeding any further, it is necessary to define the concept of "community," one of the most elusive ideas in American historical scholar-

76

ship. One of the best definitions of the word is found in Thomas Bender's 1978 study, *Community and Social Change in America*. Bender defines community as "a network of social relations marked by mutuality and emotional bonds." It involves "a limited number of people in a somewhat restricted space or network held together by shared understandings and a sense of obligation."[2] Community may exist in virtually any geographical location, as long as the individuals within that location develop a shared purpose and commitment to each other. The definition of community has the capacity to change over time, and be redefined by the changing circumstances of life in any given locality.

The degree to which community existed in the rural Midwest is a subject of debate. As Bender notes, a number of historians of the United States assume that community, in a sense, ceased to exist in nineteenth-century America. The citizenry was on the move from frontier to frontier, settling on isolated 160-acre plots, far from other farming families. Once Americans strayed from the New England village, the proper environment for the creation of community no longer existed.

Nevertheless, historians of the Midwest have found that settlers, despite their mobility, managed to build communities. Although not bound as tightly as residents of village societies, farming men and women found common ground. As John Mack Faragher describes in *Sugar Creek: Life on the Illinois Prairie*, "with a remarkable degree of gregariousness, farm families reached out from their log cabins to their neighbors for work and play, politics and prayer."[3] What he also discovers is that this was a community divided in several directions. Established families formed the core of the community, with migrants at the periphery. Men also formed the core of public life, while women lived in their shadows. Women's work isolated them in the home, and they bore a very high number of children. There were communities within communities, and women played a segregated and subordinate role within them.[4]

Although not dismissing the idea of a sex-segregated society in midwestern farming areas, other historians paint a much more positive picture of female roles within farming communities. Deborah Fink, in *Open Country, Iowa: Rural Women, Tradition and Change*, constructs a model of the rural neighborhood in which "woman's social space can be pictured as a series of concentric circles representing household, (extended) family, church, the farm or town community, and Open Country as a whole."[5] Fink challenges the idea that isolation marked the life of the rural, midwestern woman. Instead, they lived lives full of visiting, neighboring, and helping. They were isolated from city life, "but little suggests that farm life in Iowa was intrinsically isolating."[6] Women found their niche within their families, their clubs, and their churches, all of which were organized around female efforts.

Glenda Riley, in *The Female Frontier: A Comparative View of Women on the Prairie and the Plains* finds that the lives of women, whether on the prairie or the plains, were quite similar. She finds active community participation by women in both environments, although that activity tended to be sex-segregated. Despite their isolation early in the frontier process, women were not "deprived of the company of neighbors, friends, and family members for very long."[7] Women set out to create communities where none had previously existed, bringing "civilization" to their localities.[8] In a 1989 article, Riley comes to the same conclusions, finding that the plains environment created problems within the working lives of women, but that it did not create insurmountable barriers to the formation of women's communities.[9]

Mary Neth's book, *Preserving the Family Farm: Women, Community, and the Foundations of Agribusiness in the Midwest, 1900–1940*, comments on the changing nature of midwestern farm communities in the first half of the twentieth century. Her study of the rural Midwest shows family and community cooperation in the creation of viable farms. Women were central in the creation of the conditions for viability through their community building, penny pinching, and maintenance of kin networks. These communities were not, however, impervious to change. The Great Depression, with its dispersal of farm communities, depopulation, and economic upheaval, weakened farm communities, and women's roles within them, in significant ways.[10]

The writings of many women's historians have assumed that the kind of community described in *Open Country, Iowa* and *The Female Frontier* existed in many, if not most, rural locations. This is also seen in the work of Nancy Grey Osterud, who emphasizes the importance of community to the lives of rural women in *Bonds of Community: The Lives of Farm Women in Nineteenth-Century New York*. She finds a strong strain of "rural feminism" in the lives of the women of the Nanticoke Valley of New York. Women in the valley lived and worked within a world of nurturance and mutual aid that included not only women, but men as well.[11]

In her most recent writings, Deborah Fink reconsiders the problems that geography imposed upon women in more sparsely settled rural communities. As farmers settled lands farther west, farm sizes grew, and towns were more infrequent. In her study of Boone County, Nebraska, *Agrarian Women: Wives and Mothers in Rural Nebraska, 1880–1940*, Fink discovers that distance could be a destructive force in the lives of rural women. Boone County's women were less likely than women in counties farther to the east to have other related women within their households, and were more physically remote from neighboring farms. The nature of their work, which centered upon the farm home and the barnyard, made contact with other fe-

males on a daily basis an unlikely event. Women in such situations would
often travel miles just to see another woman.[12] Such isolated rural women
generally exercised less power within their marriages, and little autonomy
in their relations with the world beyond the farm home.[13] Their aloneness
placed great emotional and physical burdens on isolated midwestern farming
women.

Both community and aloneness are illustrated in the history of the
Friesen family in Hamilton County, Kansas. The possibilities for community
in Lamont Township changed dramatically over time. The agricultural set-
tlement of the area began as a migration of like-minded individuals. In 1904
and 1905, the members of a number of households, both young and old,
migrated from Russian Mennonite settlements in McPherson and Marion
Counties in central Kansas, to Hamilton County in western Kansas. Martha
and George Friesen were among those settlers. They made the journey with
the members of approximately ninety other households.[14]

While the settlement lasted, the prospects for women's community
building in Menno were strong. There were a large number of females in
the settlement, from the very young to the old, all living in relatively close
proximity to each other. Although families lived on their separate 160-acre
plots of homestead land, the settlement pattern in Lamont Township was as
dense as it ever would be. The members of the community had a shared
language (German), shared beliefs, and shared dress. The community wor-
shipped at the Ebenflur Church, the only church within miles. Although the
demands of homemaking in a raw, frontier settlement would have been sub-
stantial, the social and spatial distance between the women in the commu-
nity would have been relatively small. As an early visitor to the community
noted "[i]n new settlements where all are beginners . . . people don't envy
each other or quarrel, but enjoy and help each other."[15]

Martha Friesen's place within the female social structure of the Menno
community was somewhat tenuous. The Friesen's 1905 marriage was an in-
terfaith union. Although George had been born and raised a member of
McPherson County's Hoffnungsau Russian Mennonite church, Martha was
not a Mennonite. She had been raised in the Evangelical Church, an offshoot
of the Lutheran Church, founded by German immigrants. Although George
and Martha migrated with the Hoffnungsau Mennonites, neither of the
Friesens were ever active participants in Lamont Township's Mennonite
community, and Martha remained a devout Evangelical at the time of her
death.[16] The hardship of Martha's first years in the Menno community
would have been softened by the fact that, despite her religious beliefs, she
was not alone in the township. Two of her sisters, one her twin, had also
married into the Hoffnungsau Mennonite community. Although she and her

husband lived at the outer edge of the settlement, and did not attend the local church, she was in close proximity to two women who shared with her a religious faith, common life experiences, and family ties.

Menno had a very fleeting existence. By the time of the 1915 state census, only seven Russian Mennonite families remained in the township. "Unfavorable climatic and economic conditions" guaranteed that the infant community would never establish itself firmly in Lamont Township's sandy soil.[17] Among those to leave were Martha's two sisters and their families.[18] In 1915, only seven Russian Mennonite families remained. Martha and George were among the few who stayed behind. Perhaps it was not surprising that they did. According to the few remaining records of the Ebenflur Church, the family had never attended, which might have been a result of Martha's continuing allegiance to her Evangelical faith.[19] The Friesens would persist in this isolated Kansas township, and in 1955, Martha would die there, one of the last remnants of the Menno settlement.[20]

Although without a supportive community, the young couple set about creating a farm of which they could be proud. In 1915, their family was complete. George was twenty-eight, Martha thirty-one, and their three children included Sally, six; Will, two; and Margaret, an infant. Their farm was not a large one, consisting of 160 acres of rented land.[21] George had patented a homestead claim in 1911, but had sold it in 1914, probably due to economic hardship. After the departure of the Mennonites, this portion of the county was rather thinly settled, with only thirty-seven farms in the township.

For the next eleven years, their farm remained a relatively small operation. Some years, the Friesens farmed as much as 240 acres, but just as often they farmed 160 acres or less. They generally planted broom corn, sorghum, milo, and pasture grasses, and moved very slowly into winter wheat production. Martha was very active in home production, regarding the flock of chickens as her sole responsibility, and sharing responsibility for the milk cows with George. Milk and cream sales, as well as sales of poultry and eggs, were an important source of income for the family. This arrangement was typical for the day, with the farm wife taking an active role in the productive activities of the farm.[22] In 1925, they again became landowners, when George purchased a quarter section in the far southeastern corner of Lamont Township.[23]

The innovation and growth of the Friesen farm continued at an even greater pace in the years leading up to the Great Depression and drought. In 1927, the Friesens began renting a considerable amount of land in addition to the acres they owned, bringing their farm size up to eight hundred acres; in 1928, they farmed over one thousand acres. Into the 1950s, they would cultivate one thousand acres or more, most years. Perhaps because of size of their farm, as well as their long tenure in the county, the Friesens were more

"progressive" farmers than many of their neighbors. They certainly appeared to be prosperous. In 1929, the family had been able to purchase two tractors, a Caterpillar and a McCormick Deering; a new truck; and two cars.[24] They were among the first in the township to own a tractor, and when radios became available in the mid-1920s, they were one of only three families in the township to own one. Martha had running water in her kitchen in 1927; in that year, only five of the fifty-four homes in the township could boast of that improvement.[25] Although not conclusive evidence, these purchases suggest a certain equality in the Friesen's marital relationship. The investments that they made in their farmstead included items that made life and work easier for both Martha and George.

Martha Friesen lived these years within a community of kin. One sister eventually returned to Hamilton County with her family, and lived nearby. As Martha's children grew to adulthood, they, along with her husband, came to form an essential part of her social network. She occasionally visited other farms to quilt and to talk, but most of her time was spent in her own home. Although she was somewhat isolated, she rarely wrote of loneliness or depression. Her life was full, and her children, now adults, formed an integral part of her everyday life. Her eldest daughter, her husband, and their children lived nearby, and her second daughter made the family farm her "home base," as did her son. Martha's circumstances, however, would change with the onset of the Great Depression and dust bowl.

The 1930s were disastrous for the people of southwestern Kansas. Prices for wheat and other farm products crashed to all-time lows in 1931, the same year an unprecedented drought and record-setting temperatures began to afflict the region. Terrible dirt storms accompanied the drought. Residents saw their topsoil and their neighbors scattered to the winds. The problems of Hamilton County were very much like those of other Dust Bowl counties, beset by drought and depopulation. Between 1930 and 1940, the population of Hamilton County fell from 3,328 to 2,645, a reduction of 21 percent. The farming population fell 31 percent.[26] The same depopulation was occurring in the Friesen's neighborhood. The township's population tumbled from 269 to 159 during the decade.[27]

Although Martha and George remained residents of Hamilton County during this difficult period, they watched their community of kin disintegrate around them. In 1931, Martha's twin, her only sibling living in close proximity, died. Her mother had died in 1924, and the only other sibling with whom she corresponded, another sister, lived half a state away, in Hutchinson, Kansas. Additionally, the Friesen children were among those who left during the 1930s, unable to make an adequate living. Instead of handing their farm over to the next generation, Martha and George watched them leave, unable to support an extended family in their reduced circum-

stances. Their eldest daughter, Sally, and her husband would depart for Oregon, hoping to find work in the timber industry. Their son, Will, would also leave, spending time as a migrant farm worker, on government relief as an employee of the Civilian Conservation Corps, and as a logger in Oregon. Their youngest daughter, Margaret, worked as hired help for other farming families, and occasionally migrated as far as Hutchinson looking for work.

As her opportunities for community within her family and immediate neighborhood shrank, Martha Friesen had little opportunity to expand her social horizons within her immediate vicinity. A number of organizations were available to women in Syracuse, the county seat. For a woman living in Syracuse, or within a few miles of town, there were more than twenty educational, social, service, and religious organizations with which to affiliate, from the Farm Bureau women's units and the Business and Professional Women's Club, to the Woman's Christian Temperance Union.[28] Syracuse, however, was at least a fifteen-mile drive from the Friesens' farm.

Kendall was closer to the Friesen home, approximately ten miles distant. In a smaller rural town such as Kendall, with a population of scarcely more than one hundred, the choices were much more limited. There were two general stores, two garages, two lumber yards, a nondenominational church, two schools, and a few other businesses.[29] Should a woman attend the Kendall Church, she could join the Ladies Aid, or the Women's Society of Christian Service. The Parent Teacher Association, Senior League, and Farm Bureau provided other opportunities for community interaction. The school, too, was a community center, sponsoring movies and other social events.[30] As with the organizations in Syracuse, participation required a woman to travel into town. The Farm Bureau was the exception, since the homemakers' units generally met in women's homes, rotating locations throughout the year.

The same pattern prevailed in Kearny County, immediately to the east of Hamilton County. Women who lived in Lakin, the county seat, had access to a wider range of social and service organizations than those in Deerfield, a much smaller community. In Lakin, there were seven churches, including all of the major denominations. Women could participate in clubs, auxiliaries of men's organizations, such as Eastern Star which was affiliated with the Masons, as well as the Grange and the Extension. In Deerfield, there were three churches, one particularly devoted to the Mexican community, and the same farm organizations as in Lakin.[31] Generally, the only organizations consistently available to women in both large and small communities were church-affiliated women's societies, and the Farm Bureau's homemakers' units. Since most country churches were already a thing of the past, the only organized women's activity that reached into the outlying community was the Farm Bureau.[32] One should not assume that the simple availability of

such organizations meant that a "community" necessarily existed within them, but they did provide isolated women the opportunity to meet with others with like interests, and build associations and friendships unavailable on isolated farmsteads, far from other women.

A rural woman's ability to take an active part in available social activities was limited by a number of factors. Transportation, of course, was essential. Whether she wished to travel into town to take part in the Ladies' Aid, or simply to visit a neighbor, the dispersed pattern of settlement and wide spacing of country towns often made the use of a vehicle necessary. The stage of a family's life also shaped a woman's opportunities. Because her children were grown and out of the home, Martha Friesen should have had more time for visiting than younger women with small children. Martha Friesen's mobility, however, was limited by other factors specific to her own situation, such as her inability to drive, her devotion to a church with no congregations in her area, and her shyness. Note however, that for a farm woman of her age, Friesen's inability to drive would not have been unusual. Historian Katherine Jellison's study of farm women and technology has shown that many older farm women did not think of automobiles as "their" technology, but "male" technology.[33] Her ethnicity may have contributed to her apparent inability to join fully into community activities as well. Research on the history of women of German descent shows that they were slow to join organizations outside of their own ethnic churches. As such a church did not exist in Hamilton County, Martha Friesen may have felt extremely isolated.[34] Her social circle, already limited, continued to shrink throughout the 1930s.

Throughout the period following World War II, the prospects for rural community building continued to shrink, as many western Kansas farmers became "sidewalk farmers." Increasing numbers of farming families gave up their homes in the countryside, and bought new ones in the state's towns and cities. As schools were consolidated, and as families relinquished their cows, chickens, and gardens, there was little or no reason to remain on isolated farmsteads.[35] Families that chose to remain witnessed the continuing deterioration of the rural neighborhoods that had once been so vital. Isolated families became even more so.

Despite these disturbing developments, the 1940s, by all rights, should have been better years for the family than the drought-ridden 1930s had been. The tide began to turn in 1939, when Sally and her family returned to farm in southwestern Kansas, and in 1940 the drought began to ease. The rains returned and war-generated demand pushed the price of grain ever upward. Farming families throughout the heartland were anticipating recovery.

Although the Friesen family recovered from the economic woes of the 1930s, the war years were destined to be much more difficult than the dark

days of the depression had been. Their son, Will, had remained in Oregon,
working in a sawmill. On May 17, 1941, Martha and George received word
that he had been critically injured. On May 21, Will died. His parents
brought him home to be buried in the Kendall cemetery.[36]

Between 1941 and 1945, Martha Friesen experienced an extended period
of grieving and deep depression. Hardly a day could go by without Martha
being reminded of her loss. Mentally and physically, Martha was "all broke
up," or "torn" with grief, the terms she most often used to describe her
condition. She cried throughout both her nights and days, suffering "mental
torcher."[37] Although the early portions of her diary had been liberally sprin-
kled with "ha has," describing the humor in her life, and that of her hus-
band, children, and grandchildren, in the years immediately following Will's
death, she rarely mentioned laughing at all.[38] Life for Martha had become
thoroughly grim, and she was generally unable to enjoy much of anything.

Martha Friesen's work suffered, she suffered, and her relationship with
her husband began to disintegrate from the weight of their sorrow. Although
Martha's diary provided fewer glimpses into George's life than her own, it
is clear from her writing that he was grieving for his son as well. On the first
anniversary of Will's death, George cried with Martha over their son's keep-
sakes.[39] With family birthdays and other holidays pending in the late fall of
1943, both of the "elderlys which where left alone at present" shed tears
together.[40] At times it was George's grief that overcame him first, and af-
fected Martha as well. Such was the case on Memorial Day in 1944, when
the family discussed flowers for Will's grave. "Pop got up from the table with
his voice broke, tears willed in his eyes so I got in the same sad mood with
a teer streeked face & heart so heavy nothing in the house could broke the
stillness, all was here just sobs omy such awful day."[41] Although George
might not have suffered as visibly as Martha, his hurt was evident in her
writings.

While the two Friesens were both grieving, they apparently were not
adequately supporting each other in their pain. Martha believed that George
was not as concerned about her sorrow as he should have been. On August
26, 1941, she wrote,

> Ma spend the most broken up day she'd endured since years ago. Soobed
> all day. So she couldn't see on account of the tears. & Pop not even tryed
> to comfort her. Was to buisy devoting time to his $3.00 hired man tryed
> to help him instead. It was the most torchered day for her she ever lived
> though. O, O, such mentil torment when will it ever go away.[42]

This was part of a pattern of behavior. George manifested his hurt by slowly
but surely distancing himself from his wife and their home. Perhaps it was
a response to Martha's overwhelming depression, and perhaps it was his own

response to his loss. The farmstead may well have reminded George of his dead son, in the same way that it was a daily reminder to Martha. George, however, had the option of escaping the family farm on a regular basis. He could come up with almost daily reasons to venture into town: to buy supplies, to sell grain, to exchange information with his fellow farmers.

The first evidence of George's efforts to distance himself from the family home came in the summer of 1942. That summer, George often failed to appear for meals. On one occasion, he told Martha that he would be bringing associates home to supper, but never arrived. He had not returned by bedtime, so Martha turned in alone. She exclaimed to her diary that "she cant depend on no one mistrusts everybody around this camp, all I am is just a slave, and nobody."[43] In mid-August, she made it clear that this had become a general pattern in George's behavior.

> I had to eat alone with the men. I've come to conclusion, that he rather eat in some old Caffee or eating joint, as to eat at home with his wife. And o boy am I ever tired of cooking, and him a eating up town. This is the first summer in all our days together, that he eat out so much and am I ever tired, tired, tired, of it. Cant hardly take it eny longer.[44]

In addition to breaking their marriage-long pattern of shared meals, George also began to make his errands to town and to neighbors' homes by himself, without giving Martha an opportunity to join him. These visits offered her rare occasions to escape her routine and escape the farm, and his behavior deeply hurt and angered her. An outburst on September 1, 1942, expressed the depth of her frustration: "no coop oration no consideration just icelated ranch all summer and no consideration. Why must it be like this why why I cant understand."[45]

The reason for the continuing disintegration in George and Martha's relationship was his growing use of alcohol. By the spring of 1944, George's drunkenness was a regular occurrence, and he remained inebriated for days at a time. Indeed, by the end of 1945, George was so unconcerned with Martha and the family that he absented himself to drink in town on Christmas Eve. "Pop run away so Margaret & Ma had to eat our dinner all by our selves."[46] Even the most important of family rituals was subordinated to his desire to escape Martha, the family, and home. This situation was all the worse because George truly was Martha's link with the world beyond the farm. Although George had tried to teach Martha to drive, she had never learned. When George or a daughter was not available to drive the car, she was quite literally stranded on the farm, more than ten miles distant from the nearest town.

By 1944, an important transition was taking place in Martha Friesen's life. While the intensity of her grief over Will's death was beginning to

lessen, her sorrow over her failing marriage and George's conduct was grow-
ing. Her diary reveals the extent to which she had become disillusioned with
her marriage and her husband. She believed that he was being "unfair with
the one who stuck by & helped him all along lifes highway."[47] But mostly,
she had lost her respect for him. Recovering from one set of miseries simply
meant having to deal more fully with her problems with George.

This was a very significant transition. Although depression and death
were not easy topics to discuss, in her grief over Will she had been experi-
encing a socially acceptable loss—one that her neighbors, relatives, and ac-
quaintances would have understood had she cared to communicate it. It was
a loss her surviving children also suffered, and could share. Her "loss" of
George, on the other hand, was a result of socially unacceptable circum-
stances. Alcoholism was rarely discussed, and certainly not accepted with any
degree of compassion. Although a few doctors discussed alcoholism as a dis-
ease rather than a moral lapse in the mid-1940s, the American Medical As-
sociation would not accept these ideas for a decade, and the general public
for many more years.[48] According to the norms of the day, his behavior was
to be hidden, and something of which she should be ashamed.

Martha found herself even more alone than she had been in dealing with
Will's death, particularly because of the way in which George dealt with his
own problems. He ran away, leaving her alone on the farm, largely without
transportation and without access to the world beyond her home. By 1945,
a pattern had been established that would persist throughout the remain-
ing years of Martha Friesen's life. Between that year, and her death in 1955,
George would drink at home and abroad, and she would be left to cope as
best she could. Her only outlet for her frustration and anger would be her
diary, the only confidant she could truly trust. When she died of a sudden
heart attack in August of 1955, she died at home, and alone.

At the time of her death, Martha Friesen had endured a fifteen-year
struggle with very little help. Martha had her diary, which she definitely
looked upon as therapeutic, and a few other resources available in her isolated
corner of rural Kansas.[49] In the end, she turned to her personal faith, and
her radio, which were not mutually exclusive. Although a religious woman,
Martha did not often write about her beliefs. However, she did occasionally
mention resorting to "prawer," or turning to "our Master to be consoled to
sleep."[50] More often, she wrote about consulting the "Unity Man," whose
messages came to her by radio from Kansas City. The Unity Man gave talks
on "comfort for folks," and sent out booklets on "Berevement, also on com-
fort & o is it ever good, but sad." Unity also sent out a paper which Martha
received, and read when she needed spiritual guidance. That she turned to
the radio for comfort should not be surprising. For farm families, radios were
an extremely important source of information and entertainment. As histo-

rian Katherine Jellison notes, many an isolated farm woman turned to the radio for religious programming as well, since travel to and from church could be difficult, if not impossible.[51] The radio was Martha Friesen's link to the outside world and to human sympathy. It had, in effect, become her "community."[52]

The course of Martha and George Friesen's grief for their son was, according to current understandings of grief and mourning, to be expected. The loss of a child is one of the most painful events a couple can endure, and the loss of an adult child has been found to be particularly painful. Grieving for a grown child involves working through years of memories, and may take a lifetime.[53] Both parents may respond with varying degrees of depression, and grieving fathers often attempt to "escape" from their families and their pain by immersing themselves in work, or in alcohol or other drugs.[54] The loss of a child often severely disrupts the parents' marriage, and may lead to divorce. This is especially true of couples, such as the Friesens, lacking a strong support network.[55] A study of grieving nineteenth-century diarists also shows that the pattern of writing that Martha Friesen employed in expressing her grief was not at all unusual. Like other diarists facing similar situations, she continued to write about her son's death over a number of years, and particularly noted the anniversaries of his death and other special dates in his life.[56]

What is unusual about this particular case is the way in which it was documented, and that it so clearly demonstrates the fragility of communities in many isolated locations in the rural heartland. Martha Friesen's diary provides a very sad and revealing look at hardships suffered by a socially and physically isolated couple as the result of their son's death. While it is doubtful that many mid-twentieth-century women would have openly shared the type of troubles that Martha Friesen faced, or sought help outside of their families and churches, her position as a farm woman in an isolated rural locality compounded the difficulties she faced in recovering from her loss. Like many farm women, Friesen's work focused upon the home, in a far corner of a sparsely settled county. Her husband's duties, on the other hand, allowed him to escape the farm in search of solace in the "outside" world, a resource Martha lacked. That neither one was well served by the available resources is evident. Martha's grief was poured out to her diary, and her almost-daily writings showed that she suffered four long years of depression, anxiety, and loneliness. George suffered too, and his grief took him farther and farther from the home, as he distanced himself from the farm and Martha, and "coped" with his grief through alcohol. Their community, the family, had been broken, and would never be adequately healed. The result was a badly broken marriage, held together by the conventions of the day.

Although Friesen was a single, isolated woman, hers was not an isolated

case. There is a geography of farm women's lives. Distance from or proximity to other women, and their ability to create communities across space, in a very real sense, dictated the quality of their lives. Fictional depictions of farm women's lives in the late nineteenth and early twentieth centuries often described the effect of a lack of community on such women. Ole Rolvaag's *Giants in the Earth*, Hamlin Garland's *Main-Travelled Roads*, and Susan Glaspell's "A Jury of Her Peers," vividly illustrate the mental anguish created by living outside the company of other women for too long.[57] In memoirs written about the early twentieth century, such as Mari Sandoz's *Old Jules* and Sanora Babb's *An Owl on Every Fence Post*, the reader will find the same stories, perhaps even more horrific because of their concrete links to an individual family's reality.[58]

Much of the recent historical analysis of farm women in the nineteenth and twentieth centuries has assumed that people like Martha Friesen operated within a supportive community of women. The literature has also often minimized the effect of geography upon women in agricultural communities, and has assumed that distances between farming folk closed over time, with the development of better transportation and communications technology. These assumptions, however, are faulty. There have always been, and always will be, areas of the rural Midwest that were and are as sparsely settled as practically any in the country. Today, many of the central and western portions of Kansas, Nebraska, and the Dakotas boast population densities not far above the two people to the square mile used by the Census Bureau to determine the existence of a frontier area in the late nineteenth century. While population densities are somewhat higher in northern Michigan, Wisconsin, and Minnesota, many of these areas were only settled in the first decades of the twentieth century, and populations remain quite low even today. Telephones and good roads were slow in reaching these communities, often coming last to the people who needed this technology the most. Families also adopted these technologies at different rates, reflecting class differences, and the arrangement of purchasing priorities within families. It was entirely possible, in the early and middle twentieth century, to be just as isolated as pioneering women in the early and middle nineteenth century.

Physical isolation could have a powerful influence on these women. It significantly limited their ability to interact with, and derive strength and community from, other women. Deborah Fink's research on rural Boone County, Nebraska, shows that this isolation increased the possibility of spousal abuse, and decreased the ability of women to pass on important information that was often carried from woman to woman, such as lore about birth control.[59] In the last fifteen years of her life, Martha Friesen's experience seemed to substantiate both historical and literary interpretations of the lives of farm women, which described them as living in isolation and as

dissatisfied drudges exploited by their fathers and husbands. While Martha Friesen might not have consistently described herself in these terms, her recordings of the years from 1941 to 1955 indicate that she was experiencing what her pioneer predecessors may well have feared; she faced loss, grief, and unremitting labor with very few resources beyond her own strength and will. Ironically, it was probably to Martha Friesen's detriment that the "frontier," and the conditions of the area's settlement, had passed, leaving her without the web of family relationships that had previously sustained her.

Notes

1. I wish to thank Thelma Warner and Verna Gragg of Syracuse, Kansas, for their permission to make use of the diary of Martha Schmidt Friesen. All names used in the discussion of this diary are pseudonyms, at the request of the diary's owners.

2. Thomas Bender, *Community and Social Change in America* (New Brunswick, NJ: Rutgers University Press, 1978), 7.

3. John Mack Faragher, *Sugar Creek: Life on the Illinois Prairie* (New Haven, CT: Yale University Press, 1986), 131.

4. Faragher, 112–13, 118, 145. See also Faragher, "History from the Inside-Out: Writing the History of Women in Rural America," *American Quarterly* 33, no. 5 (Winter 1981): 535–57, and *Women and Men on the Overland Trail* (New Haven, CT: Yale University Press, 1979).

5. Deborah Fink, *Open Country, Iowa: Rural Women, Tradition and Change* (Albany: State University of New York Press, 1986), 77–78.

6. Ibid., 80.

7. Glenda Riley, *The Female Frontier: A Comparative View of Women on the Prairie and the Plains* (Lawrence: University Press of Kansas, 1988), 95–96.

8. Ibid., 96–101.

9. Glenda Riley, "Women's Responses to the Challenges of Plains Living," *Great Plains Quarterly* 9 (Summer 1989): 174–84.

10. Mary Neth, *Preserving the Family Farm: Women, Community, and the Foundations of Agribusiness in the Midwest, 1900–1940* (Baltimore: Johns Hopkins University Press, 1995).

11. Nancy Grey Osterud, *Bonds of Community: The Lives of Farm Women in Nineteenth-Century New York* (Ithaca, NY: Cornell University Press, 1991).

12. Deborah Fink, *Agrarian Women: Wives and Mothers in Rural Nebraska, 1880–1940* (Chapel Hill: University of North Carolina Press, 1992), 70–74.

13. Deborah Fink and Alicia Carriquiry, "Having Babies or Not: Household Composition and Fertility in Rural Iowa and Nebraska, 1900–1910," *Great Plains Quarterly* 12 (Summer 1992): 166.

14. Department of Commerce, Bureau of the Census, *Thirteenth Census of the United States, 1910, Population*, Lamont Township, Hamilton County, Kansas.

15. Notice, *Inman Review*, September 14, 1906, 6.

16. "History of Syracuse, Kansas, Mennonite Church," File 1301, Box 55, Mennonite Library and Archives, Bethel College, North Newton, Kansas; "Obituary," *Syracuse Journal*, August 18, 1955, 4.

17. Cornelius Krahn, ed., *The Mennonite Encyclopedia*, v. II, D–H (Newton, KS: Mennonite Publication Office, 1982), 137.

18. Kansas, *State Census, 1915*, v. 110, Lamont Township, Hamilton County.

19. "History of Syracuse, Kansas, Mennonite Church," Box 55, File 1301, Mennonite Library and Archives.

20. Obituary, *Syracuse Journal*, August 18, 1955, 4.

21. State of Kansas, *State Census, Hamilton County*, v. 110, 1915.

22. Dorothy Schwieder and Deborah Fink, "Plains Women: Rural Life in the 1930s," *Great Plains Quarterly* 8 (Spring 1988): 80.

23. Transfer Records, Register of Deeds Office, Hamilton County Courthouse, Syracuse, Kansas.

24. Chattel Mortgage Records, Hamilton County, Kansas, 1929. Register of Deeds Office, Hamilton County Courthouse, Syracuse, Kansas.

25. Kansas, Statistical Rolls, Lamont Township, Hamilton County, 1922, 1926, 1927, Archives Division, Kansas State Historical Society.

26. United States Department of Commerce, Bureau of the Census, *15th Census of the United States: 1930 Population*, v. III, pt I (Washington, DC: U.S. Government Printing Office, 1932); United States Department of Commerce, Bureau of the Census, *16th Census of the United States: 1940 Population*, v. II, Characteristics of the Population, pt. 3 (Washington, DC: U.S. Government Printing Office, 1943).

27. Kansas State Board of Agriculture, *Biennial Report of the State Board of Agriculture*, vs. 27, 32 (Topeka: Kansas State Printing Plant, 1931, 1941).

28. *Syracuse Journal*, January-December 1941.

29. Floyd Edwards, ed., *Hamilton County, Kansas History* (Holly, CO: Holly Publishing Company, 1979), p. 51.

30. *Syracuse Journal*, January-December 1941, and *Lakin Independent*, January-December 1941.

31. Kearny County Historical Society, *History of Kearny County, Kansas*, vs. I and II (North Newton: Mennonite Press, Inc., 1973).

32. *Lakin Independent*, January-December 1941.

33. Katherine Jellison, *Entitled to Power: Farm Women and Technology, 1913–1963* (Chapel Hill: University of North Carolina Press), 153.

34. Linda Schelbitzky Pickle, "Rural German-Speaking Women in Early Nebraska and Kansas: Ethnicity as a Factor in Frontier Adaptation," *Great Plains Quarterly* 9 (Fall 1989): 247.

35. Walter Kollmorgen and George F. Jenks, "A Geographic Study of Population and Settlement Changes in Sherman County, Kansas," *Transactions of the Kansas Academy of Science* 55, no. 1 (March 1952): 31–34.

36. Friesen, June 24, 1941.

37. Friesen, June 29, 1942.

38. Friesen, June 2, 1942.

39. Friesen, May 21, 1942.

40. Friesen, November 1 and November 6, 1943.

41. Friesen, May 30, 1944.

42. Friesen, August 26, 1941.

43. Friesen, July 27, 1942.

44. Friesen, August 12, 1942.

45. Friesen, September 1, 1942.

46. Friesen, December 24, 1945.

47. Friesen, April 24, 1945.

48. Mark Edward Lender and James Kirby Martin, *Drinking in America: A History* (New York: The Free Press, 1987), 188–90.

49. Friesen, July 23, 1942.

50. Friesen, September 14, 1943, and May 24, 1944.

51. Jellison, 153–54.

52. Ibid.

53. Theresa A. Rando, "Death of the Adult Child," in Theresa A. Rando, ed., *Parental Loss of a Child* (Champaign, IL: Research Press Company, 1986), 223–24.

54. William H. Schatz, "Grief of Fathers," in Rando, 300.

55. Rando, "The Unique Issues and Impact of the Death of a Child," in Rando, 25–26; Vanderlyn R. Pine and Carolyn Brauer, "Parental Grief: A Synthesis of Theory, Research, and Intervention," in Rando, 91–92.

56. Paul C. Rosenblatt, *Bitter, Bitter Tears: Nineteenth Century Diarists and Twentieth Century Grief Theories* (Minneapolis: University of Minnesota Press, 1983), 16–31.

57. Ole Rolvaag, *Giants in the Earth* (New York: Harper, 1929); Hamlin Garland, *Main-Travelled Roads* (New York: Penguin Books, 1962); Susan Glaspell, "A Jury of Her Peers," in Joan Jensen, ed., *With These Hands: Women Working on the Land* (Old Westbury, NY: The Feminist Press, 1981), 172–80.

58. Mari Sandoz, *Old Jules* (Lincoln, NE: Bison Books, 1985); Sanora Babb, *An Owl on Every Post* (Albuquerque: University of New Mexico Press, 1994).

59. Fink, *Agrarian Women*; and Fink and Carriquiry, "Having Babies or Not."

II.

Community and Leadership

5

For the Good of Her People

Continuity and Change for Native Women of the Midwest, 1650–1850

TANIS C. THORNE

The Wisdom of ages was in your heart
Faithfully and bravely you took your part
When the tribes were fighting a bitter strife
Undismayed you stood for a better life.

—Susan Bordeaux Bettelyoun to her mother

IN HER AUTOBIOGRAPHY, Susan Bettelyoun honors her mother, Hunt-kalutawin, whose marriage to a French trader consolidated a friendship between the Brulé band and the white people. "[I]t was the fate of my mother to be a leader among her people, that her influence would [serve] the destiny of her band. . . . Her influence was always for the good of her people," her daughter writes.[1] Bettelyoun's memoir supplies an all too rare affirmation of full-blooded women's agency in the shaping of history. Despite some progress in discrediting the stereotype of the Native woman as passive "drudge," Native women continue to lack visibility in the historical literature both because of the sparsity of documentary sources describing their activities and the lingering androcentric biases in scholarship. Even among those feminist scholars who have worked diligently to bring Native women's significant economic and political contributions out of the shadows in recent years, there is a general agreement that the experience of European colonialization undermined Native women's power relative to men. After the Europeans settled in North America, the importance of Native men's activities in hunting, trading, warfare, and diplomacy was heightened. Consequently, gender relations were restructured in dramatic ways. There was a general and pervasive shift to patridominance.[2]

Without question, the Native women of the American Midwest—like

95

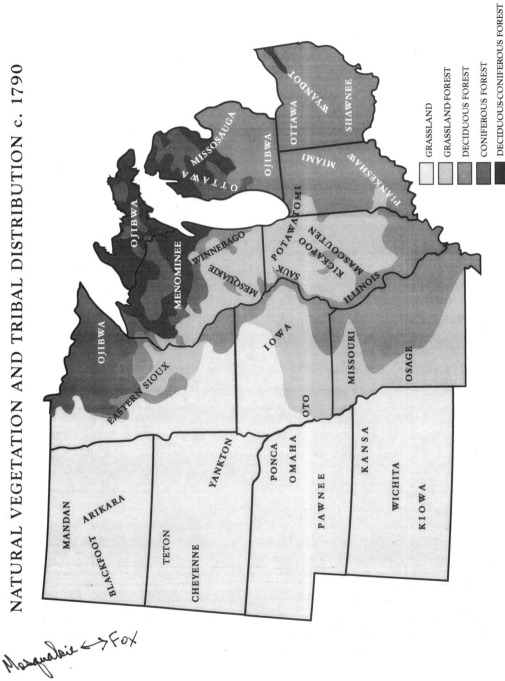

NATURAL VEGETATION AND TRIBAL DISTRIBUTION c. 1790

GRASSLAND

GRASSLAND-FOREST

DECIDUOUS FOREST

CONIFEROUS FOREST

DECIDUOUS-CONIFEROUS FOREST

Mesquakie ←→ Fox

Native women throughout the Western Hemisphere—experienced sweeping changes with the arrival of the Europeans. However, the women of the Midwest are in some significant respects distinctive. What appears to be exceptional about the experience of midwestern tribespeople is the extent to which they embraced relatively gender-balanced economies and ideologies while actively participating in trading activities with other Natives as well as Europeans from the mid-1600s to the mid-1800s. This was the result of unique historical conditions that gave midwestern peoples more latitude to experiment with different economic and political forms and to choose flexibly among the old and the new, indigenous and borrowed practices, for those with the most life-sustaining value. Arguably, this midwestern pattern was the culmination of a combination of different forces: historical and environmental conditions and human agency, as well as cultural inheritance and modifications. The experience of midwestern women causes us to rethink the way scholars have looked at the shift to patridominance from the early to late fur trade period. Furthermore, scholars have traditionally seen "the traffic in women"—that is, arranged political marriages such as that between Hultkalutawin and the French trader James Bordeaux—as a type of bondage or commodification of women. This too needs to be reexamined, giving appropriate weight to the cultural construction Native people placed on such events. The religious symbolism associated with such unions provides some important evidence of the high esteem in which women were held in these societies. To demonstrate these assertions, this study will focus on case studies of Mandan, Omaha, and Fox women of the Midwest; all were members of semi-sedentary village tribes that appear to have deliberately perpetuated ancient precontact gender roles and ideologies into the 1700s and 1800s.

Encompassing the present states of Ohio, Michigan, Illinois, Indiana, Wisconsin, Minnesota, Iowa, Missouri, North Dakota, South Dakota, Nebraska, and Kansas, the Midwest was occupied in historic times by an array of geographically mobile, autonomous tribes speaking a variety of dialects. Generally, Algonkian-speaking peoples predominated east of the Mississippi River, while Siouan- and Caddoan-speaking peoples dominated to the west. These tribespeople were engaged in a spectrum of subsistence activities including fishing, horticulture, craft production, trading, gathering wild foods, and hunting buffalo and other game.

Despite the many dialects spoken and the remarkable diversity in subsistence strategies and food resources within particular locales, the cultural landscape of the Midwest—and women's gender roles within this landscape—had some general continuities that can be identified. The Midwest was predominantly a prairie environment in which certain types of plant life, levels of rainfall, subsistence patterns, and social relationships tended to pre-

vail. The Native peoples of the Midwest thus have some fundamental cultural similarites that contrast with those of Native people of other regions.[3] Native women cooperatively grew garden plots of corn, squash, and beans with their female kin while men contributed foods from the hunt. Most of the tribes of this region were engaged in horticulture to a lesser or greater extent and lived in either permanent or semipermanent villages along waterways of the Ohio, Mississippi, and Missouri river drainage systems. Midwestern women enjoyed traditional rights to their gardens, their homes, and the products of their labor. Food production activities were strictly gendered. However, in tribal communities, kinship regulated the political realm rather than gendered concepts of a "female" domestic sphere and a male "public" sphere. In the indigenous communities of the Midwest, therefore, women's roles vis-à-vis men's roles could more accurately be described as reciprocal and complementary.

The mixed economy of hunting and horticulture was by no means unique to the Native peoples of the Midwest, nor was the greater emphasis on males' activities in hunting and warfare once Europeans arrived. Participation in the fur trade led to overkill of game and indebtedness to fur traders, and eventually undermined the subsistence base of Native peoples of the woodlands, prairies, and plains environments. Horticulturally based tribes clearly had greater short- and long-term economic stability, however. They could garner corn reserves for emergency food supplies and for trade in other needed commodities. Moreover, they tended to be more structurally differentiated than hunting tribes, and thus were more adaptable to change.[4] Those horticultural tribes like the Huron and the Iroquois confederacy of the eastern woodlands, for example, took advantage of brokerage positions in trade and diplomacy, and they experienced an era of prosperity, power, and security in the postcontact period. A number of horticultural midwestern tribes had comparable success in the early historic period as well. Among others, the Mandan, Omaha, and Fox village peoples found successful niches as middlemen and middlewomen in trade during the eighteenth and early nineteenth centuries.

Long before reports made by literate European observers provided information regarding intertribal relationships, locations of villages, sizes of communities, patterns of subsistence, gender relations, and political organization, the lives of Native women of the Midwest had undoubtedly undergone major changes in work, community life, and power relationships. Like all other Native Americans, the Midwest peoples suffered devastating population losses due to the introduction of European diseases, and major modifications in lifeways because of the introduction of European trade goods. In the prehistoric period, Caddoan-speaking peoples—predecessors of the Pawnee and Arikara—occupied the prairie-plains fringe. They lived in large,

earth-lodge villages along the waterways, grew corn, and enjoyed a complex ceremonial life involving a sophisticated knowledge of the cosmos in which the deity, Evening Star, was the model for industrious female behavior in cultivating crops such as Mother Corn. Evening Star was associated with the powers that never sleep: Wind, Lightning, Thunder, and Clouds.[5] In the ninth century A.D., the Siouan-speaking Mandan, refugees of a legendary flood, made their way up the Missouri River and established villages in the present-day Dakotas, adapting themselves to the culture and lifeways of the older Caddoan-speaking inhabitants.

After the Spanish established colonies along the Rio Grande, horses were introduced into the Midwest and rapidly became prized items in the inter-tribal trade. Horses dramatically increased the mobility of tribal populations, making prolonged hunting trips and long-distance warfare possible. At the same time as horses were opening up new avenues for Native people, trade goods such as guns, kettles, and cloth became available to the tribes in the vicinity of the Great Lakes and Louisiana, where the English and French had established trading posts and colonies. The stimulus of the fur trade encouraged the diffusion of cultural knowledge among Caddoan-, Siouan-, and Algonkian-speaking peoples.

Historical developments east of the Mississippi after 1650 profoundly shaped the experiences of midwestern tribespeople by stimulating westward migration of the Algonkian and Sioux. The Iroquois confederacy of the eastern woodlands, armed with Dutch and English guns, delivered a near-fatal blow to the Algonkian dwelling south of the Great Lakes in the late 1600s. Major population centers were disrupted, and the numbers of men were greatly reduced by warfare with their superior foes. Survivors fled to safe areas, consolidating themselves in large multi-ethnic villages of upwards of 10,000 people, leaving large areas in the *pays d'en haut* (the French term for the Upper Country) denuded of population. The "Beaver Wars" of the Iroquois had an ever-widening effect as populations put to flight spread diseases and encroached on territories of western tribes. Caught between hostile Siouan peoples on the west and Iroquois on the east, many Algonkian tribes of the Midwest, like the Miami, forged an alliance with the French against the Iroquois and English. Armed and gifted by the French "father," some of these Algonkian peoples east of the Mississippi regained a degree of territorial security in the 1700s and reoccupied areas abandoned earlier.[6] Though Siouan peoples west of the Mississippi may not have directly experienced the life-threatening effect of trade-induced warfare as did these Algonkian between 1650 and 1730, changes were no less radical. During these years, midwestern populations were greatly disrupted by slave raiding, disease epidemics, village movements, schisms, and mergers. For example, the devastating effect of disease on Caddoan village populations in the late eight-

eenth century allowed various Siouan peoples—such as the Omaha, Osage, and Iowa, whose movement westward and southward from the Ohio River had begun in the sixteenth century—to gain territorial control of new territories on the prairies and plains.[7]

It would be difficult to overestimate the effect this era of rapid change in the seventeenth and eighteenth centuries had upon the traditional roles and prerogatives of women. On the one hand, there were increased opportunities to trade. This encouraged specialization and stimulated the production of surpluses. In addition to processing hides and creating decorative items like beadwork for use by their kin groups, women also produced items for trade. For example, women grew more vegetables to exchange for desirable items like cloth, metal implements, and glass beads, which lightened their workload and improved the quality of their lives. Some individual women even became entrepreneurs in trade.[8] On the other hand, the disease epidemics, brutal warfare, territorial dislocations, and starvation conditions visited varying degrees of misery upon all tribespeople. Some densely populated and stable horticulturally based Algonkian or Siouan communities of the Ohio, for example, found it necessary to break into small mobile bands to scavenge for food. Survivors of clans that previously controlled certain territories and rights to resources now joined together for protection in multiclan villages for mutual protection. Instead of tending and harvesting crops, women's energies were devoted to gathering wild foods. The reestablishment of sedentary villages was hampered by armed bands who preyed on undefended populations of women and children to capture slaves for barter to French and English buyers. Women facing these circumstances were forced to leave homes and lost traditional control over fields, resources, inherited rank and other prerogatives, such as the opportunity to participate in female ceremonial organizations. Such women seem to have experienced an abrupt transition to patridominant societies. Other Native women were more fortunate; though they faced the pain of relocation, they were able to replant crops and reestablish continuity with the past cultural traditions.[9]

The combined effect of disease and the fur trade created a "new world" for Native people—a new world requiring numerous political and economic adjustments. At least three interrelated changes for midwestern women in the eighteenth century can be postulated (although this is somewhat speculative due to a lack of historical documentation). First, there is the increased importance to group survival of male achievements in the hunt and in warfare and the concomitant decline in female horticultural activities. Second, there is the overall shift from matrilocal and matrilineal organization to patrilocal and patrilineal patterns. Third, there is increased reliance on women in alliance formation due to the necessity of establishing wider political and economic networks. Warfare severely skewed sex ratios; disease epidemics ne-

cessitated the consolidation of populations into new communities for survival; these, combined with the opportunities for trade, all enhanced the need for alliances via intermarriages.

When anthropologist Harold Driver began systematically studying the tribes of this region through cultural trait analysis, he concluded that, in the prairie environment of the Midwest, men's contributions in the hunt were more important to group survival than women's horticultural activities. This provided a theoretical explanation for the prevalence of social forms here that recognized and promoted male bonding and cooperation in economic activities. Although there were some notable exceptions, midwestern tribes tended to be both patrilocal—that is, residency after marriage was with the family of the groom—and patrilineal, wherein the inheritance of offices, identities, and statuses within the kin group descended through the male line. This contrasts with well-known horticulture-based tribes such as the Cherokee and Choctaw of the Southeast, woodlands tribes of the Iroquoian confederacy, and the Pueblo societies of the Southwest, where residency was matrilocal and descent was matrilineal. Driver writes, "One gets the impression that the matrilocal bias may have been more obtrusive at an earlier date, and that the shift has been toward the patrilocal, perhaps again aided by the fur trade, the horse, and the buffaloe."[10] In a landmark study, archaeologist James Deetz documents the shift from matrilocality to patrilocality in the eighteenth century among the Caddoan-speaking Arikara by charting the disruption in pottery styles.[11]

The shift from matrilocal to patrilocal residency had ramifications beyond the irretrievable loss in the cultural continuity of artistic styles Arikara mothers passed to their daughters. In addition, wives would be subject to their husband's authority to a much greater extent and could not rely on the emotional or material support of female kin if not residing in the same household, band, or village. In effect, women lost the basis for female solidarity and power when female kinship connections were trivialized or severed. In sedentary, horticultural societies, women were more likely to form women's sodalities and to worship female deities, such as the Corn Mother.[12] One tragic by-product of such reorganization in normative expectations may have been increased violence against women by men. Unfaithful wives among the Central Algonkian—Illinois, Miami, Wea, Piankeshaw, and Shawnee— were subjected to various violent actions in the seventeenth and eighteenth century, such as being scalped, mutilated, or gang raped.[13] One explanation for the sexual double standard in punishing women much more severely for such offenses was provided by an Indian man who said it was because "beloved brisk warriors" facing lurking dangers from enemies could not tolerate women's betrayals or "their habitations [would be] turned to wild waste."[14] This suggests that increased militarism was the rationale for violence against

women. Even in horticultural tribes such as the Caddoan Pawnee, the historic shift to patridominance was evident. An old Pawnee Republican chief told a French trader in the 1790s, "[I]s not man the king and master of all other animals? Is it not he to whom the great spirit has given the strength and courage to fight enemies and to kill the most savage beasts? Why then does [the French Creole in the Illinois country] serve a weak and lowly woman, when it is she who should serve and obey him?"[15]

Whether there was a structural shift from matrilineality to patrilineality and matrilocality to patrilocality remains controversial. There is, moreover, a danger of overstating the case for female empowerment in matrilineal societies.[16] Conversely, one can underestimate female empowerment and status in patrilineal societies. Women made vital contributions to their communities as producers of many different goods and services; they were child bearers, culture bearers, cultural innovators, and occasionally holy women and prophets. One of the most important culture bringers among the Teton Sioux was White Buffalo Calf Woman, who brought the sacred pipes to the people.[17] Ambitious, industrious, and spiritually empowered women—along with wise and capable females who were revered elders in their clans—undoubtedly participated in family and group decision making. There are a few documented examples of midwestern women occupying positions of tribal leadership in the historic era: the Winnebago, for example, were ruled by "Queen" Hopekaw or Glory in the Morning, who married a French soldier-trader in 1729.[18] Numerous reports have survived, indicating that women from chiefly lineages were known to accompany males on important diplomatic embassies to other tribes.[19] Evidence of women's explicit exercise of power in political leadership positions in the eighteenth and nineteenth centuries is nonetheless scanty and circumstantial. Most scholars agree that historical forces did augment the position of men at the expense of women.

While women's bonds to one another and women's bonds to female deities seem to have diminished in the postcontact era, there are, on the other hand, indications that women's importance as intermediaries and producers of commodities for trade may have increased. There are, for example, many documented examples of intermarriages sealing political and economic alliances with alien groups.[20] Structural anthropologists have endeavored to explain the pivotal role of women in alliance formation, suggesting that the the exchange of "gifts"—goods, services, and women—was a critical factor in socially integrating societies that otherwise lacked specialized government institutions to do so. Those linked by marriage and reciprocal gift giving could count on each other for support: for example, material aid in times of need, and political or military assistance.[21]

Marriages that established kin ties between tribal groups and fur traders

provided tribespeople with access to supplies of guns, ammunition, and other trade goods. They were in the interests of group welfare, and therefore tribal leaders promoted them. Whether Native women had any agency in these marriages arranged by their male kin is open to question. Were women merely "commodities" exchanged by men? To answer in the affirmative would be to ignore both the political and cultural context in which these transactions occurred. One must give appropriate weight to the cultural construction Native people placed on such diplomatic events and their intended long-term consequences. The intermarriages were embedded in religious ceremonies fraught with symbolism involving beliefs about power and its transfer, femininity and masculinity, and idealized interpersonal relationships defined by kinship. Intermarriages among contracting groups brought strangers into a moral universe as predictable beings, their behaviors circumscribed by kinship responsibilities. "Kinship systems do not merely exchange women," writes Gayle Rubin. Genealogical statuses; rights to land use and domicile; the privilege of acquiring ceremonial knowledge, material, and political responsibilities; and other obligations and privileges are also transferred.[22] That Europeans, and later Americans, frequently conformed to Native diplomatic protocol that established fictive and real kinship ties without fully understanding or meeting the familial obligations expected of them— and sometimes abused their Native "wives" as slaves or sexual objects—is not disputed here.[23]

It is beyond the scope of this chapter to attempt to describe the varied historical experiences of many independent kin groups of Algonkian-, Siouan-, and Caddoan-speaking peoples who inhabited the Midwest in the seventeenth, eighteenth, and nineteenth centuries. All experienced to a lesser or greater degree the shift toward patridominance, geographic dislocations, population losses from disease and stepped-up warfare, and the direct and indirect influences of the fur trade. The survivors rebounded to win military victories, to absorb captives and fugitives, and to regain some territorial security. Generally, the kin groups followed two major paths: (1) those—like the Teton Sioux (e.g., Oglala, Hunkpapa), Arapahoe, and Cheyenne—who forsook sedentary living and horticulture altogether and embraced the life of equestrian nomads on the plains on the western periphery of the Midwest; and (2) those—like the Pawnee, Omaha, Fox, Kansa, and Mandan—that combined semi-sedentary village life with hunting. All nomads and semi-sedentary midwestern peoples participated in the fur trade because horses and guns were essential for survival in the historic period *and* because exchange networks were also political networks. However, those that retained a horticultural base were more conspicuously involved in middleman and middlewoman roles in exchange during this time period. The women in this

→ maintained some horticulture; semi-sedentary

latter group had more cultural continuity over time and also were more representative of the experience of Native women of the midwestern prairie from 1650 to 1850.

Mandan Women: Sexual Symbolism, Hierarchy, and Exchange

continuity

The Mandan illustrate persistence in midwestern women's gender roles from the precontact to the late historic period, and hence provide a case study of relatively unmodified gender symbolism and traditional female behavior. Unlike many other midwestern tribes, the Mandan appear to have maintained unbroken residential stability in their earth-lodge villages along the banks of the Missouri, and hence a higher degree of continuity in their ceremonial practices, in corn cultivation, and in the roles of women in their communities. (The Mandan and their neighbors the Hidatsa were exceptional among the midwestern tribes in that they were matrilineal.) Before Europeans usurped the middleman or middlewoman position, Mandan villages were important trading centers where horses and buffalo hides were exchanged for corn and items of European manufacture. Eighteenth-century accounts of the Mandan trade suggest a two-tiered interaction in exchange seems to have prevailed. At one level of intercourse was a trade in status items and ceremonial artifacts invested with sacred qualities which enhanced the standing of the owner and the purchaser. The ceremonial exchange was followed by the free exchange of utilitarian commodities by anyone in the village and a visiting trade party. Women were involved at both levels as persons invested with magical-political power and as tradeswomen. The first level was explicitly political and ceremonial, and the second was economic, according to non-Indian categorization. For Native people, it is doubtful if this kind of compartmentalization had any meaning, as politics, religion, kinship, and economics were all closely intertwined.

Mandan women were producers of corn surpluses for trade, and individual Mandan women of distinction played important symbolic roles both in religious ceremonies and in the rituals regulating diplomatic contact with other nations. In terms of both gender roles and gender ideology, Native women had empowerment and status.[24] Mandan women enjoyed considerable sexual freedom as well, as many early fur traders noted. What is particularly insightful about the Mandan is the Native beliefs about the transfer of power via sexual intercourse. As part of the ranking system regulating relationships of authority exercised by elders, sacred bundles and sacred knowledge could be purchased from the elderly owner by a younger aspirant seeking greater power and status. "A superordinate-subordinate, fictive kin relationship (father-son or grandfather-grandson) was established between buyer and seller," writes archaeologist Joseph Tiffany. In a public ceremony

in which this fictive relationship was established, gifts were exchanged, and sexual privileges to the wife of the "son" were extended to the ceremonial "father." Power purportedly was mystically transferred from the older man to the younger through the medium of sexual intercourse with the younger man's wife.[25] Similar beliefs and practices were to be found among the Hidatsa and some Algonkian groups, and it can be argued that certain analogous symbolism became part of standard trade protocol in the Midwest. In other words, there was a belief that power—spiritual, secular, or both—could be transferred from a wealthier or more technologically advanced individual or group (symbolized by Grandfather Sun) to a less fortunate individual or group via sexual contact with the latter's women. Based on field research, anthropologist Alfred Bowers states that, in the historic era, the Mandan and Hidatsa believed whites had "greater supernatural powers than Indians because of their richer material culture and technology."[26]

This ancient belief about power transferred through sexual contact explains the kinship metaphors used by numerous midwestern tribes in their early trade contacts with Europeans. In 1722, for example, the Kansa tribe (inhabiting a territory that later became the state of Kansas) were anxious to secure trade relations which the French, who in turn wished to open a trade route between French Louisiana and Spanish Santa Fe. A deserter and outlaw, Etienne de Veniard, sieur de Bourgmont, was reprieved by the Crown and given the responsibility for this delicate diplomatic mission of negotiating a rapprochement with the western tribes. He was familiar with the terrain and the Siouan languages spoken by several tribes along the lower Missouri River, having married "according to the custom of the country" the daughter of the chief of the Missouri tribe several years previously. Arriving at the Kansa village, Bourgmont was welcomed by calumets of peace (or peace pipes) and presents of horses. After further gift giving and haggling over exchange rates, the Kansa ceremoniously presented Bourgmont with the fourteen-year-old daughter of the head chief. Refused by the Frenchman, who professed he was already married, the chiefs offered the young woman to Bourgmont's ten-year-old son by the Missouri woman instead, saying "[your son] will be our head chief, and you will be our true father" or "protector" of the tribe.[27]

Although it appears that the Kansa leaders were prostituting the young daughter of the chief in order to "buy" the Frenchmen's favor, there is an alternate explanation more difficult to comprehend: that such ritual enactments of sexual contact expressed Native religious beliefs about the generation of life forces between male and female principles and the transfer of power between elder and younger males. In this dimly understood but apparently fairly widespread belief complex so alien to a modern, Western sensibility, interpersonal relationships were expressed in terms of kinship meta-

phors; ideas regarding secular and spiritual power were conflated, as were concepts of material and spiritual reciprocity.[28] Such relationships were reinforced by commonly held beliefs regarding cosmic dualism. In ritual activities, as well as in mundane affairs such as use of household space, Native peoples endeavored to maintain the balance and generative power of the countervailing forces—conceived in terms of paired opposites like male and female, night and day, sun and moon—that ruled the universe.

Calumet Pipes: Religious and Sexual Symbolism in Intergroup Trade

The centrality of beliefs about the generative powers of female and male principles in the realm of intergroup exchange practice is clearly evident in the symbolism associated with calumet pipes. Calumet pipe ceremonialism was a pervasive midwestern ritual device facilitating trade relationships between alien groups. There are two paired calumet pipes decorated with fans of eagle feathers, associated with the empyrean powers of the sun. The "female" calumet pipe had decorations representing the sky and the male principle; the "male" pipe had decorations representing the earth and the female principle. This ceremonial exchange between "trade chiefs" via the sacred calumets was analogous to the transfer of sacred objects or knowledge between elder and younger clansmen. As in the exchange of sacred bundles between an older and younger man among the Mandan, the calumet pipe ceremony established a fictive kin relationship through adoption between the initiator of the transaction, the "Father" who carries the pipes to another tribe, and the recipient, the "Son." Based on the overriding symbolism of fertility involved, anthropologist Alice Fletcher concluded that the twofold purpose of the pipe ceremony was: (1) the wish for children and (2) the desire to form social bonds among groups. "[T]hrough this mother [feminine principle, corn] element life was given, and a bond was established between the Father and Son of another tribe."[29]

The calumet pipe ceremony originated among the prehistoric, corn-growing inhabitants of the Midwest prairie, the Caddoan-speaking peoples, and it became popular among the Mandan, Fox, Omaha, and other tribes occupying the Midwest from the plains to the woodlands in the early fur trade era. Pipe ceremonialism and diplomatic intermarriages were particularly useful devices among tribes situated at the crossroads of trade, who sought to create and maintain strategic positions for themselves as politically neutral, economic intermediaries. Pipe ceremonies helped forge binding political alliances, facilitate exchange, and encourage peaceful and cohesive relations among bands, clans, and tribes. As horticulturalists and traders, women, perhaps more than men, benefited from the restabilization of village

life, and there is every reason to conclude that women heartily endorsed the peaceful policies that made this possible. Thus, during the postcontact period of rapid change and adaptation, women exercised agency in endorsing the tribe's investment in pipe symbolism. The pipes represent an ideology of gender balance that explicitly identifies women's centrality and indispensability as intermediaries in the formation of harmonious and fruitful bonds between unrelated men. Women had empowerment in this ideological system: they had the awesome sexual power of fertility associated with corn; as wives they helped bind kin groups into communities, which would then enjoy regional political power, economic security, and prosperity. The historic record reveals a close correlation among the use of the calumet pipes in diplomacy, the strategic maneuvering for broker positions in corn and horse trade, and the honoring of women for their public services in ceremonies. The pipes and their symbolism appear to have created a healthy balancing force in a world becoming skewed toward militarism, mobility, insecurity, and patridominance.

Fox Women: Female Agency as Intermediaries in Trade Networks

Many midwestern tribes consciously used strategic intermarriages and pipe ceremonialism to maneuver a favorable position for themselves in the exchange network in the early fur trade period. While some Algonkian tribes east of the Mississippi were "pipe dancing" the French and intermarrying with them in the seventeenth century, the Fox (or Mesquakie people) utilized the calumet pipes to forge an alliance network with other tribes *against* the French and their Illinois allies. This pan-Indian alliance network extended from the Iroquois of the northeast woodlands to the Omaha, Iowa, and Oto of the prairies. Correctly perceiving this alliance network as an economic and military threat, the French encouraged their Indian allies to wage a genocidal war against the Fox in the early 1700s. The Fox recovered and later in the century developed friendly relations with the English. The Fox village of Prairie du Chien along the Mississippi River, like the Mandan villages, became a prosperous free trade zone, where large amounts of corn, furs, and European trade goods changed hands.[30]

The aggressive participation of the Fox tribe in trade and their resiliency and resourcefulness after near annihilation provide indirect evidence of women's agency. They reveal women's commitment to and sustained effort in growing corn surpluses for exchange. At the very least, the women's acquiescence to the Fox's course of action in striving for intermediary positions in the exchange network was necessary. This is all the more persuasive when one considers that women of the Midwest appear to have controlled trade in the various commodities they produced. For those like the Mes-

quakie, Mandan, and other horticulturally based tribes, the desire for new material items stimulated the production of these female-generated surpluses. Women had an incentive to produce more corn, process more hides, and manufacture more decorated items for interregional trade. Fox women even mined lead to exchange in the market.[31] Without women's efforts in producing these surpluses, the acquisition of coveted European goods would not have been possible.

In some cases, women benefited from inflated prices for garden produce. Wherever English or French garrisons and trading posts were located in remote areas of the Midwest, the men there were dependent on securing food supplies from horticultural tribes, and, therefore, they actively sought coresidency and intermarriage with women of the nearby villages. Well into the nineteenth century, midwestern tribes such as the Mandan, Pawnee, Arikara, Sac, Fox, Iowa, Omaha, and Kaskaskia tribes were active in the corn trade, though this exchange in commodities produced and controlled by women has not been generally appreciated by historians. In 1820, the Sac and Fox women at Prairie du Chien were producing 8,000 bushels of corn; they sold 1,000 bushels to white traders. The Omaha were trading buffalo meat, tallow, corn, and marrow squash in 1811; in 1834 one bushel of corn was exchanged for one yard of calico, worth one dollar.[32] Women benefited in other ways besides having access to markets for their goods; arduous tasks were made easier by the acquisition of metal awls and cooking utensils to replace stone, bone, and pottery implements. Although the long-term erosion of Native economic self-sufficiency is not to be disputed, in the short term, Native women, like Native men, enjoyed many benefits and eagerly participated as producers and consumers in the market economy. One salient example of the benefits of participating in the market economy is provided by the Bettelyoun family. Susan Bettelyoun's great-grandfather was born of an interband union between a Santee Sioux woman and a Brulé man. Her grandfather, a chief of the Brulés, caught wild horses in the Platte River country and traded them principally with his mother's people, the Santee, in Minnesota and Wisconsin for guns, powder, awls, knives, hoes, paints, blankets, and beads.[33] Thus, this interband marital union provided both groups with an important linkage through which to exchange life-enhancing material goods. Bettelyoun's mother also extended her people's sphere of kin and resources by marrying a white man, and this act was duly credited as making a vital contribution to her band's welfare.

Women's Agency in Alliance Formation: Benefits and Liabilities

Did women have any agency in marriage alliances with outsiders, or were they were forced into marriages against their will? The historical record is

too complex to answer this question definitively one way or another. The ethnological record strongly suggests that young Native girls rarely had much choice in the selection of their first husbands. Youthfulness rather than gender may have been a more important element in their relative powerlessness when faced with the wishes and interests of their elder relatives, however. Such women in arranged marriages may have subsumed their own preferences to the interests of their kin group. They may also have subscribed to the belief that some "powers" would be acquired by sexual and kinship ties with more technologically advanced groups. From the woman's perspective, it could be seen as an opportunity to exert influence in a wider sphere or as an onerous responsibility to one's kin; unquestionably, it was both an honor and a duty. Women might eagerly desire unions with outsiders for the tangible advantages they would enjoy: more material items, more leisure, higher status, and more political power as intermediaries.

There were also liabilities to such arrangements. A woman marrying an outsider may have been required to leave her own kinfolk to reside among strangers and to suffer these strangers' suspicions or hostilities in addition to the burden of her own isolation. Certain Siouan tribes kept a calendric record of events important to their communities. These were called "winter counts," and in these calendars are examples revealing that the breaking of these liaisons could result in death for the woman and war for their families. Women who became very unhappy with arranged marriages were unable to exercise their customary prerogative of divorce in such political unions. The Corbusier winter count reveals that women occasionally resisted these unions and became targets of violence. In the winter count of 1784–85, for example, the event recorded was the murder of an Omaha woman living with the Oglala, who attempted to run away; her death resulted in warfare between the two tribes.[34] In the 1799–1800 winter count given by Cloud Shield, a woman given to a white man by the Teton Sioux was killed because she ran away from him. In the 1804–5 winter count of American Horse (perhaps recounting the same incident), an Indian woman unfaithful to her white husband was killed by a Ponca Indian.[35] These examples suggest women's unhappiness with their marital arrangements, and further indicates that their failure to cooperate could result in bloodshed because of the symbolic importance of these political unions to the allying groups.

In addition to evidence of intertribal and interband marriages, examples of intermarriages between Indian women of the Midwest and fur traders abound. Overtures for marital unions were often initiated by Native leaders. Marriage ties between a reigning chief's daughter and a European trader helped consolidate a chief's power against potential rivals, for he was ensured a steady flow of status goods for himself to redistribute to followers to maintain their loyalty. Perrin Du Lac noted in 1802 that to accept the daughters

of a great chief was a prerequisite to negotiations for Kansas fur. Regis Loisel declined the daughter of a Teton warrior along the Missouri River and suffered revenge in having his trading vessel stopped from moving upriver. When Manuel Lisa was dealing with the Omaha in 1810, he was pressured into taking the daughter of a leading man among the Omaha as a wife, though it is clear from his correspondence that he found such an arrangement distasteful.[36]

Cultural conflicts created tensions in such interracial marriages, especially when the upbringing of bicultural children was involved. Manuel Lisa left his Omaha Indian wife, Mitain, for a white wife; he added insult to injury by attempting to take Mitain's two small children to be educated in St. Louis. Mitain lamented her fate bitterly, for she had to endure his betrayal and abandonment as well as the separation from her small daughter, Rosalie. In the early years of the nineteenth century, Rosalie Lisa was taken to St. Louis, raised as a Catholic by the Sisters of the Sacred Heart and later married a white man. Mitain successfully kept her younger boy child with the help of sympathetic friends. Other Omaha wives of French fur traders in the first half of the nineteenth century faced similar conflicts, stemming from different cultural expectations regarding matrilocal or patrilocal residency patterns and the education of children.[37]

Omaha Women Chiefs: Rank and Marriage

Because of the exceptionally rich and thorough ethnographic record on Omaha culture, there is a greater possibility for a fuller understanding of the gender roles and gender ideology and their transformation here than among other groups. The Omaha, like kindred groups of Siouan-speaking people, were politically destabilized and geographically dislocated due to the fur trade, the effect of disease, and the introduction of the horse. They moved from the eastern woodlands and eventually situated villages on the Missouri near the Platte River. As a relatively small tribe of no more than 5,000 persons, they were active in the regional trade network via calumets and tenaciously held to an ethos of peace. Intermittently in trade alliance with Caddoan, earth-lodge-dwelling Arikara, and Pawnee, the Omaha may have been the group who desseminated the knowledge of the calumet pipe ceremony to Siouan-speaking people in historic times. Unlike the fully nomadic western Sioux, the Central Siouan peoples like the Omaha grew corn and maintained a semi-sedentary village life along with buffalo hunting, and they had a relatively rigid ranking system composed of royalty, nobility, and commoners. Marriage unions were made between persons of the same rank. Women of the elite families enjoyed high status, and some were "women chiefs" with special responsibilities, privileges, and markings.

In contrast to the Mandan practice of transfer of authority through purchase of sacred bundles, the Omaha, like other midwestern Siouan peoples, adopted more democratic methods of awarding status, rewarding individual initiative linked to public service in order to promote tribal unity and harmony. For women as well as men, one's personal traits and accomplishments—such as generosity, bravery, industry, and virtue—were a necessary supplement to reputable kin connections to achieve a highly honored position in the tribe.

One primary way in which the elite set themselves apart from commoners was by tattooing. Many Algonkian and Siouan peoples of the early historic era were conspicuously marked with tattooed symbols. Customs regarding tattooing had considerable uniformity and persistence among the midwestern people of the Central Siouan tribes, suggesting a regional sharing of certain symbols and normative practices. A man won the honor of having himself tattooed by hereditary privilege or by tribal services in war, horse raids, or peace embassies. Reminiscent of the Pawnee religious symbolism associating the feminine principle with the Evening Star, among the Omaha there was a prestigious male sodality of honorary chiefs, called the "Society of Those Blessed by the Night," which was composed of those thought to be blessed by the feminine principle of night and heavenly bodies seen only at night. A society member gained permission from the seven Omaha clan chiefs to have a woman tattooed with cosmic symbols when he achieved a certain number of credits for contributing to Omaha welfare through a combination of acts of merit involving generosity, peace making, or military valor. Presumably, women were chosen who met the highest standards of femininity by their exemplary character and exceptional industry. Once a man had obtained permission to have the woman of his choice tattooed, he was required to give away many horses and other gifts. A nineteenth-century traveler, Rudolph Kurz, noted that the men of the Iowa tribe were tattooed on their throats, breast bones, chests, and shoulders, while Iowa women had a large dot between their eyebrows. One dot signified that a woman's family had given away ten horses; a few had two dots meaning twenty horses had been distributed.[38]

A tattooed woman was called *Ni'kagahi wau* or "woman chief." She enjoyed certain ceremonial responsibilities and was sought after as a marriage partner, for it was believed she would have many, long-lived children. A tattooed woman was considered to be "like a Queen," according to an Iowa chief, and no one was to bother her. Such Osage women of the elite were "position proud," jealous of any usurpation of their duty to provide material aid to the needy.[39] Female tattooes among the Central Siouan peoples took the form of stars, circles, or dots on the forehead or on the back of hands. The tattooed symbol of the sun symbolized life-giving power and the four-

pointed star, the Morning Star. Sometimes a turtle was tattooed on a woman's hands and a crescent moon on her neck as well. Songs and ceremonies of the Society of Those Blessed by the Night celebrated creative cosmic forces, represented by binary opposites: male and female, earth and sky, night and day. Tattooing was "an appeal for the perpetuation of all life and of human life in particular." Thus, the female and male characteristics upon which group welfare depended were exhalted: the industry and valor of males and the virtue, fertility, and industry of females.[40]

The special order of tattooed women chiefs among the Omaha enjoyed high status, which was linked to specific social, ceremonial, and political responsibilities to ensure tribal welfare. One special honor was the exclusive right to dress the rare white buffalo robes, when such sacred creatures were found and killed. Similar religious beliefs and analogous practices seem to have prevailed among many Native peoples of the Midwest, for a tattooed class of prestigious females are to be found among the nomadic Sioux as well. Susan Bettelyoun's mother, Huntkalutawin, was in the *Hunka* order, a very select sodality or society that was expected to give away horses and robes to the poor. Bettelyoun writes, "[T]his was the only order where women were entered and it was only a privilege given to a very few. Those who came from families that were considered worthy were allowed. My mother was the virgin who was the pipe-bearer in the ceremony in the worship of the white buffalo robe."[41]

Huntkalutawin's personal family history is representative of a broader regional pattern in many respects. Those women who possessed high status in midwestern tribes were those from elite families rich in horses and active in regional trade. Honored women from such families were more likely to become marriage partners to men of equal rank outside their own tribes or bands for a number of reasons. Their wealth made them attractive partners, and they had greater opportunities for outmarriage than women from families not active in trade; also these kinship unions served the political and economic ends of creating ties of reciprocity between groups. Indeed, it might be argued that these tattooed women were raised with the expectation that such relationships with outsiders were their "fate," as Bettelyoun writes.[42]

In the last quarter of the eighteenth century, many midwestern tribes such as the Omaha were engaged in middle-person roles in the trafficking of horses from the Southwest in exchange for European items of manufacture coming in from the Northeast. From 1790 to 1819, horse procurement, warfare, and contact with whites and non-Dakota Indians were the events of consequence listed in the winter counts of the Teton Sioux.[43] A person who initiated a calumet pipe ceremony was a wealthy individual, able to af-

ford the many gifts of catlinite (red pipestone, named for George Catlin) to be presented in return for horses. Nadawin of the Omaha married the Oto chieftain, Having-Many-Horses, in the latter half of the eighteenth century, the name of the groom suggestive of the motives for the marriage union between these neighboring tribes. Their only daughter, Kazawin, in turn married a son of Black Bird, the autocratic Omaha chief, and then she married the Iowa Chief Wachin-Wascha. The Omaha-Otoe-Iowa daughter of this union, Nicomi, married a French trader, Peter Sarpy. Her influence consolidated his business interests. True to the prerogatives of her ascribed station, Nicomi was a willfully independent person. Refused some blankets she demanded, Nicomi burst into the storehouse and began dumping quantities of calico into the river until Sarpy relented. Sarpy provided handsomely for Nicomi in his will. Joseph La Flesche, Sarpy's French-Ponca clerk, wed Nicomi's daughter (by a first marriage), Mary Gale. Gale occupied a position of honor and respect among the Omaha. La Flesche and Gale were under strong pressure to have their daughters of the chiefly lineage tattooed with the cosmic marks of honor, but La Flesche refused, for he wanted them to be able to assimilate into the white world.[44]

Summary: The Historic Experiences of Native Women of the Midwest, 1650–1850

The evidence derived principally from sources on the Omaha, Fox, and Mandan—but supplemented by comparative information from other tribes— suggests the following conclusions about the historical experience of Native women of the Midwest. First, there was a respected female elite within tribes, who had certain ceremonial responsibilities and who were symbolically associated with the feminine principles necessary for spiritual and secular survival. This elite was recognizable because of distinct tattooing markings, and among the Omaha at least they were members in a select society. Second, these women gained such honors in large part because of their inherited status as members of the tribal nobilities and because of their familial ties to men who had made important contributions to tribal welfare; however, their positions of merit were also due to their own achievements and personal characteristics, for example, their industry, artistry, virtue, and faithful adherence to ritual practices. Third, while Native peoples moving onto the midwestern prairies may have been successfully reproducing the ranked societies and religious practices of their ancestral culture, the hierarchical social system and religious culture also appear to be heavily shaped by the competitive and destabilized geopolitical conditions. Finally, by virtue of high social standing and associated responsibilities and privileges, the amount of

political power truly exercised by women during this time period has been underestimated. Women of the elite clearly were groomed to be role models, to show initiative and leadership, and to perform their duties as political and cultural brokers effectively. Power, agency, and esteem, of course, were not restricted to the elite women alone. The elite merely represented the fulfillment of the feminine potential in these communities.

The realization of the female potential can be clearly witnessed in the mixed-blood La Flesche family. The La Flesche children, who were raised by their Indian mothers in Native communities, maintained a clear sense of their responsibilities as members of a chiefly lineage. Mary Gale and Joseph La Flesche successfully inculcated in their children the need to blend the best of white and Indian cultures. Believing that the white way was the way of the future, the parents put a high value on education in white schools. At the same time, the children's high public responsibility of serving the Omaha people was also a part of their upbringing. While Francis La Flesche became an ethnologist, recording for posterity the culture of the Dhegiha, his sister Bright Eyes Tibbles became a reformer, publicizing to the nation the injustices done to the Omaha's kinsmen, the Ponca, and helping stimulate a national reform movement. Another sister in this remarkable family, Susan La Flesche Picotte, attended medical school and became the first Native American woman doctor. Though Bright Eyes served her people as a "woman chief," it was Susan who was closer to the heart of her people, for she resided on the reservation in the mid-nineteenth century and provided a tangible form of aid as a healer. Though Susan's own short life was marred by poor health, she dedicated it to public service, improving the health of the Omaha people that they might flourish in a changing world.

Like many midwestern Indian women who had preceded her, Susan La Flesche Picotte served as an intermediary, facilitating cultural exchange and beneficial change that her people might have a better life. Doing research among the Omaha in the 1930s, Margaret Mead identified mixed-blood women as exercising considerable power in tribal affairs. "Their advice was sought and heeded in all tribal affairs, for their generosity and loyalty to Indian things."[45]

Due to the highly adaptive value of creating kinship ties with alien groups to facilitate peace and trade, the public responsibility of women as cultural brokers and political intermediaries was perhaps more highly developed in the Midwest than elsewhere during this time period. Native people of the Midwest were economically diversified and politically flexible, exalting and rewarding the achievements and productivity of both men and women. They adopted a formula for survival and prosperity that proved its utility and integrity through various changes of the seventeenth through the nine-

teenth century: <u>they balanced a reverence for the ancient and revered concepts of femininity with the responsibility of meeting the challenges of new political and economic conditions.</u>

Notes

1. Susan Bordeaux Bettelyoun (1857–?) Manuscript [Correspondence and Autobiography], Microfilm, Nebraska State Historical Society, 1963, pp. 4–5.

2. Eleanor Leacock and Nancy Lurie, *North American Indians in Historical Perspective* (New York: Random House, 1971), pp. 20–21; Mona Etienne and Eleanor Leacock, eds., *Women and Colonization: Anthropological Perspectives* (New York: Praeger, 1980), pp. 6, 14; Karen Anderson, *Chain Her by One Foot: The Subjugation of Women in Seventeenth-Century New France* (London: Routledge, 1991); and Carol Devens, *Countering Colonization: Native Women and the Great Lakes Missions, 1630–1900* (Berkeley: University of California Press, 1992). See also Judith Brown, "Economic Organization and the Position of Women among the Iroquois," *Ethnohistory* (1970); M. Thomas Hatley, "The Three Lives of Keowee: Loss and Recovery in Eighteenth Century Cherokee Villages," in *Powhatan's Mantle in the Colonial Southeast*, ed. Peter Wood et al. (Lincoln: University of Nebraska Press, 1989), pp. 223–48, esp. pp. 232–38; and Kathryn E. H. Braund, "Guardians of Tradition and Handmaidens to Change: Women's Roles in Creek Economic and Social Life during the Eighteenth Century," *American Indian Quarterly* 14 (Summer 1990): 239–58.

3. This is according to the exhaustive work of Harold Driver in his statistical correlation of cultural traits compiled in *Indians of North America* 2nd edition, revised (Chicago: University of Chicago Press, 1969); cf. maps 1–37 and especially maps 31 and 32 from Driver and William Massey's "Comparative Studies of North American Indians," *Transactions of the American Philosophical Society* 47, pt. 2 (1957). Other scholars define the "prairie" culture area more narrowly, describing the tribes east of the Mississippi as inhabiting a "woodlands" environment.

4. Duane Champagne, *American Indian Societies: Strategies and Conditions of Political and Cultural Survival* (Cambridge, MA: Cultural Survival, Inc., 1989).

5. Patricia J. O'Brien, "Evidence for the Antiquity of Women's Roles in Pawnee Society," *Plains Anthropologist* 36, no. 134, Memoir 26 (1991): 56. Paul Radin, like O'Brien, found residual elements of this older civilization in his fieldwork among the Siouan-speaking Winnebago. "Sacral Chiefdom among the American Indians," *La Reglia Sacra* (Leiden: E. J. Brill, 1959), pp. 83–97.

6. Joseph Jablow, *Indians of Illinois and Indiana* (New York: Garland Publishing, 1974), pp. 85–86. See Richard White's *Middle Ground: Indians, Empires and Republics in the Great Lakes Region, 1650–1815* (Cambridge: Cambridge University Press, 1991) for the best synthesis of these developments.

7. See Willard Rolling's *The Osage: An Ethnohistorical Study of Hegemony on the Prairie-Plains* (Columbia: University of Missouri Press, 1992) for a modern treatment of these poorly understood tribes who occupied what can be described as a transitional position between the woodlands culture of origin and classic plains equestrian nomadism.

8. Carl J. Ekberg and Anton Pregaldin, "Marie Rouensa-8cate8a and the Foundations of French Illinois," *Illinois Journal* 84, no. 3 (Autumn 1991): 146–60; John McDowell, "Therese Schindler of Mackinac," *Wisconsin Magazine of History* 66, no. 2 (Winter 1977–78): 125–43; and John McDowell, "Madame La Framboise," *Michigan History* 56, no. 4 (Winter 1972): 271–86; for a nonmidwestern woman entrepreneur, see E. Merton Coulter, "Mary Musgrove, 'Queen of the Creeks,'" *Georgia Historical Quarterly* 11, no. 1 (March 1927): 1–30.

9. See Richard White, *The Middle Ground*, for excellent documentation and exemplification of stress in gender relationships induced by these historic developments among the seventeenth- and eighteenth-century Algonkians of the Midwest, pp. 60–75.

10. *Indians of North America*, p. 238. Margaret Mead found evidence of matrilocality among the Omahas in her fieldwork in the 1930s. *The Changing Culture of an Indian Tribe* (New York: Columbia University Press, 1932); William Whitman, "The Oto," *Columbia University Contributions to Anthropology* 22 (1937): 15, 48–49, 51–53.

11. James Deetz, *The Dynamics of Stylistic Change in Arikara Ceramics* (Urbana: University of Illinois Press, 1965).

12. Ann Thrift Nelson, "Women in Groups: Women's Ritual Sodalities in Native North America," *Western Canadian Journal of Anthropology* 6, no. 3 (1976): 29–67.

13. John Moore, "Evolution and Historical Reductionism," *Plains Anthropologist* 94 (1981): 261–69; Lawrence A. Conrad, "An Early Eighteenth-Century Reference to 'Putting a Woman on the Prairies' . . . ", *Plains Anthropologist* 28, no. 100 (May 1983): 141–42.

14. This statement was from an eighteenth-century Chickasaw man from the southeastern culture area. Quoted in Arrel Gibson, *The Chickasaws* (Norman: University of Oklahoma, 1971), p. 24.

15. Quoted in John Francis McDermott, ed., *Travelers on the Western Frontier* (Urbana: University of Illinois Press, 1970), p. 21.

16. Regardless of the form of kinship organization, males occupy the highest statuses and exercise authority over women in the domestic, religious, and political spheres. David Schneider, "Introduction: The Distinctive Features of Matrilineal Descent Groups," in *Matrilineal Kinship*, edited by David M. Schneider and Kathleen Gough (Berkeley: University of California Press, 1966), pp. 5–9, 14, 19. See also Elizabeth Tooker, "Women in Iroquois Society," in Michael K. Foster et al., eds., *Extending the Rafters* (Albany: State University of New York Press, 1984), pp. 109–25.

Several studies have persuasively demonstrated that, in societies based on horticulture and matrilineal descent, Native women enjoyed considerably more influence in public affairs than in patrilineal societies. For example, Iroquois Sachem, speaking for the women he represented, said in 1791, "You ought to hear and listen to what

we women shall speak . . . for we are the owners of the land and it is ours." Quoted in Diane Rothenberg, "Mothers of the Nation: Seneca Resistence to Quaker Intervention," Etienne and Leacock, eds., *Women and Colonization*, p. 68.

Petitioning the "Washington Chiefs" regarding matriarchal landholding patterns in 1894, a Hopi delegation from the Southwest wrote, "The family, the dwelling house and the field are inseparable, because the woman is the heart of these and they rest with her." Quoted in Mary E. Young, "Women, Civilization, and the Indian Question," in *Clio Was a Woman*, edited by Mabel E. Deutrich and Virginia C. Purdy (Washington, DC: Howard University Press, 1980), p. 102.

17. One of the Sioux winter counts includes the ideograph regarding the Wankan (or Holy) Woman, who was quickly released by her captors when they realized she had tremendous powers.

18. Jonathan Carver, *The Journals of Jonathan Carver and Related Documents, 1766–1770*, edited by John Parker (St. Paul: Minnesota Historical Society Press, 1976), p. 79. Examples among the Algonkians are Weetoomo, a force in King Phillip's War, and the Queen of Pamunkey. Martha W. McCartney, "Cockacoeske, Queen of Pamunkey: Diplomat and Suzeraine," in *Powhatan's Mantle: Indians*, pp. 173–95. De Soto's expedition dealt with the Queen of Cofitachiqui.

19. Mary Wright, "Economic Development and Native American Women in the Early Nineteenth Century," *American Quarterly* 33, no. 5 (1981): 526–27; Priscilla K. Buffalohead, "Farmers, Warriors, Traders: A Fresh Look at Ojibway Women," *Minnesota History* 48 (Summer 1983): 243; Donald Jackson, ed., *Black Hawk, An Autobiography* (Urbana: University of Illinois Press, 1955, 1990), p. 12.

20. There is a growing body of scholarship on fur trader marriages to Native women, and the families that were engendered by such unions. See, for example, Sylvia Van Kirk's *Many Tender Ties: Women in Fur-Trade Society, 1670–1870* (Winnipeg, Manitoba: Watson & Dwyer Publishers, 1980); Jennifer S. H. Brown, *Strangers in Blood: Fur Trade Company Families in Indian Country* (Vancouver: University of British Columbia Press, 1980); Brown, "Women as Centre and Symbol in the Emergence of Métis Communities," *Canadian Journal of Native Studies* 3 (1983): 39–46; Jacqueline Peterson, "Prelude to Red River: A Social Portrait of the Great Lakes Métis," *Ethnohistory* 25, no. 1 (Winter 1978): 41–67; Peterson, "The People in Between: Indian-White Marriage and the Genesis of a Métis Society and Culture in the Great Lakes Region, 1680–1830" (Ph.D. dissertation, University of Illinois, 1981); Tanis C. Thorne, "People of the River: Mixed-Blood Families on the Lower Missouri," (Ph.D. dissertation, University of California, Los Angeles, 1987); Thorne, *Many Hands of My Relations: French and Indians on the Lower Missouri* (Columbia: University of Missouri Press, 1996), ch. 1; and John C. Ewers, "Mothers of Mixed-Bloods: The Marginal Woman in the History of the Upper Missouri," in *Probing the American West*, K. Ross Toole, et al., eds. (Santa Fe: Museum of New Mexico, 1962), pp. 62–70.

21. Structuralism was developed by Marcel Mauss and Claude Lévi-Strauss, beginning with Mauss's *Essay on the Gift*, published in 1925; Lévi-Strauss focused on the most valuable "commodity," women, in his 1949 book, and further developed his ideas in his 1953 book and in *Elementary Structures of Kinship* (1969). See also Schneider and Gough, *Matrilineal Kinship*. While creating linkages, exchanges also imply separateness and even hostility between those groups. Different kinds of ex-

change systems were associated with different social structures. The exchange of women and other "gifts" thus defines social organization: whom one may mate and whom one may not mate, as Lévi-Strauss argued in *The Elementary Structures of Kinship*, marked the beginnings of human social organization.

22. "The Traffick in Women: Notes on the 'Political Economy of Sex,'" in *Toward an Anthropology of Women*, edited by Rayna Reiter (New York: Monthly Review Press, 1975), pp. 172–207.

23. In a recent study of French-Choctaw relations in the eighteenth century, for example, Patricia Galloway suggests that calumet ceremonialism, by which alien nations were adopted as a fictive lineage within the tribe, was a practice characteristic of matrilineal descent groups seeking alliances. The patricentric bias of the French prevented them from appreciating the matrilineal forms of kin relations embraced by the Choctaw, resulting in fundamental miscommunications and disappointments regarding expected behavior on both sides. "The Chief Who Is Your Father: Choctaw and French Views of the Diplomatic Relation," in *Powhatan's Mantle*, p. 257.

24. Rebecca Tosie, "Changing Woman: The Cross Currents of American Indian Female Identity," *American Indian Research and Culture Journal* 12 (1988): 1–38. See George Catlin's account of the Mandan Okeepa ceremony, edited by John Ewers, in which customary sexual roles were ritually reversed, practices fraught with fertility symbolism.

25. Alice Kehoe, "The Function of Ceremonial Sexual Intercourse among the Northern Plains Indians," *Plains Anthropologist* 15 (1970): 99–103.

26. Joseph Tiffany, "Modeling Mill Creek–Mississippian Interaction," *New Perspectives on Cahokia: Views from the Periphery* (Madison, WI: James B. Stoltman, 1991), pp. 327–28; Alice Fletcher and Francis La Flesche, *The Omaha* (Lincoln: University of Nebraska Press, 1972), reproduced from the Twenty-Seventh Annual Report of the Bureau of American Ethnology to the Secretary of the Smithsonian Institution, 1905–1906 (Washington: U.S. Government Printing Office, 1911), p. 495. There was a shell society among the Omahas, and Kansa leaders wore shell disks in the protohistoric era. Bowers, "Hidatsa Social and Ceremonial Organization," Smithsonian Institution Bureau of American Ethnology, *Bulletin 194* (Washington, DC, 1965), p. 462; John Blakeslee, "The Origin and Spread of the Calumet Ceremony," *American Antiquity* 46, no. 4 (1981): 764–66.

27. Frank Norall, *Bourgmont: Explorer of the Missouri, 1698–1725* (Lincoln: University of Nebraska Press, 1988), pp. 56, 127–33.

28. Newer interpretations of gender must be sensitive to the cultural worldviews of native peoples. Kinship patterns and gender roles, after all, are culturally relative. As the structural anthropologists correctly observed, both are socially constructed realities imposed by human beings on the natural world to create order in social relationships. Studying material relations alone would produce an incomplete and distorted view of human behavior. Human beings create symbols to give meaning to human behavior. Not understanding the symbolic associations Native people placed on sexuality and femininity hampers a full appreciation of Native behavior. As Keith Basso has argued effectively, materialistic interpretations of Native populations' relationships to their ecological settings are incomplete as well as distorting, for they neglect the symbolic relationships people have to the land, that is, how peoples socially construct reality and give meaning to what people do in their envi-

ronments. "[C]ultural meanings are 'epiphenomenal' only for those who choose to make them so." Keith H. Basso, "'Stalking with Stories': Names, Places, and Moral Narratives among the Western Apache," in Edward M. Bruner, ed., *Text, Play, and Story: The Construction and Reconstruction of Self and Society* (1984), pp. 48–49.

For a related argument see Patricia O'Brien's article, "Evidence for the Antiquity of Women's Roles in Pawnee Society," in which she argues that precontact religious concepts about women in Pawnee thought persisted, despite material changes, into the postcontact era.

29. Alice Fletcher, *The Hako: A Pawnee Ceremony,* Twenty-second Annual Report of the Bureau of American Ethnology, 1900–1901 (Washington, DC, 1904), pp. 279–301.

30. *Journals of Jonathan Carver,* p. 88.

31. Lucy Eldersveld Murphy, "Autonomy and the Economic Roles of Indian Women of the Fox-Wisconsin Riverway Region, 1763–1832," in Nancy Shoemaker, ed., *Negotiators of Change: Historical Perspectives on Native American Women* (New York: Routledge, 1995), pp. 72–89.

32. Notable exceptions are George Will and George Hyde, *Corn among the Indians of the Upper Missouri* (Lincoln: University of Nebraska Press, 1917), p. 193 and ff; and Joseph Jablow, *The Cheyenne in Plains Indian Trade Relations, 1795–1840* (Seattle: University of Washington Press, 1950, 1966), pp. 22–31.

33. Bettelyoun Ms., pp. 4–5.

34. Garrick Mallery, "Pictographs of the North American Indians," *Fourth Annual Report of the Bureau of Ethnology, 1882–1882* (Washington, DC: U.S. Government Printing Office, 1886), pl. XXXV and p. 132.

35. Ibid., pl. XXXVIII and p. 134.

36. "Extract from the Travels of Perrin du Lac, 1802," in Abraham Nasatir, *Before Lewis and Clark* (St. Louis: St. Louis Historical Documents Foundation, 1952), pp. 655, 708, 258, 655; Pierre Tabeau, *Tabeau's Narrative of Toesel's Expedition to the Upper Missouri,* ed. Annie Heloise Abel, trans. Rose Abel Wright (Norman: University of Oklahoma Press, c. 1939, 1968), pp. 10–11, 107, 118–19, 167.

37. Richard Oglesby, *Manuel Lisa and the Opening of the Missouri Fur Trade of the Far West* (Norman: University of Oklahoma Press, 1963), pp. 152–53. Lucien Fontenelle who married Rising Sun, the daughter of Chief Black Elk, in the early nineteenth century desired to take their daughter to be raised by his aristocratic sister in Louisiana.

38. See Janet Spector, *What This Awl Means: Feminist Archaeology at a Wahpeton Dakota Village* (St. Paul: Minnesota Historical Society Press, 1993), pp. 26–27, for an argument for women attaining status through their own achievements, rather than merely because of their kin ties to a prominent male. *Journal of Rudolph Frederich Kurz,* J. N. B. Hewitt, ed., Smithsonian Institution Bureau of American Ethnology, *Bulletin 115* (Washington, D.C.: U.S. Government Printing Office, 1937), pp. 173–74. Cf. Francis La Flesche, *The Osage Tribe: Rite of the Wo-Xo-Be,* 45th Annual Report of the Bureau of American Ethnology (1927–28).

39. Alanson Skinner, *Societies of the Iowa, Kansa, and Ponca Indians, Anthropological Papers of the American Museum of Natural History,* vol. 11, pt 9 (New York: Order of the Trustees, 1915), p. 798; and Skinner, *Ethnology of the Ioway Indians, Bulletin of the Public Museum of the City of Milwaukee,* vol. 5, no. 4 (1926): 221.

40. Robin Ridington, "Mottled as by Shadows: A Sacred Symbol of the Omaha Tribe," *Voices of the First America: Text and Context in the New World* (San Diego, CA: New Scholar, 1986); Fletcher and La Flesche, *The Omaha* vol. 2, pp. 458, 494, 504–507, 509.

41. Bettelyoun Ms., pp. 4–5.

42. In ranked-chiefdom Hopewell societies of the prehistoric period (100 B.C. to A.D. 400), there is some evidence of regional intermarriages among elites as attested by taller height for elites than commoners, suggesting access to a large gene pool. Stuart Fiedel, *Prehistory of the Americas*, 2nd edition (Cambridge and New York: Cambridge University Press, 1992), pp. 246–48.

43. Elizabeth R. P. Henning, "Western Dakota Winter Counts: An Analysis of the Effects of Westward Migration and Culture Change," *Plains Anthropologist* 27, no. 95 (February 1982): 64.

44. Norma Kidd Green, *Iron Eyes Family: The Children of Joseph La Flesche* (Lincoln: Nebraska State Historical Society, 1969), p. xiii; John Wickman, "Peter Sarpy," in LeRoy Hafen, ed., *The Mountain Men and the Fur Trade of the Far West*, 10 vols. (Glendale, CA: Arthur Clark Company, 1965–1972), pp. 6, 283–96; J. A. MacMurphy, "Some Frenchmen of the Early Days on the Missouri River," Nebraska State Historical Society *Transactions and Reports* 5 (1893): 52–55.

45. Mead, *The Changing Culture of An Indian Tribe*, pp. 153–54.

6

"Those with Whom I Feel Most Nearly Connected"

Kinship and Gender in Early Ohio

TAMARA G. MILLER

Early in October of 1788, Rebecca and John Rouse and their family of eight children left their small farm in Rochester, Massachusetts, for the new settlement of Marietta on the banks of the Ohio. The Rouses began their journey by traveling to New Bedford, where John had been a whaleman before the Revolution and where Rebecca and the children had lived while he was at sea. The Rouses stayed in New Bedford for almost a week, making final visits to their relatives and friends. After the last tearful good-byes, they continued on to Providence where they were joined by Rebecca's sister, Nancy Devol, and her five children. Nancy's husband, Jonathan, was already in Ohio, having gone with the first party of pioneers the previous winter. Nancy and Rebecca's younger brother, Isaac Barker, would drive the Devol wagon to Ohio. Isaac was leaving behind a family in Rochester, planning to return for them the following year after he had prepared a home for them in the wilderness. After bidding farewell to yet another sister, the three siblings headed for their new home in the West.

The journey was a long one; they would be on the road for two months. But both the journey and their apprehensions about living on the frontier were lightened by the presence of kin. By the end of November, they had reached Sumrill's Ferry on the Youghiogheny River in Pennsylvania. Here they abandoned their wagons and finished their journey by boat, floating down the "Yoh" to the Ohio, and down the Ohio to the mouth of the Muskingum. Early in December, they reached their destination and received a warm welcome from Jonathan Devol and the eighteen families already in the settlement.[1] After moving everyone into the two-story house Jonathan had built in the garrison, they were ready to begin their part in the building of a new community.[2]

Jonathan Devol's was not the only familiar face these travelers found in

Marietta. Jonathan was one of the original forty-eight pioneers. Two of his nephews, Allen Devol and Gilbert Devol, Jr., had made the journey with him, and were also there to welcome their aunt and cousins. Other Devols would soon join them, including two of Allen's brothers and Gilbert's parents and eight siblings. Jonathan's brother Stephen and his family also arrived at about the same time, reuniting three of the six Devol siblings.[3]

Two more Barker sisters would also eventually come to Ohio, leaving only three Barker siblings in the East. Isaac Barker brought his wife, Rhoda Cook, and their children out later in 1789 as planned. Elizabeth Barker Cook, her husband Joseph, and their children moved to Ohio in 1796. The last to arrive was Rhoda Barker Cook. Rhoda moved to Ohio in 1804, one year after the death of her husband, and settled with her children on a farm in Belpre, close to her brother and sisters.[4] Within a few short years, a laterally extended family network had been transplanted to the West. Rhoda, Elizabeth, Nancy, Rebecca, and Isaac Barker; Rhoda and Joseph Cook; and Jonathan, Gilbert and Stephen Devol helped to link together several families and create a foundation on which to build a new community.

The American frontier, at least since the time of Frederick Jackson Turner, has been viewed as a place where rootless young men sought to escape the confines of society and seek their personal fortune. More recent scholarship has begun to correct and refine this interpretation. The Midwest, in the late eighteenth and early nineteenth centuries, was a place where many different cultures came in contact: northern, southern, and backcountry; Native American, French, and Anglo-American; black, white, and red. As a result, it is very difficult to generalize about the Midwest as a region during this period. While a distinctive midwestern culture may have emerged by the late nineteenth century, during the early years of that century it was still a region of many cultures. However, perhaps a few tentative generalizations can be made. One such generalization emerges from a growing number of studies of communities in the Old Northwest, and that is that even in the earliest frontier stage of settlement, a significant portion of the settlers were part of family groups. Whole kinship networks moved to these new lands. Those who did not come with relatives were often soon joined by kin. These family networks became the basic building blocks of community. Those settlers surrounded by kin were the ones who stayed to build these new communities.[5]

A recognition of the importance of family ties in the settlement of the Midwest significantly alters our view of the frontier, especially in forcing us to examine the role of women in the settlement process. Few of these studies of midwestern communities in the early nineteenth century, however, give much recognition to the importance of female ties in community formation.[6] But kinship networks were made up of both women and men, and the

kinship ties of both were important in migration, persistence, and the creation of a social community. Marietta and the surrounding towns in southeastern Ohio were no different. While not all of the kinship networks that migrated to the area were as dense as the Barker-Cook-Devol-Rouse network, after a few years of living and marrying in Ohio many individuals found themselves part of family associations that were even more complex.

Marietta, located where the Muskingum River meets the Ohio, was the first permanent Anglo-American settlement of the Northwest Territory and later became the county seat of Washington County. The first group of pioneers to reach Marietta in April of 1788, the original forty-eight, were all male. These men were sent out in advance of any families by the Ohio Company, which owned the tract, in order to survey the area, clear land, plant crops, and build shelters before families arrived. Many of these men were young and single, hired by the Ohio Company to do this manual labor. Some of these young men had no intention of permanently moving to the Ohio Country but wanted to see it nonetheless. Others were sons of families contemplating the move, checking out the land and the prospects for their families. And a significant number, like Jonathan Devol, were married and assessing the prospects themselves. Thirteen of the forty-eight pioneers were married, and not surprisingly they were more likely to settle and remain in Washington County than were the single men. Only one of these thirteen did not settle in the county. Over half of the single men became permanent settlers as well. Several, like Gilbert and Allen Devol, were sons or nephews of other pioneers. Others, such as Anselm Tupper and Phineas Coburn, were joined by their parents and siblings within a few years. And kinship ties between the pioneers were strengthened by marriage as families arrived.[7]

The first party of families arrived in Marietta on August 19, 1788. The party included eight families, and a few of them were already related. Huldah and Benjamin Tupper traveled with their two unmarried daughters and two unmarried sons. Also in the party were their daughter Minerva, her husband Ichabod Nye, and the Nyes' two young children. Asa Coburn, Sr., brought his family out to join his son Phineas. The senior Coburns were accompanied by their married daughter and their married son and both the daughter's and the son's families.[8] Clearly, Marietta was going to be settled by families.

The women and men who moved their families to Marietta did so because they believed that they could better provide for their families in the West. They wanted to keep their families together, to have their children settle near them and raise families of their own. This goal was becoming increasingly difficult to realize in New England. As the population grew, land grew scarce, and many parents could no longer provide all sons with farms nearby.[9] Even those not directly engaged in agriculture perceived that their opportunities were shrinking. The male founders of Marietta were primarily

veterans of the American Revolution and were either substantial farmers or artisans or the sons of such men. Many of them found their social and economic standing eroding and were generally distressed by the social upheaval of the 1780s that culminated in Shays' Rebellion. For the most part, they came from the towns of eastern Massachusetts, Connecticut, and Rhode Island that were becoming integrated into a market economy. Many of the migrants were themselves part of the emerging commercial classes. These men generally accepted and even welcomed the changes in New England's economy, but they did not welcome the accompanying social changes. Several, including Rufus Putnam and Benjamin Tupper, helped suppress Shays' Rebellion. They did not welcome the decline in deference or the loss of a more communal society that followed the Revolution. These men wanted to maintain their personal status both within their community and within their families, but were finding it increasingly difficult to do so.[10]

Like their husbands, the women who migrated from New England to Washington County hoped that the move would lead to better opportunities for their children. But while family considerations persuaded women to make the difficult move, concerns for family also held them back. For women, more so than for men, the necessity of parting with aging parents, as well as with other relatives and friends, made the decision to move to the Midwest a particularly difficult one.

Lucy Backus Woodbridge, of Norwich, Connecticut, was just one of many women who struggled with this conflict between her desire to provide for her children and her devotion to her parents. She was the oldest child of Lucy and Elijah Backus to survive to adulthood. Her father, Elijah Backus, Sr., was a farmer and owner of a gristmill and ironworks, and also owned shares in the Ohio Company, though he never intended to settle in Ohio himself. Perhaps he invested in midwestern lands in order to provide better for his children. In any case, three of Lucy and Elijah's five children did settle in Ohio, and the two remaining children spent considerable time there. James, the oldest Backus son, went to Ohio with the first band of pioneers, though he eventually returned to Norwich. Lucy and her family went out the following year, and Elijah, Jr., made the trip in 1790. The Backus's remaining son, Matthew, moved to Ohio in 1793. Their daughter Clarina never married. She moved back and forth between Connecticut and Ohio, helping out wherever she was needed.

Lucy had married Dudley Woodbridge, a young lawyer and merchant of Norwich, just prior to the Revolution. Lucy and Dudley had six children, all born in Norwich. By 1788, they were beginning to think that the Midwest offered a better hope for these children than did New England. Lucy's brother James reported back favorably about conditions in Ohio, while Dudley told James that prospects in Connecticut were "gloomy and dull."

Lucy too began to accept the idea of leaving her parents and moving to Ohio, but only because it was best for her children. "I feel reconcile'd myself to any step that will promote the interest of my family," she wrote.

> In this place their is very little for any one to expect of course we do not hazard much in the attempt, and the descriptions of the western world are truly flattering. If the half of them are just I shall chearfully quit my prospects here. It would be painful parting with connections I must leave behind me, but the society of our friends but poorly compensates for the want of a subsistence. We have a large circle of little ones dependent on us, and I know of no persuit that would give me more pleasure than that of provideing an easy Liveing for them.

The only reason Lucy could justify leaving her parents was the necessity of providing for her own children. It was a difficult decision, and Lucy knew it would be hard on her parents. Family was as important to Lucy and Elijah Backus as it was to Lucy Woodbridge. As Lucy told her brother James, "were I determin'd on going I should wish to conceal it from our good Parents; It would be an affliction to them tho they can well spare me."[11]

Lucy and Elijah Backus were not the only parents reluctant to see their children emigrate to the midwestern frontier. Parents longed to have their children around them in old age to provide both economic and emotional support. Jane Robbins of Plymouth, Massachusetts hated to see her daughter Hannah leave for Ohio. Hannah Robbins Gilman moved to Marietta in 1790 with her new husband. Her husband's parents were already in Ohio, waiting to receive their new daughter-in-law. Jane Robbins wrote to Rebecca Gilman, trusting her daughter to her care. She confided to Rebecca, "I once pleas'd myself with the fond expectation that my Children (particularly my daughters) would live near me and be the solace of my declining years." While fathers desired to establish sons on farms or businesses near home, mothers cherished the company of daughters who could help with household tasks and provide emotional support. "If any persons are to be envied tis those parents, that have their Children settl'd, where there is a possibility of seeing them," Jane wrote to Hannah.[12] But fewer and fewer New England parents were able to keep all their children nearby.

The families that moved to Marietta were not all young families just starting out in life. Many were families in their middle and later years, with children entering adulthood. For these families, the need for providing a start for their children was felt most severely. Many such parents who wished to keep their children around them could not hope to do so if they remained in the East, so they moved their whole family to Ohio in the hopes of establishing a new lineal family in the West. Zara Howe, searching for land in Pennsylvania and Ohio, expressed the motivation of many: "I want to git

on some Land where I can have my Children round me," he wrote.[13] Lucy Woodbridge was thirty-two and Dudley was forty when they moved to Marietta. Their six children were between the ages of fourteen and four. Nancy and Jonathan Devol were about the same age. They had five children, the oldest age twelve, the youngest only one. Rebecca and John Rouse were slightly older. Rebecca was thirty-seven and John was ten years older. Their eight children ranged in age from twenty-two to four.

The women and men who moved to Marietta in the late eighteenth century did so not to seek personal independence or personal profit, but for the financial security of their families. In moving to the Midwest, clearly, many relatives had to be left behind. But had they remained in New England, their families would likely have been broken up also, and perhaps even more scattered. In moving to Ohio, lineal family values could be preserved. Daughters and sons could remain near their parents. Eventually, they hoped, granddaughters and grandsons would be able to do so as well.[14]

While migration generally meant leaving relatives behind, bonds with extended kin remained important to midwestern families. Indeed, the families of southeastern Ohio may have placed even greater value upon extended kin ties than did the New England families who stayed behind. The importance of family ties for these migrants is evident in the names they chose for their children. For the most part, these families followed traditional New England naming practices, more often naming first-born daughters and sons for parents than for grandparents. But grandparents were honored at least as frequently as among families that remained in New England; and as new families were formed in Ohio, grandparents were recognized even more often. On the other hand, parents who settled in Ohio were less likely to name a child for themselves than were their New England counterparts. Distance may have reduced generational tensions. Feelings of guilt over leaving aging parents may have played a role as well. And nearby extended kin may indeed have been more important to families in these new settlements than in the long-established towns of the East. In any case, these midwestern families were less likely than New England families to emphasize the importance of the nuclear family at the expense of lineal ties.

Only 14 percent of those Ohio parents who married by 1800 named their first daughter for her mother, and only one quarter of first sons received their father's name. In Hingham, Massachusetts, however, over 50 percent of parents who married between 1761 and 1800 named their first daughter for her mother, and nearly 60 percent named their first son for his father. First-born daughters of these Ohio families were more likely to be named for a grandmother. One quarter of first-born girls received the name of one of their grandmothers, slightly higher than the percentage so named in Hingham. First-born sons were less likely to be named for grandparents than

lineal ties [handwritten marginal note]

were first-born daughters, among both Massachusetts and Ohio families. But again, Ohio sons were more often named for grandfathers than were Massachusetts sons. The grandparents so honored were as often the mother's parents as the father's (see Table 2).[15]

Not all families named children for grandparents first. Lateral ties also appear to have increased in importance for midwestern families, and children were frequently named for their parents' siblings. No one naming pattern stands out as clearly dominant in early Washington County. Some families placed more emphasis on generational ties, others on bonds with siblings. Most chose names from both sides of the family equally, suggesting that female ties were as important as male ties for these Ohio families. When both sides of the family were not equally represented, it was generally because one side lived in Ohio and the other did not. The family that was part of everyday life was the one most often recognized in naming. But whether they emphasized female, male, generational, or lateral ties, the families of southeastern Ohio placed a greater importance upon bonds with extended kin than did New England families.

Kinship ties influenced migration to Marietta. The continued and heightened importance of bonds with relatives was reflected in child-naming patterns. Kinship ties remained central to the formation of community in Marietta well into the nineteenth century. One important indicator of the importance of kinship ties in the building of community is the significant role such ties played in determining whether or not a family would stay. The presence of relatives was especially important to persistence in Marietta's earliest years. While it is impossible to identify all kinship ties between Marietta residents, common surnames are one indication of kinship. Marietta heads of households who shared a surname with another household head were much more likely to remain in town for ten years or longer than were those without such ties. Fully 50 percent of heads of household on the 1800 census that shared a surname with at least one other head of household appeared on the Marietta census ten years later, while only 26 percent of those who did not remained in Marietta that period of time. Between 1810 and 1820, 40 percent of those with kin identified by surname persisted, while 30 percent of those without kin did. The presence of relatives continued to be an important factor in persistence though its significance was greatest in Marietta's early years, before the development of strong institutions (such as churches and voluntary societies) that helped bind individuals to the community. Could female kinship ties be easily identified, the relationship between the presence of kin and persistence would undoubtedly be even more striking.

The significance of non-same-name kin and of female ties becomes obvious when marriage patterns are examined. Many emigrants to Marietta

Table 2 Ohio Child-Naming Patterns by Marriage Cohort, pre-1781–1860

Cohort*	n**	1st Daughter Named for			1st Son Named for			2nd Daughter Named for			2nd Son Named for		
		Mo***	FaMo	MoMo	Fa***	FaFa	MoFa	Mo***	FaMo	MoMo	Fa***	FaFa	MoFa
Pre-1781	10	10%	20%	10%	30%	10%	0%	44%	11%	0%	33%	0%	11%
1781–1800	19	17%	11%	11%	21%	11%	11%	22%	11%	11%	13%	0%	6%
1801–20	30	24%	3%	14%	18%	4%	25%	4%	12%	4%	9%	13%	17%
1821–40	45	8%	10%	23%	14%	11%	23%	7%	6%	9%	29%	7%	10%
1841–60	41	14%	3%	16%	20%	14%	14%	17%	0%	0%	21%	7%	7%

*Cohorts are based upon date of parents' marriage.

**The couples considered were all those first marriages, or second marriages when there were no children in the first marriage, for whom the names of all children were known as well as order of birth, and for whom the names of all four grandparents were known.

***In cases in which both the parent and grandparent shared a name, the child was considered to be named for the parent.

were already related to other settlers when they arrived, but as more families began to put down roots in Marietta and as their children began to marry, kinship networks expanded. The overwhelming majority of marriages performed in Washington County involving at least one partner from Marietta were endogamous. Fully 89 percent of Marietta women and men who married in the county before 1801 married someone else from Marietta. Only 6 percent of the marriages involving a Marietta resident were to someone outside of the county. The proportion of endogamous marriages declined over time as more towns were founded in the county. But most Marietta women and men continued to marry fellow Mariettans. Those who did not still found partners close to home, as it was the proportion of marriages to other country residents rather than to partners farther away that showed the greatest increase. As late as 1840 to 1850, 71 percent of Marietta women and 78 percent of Marietta men tying the knot in Washington County married someone else from Marietta. Only 12 percent married someone who lived outside of the county.[16] Such marriage patterns served to widen the circle of kin and knit together the community. The relationships of father and son, brother and brother, uncle and nephew were important, but so were those of mother and daughter, sister and sister, and aunt and niece. Through marriage, both women and men united families and brought cohesion to the new communities on the early midwestern frontier.

Which brings us to the question of the relationship between kinship and gender. In most respects the late-eighteenth and early-nineteenth century family was clearly patriarchal. Women were subordinate to men both legally and economically. Upon marriage a woman lost control of any property she owned, her husband becoming the sole owner of her property. Any money she might earn would also legally be his. As a wife, a woman could neither sue nor enter into a contract on her own. In all economic and legal matters, she was to be represented by her husband. In return, she was to receive support from her husband during her life and dower upon his death. A widow was entitled to one-third of her husband's personal property and the use of one-third of his real property during the remainder of her life or widowhood. Upon her death or remarriage, the real property would most likely go to her sons. Throughout the first half of the nineteenth century, Marietta fathers tended to bequeath land to sons and personal property to daughters. Sons also were likely to receive a larger share of their father's estate than were their sisters. Both law and custom recognized the kinship ties of men at the expense of bonds with women.[17]

The women of Marietta and the surrounding towns did not directly challenge this patriarchal family system. For the most part, they accepted it as the natural order. Women did not view themselves primarily as individuals, but as members of families; as daughters, sisters, wives, and mothers. Yet

because women were defined, by themselves and society, by their relation-
ships with others, kinship was at least as important to women as it was to
men. Women, therefore, played a crucial role in cementing kinship ties. In
doing so, women both mitigated the inequalities of the gender system and
improved the quality of their lives.

Recognizing their dependence upon men, both legally and economically,
the women of Washington County sought to strengthen ties with kin in
order to provide themselves with an alternative source of material and emo-
tional support. Women looked to their own kin when their husbands died
or deserted them. Lucy Woodbridge's daughter, Lucy Petit, left an abusive
husband, with the support of her family, telling the judge "that the fear of
her friends alone restrained him often from treating her with the most cruel
personal abuse."[18] Women also depended upon their female kin to help them
through less trying times, exchanging labor, providing comfort during
childbirth, and caring for one another's children. While most women's
strongest bonds were with their own parents and siblings, wives adopted
their husband's kin as well. Women sustained ties with relatives on both
sides of the family to the benefit of both husband and wife. The nuclear
family has never been self-sufficient. In the eighteenth and nineteenth cen-
turies, that meant most families relied upon extended kin. Although the fam-
ily system was patriarchal, women exerted considerable influence and power
in their control over relationships with kin. The centrality of women to kin-
ship networks assured them an important place in community life.[19]

In early Marietta, kinship bonds between men were reinforced by ties
of property. Fathers controlled property that was handed down to sons.
Some fathers took sons into partnerships; others set sons up in businesses of
their own. Brothers and brothers-in-law, too, often went into business to-
gether. Such economic ties could be fragile. Businesses did not always suc-
ceed, partnerships were often short-lived, tensions could arise over the con-
trol of property. Ties between men were not solely economic, but to the
extent that they were, they were easily frayed. Bonds between women tended
to be more enduring. Connections between female kin were based upon
mutual aid and sharing. A mother would help a daughter through childbirth.
Several years later that daughter would nurse her mother in her final illness.
The exchange of labor was not always direct. Those who could best lend help
at a particular time were expected to do so. In time, all would be repaid. By
helping her female kin, a woman could expect assistance in her time of need.
Such ties tended to be more intimate and lasting than those between male
kin. These bonds of obligation and love were often passed on from genera-
tion to generation.

Mothers, daughters, and sisters were the most important links in these
networks of female kin. Daughters, for their part, provided essential house-

hold labor for their mothers while they lived at home. When a woman married and moved away from home, her mother and sisters helped her to begin housekeeping. Mothers, daughters, and sisters continued to exchange labor and emotional support throughout their lives. For most women, the sharing of work did not end with the establishment of separate households.

Women's work lent itself to sociability. Those women who lived near their female kin worked together often. But even distance did not prevent women from exchanging labor and goods. Susanna Stone of Belpre spent at least part of the winter of 1817–18 weaving blankets for her daughter, Melissa Barker, who had moved with her husband Joseph up the Ohio to Newport. One and a half years later, as Melissa was making beds in preparation to move onto their new farm, she informed her mother that she still needed to purchase feathers and told Susanna, "if you should hear of any for sale I wish you would engage them for us." Elizabeth Barker, Melissa's mother-in-law, continued to provide for her children up until her death in 1835, at the age of sixty-five. Just months before her death, Elizabeth had been preparing cloth for her daughters. "I send you a couple of pieces of cotton and wool hoping they may be of use to you at this time," wrote Charlotte Barker in a note to her sister Catharine shortly after her mother's death, "they are some that ma coloured in the spring, I suppose that she intended them to some of you, she was always laying up something for her children." A year after her marriage in 1843, Mary Maddox thanked her mother and her sister Elizabeth "for the pains you have taken to prepare me a carpet and rug." A few years later, Mary asked her sister Sarah, who cultivated a flower garden to send her some dahlia roots.[20]

By bestowing cloth, carpet, and dahlia roots, women strengthened ties with their female kin, both near and far. But perhaps women established their most intimate bonds with female kin through caring for each other during childbirth, sickness, and death. While Marietta and Washington County had their share of male physicians who were called in in serious cases, women, and especially female family members, were responsible for most health care. Mothers tended to their sick children and assisted their daughters in pregnancy and childbirth; sisters cared for their siblings and families; and daughters nursed their parents in old age. To fall ill without a female relative near was indeed a calamity.[21]

The Barker women knew that they could rely on their female kin in times of sickness or travail. Childbirth, in particular, brought the Barker women together. They depended upon their female kin both during their travail and in the weeks afterward. Betsey Stone gave birth to her third child on November 12, 1818, much later that she had expected. Betsey's mother, Elizabeth, who had traveled thirty miles to be with her daughter, arrived at the end of September. Elizabeth stayed with her daughter despite the fact that

she had pressing work to do at home. Elizabeth could stay as long as she did because she had other daughters at home. But still, Sophia, who was left in charge of the Barker household, imagined her mother growing "impatient enough sometimes to juggle her I daresay for we have considerable spinning to do yet."[22] But evidently Elizabeth believed that helping her daughter through her confinement was important enough to justify leaving home for so long.

Several months earlier, another grandchild of Elizabeth Barker's had been born to her son Joseph and his wife Melissa Stone. A month before her confinement with her first child, Melissa wrote to her mother in anticipation of the event: "a thousand fears and aprehensions crowd upon me," she confided. "My fortitude forsakes me as the approaching crisis advances when I shall need your motherly advise and care to support me." But Susanna Stone had no daughters at home and it was difficult for her to get away, and she did not make it to Newport for her grandson's birth. Fortunately, Melissa was with her sister Grace and could look forward to the support of her friend and sister-in-law Sophia Barker, who asked Melissa to "write the first opportunity and tell me when I shall come and help escort the cradle to the parlor."[23] Melissa would have family around her long after her baby was born.

In 1825 Betsey Stone gave birth to her sixth child, a girl she named Catharine for her sister. Betsey had a difficult labor and recovery. Once she was about, baby Catharine burned her face by falling onto the hearth. "But through all I have been blessed with the kind care of friends," Betsey wrote thankfully. Her husband's sister Grace Stone had been present for the birth and remained until Betsey's sister Catharine arrived. Catharine remained for several months. Five years later, in 1830, Catharine gave birth to her first child, a stillborn son. Catharine had moved to McConnelsville after her marriage and so was near her sister Betsey, as well as her brother Luther and his wife Maria. Her husband's sister Catharine also lived with them. Catharine went into labor a few weeks earlier than expected while her husband was away on a trip. "But I had sisters near and neighbors kind,"[24] she recalled. Catharine could rely upon her sisters for support, just as they had so often relied upon her.

Childbirth brought female kin together like no other event. Daughters especially valued the help of their mothers, and mothers too believed that their daughters needed a mother's care during their travail. Daughters in turn made extended visits to their mothers when their mothers were sick. In 1823, Melissa Barker traveled to Belpre to care for her sixty-seven-year-old mother, reporting back to her husband that her mother "was so gratified to see me that I could not regret the exertion I made to come." Melissa stayed with her mother about six weeks. Such absences from home, of course, caused inconveniences for the husbands and children left to take care of their

households themselves, but both women and men understood that women's duty to their parents at times outweighed their obligations at home. In 1830, Marietta's Mary Emerson spent several weeks in Belpre caring for her seventy-eight-year-old mother. Mary left behind a large family, including a baby not yet weaned. When Mary suggested to her husband Caleb that she might stay in Belpre longer than she originally intended, he recognized her importance both at home and to her mother, responding that "so long as your attendance on mother seems not only useful but peculiarly grateful to her, ought we not as a matter of duty to her, to forego the advantages of your being at home?"[25]

While all women were expected to fulfill important kinship duties, single women played a special role in maintaining kin ties. Free of the cares of managing a household of her own, a single woman could devote her time to helping her parents, siblings, and other nearby relatives and to visiting and writing to distant kin. Single women were by no means free from family obligations. Indeed, single daughters often had less autonomy than their married sisters, as parents and siblings frequently decided where they could live and where they would be most useful. Yet for the most part, the unmarried women of Washington County willingly accepted their position. They recognized their dependence and were frustrated by it, but they also recognized their importance to their families and to their community. "They call me an old maid already," wrote Catharine Ward to her widowed aunt when she was twenty-seven. "But it does not scare nor offend me—They are useful appendages to society." Married women relied upon their single sisters and sisters-in-law to help care for their children, maintain their households, and for female companionship. While some unmarried women felt that they imposed a burden upon their families, married women generally welcomed the company and assistance of female kin.

The single Barker women spent considerable amounts of time in their sisters' households. Betsey Barker, the oldest of the Barker sisters, married in 1814 and moved thirty miles away from her parents' home. Her eight-year-old sister Catharine spent the summer with her to keep her company. Catharine spent many months with Betsey between the ages of ten and twenty-one, providing her with companionship and helping her with her household work. When she was not with Betsey, Catharine was often with other kin, visiting her brothers in Newport or her sister Sophia in Belpre. Catharine stayed with Sophia in the autumn of 1820, after the birth of her first child, and was with Sophia again two years later when her second child was born. Catharine spent at least two winters in Belpre with her sister, helping with the children and housework while attending school.[26]

Catharine married in 1825 and thereafter spent less time in her sisters' households. Charlotte Barker, however, the youngest of the sisters, never

married, and spent her life caring for her parents and siblings. Elizabeth
Barker died in 1835, when Charlotte was twenty-three years old. Charlotte
kept house for her father for the next eight years, until he died in 1843 at
the age of seventy-eight. In devoting herself to her father's care Charlotte
relieved her brothers and sisters of part of their responsibility to him and
allowed them to focus their energies upon their own families of procreation.
Betsey Barker Stone well understood the value of her younger sister's work.
"She is more to you than all the rest of your Children," she told her father,
"we all know how to estimate her worth and desire to be grateful and thank-
ful that we have such a sister and you such a daughter." After Joseph's death,
Charlotte lived with her brother George, but spent much time with her other
siblings as well, doing whatever she could to help.[27] Long after their fa-
ther's death, the Barker siblings continued to depend upon their maiden sis-
ter. Through her work and travels, Charlotte bound together the scattered
Barker kin.

The women of Marietta, Belpre, Newport, and other southeastern Ohio
towns enjoyed the company of their female kin and encouraged them to
visit. When Rufus Stone wrote to his brother John in 1823, he included a
message from his wife for John's wife Charlotte: "Betsey says Charlotte must
come up with Sophia [Betsey's sister] & bring all the girls you have." She
also wanted her mother-in-law to visit them that summer.[28] Women demon-
strated their commitment to kin by sending their daughters into the homes
of others and by welcoming their sisters, mothers, nieces, cousins, and
granddaughters into their own households.

But while women's strongest ties were with their female kin, they also
sought to draw men into their kinship networks. Frances Dana gently re-
minded her brother Charles to visit their Aunt Gilman's family often when
he was at college in Marietta. Abby Putnam, whose husband Charles was a
missionary, wanted her husband to become better acquainted with her fam-
ily and to spend more time with his own. While staying in Marietta with
Charles's mother while Charles was in Granville, Abby wrote urging her hus-
band to spend some time in Marietta. "Your mother thinks she has seen you
scarcely at all," she informed Charles. She hoped that, the next time he came
to Marietta, Charles could spend more time there. "I want you should see
Grandmama who has returned from Newport," she told him, "and get ac-
quainted with [my brother] Luther."[29] While Charles was busy traveling
around Ohio, Abby made an effort to sustain ties with Charles's family and
to bind Charles to her own kinship network.

Although men tended to leave the nurturing of kin ties to women, men
clearly did appreciate the importance of kin and depended upon the bonds
that their mothers, sisters, and wives forged. In early Marietta, most business
relationships were based upon kinship. Marietta's men most often turned to

sons, brothers, and brothers-in-law when looking for a partner they could *leon*. trust. Men relied upon both their own relatives and those of their wives. While most partnerships probably involved fathers and sons, or brothers, a striking number of Marietta's partnerships were between brothers-in-law. In 1789 James Backus and his sister's husband Dudley Woodbridge opened the first store in the Northwest Territory. Two years later, James returned to Connecticut but continued his business connection with his brother-in-law, supplying him with merchandise from the East.[30] The members of the Dodge family also formed a number of kin-based partnerships. Nathaniel and Rebecca Dodge had two sons who entered the mercantile business, and three daughters who married merchants. Oliver Dodge went into partnership with Augustus Stone, the husband of his sister Rebecca. Nathaniel Dodge, Jr., formed a partnership with Jonathan Cram, husband of Sally Dodge. Thus, two separate partnerships involving sons of the Dodge family and their sisters' husbands were formed. Undoubtedly, the Dodge sisters were involved in these businesses as well. Sally Dodge Cram at least gained enough experience that, when her husband Jonathan Cram died in 1821, she formed a partnership with her brother Oliver. Sally Cram remarried John Greene in 1826 and, soon after, John Greene and Oliver Dodge entered into partnership in both a steam mill and a store. Hannah Dodge, the third sister, married Daniel Bosworth in 1824, but died just four years later. Daniel then married Deborah Wells in 1838, and two years later began a hardware business with her brother George.[31]

Kinship influenced church membership, associational affiliations, and political alliances as well. The men, as well as the women, of Marietta and Washington County recognized kinship as an important organizational component of society well into the nineteenth century. Kinship was the cornerstone of community life, and it was largely supported by women. While the women of southeastern Ohio especially valued and nurtured their ties with female kin, they did not understand their relationships with kin as part of a separate female sphere. Rather, they recognized their special role in a kinship system that included both women and men. Through their efforts to maintain kin ties and bind men to their kinship networks, women assured themselves of an important place in community life. Community would be built upon female as well as upon male terms.

Women most likely did not think of their relationships with kin and their role in the formation of community in these architectural terms. More likely, they understood their lives in more familiar terms. Women helped stitch together the families that made up the community, much as they worked side by side to stitch together the pieces of a quilt. In 1850, when Catharine Barker returned from her new home in Iowa to visit her family and friends in southeastern Ohio, she was presented with ninety-seven

squares for an "album quilt." Each friend had pieced a square made in purple and white and had sewn her name in the center of it. Each relative had pieced a square in scarlet calico and white. The scarlet squares made by kin were to be placed in the center of the quilt, surrounded by the purple squares. Catharine had many relatives and friends and received almost enough squares to make four quilts. Each quilt would be a vivid reminder of the centrality of kin, and especially of female kin, in the life of Catharine Barker and in the life of the communities of southeastern Ohio.[32]

Notes

1. Rufus Putnam, "Memoirs of the Putnam Family," p. 138, Special Collections, Marietta College (microfilm edition, Harvard University). According to Rufus Putnam's memoirs, fifteen families arrived in 1788. He says that the Devols and Rouses arrived in 1789. The Rufus Putnam list printed in Martin R. Andrews, *History of Marietta and Washington County, Ohio* (Chicago: Biographical Publishing Co., 1902), p. 67, indicates eighteen families arrived in 1788. Samuel P. Hildreth, in his narrative of the Rouses' journey, based on Rebecca Rouse's daughter Bathsheba's account, says that this party arrived in December 1788. Samuel P. Hildreth, "Early Emigration, Or, the Journal of some Emigrant Families 'across the Mountains,' from New England to Muskingum, in 1788," *American Pioneer* 2 (March 1843): 131.

2. Hildreth, "Early Emigration."

3. Eleanor Marietta (Devol) Long, *Devol, Long, and Allied Family Histories: Genealogical and Biographical* (New York: National Americana Publications, Inc., 1942), pp. 3–7, 158–62; Elizabeth Frye Barker, *Barker Genealogy* (New York: Frye Publishing Co., 1927), pp. 174, 183–84.

4. Samuel P. Hildreth, *Genealogical and Biographical Sketches of the Hildreth Family: From the Year 1652 Down to the Year 1840* (Marietta, OH, 1840), pp. 296–99. The three Cooks—Rhoda, Joseph, and Pardon (Rhoda Barker's husband)—were also siblings. Three Cook siblings married three Barker siblings, making the web of family ties even more dense.

5. Don Harrison Doyle, *The Social Order of a Frontier Community: Jacksonville, Illinois, 1825–70* (Urbana: University of Illinois Press, 1978), pp. 110–18; John Mack Faragher, *Sugar Creek: Life on the Illinois Prairie* (New Haven, CT: Yale University Press, 1986), pp. 56–60; see also Robert E. Bieder, "Kinship as a Factor in Migration," *Journal of Marriage and the Family* 35 (1973): 429–39; Jack E. Eblen, "An Analysis of Nineteenth-Century Frontier Populations," *Demography* 2 (1965): 399–413; John Modell, "Family and Fertility on the Indiana Frontier, 1820," *American Quarterly* 23 (1971): 615–34. Gregory H. Nobles, "Breaking into the Backcountry: New Approaches to the Early American Frontier, 1750–1800," *William and Mary*

Quarterly 46 (1989): 648–50, summarizes recent studies of the eighteenth-century frontier.

6. Influenced by Frederick Jackson Turner, frontier community studies of the old Northwest have tended to focus on democracy, individualism, and the ordering of society through the development of political, social, and economic institutions. Community building is often equated with institution building, especially with the development of political and economic institutions, traditionally male preserves. For examples of such an approach see Merle Curti, *The Making of an American Community: A Case Study of Democracy in a Frontier County* (Stanford, CA: Stanford University Press, 1959); and Doyle, *The Social Order of a Frontier Community*. While John Faragher's work on Sugar Creek, Illinois, provides a definition of community that is less institutionally bound, and though he does discuss kinship connections, he, too, pays little attention to the importance of female ties. Faragher describes kinship ties primarily as the foundation upon which public male relationships were built. Believing that men's power was so complete that women could not make a real contribution to community life, Faragher concludes that, "despite the importance of women's roles in the families and kin networks that structured and supported the local community, Sugar Creek was, finally, a community of men, led by fathers, to whom women as a group were 'subject'." See Faragher, *Sugar Creek*, p. 155. While Faragher is right to point out the patriarchal nature of midwestern society, at least in southeastern Ohio, community was much more than public institutions, and women were central to the more "informal" and private organization of community. The only study to date that takes seriously the importance of women's kinship connections in the Old Northwest is Marilyn Ferris Motz, *True Sisterhood: Michigan Women and Their Kin, 1820–1920* (Albany: State University of New York Press, 1983).

7. Julia P. Cutler, *The Founders of Ohio: Brief Sketches of the Forty-Eight Pioneers* . . . (Cincinnati: Robert Clarke & Co., 1888); Bernice Graham and Elizabeth S. Cottle, comp., *Washington County, Ohio Marriages (1789–1840)* (Marietta, OH, 1976).

8. Alfred Mathews, et al., *History of Washington County, Ohio, with Illustrations and Biographical Sketches* (Cleveland: H. Z. Williams & Bro., 1881), p. 52; Samuel P. Hildreth, *Pioneer History: Being an Account of the First Examination of the Ohio Valley and the Early Settlement of the Northwest Territory* (Cincinnati: H. W. Derby & Co, 1848; reprint ed., NY: Arno Press, 1971), p. 234.

9. This process began well before the Revolution, and contributed to the general discontent leading up to it. See Robert A. Gross, *The Minutemen and Their World* (NY: Hill and Wang, 1976), pp. 68–108; Philip J. Greven, Jr., *Fathers and Sons: Population, Land, and Family in Colonial Andover, Massachusetts* (Ithaca: Cornell University Press, 1970), pp. 125–72 and 222–38; Kenneth A. Lockridge, "Land, Population and the Evolution of New England Society, 1630–1790," *Past and Present* 39 (1968): 62–80.

10. Andrew R. L. Cayton, "'A Quiet Independence': The Western Vision of the Ohio Company," *Ohio History* 90 (1981): 5–12; Timothy J. Shannon, "The Ohio Company and the Meaning of Opportunity in the American West, 1786–1795," *The New England Quarterly* 64 (September 1991): 393–401; David P. Szatmary, *Shays' Rebellion: The Making of an Agrarian Insurrection* (Amherst: University of Massachusetts Press, 1980), pp. 86–87.

11. Louise Rau, "Lucy Backus Woodbridge, Pioneer Mother," *The Ohio State Archaeological and Historical Quarterly* 44 (1935): 405–13; Dudley Woodbridge (Norwich) to James Backus (Marietta), December 9, 1788, Backus-Woodbridge Collection, Ohio Historical Society (OHS) (microfilm edition), box 1, folder 1.

12. Jane Robbins (Plymouth, MA) to Rebecca Gilman (Marietta), June 6, 1790, and Jane Robbins (Plymouth) to Hannah Gilman (Marietta), October 5, 1792–January 26, 1793, in Mrs. Charles Noyes, *A Family History in Letters and Documents 1667–1837* (St. Paul, MN: privately printed, 1919), pp. 168–89 and 182–93.

13. Zara D. Howe (Erie, PA) to Perley Howe, June 30, 1817, Perley Howe Papers, Campus Martius Museum (CMM), Marietta, OH.

14. See James A. Henretta, "Families and Farms: Mentalité in Pre-Industrial America," *William and Mary Quarterly* 35 (1978): 3–32, on the importance of lineal family values.

15. Daniel Scott Smith, "Child-Naming Practices, Kinship Ties, and Change in Family Attitudes in Hingham, Massachusetts, 1641 to 1880," *Journal of Social History* 18 (Summer 1985): 541–66. David Hackett Fischer also examines naming patterns in New England for the same period in "Forenames and the Family in New England: An Exercise in Historical Onomastics," in Robert M. Taylor, Jr., and Ralph J. Crandall, eds., *Generations and Change: Genealogical Perspectives in Social History* (Macon, GA: Mercer University Press, 1986), pp. 215–41. Fischer finds that the percentage of Concord parents naming children for themselves before 1780 was lower than in Hingham, though still quite high. Washington County's figure more closely matches Concord's than Hingham's in this respect. Fischer describes a revolution in naming patterns in New England between 1770 and 1820, in which there was a sharp decline in the naming of children for parents and grandparents. The decline in southeastern Ohio was not as marked, especially with regard to naming children for grandparents. In fact, there was a slight increase in the percentage of Ohio parents naming children for grandparents between 1800 and 1840. A significant decline is not clear until after 1840. For other studies of naming practices see, David W. Dumas, "The Naming of Children in New England, 1780–1850," *New England Historic Genealogical Register* 132 (1978): 196–210; John J. Waters, "Naming and Kinship in New England: Guilford Patterns and Usage, 1693–1759," *New England Historic Genealogical Register* 138 (1984): 161–81; Edward Tebbenhoff, "Tacit Rules and Hidden Family Structures: Naming Practices and Godparentage in Schenectady, New York, 1680–1800," *Journal of Social History* 18 (Summer 1985): 567–85; Darret B. Rutman and Anita H. Rutman, "'In Nomine Avi': Child-Naming Patterns in Chesapeake County, 1650–1750," in Taylor and Crandall, eds., *Generations and Change*, pp. 243–65.

16. Graham and Cottle, *Washington County, Ohio Marriages (1789–1840)*; and Washington County Marriage Records, 1840–1850, Washington County Courthouse, Marietta, OH (microfilm edition, Church of Latter-Day Saints).

17. See Marylynn Salmon, *Women and the Law of Property in Early America* (Chapel Hill: University of North Carolina Press, 1986); and Norma Basch's summary of literature on the legal status of women, "Invisible Women: The Legal Fiction of Marital Unity in Nineteenth-Century America," *Feminist Studies* 5 (1979): 346–66; also Eleanor Flexner, *Century of Struggle: The Woman's Rights Movement in the United States*, rev. ed. (Cambridge: Harvard University Press, 1982), pp. 7–8, 62–65; Nancy F. Cott, *The Bonds of Womanhood: "Woman's Sphere" in New England, 1780–1835* (New Haven, CT: Yale University Press, 1977), p. 21; Suzanne Lebsock,

The Free Women of Petersburg: Status and Culture in a Southern Town, 1784–1860 (NY: W. W. Norton & Co., 1984), pp. 22–24; Marilyn Ferris Motz, *True Sisterhood: Michigan Women and Their Kin, 1820–1920*, pp. 22–24; and Nancy Grey Osterud, *Bonds of Community: The Lives of Farm Women in Nineteenth-Century New York* (Ithaca, NY: Cornell University Press, 1991), pp. 62–67; and the Washington County, Ohio Probate Records, 1789–1855, Washington County Courthouse, Marietta, OH (microfilm edition, Church of Latter-Day Saints).

18. Paper pertaining to the Petit Divorce, Backus-Woodbridge Collection, OHS (microfilm edition), box 5, folder 3.

19. Two recent studies that examine the role of women in maintaining kinship networks are Motz, *True Sisterhood*, and Osterud, *Bonds of Community*. Both agree that extended kin networks remained important throughout the nineteenth century. Motz focuses on what she terms the "female family," networks of female kin that provided women with security and allowed them to maintain some autonomy within marriage. Osterud is critical of Motz's exclusive focus on female bonds and is more interested in how women used kinship to bind men and women together. Both points of view have validity. Men and women did view kinship differently and Ohio's women, at least, did form their closest bonds with other women. But kinship did serve to bring men and women together. Women did not view their relationships with kin as part of some "separate sphere," but rather as central to the whole organization of family and community. Women recognized their central role in the kinship system that was composed of both men and women.

20. Melissa Barker (Newport) to Susanna Stone (Belpre), January 3, 1818, and June 20, 1819, "History of Melissa Wilson Stone," v. 2, pp. 19, 24–25, CMM; Catharine Barker, "Journal," v. 1, p. 65, Special Collections, Marietta College; Mary Maddox (Bridgeport, VA) to parents (Marietta), August 20, 1844, and June 29, 1846, Caleb Emerson Family Papers, Western Reserve Historical Society (microfilm edition, OHS, roll 2).

21. Motz, pp. 97–110; Osterud, pp. 193–94; also Laurel Thatcher Ulrich, *A Midwife's Tale: The Life of Martha Ballard, Based on Her Diary, 1785–1812* (New York: Random House, 1990), pp. 61–66 discusses social healing, nursing as a universal female role, and the specialization among women. She does not discuss the importance of female kin in nursing, but rather the role of neighbors. The preference for kin in the nineteenth century may have been a part of a new idealization of family relationships.

22. Sophia Barker (Union) to Melissa Barker (Newport), October 17, 1818, "History of Melissa Wilson Stone," v. 2, p. 22, CMM.

23. Melissa Barker (Newport) to Susanna Stone (Belpre), March 8, 1818, and April 5, 1818, and Sophia Barker (Union) to Melissa Barker (Newport), March 23, 1818, "History of Melissa Wilson Stone," v. 2, pp. 19–22, CMM.

24. Betsey Stone (Morgan) to Melissa Barker (Newport), December 26, 1825, "History of Melissa Wilson Stone," v. 2, pp. 47–48, CMM; Catharine Barker, "Journal," v. 1, pp. 31, 62, Special Collections, MC.

25. Melissa Barker (Belpre) to Joseph Barker (Newport), September 13, 1823, and Joseph Barker (Newport) to Melissa Barker (Belpre), October 28, 1823, "History of Melissa Wilson Stone," v. 2, pp. 39–40, CMM; Caleb Emerson (Marietta) to Mary Emerson (Belpre), March 18, 1830, Caleb Emerson Family Papers, WRHS (microfilm edition, OHS, roll 1).

26. Catharine Barker, "Journal," v. 1, pp. 3–4, 12, 27, 30–31, 41, Special Collections, MC; Sophia Browning (Belpre) to Melissa Barker (Newport), October 29, 1820, and January 1823, "History of Melissa Wilson Stone," v. 2, pp. 28–29 and 36–37, CMM.

27. Catharine Barker, "Journal," v. 2, pp. 26, 45; v. 3, pp. 30–32, 62; and v. 4, pp. 3–4, 11, Special Collections, MC; Betsey Stone to Joseph Barker, March 29, [18–], Stone Family Papers, CMM.

28. Rufus Stone (Morgan) to John Stone (Belpre), May 21, 1823, Stone Family Papers, CMM.

29. Frances Dana (Putnam) to George Dana (Marietta), November 13, 1836, Dana Family Papers, OHS, folder 14; Abby Putnam (Marietta) to Charles Putnam (Granville), November 19, 1829, Putnam Family Papers, OHS, box 1, folder 2.

30. Backus-Woodbridge Collection, OHS, (microfilm edition), box 1, folder 1.

31. Mathews, et al., pp. 366–68, 480; Andrews, pp. 255–57, 267–68 and 903–904.

32. Catharine Barker, "Journal," v. 4, p. 1, Special Collections, MC.

7

The Ethnic Female Public Sphere

German-American Women in Turn-of-the-Century Chicago

CHRISTIANE HARZIG

FOR OVER THREE decades, the concept of spheres—perceived as gender-segregated separate spheres—has structured historical research on women. It provides a powerful analytical framework in which to make the participation of women in social development visible, and thus it has provoked the reevaluation of established historical paradigms.[1]

At first, this concept was used as a bipolar model, creating pairs such as male-female, public-private, production-reproduction, and work-home that not only revealed formerly unnoticed facets of women's social activity but also pointed to the power structure in gender relationships. It became apparent, however, that especially the dichotomy that equated private with female, and public with male, did not capture the many ways the public and the private were interrelated. It neither depicted the experience of working women nor helped analyze the activities of those mostly middle-class women who made themselves known in the public arena of reform work. Feminist historians, by maintaining the concept of gender-motivated separateness but applying it to the public sphere, have been able to add additional dimension to the bipolar model.[2] The concept of female institution building and the clubwomen's movement have come to illustrate both the politicization of women's institutions and the limitations of their politics.

The women who gained political power and feminist insights in separate political organizations were mainly white, Anglo, and middle-class. More recently, however, we have become aware of the multicultural facets of and approaches to feminism and women's history. The narrative line describing a separate domestic sphere marginalized women who were not white or could not afford any leisure time.[3] The concept of universal womanhood also blurred the reality of power relationships and struggles among women of different classes and ethnic groups. The women contributing to the influen-

tial volume edited by Ellen DuBois and Vicky Ruiz belong mainly, as subjects as well as objects of historical research, to the so-called visible minorities (African American, Asian American, and Mexican American) or are members of the working class. They already provide us with a good understanding of the many alternative forms and approaches that feminism and women's liberation and activism can take.

European immigrant women, being neither Anglos nor visible minorities, still fall between the cracks. So far, social historical research on immigrant women has searched for women in the labor force or looked into the changing roles of wives and mothers in the migration process. Little is known about immigrant women in the public sphere, in the community-building process, and in the women's movement.[4] What space did European immigrant women occupy in the city in which they lived? Were they able to create their own separate sphere? What did they do when they were together? How did they affect gender relations in the ethnic community? And did they use their separate space to develop a feminist understanding of their positions?

In the nineteenth century, people spoke of "the woman movement" when referring to organized women's activities in the arenas of social action, equal rights, and self-determination. According to Nancy Cott, the women engaged in these activities were linked by their belief that revisions of gender relations were necessary. The term "feminism" only came into usage early in the twentieth century. Aware of the fact that the meaning and usage of the word varied according to time and context, Cott provides her own definition, which comprises the following elements: an opposition to the sex hierarchy, an awareness of the social construction of women's condition, and an understanding of women as a social group. Due to this definition, her study "mainly brings forward the big-city, well-educated, white, usually Protestant, gainfully employed or politically active women. . . . "[5] Did German-American women in Chicago, who possessed at least the first four of these characteristics, generate the same understanding of feminism and womanhood, or do we have to broaden our definitions?

For several reasons, middle-class German-American women in turn-of-the century Chicago are an appropriate group to analyze with respect to the contours of an ethnic feminism. For one, Chicago had emerged as the leading metropolis in the Midwest, a region that was characterized not only by homogeneous geographic features and industrial developments, but also by the presence of a large population of German heritage.[6] In the cities of the heartland, Jon Teaford argued, citizens of German descent left their imprint as much on social and industrial relations as on the concepts of leisure, culture, and refinement that the cities struggled so much to develop.[7] The paths by which this influence could spread into midwestern urban culture were the ethnic communities and the culture of community life.

By 1900, for example, German-Americans accounted for almost one-fourth of the population of Chicago. During their 60-year history, they had developed a complex community, with Catholic and Protestant churches and Jewish synagogues; a tremendously prolific press; schools, theaters, beer gardens, and neighborhood businesses; and countless clubs and associations. German-Americans were present at every level and in every area of Chicago's occupational structure. They lived in ethnic neighborhoods spread throughout the city (but mainly on the North and Northwest Side), and a differentiated class structure had developed. Middle class and working class were conscious of their positions, living in different neighborhoods, often reading different newspapers, and joining different associations.[8] Cincinnati, Buffalo, St. Louis, and especially Milwaukee had equally vigorous German-American communities.[9]

Thus, more than any other ethnic group at the time, German-Americans in midwestern cities had acculturated by creating a specific hyphenated culture, and their numbers were great enough to influence the urban culture of the heartland metropolises.

Another aspect of Midwestern development was a large and articulate German-American middle class. When we look mainly at middle-class women, as Cott did, we find German-American women are an instructive reference group to expose the contours of an ethnic feminism. However, except for Chicago, we know little of how immigrant women participated in community life and whether a concept of feminism evolved among them. Kathleen Conzen's and David Gerber's studies on Milwaukee and Buffalo specialize on the pre–Civil War period of German community building. Conzen notices a *Frauen Verein*, an umbrella organization of various women's groups, which was under the influence of the freethinking German element. She points to the important position women held in the various musical, dramatic, and fund-raising groups.[10] Gerber, though describing the same associational system, does not mention German women's participation in the community-building processes. The studies on Cincinnati (written in 1965) and St. Louis carry into the 1890s and further. They describe similar associational structures; however, they do not mention any women's associations. Very likely, a more gender-conscious analysis of the German communities in these midwestern cities would discover female public spheres similar to those in Chicago.[11]

This chapter examines the manifold activities of Chicago's German-American women in creating a separate public sphere. It analyzes the gender relations evolving in the process, and assesses their effect on the ethnic community. Second, it looks at the discourse on feminism and women's role in society, expressed in the women's pages of the city's two leading German-American newspapers. The concluding section compares these ideas to the well-known feminism of middle-class Anglo women.

The German-American female public sphere is defined as the space in which these women came together outside the home, pursuing goals beyond the immediate concerns of the family.[12] This definition says nothing about the aims and goals of the women activists, or about the nature of the public—whether it was the city at large, the ethnic community, or a women's meeting. The German-American women's movement is defined as the collectivity of organized activities in this public sphere.

Function, Fun, and Fund-Raising: German-American Women's Clubs

As research on midwestern cities has shown, and as Stanley Nadel notes for New York, the "Verein way of life, or Vereinswesen, dominated social life . . . in most large German-American communities."[13] Associations organized the calendar year: members and friends met for picnics and excursions in the summer, prepared the Christmas season with uncountable bazaars and fancy balls, and met for *Narrensitzungen* during carnival season. Besides these leisure activities, they also provided the organizational form for mutual aid and benefits and charity work.

In turn-of-the-century Chicago, women participated in many ways in the various associations and institutions. Activities within the ethnic community in general tended to be segregated by sex; the German-American community, however, provided a large number of "mixed choirs," social clubs, and regionally based mutual-support societies that attracted men and women alike, although women participated in smaller numbers.[14] However, in these mixed groups, women never took on leadership positions. Some organizations had subgroups, such as the female gymnastics societies or female choirs, and lodges tended to have parallel organizational structures for women. But there were also independent women's clubs organized exclusively by and for women. The founding principle of these women's clubs was usually the desire to socialize with other women. Only later did the women select a task, usually some aspect of charity or benevolent work.

Throughout the 1870s, women's activities in the ethnic community were "limited" to auxiliary work. Women supported "their" association; for example, the gymnastics society that their husbands and brothers had joined. They helped to organize larger festivities and arranged entertainment. Sometimes they donated the ornate and richly decorated banner, thus earning an important place in the club annals. The Turnverein Vorwärts, a gymnastics association with a labor-aristocratic clientele, regarded the female contribution to the successful development of their society so highly that they established an all-male (!) committee to initiate the foundation of a *Damenverein*, a ladies' group. Not all women depended on this form of male impetus. The

women of the Chicagoer Turngemeinde, another gymnastics group, initi-
ated their own association and did not wait until men asked them to go
ahead.[15]

Even after a separate women's gymnastic group was established, women
remained responsible for the social aspects of men's club life. Women organ-
ized Christmas fairs or summer picnics; they boosted the club's finances by
promoting fund-raising activities; and they made sure that all club members
received the appropriate honors and attention when celebrating a victorious
homecoming. The remainder of their time they devoted to the welfare and
development of the junior gymnasts; the physical education of girls became
their main concern.

Although at first they had to fight "petty prudery," female gymnastics
were generally morally accepted by the end of the 1880s. Gymnastics was the
German-American answer to the post–Civil War public debate over conflict-
ing models of womanhood. Women were torn between the "true" woman,
who was subject to chronic indisposition related to child bearing, and the
"new" woman, who went bicycle riding and rowing and thus negated her
"true" nature. Gymnastics allowed women to be feminine and physically fit
at the same time. And by being especially concerned with female gymnastics,
clubwomen moved beyond the function of a mere auxiliary. They were able
to fulfill their own dreams and invest in the future of their daughters.[16]

Women organized their own activities parallel to that of the men's. They
did not intrude on each other's turf, and the separate spheres of interest were
well defined. There was no need for joint planning committees; when either
group needed support, the other group knew what to do. Thus, the men
did not feel it necessary to interfere with the doings of the women's groups,
and the women, most likely, were glad to be left alone.

German-American women were interested in educating the mind as well
as the body. The Columbia Damen Club did not focus on social nurturing,
as did the auxiliaries and charity groups. Its main interest was to educate
women and to provide a forum for information, discussion, and artistic per-
formances. It claimed to be "the only German women's association" with
"purely intellectual aspirations," and it maintained some contact with the
American women's movement.[17]

The club had its origin in 1893, when organizers of the Women's Temple
of the Columbian Exposition were looking for representatives of the Ger-
man women's movement to participate in the Women's Congress. They con-
tacted several prominent German-American women, including Hedwig Voss,
Dorothea Boettcher, and Maria Werkmeister. After some counsel with other
women, they decided to invite Helene Lange, the leading figure in the con-
servative bourgeois women's movement in Germany, to participate in the
Congress.[18] She declined due to time constraints. Instead Käthe Schirmacher,

who was in Chicago at that time, agreed to participate.[19] She lectured on the topic, "Why German Universities Are the Last Ones to Admit Women." The Women's Temple and the female potential it exhibited had lasting effects on German and German-American women alike. On their return to Germany, German women decided to establish a national umbrella organization for the women's movement;[20] and the German-American women who participated in the initial meeting decided to turn their informal gathering into a permanent association.

During the following years, that club prospered and stabilized; a year after its foundation, more than sixty women had joined. To become a member of the club, a candidate had to have a recommendation from at least one member and the support of all the officers. The program offered "literary, musical and declamatory recitals" aiming to entertain and to educate. Dorothea Boettcher, a poet who had emigrated from Mecklenburg in 1876, became the leading figure of the club, which is still in existence today and awaits further study.

Charity work was by far the most prominent form of public activity in which German-American women participated. They did so as members of lodges, in smaller neighborhood groups, or as members of larger, citywide organizations.

By far the most interesting and most successful example of charity work in the female public sphere is the Frauenverein Altenheim and the old people's home they helped to build.[21] In 1878, a women's group was founded to support the work of the prestigious German Aid Society in Chicago. This society, which existed in many U.S. cities, supported newly arrived immigrants. At first, the women's auxiliary helped to raise money and organize its distribution, but then, in the early 1880s, the women decided to form an independent association. At the same time, they wanted to restructure their charity work. Instead of distributing small sums of money here and there, they wanted to create something larger, an institution, whose social value would be long-lasting. They decided to build an *Altenheim*, old people's home.

Maria Werkmeister became the heart and soul of the idea and later of the institution. Due to her apparent ability to integrate and mediate between conflicting parties, she soon became president of the Frauenverein Altenheim, and remained in this office until her death in 1902. She was born in 1844 in a small town in Württemberg, where her father was the mayor. She came to live with her uncle in Hazelton, Pennsylvania at the age of twenty, met and married the druggist Martin Werkmeister, and moved to Chicago in 1867. In 1900, she headed an extended household on South Ashland Avenue, which included her husband, her three adult children, her son-in-law, the grandchildren, two boarders, and three servants. Her oldest daughter

was married to a German architect; her son was a physician; and her youngest daughter worked as a high school teacher.

Working for the *Altenheim* brought about a vast number of changes in the lives of the activists, and it offered new experiences and learning processes. The women had to deal with faction and in-group fights; they had to defend themselves against personal defamation; they were confronted with competing organizations; and, most of all, they had to accept some form of work discipline among themselves. After a period of five to six years, the group had consolidated and expanded. In 1885 it had about 500 members, although in the late 1890s it was down to 350 members. The meetings became a model of structure and discipline. The board members had to arrive on time; latecomers had to pay a fine; their discussions followed a speakers' list; and private conversations were limited. By holding their meetings in public rather than in private space, their work was more apt to get public recognition. In later years, when the activities became more numerous and complex, the *Frauenverein* had one secretary to record the minutes and another for financial affairs. For almost fifteen years, Hedwig Voss, a respected and well-known member of the German-American community, diligently kept the minutes.

After a large fund-raising fair in 1884, which returned a profit of $12,000, the *Frauenverein* had collected enough money to think about buying land and beginning the construction of the *Altenheim*. At that point, members sought the help of men. Under the auspices of the newspaper *Illinois Staats-Zeitung* and its owner Anton Hesing, a men's committee was formed whose task it was to advise on the building site, on the construction contracts, and on financial affairs. Many elite men of the community were eager to donate their expertise for this cause. Soon an appropriate building site was found in suburban Harlem, and in July 1885 the cornerstone was laid. By spring 1886, the women were busy decorating the rooms in the new building. In June 1886, the German Old People's Home was inaugurated, and by July it already had twenty-nine residents.

In the meantime it had become apparent that it would be necessary to solicit a steady flow of donations in order to maintain the Old People's Home. The women continued to organize all kinds of social gatherings for fund-raising purposes. Their fairs, dances, and *Kaffeekränzchen* (coffee afternoons) became popular events in the German-American community, and other prominent associations participated in and supported their activities. When even this turned out to be insufficient, the women founded a men's auxiliary. The men were to make use of their business connections in support of the institution, besides giving generously themselves. To prevent the battle cry of "no taxation without representation," the women designed a democratic system for shared rights and duties: the women's association and

the men's association were each to elect fifteen male and female directors who, together, formed the executive committee. The executive committee governed the affairs of the Old People's Home, but it was to report annually to the *Frauenverein*.

Throughout the 1890s, the German Old People's Home remained a popular institution for large parts of the German-American community in Chicago. The home, which maintained a picnic ground and a cafeteria, was frequently the destination of summer excursions, and the annual "Altenheim picnic" and summer festival became very popular events. Almost all of the other German-American associations participated. The women's association also organized a large, elegant dance whose profits were to benefit solely the Old People's Home. This ball became so popular and successful that it turned into the major social event of the year for the elite. Copying the American model, the German-American upper class proudly presented itself to Chicago at large. In the late 1890s, women lost control of the ball when the German-American Charity Association was founded for the purpose of organizing and promoting it. Now the Old People's Home was no longer the sole beneficiary; it had to share the profits with other objects of German-American charity, such as the Catholic Alexian Brothers' Hospital and the Protestant Uhlich's Children's Home. The ball had become the most successful fund-raising event of the year. Thus the women had not only created a successful charity institution but had also constructed social structures that were of large and lasting influence in the German-American community.

Working for the women's association was almost a full-time job, especially for members of the executive committee. Time and again, the women had to face new tasks and solve new problems. And when they asked for the help of men, it was because of the men's expertise, not because the women considered it inappropriate to operate in the public sphere themselves. Despite the many forms of cooperation they had created to generate the participation and interest of the male members of their social class, they did not give up their separate sphere and did not surrender control. Whether that led to a feminist understanding as we know it today is the subject of the next section.

Sexless Humanism and Scientific Domesticity:
Discourse on German-American Womanhood

In the 1890s, middle-class German-American women began to reflect publicly about their position in society, their role in the family, and their specific responsibilities as women rooted in two different cultures. The evolution of these ideas was encouraged by the fact that the press had discovered

the female reader. Like the Anglo-American press in the 1880s and 1890s, the German-American press also realized that women were potential buyers of newspapers and thus an audience that deserved special attention.[22] In April 1891, the *Illinois Staats-Zeitung* (ISZ) began to publish a *Damen-Zeitung* (ladies' paper), which, three years later, came to be called *Frauen-Zeitung* (FZ, women's paper). In December 1893, the *Chicagoer Freie Presse* followed suit and published the *Chicagoer Frauen-Zeitung* (CFZ). The FZ appeared weekly as part of the Sunday supplement *Der Westen*. It consisted of only one page and remained under the supervision of male editors. The CFZ, though also part of the Sunday edition of the *Chicagoer Freie Presse*, was a four-page paper and was edited by women only.[23]

Four women came to dominate the two papers and may be considered the most articulate voices of middle-class German-American feminism. Amalie von Ende and Hedwig Voss both published in the FZ, whereas Clara Michaelis and Dorothea Boettcher shaped the outlook of the CFZ. Amalie von Ende was by far the most articulate and complex personality of the four. In 1880, she lived on the North Side in a boardinghouse run by her mother; she was then twenty-three years of age, already a widow with two small children. Toward the end of the century, she moved to New York and lived there for the rest of her life. She continued to work as a journalist, writer, and translator. Judging from her essays, which she published almost every week, she was a reserved and refined lady, very well educated and knowledgeable, and perhaps sometimes a little lonely.

Hedwig Voss, on the other hand, was an active, well-respected member of the German-American community, participating in numerous organizations and events. Of course, she was also refined, always maintaining high morale and propriety—as was considered appropriate for an elderly widow. She later came to live in the Old People's Home for which she had worked so hard throughout the later part of her life. In her articles, she reported on current events and also gave hints and tips on how to run a household. She had precise ideas about healthy nourishment and the proper education of children, and she considered it her responsibility to explain American society to her German-American readers. She reported about activities in Hull House, reflected on the necessary tasks in charity work, visited industrial schools for girls, and informed her readers about American holiday customs. Although she was very critical of what she considered "typically American," she was also a firmly conservative American patriot. Unlike the highly esteemed Jane Addams, she advocated a very rigid Protestant work ethic, attributing the distress and poverty of the Chicago working class to personal failures and inabilities.

Clara Michaelis was the wife of the publisher and editor Richard Michaelis. They had married in 1867 while still in Berlin, and emigrated in

1868—for him it was a return—to Milwaukee. Later they moved to Chicago, where Richard Michaelis founded the *Chicagoer Freie Presse* in 1872. It is said that Clara supported the endeavors of her husband from the beginning and soon began to write columns for the paper, particularly addressing female readers.[24] Dorothea Boettcher, her partner in editing the CFZ, was one of the founding members of the Frauenverein Altenheim but later concentrated all of her energies in support of the Columbia Damen Club. She turned the CFZ into a major public forum for this club, ensuring that its activities found adequate coverage.[25]

Both women's papers particularly addressed the middle-class woman in the German-American community. They introduced her to a wide array of women's issues but also focused on her everyday life, her private and public spheres, and her participation in society. Although the papers and their readers were firmly rooted in the middle class, the position this German-American middle class held in Chicago had to be constantly renegotiated, and the women were part of this process.

Although the papers did not differ very much concerning the issues they presented and the positions they took, they nevertheless emphasized different aspects. Whereas the CFZ especially addressed the personal concerns of its readers, the FZ was more interested in the general aspects of the "woman question." Three main themes dominated the FZ. Since Amalie von Ende favored intercultural communication and international cooperation, "international womanhood" took a very prominent position. Whether it was the plight of women servants in Russia or South Africa, the wedding rites in Japan, or the working conditions of women in the Klondike, no nation was too remote, no ethnic group too small to be of interest to the FZ. This area of interest also included the organized women's movement of central and western Europe.

The second major theme was women in Germany and the German women's movement. Readers were informed about women's work and working conditions and about women in literature and history; even the famous book, *The Woman in Past, Present and Future* by German socialist August Bebel was favorably reviewed. Nevertheless, the point of reference was usually the conservative branch of the bourgeois German women's movement. The FZ conveyed a sense of pride in this movement and wanted to defend German women against the charge of being submissive, domestic, and uneducated. Amalie von Ende claimed that, on the contrary, the women's movement in Germany was theoretically more sophisticated than movements anywhere else in world.[26]

The third group of themes evolved around the greater chances for women in American society. This issue was usually discussed only by way of example, introducing individual successful women in science, medicine, edu-

cation, and other areas of public life. Unlike the German women's movement, however, the American women's movement was never presented as a positive point of reference. There was never any reference to the National American Women's Suffrage Association. Susan B. Anthony and Elizabeth Cady Stanton were hardly ever mentioned. Only Frances Willard's Woman's Christian Temperance Union received some, though always negative, attention. Here German-American women held ethnicity over gender by following their men in their distaste for the temperance movement. There was also information on education and professional life and on literature and the arts. Politics, sports, and household and family life were of minor interest to Amalie von Ende.

Women at the CFZ, on the other hand, had moved the German-American housewife to center stage. Since they advertised their paper as "the only newspaper in the U.S. catering exclusively to the interest of German-American women," they reported on themes closer to home. An ongoing concern was direct comparison between "the German" and "the American" woman. Here the German-American woman was advised on how to deal with American women, whom they apparently experienced as arrogant and presumptuous. Second, the writers discussed everyday tasks such as efficient household management and child rearing, especially those aspects that related to girls. They gave advice on how to handle difficult shopping situations in a sometimes foreign and non-German-speaking environment, and discussed problems related to family crises and husbands. Clara Michaelis's major concern was household labor and household management. She was not in favor of women's work outside the home, arguing that women already contributed greatly to the social and economic development of society by laboring inside the home. In her opinion, it was of utmost importance that they should receive the appropriate recognition and appreciation for it. The third major emphasis of the CFZ was coverage of the activities of German-American women's associations. The various clubs were constantly asked to report on planned activities, membership development, and meeting places. The editors made every effort to keep in touch with the German-American women's movement.

Compared to the FZ, the CFZ was a little more "feminist." Not the least important indicator was that it did not print any misogynist jokes—which were common in the FZ. Clara Michaelis had a deep understanding of women as a socially constructed group and recognized the fundamental oppression and disadvantages of women. Despite her standing and her insight, however, despite her acknowledgment of expanded opportunities in American society and her contempt for reactionary patriarchal structures in German politics and academe, she remained aloof from the American women's movement and the suffrage campaign.

The images and role models promoted in the newspapers constituted the mental framework in which the women of the German-American community operated, a framework structured and bounded by German traditions of middle-class, housewifely decorum on the one hand, and greater social, economic, and professional opportunities for women in the American environment on the other. Just as there were different factions and different ideologies represented in the Anglo-American women's movement, German-American women did not speak with one voice, either, when it came to their understanding of womanhood or women's position in society. Nor did the newspapers present a consistent image. However, the range of opinions had limits: there was a fairly universal rejection of the American suffrage and woman's movement on the one hand, and a highly positive regard and respect for the family and family labor on the other.

Amalie von Ende had very striking ideas about the future of womankind. She favored a generally more humane society, in which women and men could relate to each other as humans and not as gendered beings. Although she did not deny the differences between men and women, she argued that each always had elements of the other.

> It would indeed be sad if . . . determination, bravery and intrepidity etc. would turn a stately, dignified and noble woman into a man and tenderness, empathy and courtesy a gentle, supportive and humane man into a woman. This shows us how superfluous it is to argue over concepts . . . which can never be ascribed in their purity to one gender or the other and how much more reasonable it would be to strive for harmonious unity in humanity.[27]

However, this goal of a universally humane society could only be reached if women developed accordingly. The modern woman, so von Ende argued, was independent in mind and in deed. She was well educated and not hysterical, self-controlled and self-assertive in her body language. And, unlike most modern American women, she was focused and she budgeted her energies. According to von Ende, American women wasted much too much time and energy by bowing to the whims of fashion and partaking in the manifold and strenuous leisure activities of middle-class society.

But men also had to adjust if a universally humane society was to work. Here von Ende was well ahead of her time, in that she was able to perceive historical development in terms of gender relationships. Men had to learn to appreciate this modern type of woman, and German men in particular had to learn to respect well-educated women. According to von Ende, no other culture showed as much disregard for female intellectual potential and as much disrespect for the highly achieving woman. She held the German gender-segregated educational system responsible and regarded the American

coeducational system as one of the reasons why the situation for women was better in the United States.

In her grand design for the future, Amalie von Ende left nothing to chance. She also made suggestions on how this new woman could come into being. First of all, young women should gain some experience as indepen-dent, gainfully employed women before marriage. These women would then be able to educate their daughters and instill in them a sense of responsibility and duty, an independent opinion, and a certain seriousness. These mothers also would arrange for some physical and mental space for themselves in the household. Ideally, they would even be able to combine motherhood, house-hold labor, and gainful employment. And, also ideally, the daughters would be able to respect that space.[28]

If Amalie von Ende represented a version of the "equalitarian view" of women's group consciousness, Clara Michaelis made use of the concept of "woman's sphere" to express her ideas about women's position in society.[29] For her, efficient household management and the responsible guidance of servants were the most important tasks of women. Because of the great macroeconomic value she attributed to housework, she considered the larger occupational opportunities for women in the United States as an economic threat to society. She did not completely dismiss these broader opportunities: the many women who were not lucky enough to have their own family should be able to find meaningful work for wages that would sustain them. Here, the greater social mobility and openness of American society were generally appreciated.[30]

Analyzing the German-American female public sphere makes some con-clusions obvious: class and urbanity accounted for several similarities with the Anglo-American women's movement. Working and living within an eth-nic community set different boundaries and opened different spaces. And being immigrants familiar with and rooted in more than one culture set additional agendas for German-American women and gave them different perspectives on commonly debated issues.

At the turn of the century, German-American women in Chicago had created a female public sphere consisting of charity organizations, auxiliaries, feminist clubs, and a women's press, which resembled in form and content the public sphere in which Anglo women had been participating throughout the century. Working within the boundaries of ethnicity and class opened some chances for cooperation (as in the case of the Women's Temple), but it foreclosed others. The rejection of suffrage may have been a position more dictated by the men of the community than by womanly insight. Amalie von Ende and Clara Michaelis were too intelligent and too well educated not

to believe in their ability to handle the vote, and yet they were hesitant about saying so. Also puzzling is the apparent lack of cooperation with members of Hull House, such as Florence Kelley. She spoke German and was familiar with German culture. Was she too socialist for the middle-class German-American taste?[31] Germans—and German-Americans—had greater difficulties cooperating across class lines than American women.

German-American women had to construct a female identity influenced by ethnicity. Their ethnic female identity arose out of a rejection of what they perceived as the American woman. "The average American woman is so completely penetrated by her feeling of superiority that she regards every other nation, and especially their women, as far below her."[32] According to Clara Michaelis, an incredible ignorance about other countries, especially Germany, was the reason for this arrogance. She also disliked the presumptuousness expressed in American women's fight for general and political emancipation. But most of all, she was worried that American women did not care enough about children and family.

The contours of a German-American female identity included: competence in household management and housework; a commitment to the family; the education of daughters to become good housewives; and a healthier lifestyle, in addition to self-control, discipline, modesty, decorum, and a sense of internationalism. Middle-class German-American women were indeed feminist in the sense that they had an understanding of themselves as a social group, and their knowledge of two cultures also made them aware of the social construction of women's position. They did not, however, necessarily seek equal rights and self-determination but maintained the family, the ethnic group, and a sense of propriety. This sense of propriety set limits: among other things it forbade competition with men.

* compare w/ def. on page 142

Notes

1. Cf. Linda Kerber, "Separate Spheres, Female Worlds, Woman's Place: The Rhetoric of Women's History," *Journal of American History* 75 (1988): 9–39.

2. Nancy Cott, *The Bonds of Womanhood: "Woman's Sphere" in New England, 1780–1835* (New Haven, CT: Yale University Press, 1977); Mary P. Ryan, *Cradle of the Middle Class: The Family in Oneida County, New York, 1790–1865* (New York: Cambridge University Press, 1981). The concept has been further developed by Lori D. Ginzberg, *Women and the Work of Benevolence: Morality, Politics, and Class in the Nineteenth Century United States* (New Haven, CT: Yale University Press, 1990) and

Kathleen D. McCarthy, *Women's Culture: American Philanthropy and Art, 1830–1930* (Chicago: University of Chicago Press, 1991).

3. Ellen Carol DuBois and Vicky Ruiz, eds., <u>*Unequal Sisters: A Multicultural*</u> ✱ *Reader in U.S. Women's History* (New York: Routledge, 1990).

4. In her bibliography on immigrant women, Donna Gabaccia lists 130 entries under the heading "Working together." They mainly point to Jewish women. Cf. Donna Gabaccia, comp., *Immigrant Women in the United States: A Selectively Annotated Multidisciplinary Bibliography* (Westport, CT: Greenwood Press, 1989).

5. Nancy Cott, *The Grounding of Modern Feminism* (New Haven, CT: Yale University Press, 1987), p. 16, quotation: p. 9.

6. In 1900, for example, 65.9 percent of Cincinnati's foreign-born population came from Germany (Cleveland, 32.6 percent; Detroit, 33.2 percent; Milwaukee, 60.5 percent; St. Louis, 52.8 percent; Chicago, 29.1 percent). U.S. Census, 1900, *Population*, Tab. LXXXIII, p. clxxvi. To assess adequately the German influence, the second and third generations have to be considered. In Chicago, 31.7 percent of the immigrant population and 24.5 percent of the total population were people of German parentage. U.S. Census, 1900, *Population*, Tab. 59–63, pp. 874–90.

7. Cf. Jon C. Teaford, *Cities of the Heartland: The Rise and Fall of the Industrial Midwest* (Bloomington: Indiana University Press, 1994), pp. ix, 85–88.

8. Cf. Hartmut Keil and John Jentz, eds., *German Workers in Chicago: A Documentary History of Working-Class Culture from 1850 to World War I* (Chicago: University of Illinois Press, 1988); Keil and Jentz, *German Workers in Industrial Chicago, 1850–1910: A Comparative Perspective* (DeKalb: University of Northern Illinois Press, 1983); Rudolf A. Hofmeister, *The Germans of Chicago* (Champaign, IL: Stipes Publishing. Co., 1976).

9. Kathleen Neils Conzen, *Immigrant Milwaukee, 1836–1860: Accommodation and Community in a Frontier City* (Cambridge, MA: Harvard University Press, 1976); David A. Gerber, *The Making of an American Pluralism: Buffalo, New York, 1825–60* (Urbana, Chicago: University of Illinois Press, 1989); Guido Andre Dobbert, *The Disintegration of an Immigrant Community: The Cincinnati Germans, 1870–1920* (New York: Arno Press, 1980); Audrey L. Olson, *St. Louis Germans, 1850–1920* (New York: Arno Press, 1980).

10. Conzen, *Immigrant Milwaukee*, p. 191.

11. Irene Haederle's Ph.D. dissertation (Technische Universitat, Berlin, 1995), on German-American Protestant women in Ann Arbor, Michigan, will be published soon.

12. This chapter does not include church-affiliated women's groups.

13. Stanley Nadel, *Little Germany: Ethnicity, Religion, and Class in New York City, 1845–80* (Urbana: University of Illinois Press, 1990), p. 110.

14. On numbers in organizations, cf. Christiane Harzig, *Familie, Arbeit und weibliche Öffentlichkeit in einer Einwanderungsstadt: Deutschamerikanerinnen in Chicago um die Jahrhundertwende* (St. Katharinen: Scripta Mercaturae, 1991), p. 26.

15. See *Der Westen* (Sunday supplement of the *Illinois Staats-Zeitung*), October 11, 1896; January 24, 1897.

16. Americans had similar ideas. Cf. Frances B. Cogan, *All-American Girl: The Ideal of Real Womanhood in Mid-Nineteenth-Century America* (Athens: University of Georgia Press, 1989).

17. *Chicagoer Frauen-Zeitung*, March 18, 1894.

18. On the history and development of the Columbia Damen-Club, see the archival material at the Chicago Historical Society as well as the extensive reporting in the *Chicagoer Frauen-Zeitung*.

19. Käthe Schirmacher was born in 1858 in Danzig, studied at the Sorbonne, worked in England, received a Ph.D. in Zürich, and traveled extensively all over Europe and America, lecturing and publishing on German literature, philosophy, and women's issues. She participated in the foundation of the Association of Progressive Women's Groups and the World Association for Women Suffrage (1904). After World War I, she turned conservative and became a German-national party representative in the National Assembly. Cf. Gisela Brinker-Gabler, Karola Ludwig, and Angela Wöffen, *Lexikon deutschsprachiger Schriftstellerinnen, 1800–1945* (München: dtv, 1986), s.v. See also Kathryn Kish Sklar, Anja Schüler, and Susan Strasser, eds., *Women and Nation-Building in Germany and the United States, 1885–1933: A Dialogue in Documents* (Ithaca, NY: Cornell University Press, forthcoming).

20. Barbara Greven-Aschoff, *Die bürgerliche Frauenbewegung in Deutschland 1894–1933* (Göttingen: Vandenhoeck und Ruprecht, 1981), p. 88.

21. See Harzig, *Familie, Arbeit und weibliche Öffentlichkeit*, pp. 269–79.

22. Cf. Monika Blaschke, "Die Entdeckung des weiblichen Publikums: Presse für deutsche Einwanderinnen in den USA 1890–1914" (The Discovery of the Female Reader: The Press for German Immigrant Women in the U.S). (PhD. dissertation, University of Bremen, 1995).

23. Throughout the 1890s, there were two leading German-American newspapers published in Chicago. The *Illinois Staats-Zeitung* (ISZ) was founded in 1848 by liberal refugees from the German bourgeois revolution and was, until the 1890s, the opinion leader among the German-American middle class, with a circulation of 24,000. The *Chicagoer Freie Presse*, founded in 1872, though less prestigious and less rich in tradition, had the more dynamic management in the 1890s and surpassed the ISZ toward the end of the century, with a circulation of 30,000. Although the two papers disagreed on some political issues, such as protective tariffs and the gold standard, this did not prevent them from merging in 1897; the ISZ became the morning edition, and the *Freie Presse* appeared in the evening. In the 1890s, the *Abendpost* appeared on the scene, known as the first German-American penny press. It soon surpassed the more traditional papers, and in 1900 had a circulation of about 37,400. The *Abendpost* remained in existence until the 1950s.

24. Deutsch-Amerikanischer Nationalbund, *Das Buch der Deutschen in Amerika* (Philadelphia: Walther's Buckdruckerei, 1909), pp. 500–501.

25. Harzig, *Familie, Arbeit und weibliche Öffentlichkeit*, p. 225–26.

26. *Frauen-Zeitung*, June 18, 1897.

27. *Frauen-Zeitung*, August 22, 1897.

28. *Frauen-Zeitung*, April 28, 1895.

29. Cf. Cott, *The Bonds of Womanhood*, pp. 197–206. In a different context, these concepts were labeled "the Anglo vs. the Germanic version of feminism." Cf. Greven-Aschoff, *Die bürgerliche Frauenbewegung*, pp. 38–39.

30. Decent work (that is, work appropriate to one's social rank) for women who, through choice or lack of marriage partners, remained single, was a major issue in the German woman's movement at the time. For various reasons, German women felt that there was a lack of suitable marriage partners at the turn of the century. Some of them decided to emigrate; others fought for better educational and occu-

pational opportunities. Cf. Ute Frevert, *Frauen-Geschichte. Zwischen Bürgerlicher Verbesserung und Neuer Weiblichkeit.* (Frankfurt a. M: Suhrkamp, 1986), ch. 2; Ute Gerhard, *Unerhört: Die Geschichte der deutschen Frauenbewegung* (Reinbek: Rowohlt, 1990), ch. 5.

31. Florence Kelley is mentioned only disdainfully in the German-American papers. Cf. Kathryn Kish Sklar, *Florence Kelly and the Nation's Work* (New Haven, CT: Yale University Press, 1995), p. 237.

32. *Chicagoer Frauen-Zeitung*, January 16, 1898.

8

Sisterhood and Community

The Sisters of Charity and African American Women's Health Care in Indianapolis, 1876–1920

EARLINE RAE FERGUSON

A T THE TURN of the twentieth century, Indiana was still primarily rural and had not yet experienced the full effect of industrialization, immigration, and urbanization. The state's population was predominately white and Protestant: immigrants, mostly from northern Europe, who assimilated quickly into Hoosier communities. African American settlement was sparse, found mostly in urban areas.[1] Between 1900 and 1920, Indiana experienced tremendous change as more Hoosiers moved into the cities and company towns, and as immigrants from southern and eastern Europe moved into the northwestern part of the state to work in the new iron and steel industry. Migration, industrialization, urbanization, and poverty characterized life in Hoosier towns and cities in those first two decades of the century. Unreceptive to new ideas, Indiana lagged behind other midwestern states in social legislation to alleviate the conditions created by those changes. Conservative Hoosier values (what one historian has called "the Indiana idea or way") combined with the inflexible state governmental structure and the nature of Hoosier politics to contribute to that position. Indiana women were a decade behind their contemporaries in taking an interest in progressive reform. By the time the Progressive movement had moved to the national arena, Hoosiers were only beginning to discuss it.[2]

The two decades before and after the turn of the twentieth century—1880 to 1920—saw the migration of African Americans from the rural areas and small towns of the South into the state's urban areas—an influx of newcomers who sought an opportunity for autonomy and self-determination, education, the vote, and employment. Their migration seriously affected housing, education, employment, and health care delivery systems in

the black community, and helped determine the course of women's club work.

Overall, worsening conditions in education, politics, and the legal system meant that African Americans had to rely upon self-help as a primary means of race survival.[3] This was the time of the great debate between Booker T. Washington and W. E. B. DuBois.[4] Indianapolis's black leadership chose Washington's proposed regeneration of the black social structure through self-improvement and vocational training over DuBois's direct assault on segregation and disenfranchisement. Local newspapers consistently promoted African American self-help, education, property ownership, and business development. Black Hoosier clubwomen, pursuing the goals of racial self-help and white America's respect, promoted the middle-class ideals of thrift, industriousness, and moral uplift. Perhaps that approach also reflected some native Hoosier conservatism. At the same time, however, their work posed a challenge to the institutionalized racism and social discrimination surrounding them.

Between 1880 and 1920, almost 3,000 black women led and were members of roughly 500 individual women's church and secular clubs, whose work covered a wide range of activity: homes for the aged like the Alpha Home; settlement work at Flanner Guild; child care facilities and rescue homes for young black women like Rosa Parks's and Annie Woodford's Boarding Homes for Infants, the Door of Hope and Rescue Home, and the Young Women's Protective Association; educational and self-improvement ventures like the Colored Rescue Training School for Girls and the Norwood Library and Boys' Gymnasium; business training programs like Ada Harris's joint venture with local tailor H. L. Sanders to train thirty-five young black women for factory work; neighborhood cooperatives like Vaughan & Company and the Glencoe Progressive Aid Club; and civic organizations like the Good Citizens League and the National Association for the Advancement of Colored People; as well as the creation of viable health care institutions like the Oak Hill Tuberculosis Camp and Sisters of Charity State Hospital.[5]

The Sisters of Charity (SofC), the second largest African American women's club in the state next to the Woman's Home Mite Missionary Society (WHMMS), organized at the Bethel AME church in 1876. By 1904 there was a lodge chapter in each of Indianapolis's African American churches, with a combined membership of about 700 women, and by 1911 the SofC claimed 1,200 members statewide.[6] Originally organized to provide its members with burial insurance, the SofC expanded its mission to provide black Hoosier women with nursing care and hospital services over a forty-year period.

An independent women's lodge, the Sisters of Charity was unaffiliated with any existing fraternal or beneficial order. The SofC was born out of a

movement among black women in Baptist and Methodist churches across the nation, which reinterpreted the church's social teachings and redefined human equality to include gender as well as race. That feminist theology replaced the fragile and passive model of womanhood with an image of woman as a dynamic and saving force.[7] Georgia Ratcliffe, SofC member and president of the WHMMS, neatly summed up woman's role in her speech to the 1901 WHMMS state convention. She reminded the membership that Christianity was

> the special friend of woman [because] . . . Jesus . . . [u]nlike other great ancient instructors, . . . welcomed her presence whenever he taught. His lessons and his precious promises were addressed to her as freely as to the most honored of men . . . [and he] gave the same attention to the agonizing cry of the poor Syro-Phoenician women that he gave to the centurion or nobleman.[8]

Asserting that black women needed organizations that permitted them to explore their own potential, Ratcliffe commended the growing memberships of woman's home missionary societies. She saw the club movement as a natural outgrowth of the recognition that Jesus extended to the women of his time who "followed Him from Galilee, stood weeping beside the cross, were the first to carry the glad tidings of his triumph over death."[9]

Rejecting the ideal of submissive womanhood, Ratcliffe went on to say that

> [Woman] no longer agrees with Plato, who says, "A woman's virtue may be summed up in a few words; for she is only to manage the house well, keeping what there is in it, and obeying her husband." That is all very good in its way, but the day is passed when woman is content to sit passively down in such a narrow sphere. We feel rather to agree with Lycurgus who wonders what may be expected of the children whose mothers' only occupation is at home weaving and spinning."[10]

"God gave woman a mind" that he expected her to use and cultivate; and black clubwomen pursued the chance for sisterhood, education, and the self-realization necessary not only for the proper guidance of their children and families, but also for community improvement and uplifting the race.[11] Self-realization enhanced their ability to achieve their goals.

The women who created the Sisters of Charity deliberately chose its form as an all-women's lodge to achieve self-realization and to ensure its independence from the male-dominated hierarchy of local churches and fraternal orders. Ruth Clinthorne, Elizabeth Enix, and Frances Stout, some of the Indianapolis women interviewed about the black women's club movement for this chapter,[12] carefully distinguished the Sisters of Charity from other

women's clubs as a *church lodge*. When asked why they made that distinction, they responded that the SofC, like the WHMMS, was clearly an interdenominational church club. Unlike the WHMMS, however, the SofC was a lodge rather than a club. SofC women's self-identification as a lodge was evidenced by the secrecy and mystic rituals incorporated into its meetings, and by the outfit that members wore at lodge convocations (black robes with a white neck ruche, white gloves, white handkerchiefs that draped the shoulders and crossed in front, and a white bonnet with long black veil).[13]

The desire for autonomy and self-determination was common among black women's clubs and often was expressed in a reluctance to seek help from whites. Dependence upon white support might ensure an organization's survival, but often fostered white control or direction of its projects. Although autonomy frequently meant insufficient financial resources and also sometimes resulted in a lack of experienced administrative personnel at the initiation of a project, black clubwomen still chose to focus on self-investment and mutual aid in order to avoid any compromise of their ability to advocate social change. The Alpha Home for Aged Colored Women (AHA), the Oak Hill Tuberculosis Camp founded by the Woman's Improvement Club (WIC),[14] and the local chapter of the National Association for the Advancement of Colored People organized by the Woman's Civic Club (WCC), all struggled to maintain control of the direction of their projects, despite occasionally tapping into the private resources of individuals in the white community.

The Sisters of Charity, like many other black women's clubs, resolved the dilemma of self-determination and extracommunity funding by placing strong women in key leadership positions. Unlike members of the WIC and WCC, they were not the well-educated wives and daughters of lawyers, doctors, barbers, bankers, and entreprenuers. SofC leaders were not DuBois's "talented tenth" in the sense of educational and economic advantage.[15]

Local black newspapers revealed the names of almost 200 women leaders in SofC chapters. With censuses and city directories, newspapers further identified 73 percent of those women. No occupation was mentioned for most SofC women. Only 6 percent were teachers; 5 percent were entrepreneurs (cateress, grocer, seamstress). Four percent, fittingly, were nurses. More SofC women worked as servants, housekeepers, cooks, and laundresses than at any other employment. Newspapers were quick to note the professional status and entrepreneurship of community women; lack of any such mention for SofC women implies an important difference between them and other leading women's clubs. They were predominantly nonprofessional, nonelite women; their husbands were employed as day laborers, waiters, farmers, merchant police (private police hired by merchants), and janitors.

Also unlike AHA, WIC, and WCC leaders, who commonly were par-

ticipants in local literary societies, few SofC women joined literary socie-
ties. Many SofC women did, however, belong to other clubs, usually the
WHMMS, other lodges, and church clubs. Joint memberships, network
sharing, and mutual support were important means black clubwomen used
to facilitate fund-raising for club projects. WIC and WCC members, the elite
women, belonged to several different kinds of clubs (reform, literary, and
social pleasure clubs), and often to as many as five or six clubs. Few WIC
and WCC women, however, belonged to the SofC, although they were often
guest lecturers at SofC meetings. Several SofC women were active mem-
bers in the Alpha Home Association, probably because Huldah Webb and
Jannetta Thomas, two of its founding members, were also organizing forces
for the SofC. SofC women commonly belonged only to their SofC lodge
chapter.

Like their lodge sisters in fraternal orders, the Sisters of Charity some-
times permitted men limited memberships in their organization, usually men
who were leaders of one of the fraternal lodges. They did so in order to avail
themselves of male expertise and resources without relinquishing their own
authority or control. Without access to real social and political power, Afri-
can American women could not afford to completely disassociate themselves
from the men in their communities. Black clubwomen clearly understood
that race issues and women's issues were intextricably tied to one another,
that the two struggles were not separate.[16]

Sisters of Charity women published meeting announcements and club
reports often directed to the "Sisters and Brothers of Charity." In 1876, even
one of the club's seven founding members was male. In 1905, when the SofC
joined the Indiana State of Colored Women's Clubs, each lodge affiliate
elected a man as trustee or superintendent. By the 1930s, Sisters of Charity
bylaws formally required all lodge chapters to recruit a male superintendent,
and the SofC state federation had thirteen men on their advisory board.
Women might also be elected as superintendents, but men were restricted to
only that office. Although the SofC invited men's assistance and tried to ally
themselves with Indianapolis's prominent male community leaders, that re-
lationship was tenuous and telling in their struggle to create a viable hospital
for black women.[17]

The racism securely established in the Progressive Era brought about
inequities in class and status that particularly affected health care delivery in
the African American community. Racism denied most black women access
to the schools and hospitals responsible for training nurses. Racism also de-
nied black graduate nurses membership in local and national nursing organi-
zations. As African American populations increased, white hospitals became

more discriminatory in their admission policies and rarely permitted black physicians, interns, and nurses to practice in their facilities. In response to the increased need for decent health care delivery systems and trained black medical personnel, individuals and communities across the nation created hospitals and other health care facilities and programs to try to meet community needs.[18]

In Indianapolis, no hospital admitted black patients as freely as whites, and no institutions allowed black doctors to attend their own patients. Although City Hospital permitted brief internships for three black physicians in the late 1800s, after 1900 it shut its doors to other blacks who wanted to intern there. In fact, in the summer of 1916, the local National Association for the Advancement of Colored People filed one of its first lawsuits against City Hospital on behalf of a young black doctor when the hospital reneged on a promised internship. The suit was dropped, however, when the young man decided to accept a position at an East Coast hospital and left town.[19]

Exclusionary practices not only applied to black medical practitioners. Indiana hospitals also often refused to admit black patients. In Indianapolis, St. Vincent's, Methodist, and Deaconess Hospitals used their sectarian affiliations to justify restrictive policies; other hospitals simply stated "no colored allowed." In 1915, Long Hospital refused to admit Ida Earnest, a black citizen of Greencastle—even though she had reserved a bed prior to arrival at the hospital. Long Hospital authorities tersely stated, "No provision has been made here for the treatment of Colored patients"—despite the fact that public moneys, including Mrs. Earnest's taxes, supported Long Hospital. J. D. Hodges, editor of the *Ledger*, one of Indianapolis's black newspapers, questioned the "strange inconsistencies" in health care policies in Indiana. Hodges reminded his readers that Dr. Robert W. Long's bequest intended the hospital to serve the "suffering and afflicted of all races in the rural districts." Black hospitals, however, often treated all patients who came to them, black or white. Hodges points out a 1914 incident when several white passengers were severely injured in a taxicab collision in Evansville, Indiana, and rushed to Walker Sanitarium, a black hospital, for care. The sanitarium did not turn them away.[20]

Although local Indiana newspapers sometimes reported African Americans as patients in municipal hospitals (usually as recuperating from or dead from various surgeries), Hoosier public hospitals as a rule turned away black patients: Ida Earnest's experience was not unusual. Equally important, the customary tradition of denying medical care to blacks surely made many African Americans delay or not even seek care at those institutions—and must have resulted in unnecessary death, disability from injury, and a higher incidence of communicable diseases.

None of the nurses' training schools in Indiana admitted African Ameri-

cans as students. That fact, however, did not deter many young black women from seeking the necessary training. From the 1890s onward, Indianapolis's black newspapers, the *World, Freeman, Ledger*, and *Recorder*, consistently reported local women's enrollment in nursing programs at Freedman's Hospital in Washington, D.C., Provident Hospitals in Chicago and Baltimore, Atlanta's Spelman College, Virginia's Hampton Institute, and Alabama's Tuskegee Institute. Black women's clubs often financed the education of those young nurses. At the same time, clubwomen struggled to fight disease and unsanitary conditions, and to provide affordable nursing and hospital care themselves. Together with other community members and organizations, they created and maintained the Oak Hill Tuberculosis Camp and Sisters of Charity State Hospital, and raised funds for two other male-owned community hospitals, Ward's Sanitarium and Lincoln Hospital.

Joseph Ward opened Ward's Sanitarium in 1909, probably the first medical facility for blacks in Indiana. Elizabeth Enix particularly remembers Ward's Sanitarium because her younger brother was born there in 1910. She remembers the Ward home on Indiana Avenue, with its spacious porch, and the large red brick building, adjacent to the Ward home, that housed the sanitarium. The sanitarium easily accommodated sixteen beds, and boasted steam heat, electric lights, and "all modern appliances and conveniences" available at that time. The surgery, lighted by a skylight and completely outfitted in sanitary white tiles and enamel, contained the most modern sterilization equipment. The sanitarium advertised "the best specialists of the State . . . on [its] consulting Staff," and patients from communities around the state came to Indianapolis for treatment. Ward owned one of the first cars in the black community, which he used to transport patients living in other communities. Additionally, C. M. C. Willis undertakers allowed him to use their ambulance when necessary.[21]

Local newspapers advertised Ward's Sanitarium as a private hospital. If Ward's Sanitarium was created as a business venture, however, that institution did not ignore the plight of the black community's poor. Elizabeth Enix pointed out that her family were not well-to-do like the Wards and some other Indianapolis families; they were hard-working poor. But she remembers several times her family and other community residents received free inpatient and outpatient care at the sanitarium.

Local black newspapers made no announcements of fund-raising activities for Ward's Sanitarium, as they did for Lincoln and Sisters of Charity Hospitals. But Frances Martin, Elizabeth Enix's mother, spent time sewing gowns, bandages, linens, and towels for the sanitarium. She belonged to both the Woman's Improvement Club and the Woman's Council, and it is likely that other clubwomen sewed with her. Ruth Clinthorne, daughter of Ella Herod (another Woman's Improvement Club founding member), re-

membered Frances Martin, Daisy Brabham, and other clubwomen sewing in her mother's kitchen for the Oak Hill Camp and Ward's Sanitarium. So although there is no formal record of fund-raising activity by Indianapolis clubwomen on behalf of the sanitarium, they supported it at least through gifts-in-kind.[22]

The opening of Ward's Sanitarium, however, affected the role of black Hoosier women in health care delivery systems in another very basic way. When Joseph Ward set up his sanitarium in August 1909, it meant that black Hoosier women had available locally another opportunity for nurses' training, an opportunity not restricted to Baptist deaconesses. Not only could they receive practical training at Ward's Sanitarium, but City Hospital's Nurses' Training School, as a concession to Joseph Ward's persistence and influence, permitted the two nurses responsible for the postoperative care of patients in Ward's Sanitarium to sit in on a course of lectures and demonstrations in bandaging, poulticing, and the application of surgical dressings. The sanitarium also gave a young medical intern the opportunity to assist at operations and to learn from patient care on a daily basis. Ward's Sanitarium, by example, encouraged the establishment of a second black hospital in Indianapolis—Lincoln Hospital.[23]

A few short months after the opening of his hospital, Joseph Ward joined several other black male physicians to found Lincoln Hospital, a public hospital for poor blacks. A twelve-room facility, Lincoln Hospital easily accommodated seventeen patients in two medical wards.[24]

Amanda Rogers, a graduate of Freedman's Hospital in Washington D.C., and Ella C. Preston, a graduate of the Red Cross Hospital in Louisville, Kentucky, were Lincoln Hospital's first superintendents. Both women also belonged to other reform-oriented clubs in Indianapolis. Ella Preston was a WIC member and brought experience from the Oak Hill Tuberculosis Camp.[25] With no endowment, the Lincoln Hospital Association was forced at the end of 1911 to seek additional funding.[26] Although some of Indianapolis's "public spirited white citizens" contributed to the initial outfitting of the hospital building, continued support came from the black community—sometimes from black philanthropists. Primary support came from the community, particularly from two women' clubs: the Patients' Club, which continued nursing care to former patients at home, and the Woman's Council, which raised money for the hospital.[27]

Sisters of Charity State Hospital also relied on women's clubs for support, but unlike Lincoln Hospital, was organized and managed by women. Between 1876 and 1910, the SofC nursed sick members at home. The Indianapolis *Recorder* and *Freeman* are full of obituary notices in which family members of the deceased thank the Sisters of Charity for kindnesses, support, and the nursing care. In the 1890s, Ada Goins's roomy, two-story, red-

roofed home on North West Street was the site of SofC headquarters. Local newspapers indicated that occasionally an SofC member would be at Goins's home recovering from illness or surgery. Goins, long-time president of the State Association of the Sisters of Charity, and Malinda Thomas, president of one of the local Sisters of Charity chapters, eventually saw the need for a larger, independent hospital facility, and in 1907–8 began lobbying their membership to open a facility that would provide their members with quality health care services.[28]

In 1911, under Ada Goins's guiding hand, the Indiana state convention of the SofC launched a drive to raise funds for the establishment of a free hospital for African American Hoosier women, at Fifteenth and Missouri Streets. Initial support came from SofC membership statewide, and soon the black medical society (whose membership extended beyond the boards of Ward's Sanitarium and Lincoln Hospital) pledged its support. Shortly afterward, the Associated Charities Committee of the Indianapolis Chamber of Commerce endorsed the project. The women leased a two-story frame house on property that covered almost a quarter of the block at 1502 North Missouri Street, with an option to buy for $10,000. Envisioning the hospital's future, they struck a bargain with John A. Victor, a local real estate agent, which included his promise to give the SofC six additional small cottages on the alley behind the property once they paid $2,500 on the purchase price. The thirteen-room house was in good condition, and easily converted into a hospital. When renovations were completed, the hospital had two reception rooms, six wards, a dining room and kitchen, one operation room and prep room, a bathroom, and a nurses' room. Operating room equipment cost approximately $800. Of that amount, $300 was donated by a white benefactress who requested anonymity.

When it opened, Charity Hospital had the capacity for twenty patients. In her dedication address, Ada Goins outlined plans to open two of the wards by June 15. The four other wards would be furnished by local black organizations and opened later that year. Charity Hospital provided care for members of all SofC chapters, and women from other parts of the state often traveled to Indianapolis for medical care at the hospital. A licensed maternity hospital, Charity Hospital also opened its doors to anyone who needed nursing care. Although Charity Hospital's original impulse was to provide care for SofC members and other community women, the SofC advertised that Charity Hospital "solicit[ed] the patronage of all patients" at reasonable rates.[29]

The SofC Hospital Board pulled several of the city's leading black doctors into the initial hospital planning process, and it hired five young African American physicians to staff the hospital—some of whom were newcomers to the Indianapolis medical scene. Charity Hospital permitted patients to

choose their own doctor, and any of the community's more-established phy-
sicians could also refer patients to the hospital and use the surgery (if he
brought his own instruments).

There appears to have been some friction between Malinda Thomas,
President of SofC's Hospital Board and the same doctors who were on the
board of Lincoln Hospital. In 1918, a few of those doctors implied to an
Indiana Department of Public Welfare (IDPW) inspector that "Mrs. Thomas
. . . [was] not absolutely honest . . . that the hospital [would] never amount
to anything as long as . . . [she was] interested in the place."[30] Perhaps some
residual enmity from the years of intense rivalry between Lincoln and Sisters
of Charity Hospitals was at play in those remarks. Local clubwomen ac-
knowledged Thomas as a dedicated and competent manager, and the SofC
membership reelected her to the Hospital's board year after year until the
hospital closed in the mid-1920s. IDPW inspection reports, however, indicate
an additional possible reason for the remarks.

In late 1913 and early 1914, editorials in the Indianapolis *Recorder* and
Ledger hinted at "strained, unsatisfactory conditions" at Lincoln Hospital
and Sisters of Charity Hospital. Several articles discussed financial difficulties
at both institutions and advertised community meetings to address "the
nursing problem." It is not clear whether "the nursing problem" referred to
the quality of nursing, a shortage of nurses, or something entirely different.
Both hospitals proudly housed a nursing school with staff trained at other
institutions—at Tuskegee Institute, the Red Cross Hospital training school
in Kentucky and Freedman's Hospital in Washington, D.C. Both hospi-
tals also claimed programs comparable to those at other black institutions.
Often, however, the two hospitals shared medical staff, and probably also
competed for nurse recruits. Newspapers also suggested a competition for
patients. Added to this was a competition for financing, and personality con-
flicts among the board members of each institution. As a result, the India-
napolis black community found itself facing the possibility of losing its two
main suppliers of general health care and hospitalization.[31]

Both the *Recorder* and the *Ledger* proposed a merger of the two hospi-
tals as a solution. Several local ministers endorsed that proposal, and the
black community pressured the executive boards of Lincoln and Charity
Hospitals to meet in mid-February 1915 to consider the possibility. A long
editorial in the *Ledger* scolded both hospital boards, urging them "to bury
the hatchet in the interest of the greatest number" and merge their mutual
interests. The editor of the *Ledger* was astute enough to point out the pos-
sible financial benefits of such a merger. "With oneness of purpose thus es-
tablished," he wrote, "the hand of the philanthropist will be more liberally
extended, and the element of doubt which has . . . perplexed him as to the
wisdom of giving to two institutions . . . where one would suffice . . . will

have been removed, and the institution [will be] entered upon his annual list of worthy charity." The meeting, however, was to no avail, and the *Ledger* reported that the bitterness reasserted by both sides at the meeting had done more harm than would "ever be effectively overcome."[32] Shortly after the failure to merge, Lincoln Hospital closed.

After 1915 and the close of Lincoln Hospital, there was no medical facility at which that hospitals' doctors could operate; nor was there a hospital to which they could refer patients for care and still keep them as their patients. City Hospital allowed no black doctors on staff—and only staff doctors could practice there. By 1915, Sisters of Charity Hospital had changed its original policy, and only permitted physicians on staff to treat patients or use the surgery. So, basically, African American doctors not on staff at SofC Hospital could only practice outpatient care. Perhaps that had something to do with Drs. Furniss, Armistead, and Brown's lack of confidence in SofC Hospital.[33]

Until the middle of 1915, Indiana Department of Public Welfare inspectors reported Sisters of Charity Hospital's facilities in fair to good condition, and recommended license renewal each year.[34] Beginning in July 1915, however, IDPW inspectors reported the Missouri Street facility "in poor repair" and in need of paint, additional equipment, and a bathtub. In July 1916, the maternity hospital license inspector reported that "the Board [was] handicapped because of lack of funds." IDPW inspection reports indicate few patients in the facility from 1914 to 1918.[35] In August 1917, Malinda Thomas was forced to close the hospital for a few weeks while she awaited the arrival of the new superintendent. At that time, she told the IDPW inspector that the board had been unable to pay any of the principal or interest on their mortgage for three years and that she had applied for a loan on the property in order to renovate the building. The loan did not come through, and the following month Thomas decided to reorganize and move the hospital to another location.[36] In 1918, a New York Bureau of Municipal Research survey of local charities and philanthropies reported that Sisters of Charity Hospital was "unwilling" to make necessary repairs. It was, however, a lack of funds that kept the hospital in disrepair.[37]

Sometime in the summer of 1918, Sisters of Charity State Hospital reopened at 502 North California Street. However, a crisis occurred when the IDPW refused to grant the SofC a maternity hospital license, based on an inspection report by M. Ellen George which stated that the hospital was "poorly heated and equipped," and which also mentioned that several prominent black doctors lacked confidence in SofC Hospital. Previous inspection reports for black Hoosier health care institutions noted at one time or another that the facilities were "poorly equipped" or in disrepair, but as a rule, unless a building was falling to the ground, the inspector recommended li-

censing because there were so few institutions serving African American communities. M. Ellen George, however, was either a new inspector and easily influenced by "prominent physicians," or not as sensitized to African American health care as previous inspectors, or the standards for inspection had tightened.

Three days after her recommendation for refusal, however, George recommended licensing saying that she had revisited the hospital "and found conditions much improved." She also mentioned, at the end of her report, that the hospital was struggling to improve its standard, that it "should be visited from time to time and encouraged," and that "[i]t would be well to discuss the situation with Dr. L. A. Lewis and Dr. S. A. Furniss." Lewis was on staff at SofC Hospital; Furniss was one of its outside detractors. Probably, Lewis and Furniss joined to petition the IDPW to license the hospital. George's report two months later stated that, while Lewis "realized that a great many things should be added and changed yet . . . the colored people are cared for better at the colored hospital"; and she recommended licensing with close supervision.[38] Although the men and women may have fallen out of grace with each other, the ultimate purpose, to provide much needed health services, prevailed.

Sisters of Charity State Hospital suspended its maternity care facility in the summer of 1921. A February inspection report noted that the hospital still used its surgery, but that there was no delivery room set up. By March 1922, the hospital had temporarily closed. The hospital board rented the first floor of the California Street building to a chiropractic school, and loaned hospital equipment and use of the second floor to the Woman's Improvement Club for the care of incurable tuberculous patients. The undertaking finally proved too expensive for the Sisters of Charity, and they did not reopen their hospital again.[39]

Responding to their community's desperate need for improved health care delivery systems, the Sisters of Charity tried to improve and broaden the scope of health care for women, and to provide an opportunity to young black women who aspired to become professional nurses. When Charity Hospital opened, there were almost 40,000 blacks in the city, with only nineteen black physicians and five black dentists to supply their medical care. The number of African American nurses practicing in the community is unknown, but local newspapers indicated a need for more nurses than those available. Charity Hospital provided a local facility in which young men and women could receive the kind of training that only comes from practical experience. To help remedy the shortage of nurses, Charity Hospital offered a nursing program to train professional nurses.[40]

In opening a woman's hospital, the Sisters of Charity also hoped to address the prevailing male bias, which trained women only to be the physician's helper. Charity Hospital offered a nurses' training program to prepare women for hospital administrative leadership. Women who created their own nursing schools saw the opportunity as "one significant means to an end, to wit, the delivery of better health care for black people and the simultaneous production of autonomous professionals."[41] Charity Hospital offered a three-year program designed to fulfill state licensing requirements and to produce women prepared to function as nursing supervisors and hospital superintendents.

The nursing program fulfilled another and even more basic function at Charity Hospital. It was critical to hospital operation, providing a trained nursing staff instead of permitting ambulatory patients to care for one another. Untrained nurses usually performed only the requisite domestic and maintenance tasks; a nursing school, however, provided a steady supply of cheap, obedient, and disciplined labor.[42] Charity Hospital also provided an employment opportunity for graduate nurses (and the young doctors who gained experience in its halls).[43] Many black women saw in professional nursing a way to achieve both self-fulfillment and economic independence. Training assured employment, and also, in the view of some black leaders, prepared "many of [the race's] young women . . . for the responsibilities of family life."[44] Held in high esteem, graduate nurses were expected to function well in the domestic domain as wives, mothers, and sisters and to work for racial uplift.

Several SofC and other black clubwomen were themselves nurses, and in 1908, six years before the Indianapolis Nurses' Association organized, they joined forces as the Nurses Club. They raised money for other black women's clubs and shared with them health information and the task of racial uplift. In 1915, O. E. Clark, secretary of the Indianapolis Nurses' Association, stressed the black nurse's racial obligation in a speech at their first annual meeting. She told her audience that "[n]ursing [was] an art which [was] one of the highest professions . . . the finest of the fine arts," and emphasized that the responsibility placed on black nurses by doctors dependent "upon the confidence, knowledge and professional etiquette [the black nurse displayed] both *in and out of* the sick room [emphasis added]."[45]

The black Hoosier community also valued its nurses and the SofC's efforts to improve health care. This is evidenced by the contributions of neighbors throughout the city and state who financed Charity Hospital's operating expenses, which ranged from $1,000 to $1,700 per year, and were met more successfully at some times than at others.[46] Reliance upon the community for support also ensured the hospital's nonexclusivity, because many, many small donations were needed to ensure a project's longevity.

Community support was crucial to the creation of network coalitions

and fund-raising. In 1901, Ada Goins initially saw a broader financial base as the benefit of creating a state federation of the Sisters of Charity. Federation enabled the SofC to campaign throughout the state and to double its membership by the end of 1912. In January 1913, the burial allowance fund had increased to $60,000, and assured each member a "proper Christian" burial. By mid-1914, the SofC was recruiting members in African American communities in Ohio, Michigan, and Tennessee.

In 1917, Charity Hospital's endorsement by the Associated Charities Committee of the Indianapolis Chamber of Commerce followed a pledge from the Colored Medical Society.[47] Outsider endorsement not only recognized the value of an institution, but usually also meant that it was eligible to apply for funds from the city and county commissioners. But there is no indication that the SofC either applied for or received any financial grant. One would imagine that, if the SofC had applied for assistance, their petition might have been hindered by negative IDPW reports on Charity Hospital and by opposition from the black doctors who were already endorsed by the white community.

The community's vested interest also influenced black clubwomen's fund-raising methods. For them, mainstream strategies were not as effective as exploiting family and organizational ties. Clubwomen recruited volunteers to solicit family members, friends, and neighbors for donations, as well as to seek larger gifts from African American professionals and businesspeople— sending volunteers to all community churches and businesses, and on occasion from door to door with subscription cards for donations.[48] Clubwomen volunteered their own time and gave their own money to projects, which made it easier to ask others to volunteer their time and assets. Other women's clubs helped with start-up costs and contributed to the hospital's upkeep. Initially, the Golden Star Club (a local embroidery club) completely furnished one of the hospital's wards. Volunteer auxiliaries were organized whose specific mission was the hospital's physical upkeep.[49] SofC women also recruited the community's children as volunteers in their fund-raising campaigns. Who could resist children? The women also sponsored junior affiliates to assist in fund-raising and to raise up a new generation of socially responsible community members. Money collected by the children from their families and neighbors filled collection boxes at local and state conventions.[50] Eventually the SofC's state federation set up an endowment board that regularly recruited women to collect supplies and money for the hospital.

The support that clubwomen asked from their neighbors was not prohibitive—a penny here and there in WHMMS mite boxes, an added collection at club and lodge meetings or church services, and participation in community events. Sometimes the amount was left to the donor's discretion; at other times it was mandated by the nature of the occasion. In 1909, Gleaners MMS gave a Martha Washington Tea to benefit the Charity Hospital fund,

and every member of the society was required to bring as many pennies as she was old. Money was not the only contribution neighbors made to the cause. They also helped care for sick members of their community, bringing them meals and cleaning their homes; and volunteered time organizing children's activities. Sometimes volunteered service turned into organizational employment or membership. Malinda Thomas, superintendent of Sisters of Charity Hospital, started her philanthropic career as a volunteer.[51]

Charity Hospital had an important place in community life besides the medical care it offered, a place ensured by SofC women's fund-raising activities. Clubwomen were very creative in the kinds of leisure activities they offered to support their projects—"silk stocking" socials; "flower fetes"; "campaign entertainments" in election years; trolley rides; "moving picture" shows; lemon, strawberry, and ice cream socials; guessing and quilting contests; an "Abe Martin wedding"; and "shadow picture" shows. Larger fund-raising events, like charity balls, fairs, vaudeville, dramas, and picnics were geared to family participation. In the summers, baseball games preceded by street parades were staged to benefit various institutions.[52] Fund-raising events met an important leisure and recreational need, and contributed to and reinforced a sense of community—both locally and nationally.

African American clubwomen perceived no requisite contradiction between community and family, male and female, or public and private spheres; rather, they embraced a fusion of race, womanhood, and community. Through their actions, the Sisters of Charity demonstrated a philosophy that embraced the interconnectedness of blackness and femaleness. While at times, their nonelite, nonprofessional status might have created friction between the SofC and leading black male medical practitioners, the community's desperate need for health care services caused the parties to put aside their dispute. The SofC women's status, however, did not negatively affect their relationship with the women in elite clubs, who often spoke at SofC convocations and who shared with them precious community resources.

Supportive relationships among Indianapolis's African American clubwomen speak to the interconnectedness of race and class and an overarching sisterhood. The Indianapolis women's club narrative implies that black Hoosier women were perhaps not as concerned with the notion of "the worthy poor," as were their white counterparts.[53] Whether elite or nonprofessional, there is no oral or written evidence that black women saw themselves as above or apart from the community. Their actions indicate they made no fine distinctions about who was or was not worthy of their help, but commonly accepted all community members as worthy, even newcomers—a belief rooted in that Baptist and AME church experience which praised the sanctity of the individual and his or her worthiness to be saved.

More research is needed to provide a clearer understanding of the effect

of westward migrations on Indiana's African American community, particularly their effect on perceived class relations and women's club work. Black feminist scholars are calling for work that would place the issue of race more predominantly in analyses of power.[54] Further research into the role of black women's organizations in community formation might help with that analysis. In what ways and to what extent did the overarching racism present at the turn of the century affect relationships and power arrangements among men and women in the black community? How did that racism influence perceived class relationships?

There were several elite African American women's clubs busy in Indianapolis at the turn of the century, but most clubs comprised "ordinary" women with the heart necessary for "extraordinary" undertakings. The Sisters of Charity well represented those women. The tenacity and resourcefulness that African American women cultivated to sustain their families and community assumed an active sense of the common historical experience shared by all African Americans. When clubwomen undertook racial uplift and created institutions like Charity Hospital, they gained a large measure of personal independence and the ability to circumvent society's built-in racial impediments and the stigma of gender. By their actions, black clubwomen achieved that essence of freedom necessary to create a space in which they might not only develop themselves, but also participate in the determination of the course of their community's future.

Notes

1. *Abstract of the Twelfth Census of the United States, 1900*, pp. 100–102. United States Department of the Treasury, Bureau of Statistics, *Statistical Abstract of the United States, 1904*, no. 24 (Washington, DC: U.S. Government Printing Office, 1904), pp. 5, 11, 14; and United States Department of Commerce, Bureau of the Census, *Thirteenth Census of the United States, 1910: Population*, II, pp. 56–57, 570; Clifton J. Phillips, *Indiana in Transition: The Emergence of an Industrial Commonwealth, 1880–1920* (Indianapolis: Indiana Historical Bureau and Indiana Historical Society, 1968); and John D. Barnhart and Donald F. Carmony, *Indiana: From Frontier to Industrial Commonwealth*, 2 (New York: Lewis Historical Publishing Company, 1954).

See also Xenia Cord, "Black Rural Settlements in Indiana before 1860," in Wilma L. Gibbs, ed., *Indiana's African American Heritage: Essays from Black History News & Notes* (Indianapolis: Indianapolis Historical Society, 1993).

2. James Madison, *Indiana through Tradition and Change: A History of the*

Hoosier State and Its People, 1920–1945 (Indianapolis: Indiana Historical Society, 1982); Barbara A. Springer, "Ladylike Reformers: Indiana Women and Progressive Reform, 1900–1920," PhD. dissertation, Indiana University, 1985, pp. 18–22, 31.

3. Dorothy C. Salem, "To better Our World: Black Women in Organized Reform, 1890–1920," Ph.D. dissertation, Kent State University, 1986, pp. 8–9.

4. See Louis R. Harlan, *Booker T. Washington: The Wizard of Tuskegee, 1901–1915* (New York, 1983) and William Edward Burghardt Du Bois, *The Souls of Black Folk* (Chicago, 1903), ch. 3.

5. Earline Rae Ferguson, "A Community Affair: African-American Club Women's Work in Indianapolis, 1895–1920," PhD. dissertation, Indiana University, 1996.

6. Indianapolis *Recorder*, October 22, 1910; September 23, November 11, and December 2, 1911; March 16, 1912.

7. See Evelyn Brooks Higginbotham, *Righteous Discontent: The Women's Movement in the Black Baptist Church, 1880–1920* (Cambridge, MA: Harvard University Press, 1993), ch. 5.

8. Indianapolis *Recorder*, November 15, 1901.

9. Ibid.

10. Indianapolis *Recorder*, November 15, 1902.

11. Ibid.

12. Interviews with Elizabeth Enix, daughter of WIC member Frances B. Martin, March 12 and June 11, 1987; Frances Stout, historian of Indianapolis Bethel A.M.E. Church, June 4, 1987; Ruth Clinthorne, daughter of WIC member Ella B. Herod, April 11, 1987; and Jean Douglas Spears, granddaughter of WIC member, Daisy Brabham, April 9, 1987.

13. Indianapolis *Recorder*, April 30, 1904, and March 9, 1912. *1939 Annual Convention Program, Constitution and By-Laws of the Grand Body of Sisters of Charity* in the "Sisters of Charity Box" in the National Council of Negro Women Manuscript Collection, Indiana Historical Society, Indianapolis, hereinafter abbreviated as NCNWMS, 27.

14. See Earline Rae Ferguson, "The Woman's Improvement Club of Indianapolis: Black Pioneers in Tuberculosis Work," *Indiana Magazine of History* 84 (September 1988): 237–61.

15. For some elite clubs see Ferguson, *ibid.*; Darlene Clark Hine, *When the Truth Is Told: A History of Black Women's Culture and Community in Indiana, 1875–1950* (Indianapolis, IN: National Council of Negro Women, Indianapolis Section, 1981); and Emma Lou Thornbrough, "The History of Black Women in Indiana," in Gibbs, *Indiana's African American Heritage.*

16. Indianapolis *Recorder*, January 5, 10, 12, and 19, June 8, August 24, and December 14 and 28, 1901; January 25, February 1 and 8, March 1, June 14, and December 15 and 20, 1902; January 10, 1903; March 30, 1907; January 2 and 26, March 2 and 30, and August 10, 1907; August 8, 1908; January 23, March 6, and May 2, 1909; January 6, 1912; June 28, 1913; and January 24 and February 7, 1914.

17. Indianapolis *Recorder*, January 5 and October 5, 1901; January 25, 1902; January 10, 1903; January 6, 1906; January 19, 1907; January 25 and July 28, 1908; January 23 and March 6, 1909; and January 6, 1912.

Indianapolis *Leader*, February 2, 1879; Indiana State Sisters of Charity bylaws and annual meeting brochure, Sisters of Charity Box, NCNWMS.

Lillian Thomas and Gertrude B. Hill, receipts for services as superintendents, Sisters of Charity Box, NCNWMS.

18. Darlene Clark Hine, *Black Women in White: Racial Conflict and Cooperation in the Nursing Profession, 1890–1950* (Bloomington: Indiana University Press, 1989).

19. Indianapolis *Recorder*, September 27, 1916.

20. Indianapolis *Ledger*, September 25, 1915, and October 31, 1914.

21. Enix, op. cit.

22. *Ibid.*; Clinthorne, op. cit.

23. Indianapolis *Recorder*, August 7, 1909.

24. "Lincoln Hospital" (Indianapolis: Sentinel Printing Company, 1911), 40–43, pamphlet in George H. Rawls, *History of the Black Physician in Indianapolis, 1870 to 1980* (Indianapolis, IN: s.n., 1984); Indianapolis *Ledger*, April 25, 1914, clipping in Community Organization file at Indianapolis/Marion County Public Library, Indianapolis, IN, hereinafter abbreviated as IMCPL; and Indianapolis *Recorder*, October 2 and January 18, 1909.

25. "Lincoln Hospital", op. cit., 43. Indianapolis *World*, June 30, 1910. Indianapolis *Recorder*, July 13, 1912, and July 19, 1913.

26. Indianapolis *Recorder*, January 18, 1909, and July 30, 1910.

27. Indianapolis *Ledger*, April 25 and October 31, 1914, and January 2, May 15, June 6, and December 19, 1915; Indianapolis *Recorder*, November 4, December 9, 16, 23, and 30, 1911. "Lincoln Hospital", op. cit., 44–45.

28. Dorothy C. Salem, "To Better Our World: Black Women in Organized Reform, 1890–1920." Ph.D. dissertation, Kent State University, 1986, p. 145. Indianapolis City Directories, 1876–1910. Sisters of Charity Manuscript Collection, Indiana Historical Society, Indianapolis. Indianapolis *Ledger*, October 24, 1914. Spears, op. cit. Enix, op. cit.

29. Indianapolis *Recorder*, May 23, 1908; May 30, 1908; January 2, 1909; and April 22, May 6 and 27, and December 9, 1911. Indianapolis *Ledger*, October 24, 1914.

30. December 28, 1918, letter from M. Ellen George, inspector, to Amos W. Butler, secretary of the Indiana State Board of Charities in Indiana State Archives, Commission on Public Records, Indiana Department of Public Welfare, Indianapolis, File 275, "Sisters of Charity State Hospital," hereinafter referred to as ISA-CPR, IDPW, File 275.

31. Indianapolis *Recorder*, November 29, 1913, p. 3. Indianapolis *Ledger*, October 24, 1914.

32. Indianapolis *Ledger*, February 20, 1915, p. 2.

33 December 28, 1918, letter from M. Ellen George to Amos W. Butler, ISA-CPR, IDPW, File 275.

34. Inspection Reports, November 17 and December 11, 1911; January 20 and June 7, 1913; and January 18 and June 2, 1914, ISA-CPR, IDPW, File 275.

35. Inspection Reports, July 24, 1915, and July 31, 1916; and July 31, 1916, letter from S. Ethel Clark, inspector, to Amos W. Butler, ISA-CPR, IDPW, File 275.

36. October 8 and November 12, 1917, letters from S. Ethel Clark to Amos W. Butler, ISA-CPR, IDPW, File 275.

37. "Colored Hospital Not Quite up to Mark, But Is Held Worthy," Indianapolis *Star*, September 19, 1918, article in ISA-CPR, IDPW, File 275.

38. Ibid. December 28 and 31, 1918, and February 28, 1919, letters from M. Ellen George to Amos W. Butler, ISA-CPR, IDPW, File 275.

39. February 17, 1921, inspection report by W. H. Long, and March 20, 1922, letter from R. L. Hill to A. W. Butler ISA-CPR, IDPW, File 275. See also Michael M. Davis, "Problems of Health Services for Negroes," *Journal of Negro Education* 6, no. 3 (1937): 438–49; W. Montague Cobb, "Medical Care and the Plight of the Negro," *Crisis* 54, no. 7 (1947): 201–211.

40. Indianapolis *Ledger*, October 24, 1914; Indianapolis *Ledger*, April 25, 1914, newspaper clipping in "Community Organizations" file, IMCPL. *First Annual Report of Lincoln Hospital Association* (Indianapolis: Sentinel Printing Company, 1911), 40 and 44–50, as found in Rawls, *The History of the Black Physician*; Indianapolis *Recorder*, October 1 and December 17, 1904, and August 1, 1914; and Indianapolis *News*, February 9, 1900.

41. Cynthia Neverdon-Morton, *Afro-American Women of the South and the Advancement of the Race, 1895–1925* (Knoxville: University of Tennessee Press, 1989), 28–31, 49–50, 180; Hine, *Black Women in White*, 10, 16–20; Indianapolis *Ledger*, April 25, 1914, newspaper clipping in IMCPL. Indianapolis *Recorder*, September 3, 1910, and June 3, 1911.

42. Charles E. Rosenberg, *The Care of Strangers: The Rise of America's Hospital System* (New York: Basic Books, 1987), 212–36, 238–58; David Rosner, *A Once Charitable Enterprise: Hospitals and Health Care in Brooklyn and New York, 1885–1915* (Princeton, NJ: Princeton University Press, 1982), 62–93; and Vanessa Gamble, *Black Community Hospitals: A Historical Perspective* (New York: Garland Publishing, 1987).

43. Janet Wilson James, "Isabel Hampton and the Professionalization of Nursing in the 1890s," in *The Therapeutic Revolution: Essays in the Social History of American Medicine*, ed. Ellen Condliffe Lagemann (New York: Teachers College, Columbia University, 1979), 201–244; Martha Vicinus, *Independent Women: Work and Community for Single Women, 1850–1920* (Chicago: University of Chicago Press, 1985), 28–29, 85–120.

44. Booker T. Washington, "Training Colored Nurses at Tuskegee," *American Journal of Nursing* 10 (December 1910): 167–71.

45. Indianapolis *Recorder*, July 27, 1912. Indianapolis *Ledger*, December 12, 1914, and January 23, 1915; Darlene Clark Hine, " 'They Shall Mount Up with Wings as Eagles,' Historical Images of Black Nurses, 1890–1950," in *Images of Nurses: Perspectives from History, Art, and Literature*, ed. Anne Hudson Jones (Philadelphia: University of Pennsylvania Press, 1988), 177–96.

46. Indianapolis *Recorder*, April 23, 1904; January 12 and April 27, 1907; and May 2, 1908.

47. Indianapolis *Recorder*, September 10, 1904; July 15 and December 12, 1913; and January 17 and May 2, 1914. Indianapolis *World*, June 17, 1911. Indianapolis *Recorder*, March 16, May 18, and June 1 and 22, 1912; and May 7, 1914.

48. Indianapolis *Recorder*, April 5 and 19, 1902; August 1 and 8, 1903; July 21 and 26, 1906; June 20, 1912; August 2, 1913; and June 20, 1914.

49. Indianapolis *Recorder*, September 10, 1904; July 15, 1913; December 12, 1913; January 17, 1914; and May 2, 1914. Indianapolis *World*, May 22, 1911; June 10, 1911; and June 17, 1911. Indianapolis *Recorder*, January 13, March 2, 16, and 23, April 6, April 13, p. 8, April 13, May 18, and June 1, 8, and 22, 1912; October 4, 1913; January

17 and 24, February 21, March 7 and 21, and April 18, 1914. Indianapolis *World*, June 17, 1911. Indianapolis *Recorder*, March 7, 1914.

50. Indianapolis *Recorder*, September 10, 1904; June 1, 1912; and May 16 and June 20, 1914.

51. Indianapolis *Recorder*, August 6, 1904; January 12, February 23, March 30, July 6, and December 28, 1907; March 28, 1908; February 6 and 20, 1909; and February 26, 1916.

52. Indianapolis *Recorder*, January 12, April 27, and November 16, 1901; March 22, April 17, and October 4, 1902; August 8, 1903; July 21, April 26, and October 20, 1906; July 27, 1907; March 14 and April 30, 1908; and July 18, 1914. Enix, op. cit.

53. For the notion of the worthy poor, see Roy Lubove, *The Professional Altruist: The Emergence of Social Work as a Career* (New York: Athenaeum, 1982). Alexis de Tocqueville observed that America was a land of great abundance and seemingly boundless wealth, and that there was no poverty in America. See Alexis de Tocqueville, *Democracy in America*, ed. J. P. Mayer and Max Lerner (New York: Harper & Row, 1966). Not only foreign visitors saw America in that light. David Potter, in *People of Plenty* (Chicago, University of Chicago Press, 1954), observed that the assumption of abundance and wealth is the single most important factor in the shaping of the American character. That assumption has had several implications in the history of U.S. philanthropic and charitable associations. First, it made poverty among the able-bodied a character fault. Second, it made American reformers argue that there actually *was* poverty. Third, it presumed that poverty was an unnatural and unnecessary ill in a prosperous nation, which could thereby be eliminated or cured. Daniel Levine, *Poverty and Society: The Growth of the American Welfare State in International Comparison* (New Brunswick, NJ: Rutgers University Press, 1988).

54. Elsa Barkley Brown, "Womanist Consciousness: Maggie Lena Walker and the Independent Order of Saint Luke," *Signs* 14 (Spring 1989): 610–33; Evelyn Brooks Higgenbotham, "African-American Women's History and the Metalanguage of Race," *Signs* 17 (Winter 1992): 251–74.

III.
Work

9

"The Indescribable Care Devolving upon a Housewife"

Women's and Men's Perceptions of Pioneer Foodways on the Midwestern Frontier, 1780–1860

SARAH F. McMAHON

SINCE THE LATE 1970s, scholars of the American frontier have documented that, across time and space, women's domestic work was essential both to the trail and to the frontier.[1] Pioneer women demonstrated remarkable perseverence and resourcefulness as they attempted to accomplish their traditional tasks under difficult and trying circumstances. In her comparative study of women on the prairie and the plains, Glenda Riley proposes that women experienced a "female frontier." She argues that "women's lives as settlers displayed fairly consistent patterns, which transcended geographic sections of the frontier. . . . Frontierswomen's responsibilities, life styles, and sensibilities were shaped more by gender considerations than by region."[2]

Did women experience the frontier always and everywhere in the same way? Did variations in the standards of domesticity that women brought with them from different sections of the East or from a recent frontier region, from urban areas or rural neighborhoods, and from different cultural backgrounds affect women's adjustment to new circumstances? Did husbands and wives always negotiate the balance of cooperation and authority in the same way? Although rural women's and men's work clearly intermeshed, rural women in settled communities claimed a domain in their kitchens and workrooms that supported their household authority.[3] On the frontier, women often lost that separate space, since families shared cramped living quarters for various activities. As a consequence, women may have lost, at least temporarily, the physical base of their authority over domestic activities and decisions. Indeed, Glenda Riley describes an "ongoing struggle in

regard to the division of limited resources between the field and the home" on the frontier.[4] The disruption of women's domestic and economic spheres may have shifted the balance of authority over the household in men's favor.

Food preparation provides a particularly good optic for examining women's experience of their work and responsibilities on the frontier. All the histories of pioneer women document the difficulty of accomplishing traditional culinary tasks on the trail and the frontier, and the necessity of women's resourcefulness, creativity, and versatility, due in large part to the inconvenience of open-fire cooking and the lack of familiar utensils and ingredients.[5] These studies present food preparation as one activity among women's various domestic responsibilities. Yet, women and their families understood and evaluated much of women's contribution to the welfare of their families by the foods that women prepared and the meals that they presented. Even among rural households, nineteenth-century culinary standards valued results over effort: families sought a varied, palatable, and aesthetically pleasing diet. In the early years of settlement on the midwestern frontier, many women were unable to meet those standards. In spite of their skills and ingenuity, even familiar tasks in food preparation were difficult to accomplish under frontier conditions, and much of the time pioneer fare was plain and monotonous. Thus, an evaluation of women's work on the frontier required an appreciation of effort as well as result.

This chapter analyzes the descriptions of food preparation and the expectations of diet on the frontier that were recorded in memoirs of early pioneer life in the Midwest. It examines retrospective accounts written by 43 women and 105 men from families of middling status who traveled to the midwestern frontier between 1780 and 1860.[6] The earliest of those memoirs detailed pioneer experiences in the post-Revolutionary frontier in Pennsylvania, Kentucky, and Ohio. Most of the accounts described the experiences on the new frontier as it moved across the Midwest from Michigan, Indiana, and Illinois to Wisconsin, Iowa, Missouri, and Kansas. In their accounts, individuals often described the methods of procuring and producing foods, of food preservation, and of meal preparation during the first year of pioneer life. They also offered their evaluations of meals, of their diet, and of the efforts to produce their daily fare. For many authors, the contrast between pioneer foodways and the daily fare in a settled society exemplified the changes in living conditions that pioneer families experienced.

Retrospective accounts tend to be shaped by selective or reconstructed memory, and by an author's assumptions of what the intended audience expected.[7] Although some degree of distortion was inevitable, a number of midwestern autobiographers expressed concern about the accuracy and representativeness of their experiences. John Allen Welch stated, "I have endeavored to relate facts, without belittling or exaggeration."[8] In spite of the ten-

dency to follow certain prescribed formats in frontier memoirs, the 148 accounts of pioneer life in the early Midwest differ quite significantly in their descriptions of women's culinary efforts. Thus, they provide a means of determining not only why women's responses to their pioneer experiences varied (at least with regard to food preparation), but how women's understanding and evaluation of that experience corresponded to and differed from men's experience and expectations. A comparison of the accounts of individuals who immigrated to the midwestern frontier from the East with those who came from a recent frontier settlement in the early Midwest suggests the influence of regional origin, cultural background, and era on both the pioneer experience and the perceptions of that experience.

By focusing on one aspect of women's contribution to their families' efforts on the midwestern frontier, this chapter suggests why women's contribution was often either ignored or devalued. It argues that the rural variant of domesticity gave women standards by which they measured and valued their culinary efforts. On the midwestern frontier, the disruption of women's domestic environment increased their work and responsibilities and, in their eyes, decreased the quality of the results. If some women soon reestablished their control over their domain, other women had a more difficult time adjusting to the changes in their domestic routines. The frontier affected men's perceptions of women's contributions in a different way. Rural men may have accepted women's authority over food preparation and meal presentation and women's consequent influence over men's decisions concerning agriculture and food production. But on the frontier, men may have come to believe that their authority in farm matters ought to extend to household decisions as well. By ignoring or devaluing women's domestic domain, men could reinforce their own authority. Indeed, from men's perspective, the midwestern frontier might have been one of the last "yeoman" societies.[9]

In their memoirs of pioneer life in the early Midwest, individuals frequently described their daily fare as a means of illustrating the contrast between their customary lifestyles and the conditions on the frontier. Most reminiscences recounted the process of procuring a subsistence that began as soon as the family reached their new home. Daniel Drake described his father's efforts in Kentucky in 1788: "The first and greatest labor after father had thus domiciliated his little family was to clear sufficient land for a crop for the following year, which was, of course, to consist of corn and a few garden vegetables. In this labor I was too young to participate, and he was too poor to hire; consequently his own hands had to perform the whole."[10] While they waited for their first crops, pioneers resorted to various wild

greens, fruits and nuts, and the plentiful supply of meat that hunting and fishing provided: "the vast forests of my adopted state abound[ed] in wild game, deer, bear, wolf, lynx, otter, mink, marten, muskrat, weasle, porcupine, rabbit, blue, red, gray, and fox squirrels, racoon, woodchuck, etc., and with wild turkey, pigeon, partridge, quail, woodchuck, snipe, etc."[11]

Despite women's considerable efforts in food production and preservation, the work of husbands and fathers typified pioneer resourcefulness in many of the memoirs. In men's accounts, references to foodways, and in particular to women's domestic and culinary work, varied remarkably in the amount of detail and the significance of the description in the narrative. Some men did not mention women's domestic work at all; other men detailed women's efforts and the difficulties women faced as they performed their domestic tasks on the frontier.

Men's reminiscences usually focused on men's work. Two-thirds of the accounts written by men who were born before 1800 and who moved to the midwestern frontier before or around the turn of the century included only the briefest descriptions of the frontier fare that their families secured: "Our living was venison and hominy with some mush and milk and some corn cakes ground on a handmill and sifted through a splinter sieve. . . . And if we could manage to raise a little corn and potatoes we felt very thankful for the supply for the winter."[12] In other memoirs, the lack of attention to women's role either in food production or preparation was even more pronounced. Thirteen percent of the men whose memoirs described foods on the midwestern frontier between 1770 and 1860 limited their discussions to the planting of their first crops and to hunting wild game (Table 3). If these men mentioned meal preparation at all, they described it only indirectly; otherwise, they omitted descriptions of domestic food routines and of typical pioneer daily fare.[13]

The rest of the memoirs written by men, and all of the women's accounts, described cooking or meal routines, and often contained an assessment of frontier diet. However, almost one-third of the men's reminiscences described the composition of the food supply, the array of cooking utensils, and various methods of food preparation without specifying women's contributions and responsibilities in pioneer foodways.[14] Elijah Iles described the foodways in his parents' "Buckeye cabin" in Kentucky in the early 1800s as a joint family concern and effort: "We had to make out with very little. . . . Our tableware consisted of pewter plates, pewter dishes and spoons and japanned tin tumblers. . . . Our cooking utensils were a small dinner pot, oven, skillet, and fry-ing pan. Our bread was always cornbread, mostly baked on a board and called johnny-cake, or in the ashes, when it was called ash-cake. Our meat, consisting of bear meat, turkey, venison, squirrel, quail and fish, was often roasted before the fire."[15] George Duffield recounted the

Table 3 Descriptions of Women's Cooking and Domestic Routines on the Frontier, by Gender and Region of Family Origin

	Men			Women		
	All	Northeast Origins*	Eastern Origins**	All	Northeast Origins	Eastern Origins
Number of memoirs	105	45/96 46.9%	59/96 61.5%	43	23/40 57.5%	24/40 60.0%
Do not describe cooking/domestic routines	13.3%	30.8%***	46.2%	0	0	0
Describe routines but do not specify as women's work	29.5%	43.3%	70.0%	2.3%	0	0
Subtotal	42.9%			2.3%		
Describe routines as women's work	41.9%	52.6%	55.3%	53.5%	33.3%	38.1%
Describe routines; note difficulty of accomplishing them on frontier	15.2%	53.3%	73.3%	44.2%	83.3%	83.3%
Subtotal	57.1%			97.7%		

*The Northeast includes New England, eastern New York and Pennsylvania, and New Jersey.
**The East includes those individuals from the Northeast plus 6 men and 2 women who immigrated to the Midwest from England (4), Europe (2), and Canada (2).
***The percentage of those individuals, who did not describe cooking or domestic routines, who originally came from the Northeast.

morning routine in an "Iowa settler's homestead" in the 1830s; his mother's presence is at best implied: "The eldest child and daughter helped prepare breakfast while boys cleared off the floor so that the table could be set. . . . The baking corn bread, the frying pork or venison, and the coffee (for father and mother only) boiling on the fire, filled the room with appetizing odors." That he viewed cooking and domestic work as women's tasks becomes clear later in his account when he notes that "The duties of a settler on his claim and of his wife about the cabin were simple though severe."[16]

The most detailed descriptions of food preparation occurred when men recounted situations on the new frontier where women were absent and men were fully responsible for cooking. In his account of an expedition to Illinois

in 1818, Gurdon Saltonstall Hubbard delineated his cooking utensils, table settings, methods of roasting game, and the culinary advantages of more elaborate utensils and ingredients. He concluded his account with: "Let me give one or two recipes."[17] Those men described their cooking efforts while keeping "bachelor's hall" with a mixture of pride in male resourcefulness and a hint of disregard for feminine standards. Elijah Iles recounted his living while in camp: "My living while in camp was very simple. My bread consisted of johnny-cake, which I baked on a board, or of ash-cake, which was baked in the ashes. I liked my meats stewed, and would often stew together in the one little pot I had, a mixture of turkey, bear, venison, squirrel, and a piece of fat bacon. I never used plates, as they would need washing, but in lieu would use a large chip or piece of bark, and would change it every meal for a new one."[18]

The disregard for the domestic routines of pioneer women contrasts noticeably with men's detailed descriptions of their own efforts in hunting and farming. Perhaps the assumption that women's work on the frontier did not differ significantly from women's customary responsibilities accounts for the lack of attention to food and meal preparation in almost half of the accounts written by men. In particular, men who came to the pioneer Midwest from a recent frontier region were less likely to address women's domestic concerns. Their previous pioneer experiences, and hence their familiarity with frontier cooking conditions, may have led them to see little disjunction between settled and frontier domestic circumstances (Table 3). In addition, men who came to the midwestern frontier as adults tended to focus on their own difficult tasks of providing a subsistence for their families.

Still, over half of the men's accounts both recounted the domestic and culinary efforts of pioneer mothers, sisters, wives, and daughters and credited women with that work. The detailed accounts suggest that, in retrospect, the requirements of women's domestic work impressed them almost as much as men's agricultural work. In addition, these authors believed that foodways well illustrated frontier living conditions "in those primitive times."[19] Almost half of the boyhood reminiscences offered considerable descriptions of their pioneer mothers' efforts in food preparation. Those accounts described the inconvenience of cooking over an open fire, the sparse selection of utensils ("Mother's cooking vessels were a pot, an oven, a skillet, an iron tea kettle and a johnny cake board"), and in particular the variety of cornmeal preparations: "As a matter of course, nearly all bread was made of corn meal . . . but was not all of one kind. First, there was what was called the 'dodger;' secondly, the 'pone,' and, thirdly, the 'johnny cake.' "[20]

As children on the midwestern frontier, some of the men had become well acquainted with their mother's kitchen routine. In their romanticized renditions, which indicated little of the difficulty of accomplishing that

work, pioneer sons presented women's culinary efforts as an example of women's nurturing role. Daniel Drake was assigned specific tasks in his mother's kitchen: he provided the "sauce" for dinner, supplied the iron mush pot with water ("Mother, or Lizzy (when old enough) generally stirred in the meal, but 'Dannel' often stirred the mush"), and "although I never made the dough, I was quite *au fait* in lifting 'wonders' out of the boiling fat."[21] Other men recorded with extremely fond memory their mothers' open-hearth cooking. In his description of his family's rough log hut in Ohio in the 1830s, Silas Packard noted, "There were no stoves in those days, either for heating or cooking; and they would have been quite out of place. What had cooking stoves to do with the toothsome Johnny cake or 'pone,' which, after having been affectionately patted with the mother's hand, was laid in the skillet to bake: How could a cooking stove improve upon the light and flaky biscuits . . . or the luscious pies that got baked, somehow, as no pies are baked these days?"[22]

Some men focused their descriptions on the contrast between pioneer cooking methods and the kitchen routines in settled households. They recognized that preparing meals in those rustic conditions was time-consuming; in addition to their domestic work, women were responsible for myriad other tasks. Marion Drury proclaimed, "What cooks our pioneer mothers were! . . . and besides their household duties performed with skill and efficiency, they usually planted and then weeded the vegetable and flower gardens, [and] looked after the poultry."[23] These men included those descriptions in their accounts to illustrate the primitive conditions of those early days. George Griffith explained that, in Kansas in the 1850s, "Cooking for a considerable family at an open fireplace was an art pioneer women acquired, but it has been practically lost by the passing of the conditions of living that rendered it necessary."[24] William Nowlin recalled the improvements that accompanied the purchase of his mother's tin baker in Michigan in the 1830s, "which she placed before the fire to bake her bread, cake etc." He explained that "This helped her very much in getting along."[25]

Although most men either romanticized or ignored women's domestic responsibilities, 15 percent of the memoirs written by men portrayed the difficulties that mothers and wives faced as they tried to accomplish their familiar tasks in their new homes. Those men who came to the Midwest from the Northeast recognized the sharp contrast between frontier and settled living conditions, and were more sensitive to the often difficult transition that confronted women on the frontier (Table 3). When he brought his family to Iowa in 1842, Charles Brown explained, "My blues went with the fog; hope, courage and cheer came with the sunshine and clear sky. But how would my dear wife feel, for I knew, and she knew, that the privation and hardship of a new country would fall most heavily on the wife and mother

in the little log cabin home."[26] Writing to his grandchildren, Thomas Banning described the working conditions in Kansas in 1855: "I have often wondered how my mother stood it with such a family of children, and no one to help her but my oldest sister Elizabeth, about fourteen."[27] Noah Major recognized that, although men's work lightened as the country became more settled, women's work did not necessarily become easier: "But in those days the mills rapidly multiplied; the roads grew better 'by neglect,' the grains, both corn and wheat, were better matured, . . . so the task of keeping 'bread for the eater and seed for the sower' grew lighter as each succeeding year rolled by. This was good for our fathers, but our mothers must still mix the dough and bake the hoecakes and dodgers as of yore. 'Man's work is from sun to sun, but woman's work is never done.' "[28] Major's description supports Riley's argument that labor-saving tools were slow to appear in the home; in the struggle over limited resources, first priority was given to men's agricultural concerns.[29]

In retrospect, some men recognized both the value of women's work to the pioneer venture and the difficulty of accomplishing that work under frontier conditions.[30] But most of the men whose accounts described women's trials, hardship, and discomfort presented those as an experience that women shared with men. Stephen Beggs credited his wife with helping him in their early Indiana days: "It is a saying that 'to every man there is one good woman.' My wife has proved so to me. . . . I thank God for the helpmeet he gave me."[31] Other men felt obliged to show that women worked as hard as men. Julius Lemcke explained, "The hardest of hard work was unremitting, not for the men alone, but for their wives as well."[32] Few of the accounts written by men described cooking and meal preparation as difficult tasks in and of themselves. They were more impressed by the accumulation of women's responsibilities than by the burden of the particular tasks. When he described his mother's contribution to the family's pioneer efforts, Thomas Banning offered both a tribute to her and a warning to his granddaughters in 1926: "She was a woman of calm, serene, and patient mind. I marvel more and more as I think of her happy, peaceful, cheerful disposition. She never complained, she never got discouraged, she never lost faith and hope. She believed that time and patience and industry would bring the rewards of effort. She had none of the feverish, restless, rebellious disposition against things as nature made them, that characterize so many women now."[33]

The tendency to view women's culinary efforts simply as part of the pioneer venture extended to men's reminiscent descriptions of the daily fare that women produced. The men whose mothers managed to prepare a succession of cornmeal concoctions found that, most of the time, they could be satisfied with the limited variety of their diet. Silas Packard compared

Thanksgiving dinner to his family's customary frontier fare: "There was one day in the year when perfection was reached in the culinary art, and that was Thanksgiving Day—for we took with us to the West this relic of our New England life. During the rest of the year we were content to jog along under the sustaining qualities of 'rye-and-indian' bread and Johnny cake, with an occasional lift from hot biscuits and buckwheat cakes, the meat end of our meals being usually taken from some part of the ubiquitous hog; but Thanksgiving Day lifted us far above this plebian fare."[34] Although Packard's mother produced that memorable meal, his description focused on the foods that were spread on the table. Other men specifically noted their mother's determined efforts to bring—and preserve—familiar eastern customs and foods with them. Edwin Coe recalled that "When [Mother] came West [to Wisconsin] she had brought yeast cakes which, by careful renewal, she kept in succession until the family home was broken up in 1880."[35]

If most men didn't enthusiastically praise the "toothsome Johnny cake," still they accepted their simple fare as one of the consequences of pioneer life. Indeed, in their memoirs, descriptions of diet were provided to show how well families adapted to frontier conditions. Marion Drury recalled that, "If I ever remonstrated against having mush so often, I was as often reminded that it was good to make strong bodies, which were necessary to physical endurance and usefulness, and so I continued to eat corn mush without complaint. . . . I quite agree with the judgment of my parents, though our plain living was then a pioneer necessity."[36]

For these men—and, they assumed, for their families—the primary concern was enough food; their "plain," "simple," "frugal" meals provided that.[37] The complaints that were registered about boyhood pioneer experiences focused on the scarcity of resources rather than on the difficulty of their mothers' culinary responsibilities. Food provision rather than food preparation was the primary concern in men's assessment of pioneer fare. As S. W. Widney explained of Illinois in 1837, "Living thus distant from mill and market, and that market so high, it may be readily imagined that the settlers would *all* sometimes be reduced to straits in the provision line. . . . Such was actually the case. . . . It was reported that one family, now in comfortable circumstances, had to live several weeks on vegetables, gathered from the woods, and cooked as *greens*. . . . you will not wonder that some were discouraged, and wished themselves back again at their comfortable Eastern homes."[38]

Boyhood reminiscences of the early Midwest often presented their descriptions of their mother's attempts to vary their fare with both admiration and a sense of humor. By contrast, pioneer men could be more sharply critical in their humorous accounts of pioneer fare, suggesting that women's higher dietary and culinary standards were inappropriate and unnecessary

on the frontier, and therefore likely only to disappoint.[39] John Nowland's anecdote about a tavern landlady's fare placed its sympathy more with her boarders than with her efforts to please:

> [A red-hot, full-blooded Kentuckian] said he thought that his landlady gave her boarders the greatest variety of any tavern in the town. He said they had three kinds of meat, ram, sheep, and mutton; three kinds of vegetables, boiled potatoes with the skins on, boiled potatoes with the skins off, and fried potatoes; two kinds of bread, corn bread baked in a skillet, and corn bread baked on a griddle; two kinds of milk, buttermilk and sour milk; he said they had one kind of fruit pie and that was pumpkin pie.[40]

William Whirry's account of early fare in Wisconsin suggested that the best strategy for getting by was to lower expectations: "Buckwheat and cornmeal was extensively used . . . and when they *had* flour they frequently had nothing to mix with it but water, and no meat, potatoes, butter or milk, to eat with it, and, after it was baked, it was as hard as stone; but it had one redeeming quality, it would keep well, so that the getting-up of a meal was a simple operation after the bread was baked. The cook was not puzzled to know whether the meal would suit the taste of all or not. . . . Hard tack was all that they expected and hard tack they got, and they were satisfied, and believed that man's natural wants were but very few indeed."[41]

For the most part, men's reminiscent accounts of pioneer fare stressed its simplicity—and they presented this first and foremost as a result of the frontier conditions in the Midwest. They managed to accept their plain and often monotonous fare by lowering their expectations; although preferences for variety remained, pioneer men had been content to wait until the country was more settled, and until *their* efforts could provide the resources for satisfying those preferences.

Although more than half of the men's memoirs described women's domestic routines, men tended not to accord the same value to women's that they gave to their own agricultural work. Most pioneer men perceived women's work as peripheral to the masculine adventure of establishing new farmsteads and procuring foods from the wild. Their lowered expectations may have enabled some of them to disregard the efforts that women made to produce even that limited fare. By separating women's work from the more significant work that men did, they could overlook—at least in retrospect—women's contribution to the settling of the frontier.

In their memoirs of pioneer life in the early Midwest, women's accounts of their domestic and culinary roles and responsibilities on the frontier differed from men's descriptions in noticeable ways.[42] Over half of the memoirs written by women emphasized women's willing contribution to their families' pioneer effort (Table 3). Although they detailed the "hardships and

privations" of early pioneer life, generally they presented those trials as a shared family experience.[43] In many ways, their renditions resembled the descriptions of women's roles in the family enterprise that emerged in boyhood reminiscences. Girlhood reminiscences, particularly about families who came to the Midwest from a recently settled frontier region, recounted with admiration their mothers' culinary efforts, presenting these as part of women's nurturing role. However, in retrospect, women were more likely than men to present women's work as integral to the pioneer venture rather than as secondary to men's work.

Women's task, as they later described it, was to find ways of adjusting to the new circumstances—and most of the time they did. Kitturah Belknap, traveling to Iowa with her new husband in 1839, explained that "We camped out every night, took our flour and meat with us and were at home."[44] When Margaret M'Coy arrived with her husband in Wisconsin in 1848, she found that "The great problem of housekeeping was now to be solved, and being a novice in that line, I had to gather information from every one within reach." Yet she illustrates that "problem" with an amusing anecdote about learning to wash linens under those conditions.[45] Melissa Anderson described her husband's effort to help her when they moved to their new home on his claim: "He had furnished it for me the best he could. Somewhere he had found a little cook stove called a step stove. . . . [with] an oven, which would hold only one pie. But it was a stove, and there were few of them in Kansas at that time."[46]

Those women who presented the best side of the venture and emphasized the importance of women's contribution tended also to approve of the results of women's culinary efforts. As Ellen Badger explained, "We had enough to eat, such as the country afforded."[47] Another woman suggested that women in early Indiana had sufficient reason even to be proud of their limited fare: "We were not what would now be called fashionable cooks; we had no pound cakes, preserves, or jellies; but the substantials, prepared in plain, honest, old-fashioned style. This is one reason why we were so blessed with health—we had none of your dainties, nick-nacks, and many fixings that are worse than nothing."[48] In a manner resembling men's acceptance of the simplicity of pioneer fare, these women tried to set realistic standards for their culinary efforts. At the same time, however, they also upheld the value that they placed on women's efforts, just as pioneer men had done with their own. In their accounts, they presented women's domestic work as admirable and significant, rather than simply a continuation of their customary routines. Consequently, they offered more detailed descriptions of women's work than men did, and they attributed the simple pioneer fare both to the condition of the domestic spaces in which women worked and to the resources that men provided.

Some women who willingly participated in the pioneer venture noted that other women had a more difficult time adjusting to frontier conditions. Sarah Cummins was surprised that there were "so many lone women out away from their own kith and kin" in Illinois in the 1830s. She also remembered that, when buffalo chips were substituted for wood on the Oregon Trail, "this caused many ladies to act very cross and many were the rude phrases uttered."[49] Mrs. Talbot Dousman recalled her sister's question to their father when they began their journey to Wisconsin: "Father! have *we* got to live in *such* a house? I . . . laughingly asked if she expected to dwell in 'marble halls' in the wilderness. She knew very little of log houses, though she 'came to' afterward."[50]

Almost half of the women recounted either their own or their mother's responsibilities, efforts, and expectations on the frontier with some degree of dismay and disappointment. Although those wives and mothers dutifully contributed to their family's efforts to relocate and succeed on the midwestern frontier, they were not eager participants in the pioneer venture. Mrs. John Weaver described her reticence about leaving New York for Wisconsin in 1836: "[My husband] often had a touch of the Western fever (as the phrase was in those days); but it did not meet my mind, exactly, to leave the old place, with all of the comforts and conveniences and high privileges that we enjoyed, neither could I make up my mind to leave my parents, brothers and sisters, and many other relatives and friends."[51] Susan Short May offered a sympathetic description of her mother's situation: "The motive which brought my father to Illinois was probably the spirit of adventure. . . . It took some time and cost many tears before mother could become adjusted to conditions in the 'black walnut house,' as father had described it to her."[52] The difficulties of pioneering were especially trying for women who came to the midwestern frontier from the Northeast and who arrived with full responsibilities as wives and mothers. Of the women who described the difficulties and burden of managing their traditional work on the frontier, 65 percent were born in the Northeast. Only 30 percent of the women who simply detailed women's domestic work were originally from the Northeast (Table 3). Similarly, women who felt that they endured the early years of their pioneer experience were far more likely to have come to the frontier as adults (and hence as women responsible for that work) than as children. Because the women who came as children from an earlier midwestern settlement tended to be born after 1820, the accounts of the earliest women's experiences tended to stress the trials that women endured.

In her study of the trans-Mississippi frontier, Julie Roy Jeffrey proposed that "women's response to difficult living conditions often seemed related to their early attitude to emigration."[53] Eliza Farnham recognized and understood this, explaining in the 1847 preface to her memoir of life on the

Illinois prairie: "It must not be forgotten, however, that a large class of minds have no adaptation to the conditions of life in the West. This is more especially true of my own sex. . . . They cannot endure the sudden and complete transition which is forced upon them by emigration to the West."[54] For some women, even subsequent removals brought the same response. When Almira Volk's husband decided to leave Chicago for Wisconsin in 1837, she recalled,

> The news that I must move again was sorrow to me, for I loved my home and was contented to remain there. When John told me of the lonely place we were going to, not a woman in less than twenty miles, no school or church, my heart sank within me, and I earnestly entreated him to give up this wild scheme and remain where we were. But it was in vain. It seemed as if he had some of the Boone spirit and wanted to get off by himself so as to have a better chance to breathe.[55]

In spite of their reactions to the process of removal, those pioneer housewives valued women's contribution to the frontier effort. Some of the women who attempted to manage under those conditions stressed the burden of that responsibility. Christina Tillson explained, "The indescribable care devolving upon a housewife in that new and rough country and the ways and means to which one must resort in order to keep up a comfortable establishment absorbed not only the physical strength of a Yankee housewife, but all the faculties of the mind had to be brought into requisition."[56] Unlike sons who tended to romanticize their mothers' accomplishments, a number of daughters recognized the remarkable efforts required of their mothers as they carried out their domestic routines. Mary Beebe Hall recalled of her mother's experience in Ohio in the 1820s, "During all the early years she endured the trials and privations of pioneer life in the even tenor of her ways, quiet and indominable, she followed out her course of life."[57] Clarissa Hobb's mother, although willing, could not manage her reponsibilities in early Illinois: "She had worn out her life in the hardships of frontier life for her loved ones, and laid down to rest at thirty-two, leaving six little ones in the little log house. . . . She was too frail for such a life."[58]

The most poignant accounts of women's pioneer experience were written by wives and mothers whose standards for evaluating their responsibilities and concerns contrasted with those of their husbands and children. They understood that much of the "proverbial" generosity and helpful spirit attributed to the pioneers was created by the food and meals that women supplied not only to their families but also to neighbors and travelers.[59] They also understood the difficulty of maintaining that generosity. In contrast to men's caustic descriptions of tavern fare, Christina Tillson remarked that, "When preparing breakfast I never knew whether it was for my own family, or several more." When her family stopped at a farmhouse on their journey

to Illinois, she watched the "good wife" prepare a meal for Tillson's hungry family, and envisioned "the havoc made on her stores of honey, bacon, and corn dodger."[60] Although Susan May's father decided to run a tavern in Illinois, the responsibility for cooking fell to her mother: "The business of keeping tavern was very hard on mother, with her increasing family, but she worked bravely, and everyone of us had to help her in some way."[61] Although women continued to be responsible for cooking, they lost some of their previous control over both the circumstances for food preparation and the company that their efforts and meals served.

[handwritten margin note: extent of previous control?]

Most of these women sought ways of coping with their new situations, despite their initial and often persistent reactions.[62] Caroline Kirkland asserted that, in Michigan in the 1830s, "It would be in vain to pretend that this state of society can ever be agreeable to those who have been accustomed to the more rational arrangements of the older world. The social character of the meals, in particular, is quite destroyed, by the constant presence of strangers, whose manners, habits of thinking, and social connexions are quite different from your own, and often exceedingly repugnant to your taste." Yet she knew that she had to adjust her expectations: "My ideas of comfort were by this time narrowed down to a well-swept room with a bed in one corner, and cooking apparatus in another. . . . By the exertion of a little patience and ingenuity, [I] discover[ed] ways and means of getting aside of what is most unpleasant."[63] Women recognized that their efforts were hindered by the primitive conditions of their domestic work space and by the loss of kitchen accoutrements and possessions that would have eased their work. When families made the journey to the frontier, women's cookstoves, cookery utensils, and dining ware often were left behind.[64] And women knew that their household goods would be replaced only after the farm was outfitted for agricultural production.

[handwritten margin note: sure!]

In addition to their depictions of the trying conditions under which they attempted to perform their tasks, many women described their disappointment with the results of their efforts. Mary Bryam Wright described the daily fare in her Illinois household in 1831:

> Our bill of fare that winter was corn bread and venison, with some sugar and coffee that we had brought with us. The flour we had brought had been used before we moved into the new house. As for butter, milk, or vegetables, we had none, and fruit was not seen in the place for years after we came. There were times in those days when, the flour being gone and the ox mill not running, and it not being convenient to send the corn away, people had to subsist upon lye hominy; and that is a thing at which a person may eat continually and never have their hunger satisfied.

She recalled missionary sermons that praised the "poetry of self-sacrifice," but, she explained, "come to try the reality, and the goodness settled down

into endurance, while the poetry vanished away, leaving nothing but the saddest of prose."[65] Rebecca Burlend described her first exposure to Indian cornmeal: "Its taste is not pleasant to persons unaccustomed to it; but as it is wholesome food, it is much used for making bread. We now had some meal, but no yeast nor an oven; we were therefore obliged to make sad paste, and bake it in our frying pan on some hot ashes."[66] Rural women as well as urban women measured their efforts by domestic and culinary standards that they could no longer meet. Although their families may have been content to lower their expectations, these women continued to uphold their previous standards.

Some women also measured the results of their culinary efforts against their familiar standards of diet and health. Sarah Brewer Bonebright described with mock amazement the ability of pioneers to survive their customary frontier fare:

> Our powers of resistance and recuperation certainly were phenomenal. When we consider the concentrated daily diet of corn dodger with a dressing so greasy that the children of today would reject it before tasting, when we reflect that this starchy dodger often was immersed in a plateful of maple syrup or cane molasses, . . . when we contemplate these flirtations with the demon of indigestion, it is quite wonderful that children lived to maturity, or that elderly people grew aged.[67]

Other women experienced the contrast between their customary diet and frontier fare quite profoundly. Tillson objected both to the meager contents of her family's larder and to the fare that resulted: "We had no market and must live as did our neighbors on cornbread and 'flitch.' 'Flitch' was the fat portion of the hog, which would be laid on the floor in one corner of their smokehouse, and salt sprinkled over it; it was a filthy process, and when cooked [fried] was a disgusting food." As she recalled, "in order to have more comfortable fare for ourselves . . . I had to recourse to all the poor wits I possessed." In case her readers felt that her complaints were exaggerated, she appealed to what she felt ought to be minimum standards: "You may feel that I have attached undue notice to the meals given and the calls on our hospitality, but could you know the labor of bringing from raw materials anything at all presentable for family use, you would understand why the impression was so lasting."[68] Perhaps the inability to meet those high standards compounded the sense of frustration and hardship. For those women who did not believe that they should have to lower their standards, the "insufferable" results of their hard efforts were an added burden.[69]

In their reminiscences, women presented their domestic responsibilities and efforts as offering an important contribution to their families' pioneer experience. Men usually described women's work as separate from men's work and therefore of secondary importance in a primarily masculine ven-

ture. Women portrayed their domestic roles as separate from yet independent of men's work, and therefore as a critical component of the family venture. The successful completion of their work required more than simply the resources that men provided; women needed to create an adequate domestic space, furnished with the necessary cooking utensils and accoutrements.

Some women found their conviction of the importance of their work and their efforts shaken by the conditions under which they managed, especially when those conditions were given little consideration and when their domestic standards were deemed inappropriate and unnecessary by the members of their families. On the frontier, they had to negotiate for a more varied food supply and for the resources to improve their working conditions and to create a homelike ambiance at the family meals that they served. Yet, in the early years, their domestic concerns were addressed only after their husbands' agricultural needs were satisfied. Women may well have perceived the contrast with their previous household authority as a decline in their control over their domestic situation. Their goal, through their persistent efforts and their attempts to set realistic standards, was to regain their domestic space and their household authority.

Reminiscent descriptions and evaluations of midwestern women's domestic responsibilities and culinary efforts varied remarkably, shaped by the age of the participant at the time of the experience, by gender, and by the perspective gained from a previous frontier experience. The accounts offer evidence of a "childhood frontier" that, to some extent, transcended both era and gender. Many of the childhood reminiscences suggest that, in spite of the difficulty that some pioneer women experienced, children savored the simple fare that their mothers prepared. Boyhood reminiscences tended to romanticize mothers' accomplishments; girlhood reminiscences more clearly described mothers' remarkable efforts. Yet, in retrospect, both women and men perceived their mothers' culinary efforts as part of women's broader nurturing role. Although some pioneer women did not feel that they succeeded in upholding their domestic and culinary standards, in their childhood reminiscences, both women and men suggested that their mothers managed well and controlled a domestic sphere of sorts.

The major contrast in the recognition of pioneer women's efforts occurs in the accounts written by men and women who came to the frontier as adults. Even when families approached the pioneer venture as a joint enterprise, men's responsibility for settling their families and creating a successful farm operation may have encouraged them to take control of the decisions of the farm and household. They perceived women's tasks and responsibilities as secondary to their own and intended primarily to support men's pio-

neer enterprise rather than to reaffirm women's domestic space and concerns. This assessment reinforced a balance of authority that was reminiscent of a traditional patriarchal corporate family economy. Since men's work shaped women's work, men could claim both more importance for their tasks and primary responsibility for the success of the frontier venture, even though women's remarkable resourcefulness in working with the often meager supplies that men provided shaped the quality of their domestic situation.

see 196

For many of the men, frontier diet was the result of the foods they produced and the game they procured. What was most remarkable to them about their early pioneer fare was its quantity—and its initial novelty—rather than its variety or preparation. They accepted frontier fare as simply a consequence of the primitive conditions. And particularly as the frontier moved westward, and the participants increasingly came from earlier frontier regions, women's work seemed both more familiar and less notable. Since many of the myths of the westward movement come from the trans Mississippi West rather than the early Midwest, that familiarity might help to explain the absence of women in the traditional record of frontier experience.

MYTH

Women recalled their responsibilities and experiences on the midwestern frontier quite differently. They knew that their working conditions were altered considerably by the frontier, regardless of how familiar that transitional experience had become. Women whose families had previous pioneering experiences found much to value in their own contribution to their families' efforts. But newcomers to the frontier still measured their work by its results. They experienced a difficult contrast between their familiar domestic circumstances and their new conditions for creating both a healthful and a varied daily fare for their families. Although Riley argues that the "female frontier" transcended location, at least in terms of the fabric of women's work, the evidence from memoirs suggests that previous experience shaped the expectations and standards that men and women brought to the frontier. Riley's model for the prairie frontier was based on women who came to Iowa primarily from the settled areas of the Midwest. For those women, pioneer experiences were generally part of their parents' if not their own experience. By contrast, women who moved to the Midwest from the Northeast experienced a greater contrast to their familiar circumstances and domestic standards and were less assured that they could reestablish that lifestyle in their new homes.

contradict
Riley

Even rural women had come to expect a certain amount of authority and control over their domestic environment. Their families had come to value the results of women's culinary efforts, in part as a consequence of women's success. But among themselves, women knew what it took to achieve those results. Thus, women's domestic values and standards offered a compensation for their efforts. Their domestic domain had given them a

space where they could exercise their own authority and determine their own efforts and results. Since much of the work space in their frontier homes was shared by their families, pioneer women temporarily lost the separate space that supported the domestic standards that they valued.

In two ways, this change of circumstance might account for some women's perceptions of their frontier experiences as difficult and burdensome. First, their high standards and expectations, which could not be met under frontier conditions, had always offered a compensation for their domestic efforts and were crucial to their sense of control over their household. Second, to become simply a support for their husbands' farming enterprise—for it rarely was a true joint venture—required that they relinquish some of their previous domestic authority. The contrasts and the conflicts in gender perceptions of women's domestic work on the frontier grew, at least in part, out of an uneasy balance between the necessity of cooperation and interdependence on the one hand and women's efforts to create their own sphere of authority on the other.

Notes

An early version of this chapter, "Meals, Mores, and the Transmission of Customs to the Early Midwest," was presented to the Social Science History Association (1984), and revised for the Berkshire Conference of Women Historians (1987) and the Conference on Women and the Transition to Capitalism in Rural America, Northern Illinois University (March 1989). Much of the research was made possible by a Post–Summer Institute Fellowship at the Family and Community History Center for work-in-residence at the Newberry Library in 1977 and a Research Travel Grant from Bowdoin College in 1985. The author is particularly indebted to Jardine Forsyth, Bob Gross, Kris Jones, Allan Kulikoff, Sally McMurray, Grey Osterud, Jan Reiff, Kidder Smith, Laurel Ulrich, and Kathleen Underwood for their close readings and comments at the various stages of this project, and to Betty W. McMahon for her assistance on our travels to midwestern libraries and historical societies.

1. See John Mack Faragher, *Women and Men on the Overland Trail* (New Haven, CT: Yale University Press, 1979); Julie Roy Jeffrey, *Frontier Women: The Trans-Mississippi West, 1840–1880* (New York: Hill and Wang, 1979); Glenda Riley, *Frontierswomen: The Iowa Experience* (Ames: Iowa State University Press, 1981); Joanna L. Stratton, *Pioneer Women: Voices from the Kansas Frontier* (New York: Simon and Schuster, 1981); Sandra L. Myres, *Westering Women and the Frontier Experience, 1800–1915* (Albuquerque: University of New Mexico Press, 1982); Lillian Schlissel, *Women's Diaries of the Westward Journey* (New York: Schocken Books, 1982); Carol

Fairbanks, "A Usable Past: Pioneer Women on the American Prairies," in Fairbanks and Sara Brooks Sundberg, *Farm Women on the Prairie Frontier* (Metuchen, NJ: Scarecrow Press, 1983).

Those initial studies inspired a critical review literature: Joan M. Jensen and Darlis A. Miller, "The Gentle Tamers Revisited: New Approaches to the History of Women in the American West," *Pacific Historical Review* 49 (1980): 173–213; Paula Petrik, "The Gentle Tamers in Transition: Women in the Trans-Mississippi West," *Feminist Studies* 11 (1985): 690; Julie Roy Jeffrey, "Women on the Trans-Mississippi Frontier: A Review Essay," *New Mexico Historical Review* 57 (1982): 395–400; Judith Fryer, "The Anti-Mythical Journey: Western Women's Diaries and Letters," *The Old Northwest* 9 (1983): 77–90.

2. Glenda Riley, *The Female Frontier: A Comparative View of Women on the Prairie and the Plains* (Lawrence: University Press of Kansas, 1988), 2, 199, 201.

3. Linda K. Kerber, "Separate Spheres, Female Worlds, Woman's Place: The Rhetoric of Women's History," *Journal of American History* 75 (1988): 31; Nancy Grey Osterud, *Bonds of Community: The Lives of Farm Women in Nineteenth-Century New York* (Ithaca, NY: Cornell University Press, 1991), 147.

4. Riley, *The Female Frontier*, 201. See also Allan Kulikoff, "The Transition to Capitalism in Rural America," *William and Mary Quarterly* (1989): 137; Carolyn Merchant, "Gender and Environmental History," *Journal of American History*, 76 (1990): 1118.

5. See Faragher, *Women and Men*, 52–53, 76–8; Jeffrey, *Frontier Women*, 54; Riley, *Frontierswomen*, 24–25, 58–64; Riley, *The Female Frontier*, 57–58, 89; Stratton, *Pioneer Women*, 62–65; Myres, *Westering Women*, 106, 123–24, 146–49; Schlissel, *Women's Diaries*, 36, 80–81.

6. A total of 280 midwestern pioneer memoirs were examined for this study. Thirty-three memoirs written by women and 99 men's accounts either did not include discussions of food or foodways, or mentioned those topics so briefly that the accounts were not included.

7. Myres, *Westering Women*, xviii; Fryer, "The Anti-Mythical Journey," 81.

8. Welch (b. 1834, family moved to Iowa, 1843), *Personal Memoirs of John Allen Welch in Narrative Form* (Hutchinson, KS: Wholesaler Printing Co., 1920), preface. See also George Griffith (b. 1833, Indiana, moved to Kansas, 1853), *My 96 Years in the Great West: Indiana, Kansas and California* (Los Angeles, 1929), preface.

9. Kulikoff, "The Transition to Capitalism," 141–44.

10. Daniel Drake (b. 1785, family moved to Kentucky, 1788), *Pioneer Life in Kentucky* (Cincinnati, OH: Robert Clarke, 1870), 21. See also the Rev. Stephen R. Beggs (b. 1801, family moved to Indiana, 1807), *Pages from the Early History of the West and Northwest* (Cincinnati, OH: Methodist Book Concern, 1868), 10–11.

11. Edwin W. Finch (b. 1831, family moved to Michigan, 1836), *The Frontier, Army, and Professional Life of Edwin W. Finch, M.D.* (New Rochelle, NY: 1909), 19. See also J. E. Godbey (b. 1839, Kentucky, family moved to Missouri, 1852), *Lights and Shadows of Seventy Years* (St. Louis, MO: Nixon-Jones Printing Co., 1913), 20.

12. Jacob Parkhurst (b. 1772, family moved to western Pennsylvania, 1773), *Sketches of Jacob Parkhurst* (Knightstown: Eastern Indiana Publishing Co., 1963), 4. See also Jacob Young (b. 1776, family moved to Kentucky, 1791), *Autobiography of a Pioneer; or, the Nativity, Experience, Travels, and Ministerial Labors of Rev. Jacob Young*

(Cincinnati, OH: Cranston and Curts, 1857), 34–35; James Finley (b. 1781, family moved to Kentucky, 1788), *Autobiography of Rev. James B. Finley; or, Pioneer Life in the West* (Cincinnati, OH: R. P. Thompson, 1853), 34–35.

13. See Nathaniel Bolton (b. c. 1795, moved to Indiana, c. 1810s), "A Lecture on the Early History of Indianapolis and Central Indiana," *Indiana Historical Society Publications* 1 (1897): 165; William Cochran (b. c. 1840, Ohio, family moved to Illinois, 1849), *Reminiscences of a Forty-Niner: Being a Brief History of Lovington and Vicinity when It Was Yet in Its Swaddling Clothes* (Lovington, IL: Reporter Printing Co., 1908), 9.

14. See D. C. Mott (b. 1858, family moved to Iowa, 1872), *Fifty Years in Iowa* (Marengo, IA, 1922), 12–13; A. H. McCrary (b. c. 1810, moved to Iowa, 1836), "Pioneer Address 1875 and 1877 Delivered before the Annual Reunions of the Pioneer Association of Van Buren County, Iowa" (Keosauqua, IA, n.d.), 3; Abel Mills (b. 1829, family moved to Illinois, 1839), "Autobiography of Abel Mills," *Journal of the Illinois State Historical Society* 19 (1926): 109; David Hoover (b. 1781, moved to Indiana, 1807), *Memoir of David Hoover, A Pioneer of Indiana* (Richmond, IN: James Elder, 1857), 13; Beggs, *Pages from the Early History*, 92.

15. Elijah Iles (b. 1796, Kentucky), *Sketches of Early Life and Times in Kentucky, Missouri and Illinois* (Springfield, IL: Springfield Publishing Co., 1883), 7.

16. George Duffield (b. 1823, family moved to Iowa, 1837), *Memories of Frontier Iowa* (Des Moines, IA: Bishard Brothers, 1906), 9, 13. See also Harrison Burns (b. 1836, Indiana), *Personal Recollections of Harrison Burns as Written in 1907* (Indianapolis: Indiana Historical Society, 1975), 17.

17. Gurdon Saltonstall Hubbard (b. 1802, expedition to Illinois, 1818), *The Autobiography of Gurdon Saltonstall Hubbard* (Chicago: Lakeside Press, 1911), 57–58. See also John Thurston (b. 1824, traveled with father to Illinois, 1837), *Reminiscences, Sporting and Otherwise, of Early Days in Rockford, Illinois* (Rockford, IL: Press of the Daily Republican, 1891), 11.

18. Iles, *Sketches of Early Life*, 10. See also Ethan Roberts (b. c. 1820, traveled to Wisconsin, 1852), *History of LaCrosse County, Wisconsin* (Chicago: Western Historical Company, 1881), 464; John Nowland (b. 1814, family moved to Indiana, 1820), *Early Reminiscences of Indianapolis with Short Biographical Sketches of Its Early Citizens* (Indianapolis, IN: Sentinel Book and Job Printing House, 1870), 49.

19. See William Borden (b. 1823, Indiana), "Personal Reminiscences of the Founder," in *Catalogue of the Borden Museum* (New Albany, IN: The Tribune Co., 1901), 20; Branson Harris, (b. 1817, Indiana), *Some Recollections of My Boyhood* (Indianapolis, IN: Hollenbeck Press, 1908), 6.

20. See Peter Cartwright (b. 1785, moved to Illinois, 1823), *Autobiography of Peter Cartwright, The Backwoods Preacher* (Cincinnati, OH: Hitchcock and Walden, 1856), 252; James Crooks (b. 1825, family moved to Indiana, 1826), *The Autobiography of James Crooks, A.M., M.D.* (Terre Haute, IN: Moore and Langen Printing Co., 1900), 16; Granville Stuart (b. 1834, family moved to Illinois, 1837), "Boyhood on the Frontier," *The Palimpsest* 7 (1926): 223; Harris, *Some Recollections*, 6; Robert Duncan (b. 1811, family moved to Indiana, 1820), "Old Settlers," *Indiana Historical Society Publications* 2 (1894): 383. Ezra Ferris (b. 1783, family moved to Indiana, 1789), "The Early Settlement of the Miami Country," *Indiana Historical Society Publications* 1 (1897): 283; Philip Mason (b. 1793, moved to Indiana, 1816), *A Legacy to My Children, Including Family History, Autobiography, and Original Essays* (Cincinnati,

OH: Moore, Wilstach and Baldwin, 1868), 107; Harvey Lee Ross (b. 1817, family moved to Illinois, 1821), *The Early Pioneers and Pioneer Events of the State of Illinois* (Chicago: Eastman Brothers, 1899), 22–23; Duffield, *Memories*, 9, 24, 37; Griffith, *My 96 Years*, 2; J. S. Clark (b. 1841, Indiana), *Life in the Middle West: Reminiscences of J. S. Clark* (Chicago: Advance Publishing Co., 1916), 18.

 21. Daniel Drake, *Pioneer Life in Kentucky*, 107–108. See also Samuel Willard (b. 1821, family moved to Illinois, 1831), "Personal Reminiscences of Life in Illinois, 1830 to 1850," *Transactions of the Illinois State Historical Society* 11 (1906): 78; James Skinner (b. 1828, family moved to Missouri, 1835), *Sketches of Pioneer Life* (Quincy, IL: John Hall Printing Co., 1917), 23.

 22. Silas Packard (b. 1826, family moved to Ohio, 1833), *My Recollections of Ohio* (Ohio Society of New York, 1890), 6. See also Marion Drury (b. 1849, family moved to Iowa, 1853), *Reminiscences of Early Days in Iowa* (Toledo, IA: Toledo Chronicle Press, 1931), 26; Edwin Coe (b. 1840, Wisconsin), "Reminiscences of a Pioneer in the Rock River County," *Proceedings of the Southern Historical Society of Wisconsin* (1907), 196–97; Henry Pitzer (b. 1834, family moved to Illinois, 1836), *Three Frontiers: Memories and a Portrait of Henry Littleton Pitzer* (Muscatine, IA: Prairie Press, 1938), 21; G. W. H. Kemper (b. 1839, Indiana), "My Childhood and Youth in the Early Days of Indiana," *Indiana Magazine of History* 19 (1923): 308; Thomas Banning (b. 1851, family moved to Kansas, 1855), "The Banning Narrative," in Paul M. Angle, *Pioneers: Narratives of Noah H. Letts and Thomas Allen Banning, 1825–1865* (Chicago: Lakeside Press, 1972), 211.

 23. Drury, *Reminiscences*, 26.

 24. Griffith, *My 96 Years*, 2.

 25. William Nowlin (b. 1821, family moved to Michigan, 1834), *The Bark Covered House, or, Back in the Woods Again* (Detroit, MI, 1876), 114.

 26. Charles E. Brown (b. 1813, moved to Iowa, 1842), *Personal Recollections 1813–1893 of the Rev. Charles E. Brown* (Ottumwa, IA: Ottumwa Stamp Works Press, 1907), 25–26.

 27. Banning, "The Banning Narrative," 182.

 28. Noah Major (b. 1823, family moved to Indiana, 1832), "The Pioneers of Morgan County: Memoirs of Noah J. Major," *Indiana Historical Society Publications* 5 (1915): 301.

 29. Riley, *The Female Frontier*, 201.

 30. See Robert Ream (b. c. 1810, moved to Wisconsin, 1838), *History of Dane County, Wisconsin* (Chicago: Western Historical Company, 1880), 692; Fabius Finch (b. 1812, Indiana), "Reminiscences of Judge Finch," *Indiana Quarterly Magazine of History* 7 (1911): 157.

 31. Beggs, *Pages from the Early History*, 85.

 32. Julius Lemcke (b. 1832, joined uncle's family in Indiana, 1846), *Reminiscences of an Indianan: From the Sassafras Log behind the Barn in Posey County to Broader Fields* (Indianapolis, IN: Hollenbeck Press, 1905), 4; see also William Jackson Knox (b. 1832, Indiana), *Personal Recollections of W. J. Knox* (Indianapolis, IN, 1910), 12; Isaac Roberts (b. 1833, family moved to Indiana, 1854), *Autobiography of a Farm Boy* (Ithaca, NY: Cornell University Press, 1946), 83; Clark, *Life in the Middle West*, 10; Ezra Meeker (b. 1830, family moved to Indiana, 1845), *Ventures and Adventures of Ezra Meeker or Sixty Years of Frontier Life* (Seattle, WA: Rainier Printing Co., 1909), 19.

 33. Banning, "The Banning Narrative," 182–83.

34. Packard, *My Recollections*, 7.

35. Coe, "Reminiscences," 192. See also E. F. Wells (b. 1835, family moved to Illinois, 1838), "Old Times in Illinois," *Journal of the Illinois State Historical Society* V (1912): 184.

36. Drury, *Reminiscences*, 16.

37. See Banning, "The Banning Narrative," 240; Harris, *Some Recollections*, 6; Mott, *Fifty Years*, 12.

38. S. W. Widney (b. 1820, family moved to Illinois, 1837), *Pioneer Sketches; Containing Facts and Incidents of the Early History of DeKalb County* (Auburn, IN: W. T. and J. M. Kimsey Printers, 1859), 5. See also Ferris, "The Early Settlement," 273–4; Noah Letts (b. 1825, family moved to Illinois, 1830), "The Letts Narrative," in Angle, *Pioneers*, 40.

39. See L. L. Greenwalt (b. 1864, Iowa), *75 Years of Progress* (Hastings, IA: L. L. Greenwalt, 1944), 56; Duffield, *Memories*, 37.

40. Nowland, *Early Reminiscences*, 187. See also Roberts, *Autobiography*, 83–84.

41. William Whirry (b. 1820, moved to Wisconsin, 1846), "Pioneer Reminiscences," *History of Columbia County, Wisconsin* (Chicago: Western Historical Company, 1880), 436–37.

42. Julia Stonebraker (b. 1833, family traveled to Iowa, 1844) was the only woman memoirist to present her brief description of housekeeping and cooking as a joint family effort rather than as her mother's responsibility, *Twice a Pioneer* (Lyndon, KS: 1897), 7.

43. See Mary Ann Ferrin Davidson (b. 1824, family moved to Indiana, 1837, moved to Iowa, 1845), "An Autobiography and a Reminiscence," *Annals of Iowa* 37, 3rd Ser. (1964): 248, 254; David Hoover's sister (b. c. 1780, family moved to Indiana, 1806), in *Memoir of David Hoover*, 24; Josephine Brooks (b. 1836, family moved to Wisconsin, 1854), *Memories of a Busy Life*, (n.p., n.d.), 11–12.

44. Kitturah Belknap (b. 1820), "The Diary of Kitturah Penton Belknap," *Annals of Iowa* 44 (1977): 32. See also Lois Murray (b. 1826, moved to Indiana, 1847, and Kansas, 1860), *Incidents of Frontier Life* (Goshen, IN: Evangelical United Mennonite Publishing House, 1880), 112, 137.

45. Margaret M'Coy (b. c. 1825, moved to Wisconsin, 1848), "Pioneer Reminiscences," *History of Green County, Wisconsin* (Springfield, IL: Union Publishing Co., 1884), 239.

46. Melissa Anderson (b. 1845, family moved to Indiana, 1832, moved to Kansas, 1857), *The Story of a Kansas Pioneer, Being the Autobiography of Melissa Genett Anderson* (Mt. Vernon, OH, 1924), 33.

47. Ellen Badger (b. c. 1840, family moved to Iowa, 1853), *Memory Links of Seventy Years* (n.p., 1923), [6].

48. David Hoover's sister, in *Memoir of David Hoover*, 24. See also Jane Stevenson (b. 1831, family moved to Indiana, 1834), "Pioneer Life in Boone County," *Indiana Magazine of History* 18 (1922): 333, 343; Eleanora Colton (b. 1845, family moved to Iowa, 1846), *Memories of Columbus City* (n.p., 1940), 12; Alzina Felt (b. 1830, family moved to Michigan, 1841), "Incidents of Pioneer Life," *Michigan History Magazine* 6 (1922): 293–94.

49. Sarah Cummins (b. 1828, Illinois, family moved to Missouri, 1844, to Oregon, 1845), *Autobiography and Reminiscences of Sarah J. Cummins* (Freewater, OR: 1914), 18, 26.

50. Mrs. Talbot Dousman (b. c. 1825, family moved to Wisconsin, 1838), "Pioneer Reminiscences," *History of Waukesha County, Wisconsin* (Chicago: Western Historical Company, 1880), 473.

51. Mrs. John Weaver (b. 1808, moved to Wisconsin, 1836), "Pioneer Reminiscences," *History of Waukesha County, Wisconsin* (Chicago: Western Historical Company, 1880), 484.

52. Susan Short May (b. 1839, Illinois), "The Story of Her Ancestry and of Her Early Life in Illinois," *Journal of the Illinois State Historical Society* 6 (1913): 120–22. See also Catherine Joss (b. 1820, family moved to Ohio, 1829), *Autobiography of Catherine Joss* (Cleveland, OH, 1891), 21.

53. Jeffrey, *Frontier Women*, 54.

54. Eliza Farnham (b. 1815, traveled to Illinois, 1836), *Life in Prairie Land* (New York: Harper and Brothers, 1847), iv–v.

55. Almira Volk (b. 1810, moved to Chicago, 1833, to Wisconsin, 1837), *The Autobiography of Almira Volk* (Milwaukee, WI: Press of the Evening Wisconsin Co., 1897), 28–29.

56. Christina Tillson (b. 1796, moved to Illinois, 1821), *A Woman's Story of Pioneer Illinois* (Chicago: Lakeside Press, 1919), 56.

57. Mary Beebe Hall (b. 1820s, Ohio), *Reminiscences of Elyria, Ohio* (Lorain County Historical Society, 1900), 17. See also Mary R. Luster (b. 1853, Illinois), *The Autobiography of Mary R. Luster* (Springfield, MO: Cain Printing Co., 1935), 12.

58. Clarissa Hobbs (b. 1829, Illinois), "Autobiography of Clarissa Emily Gear Hobbs," *Journal of the Illinois State Historical Society* 17 (1925): 613–14.

59. Sarah Brewer Bonebright (b. 1836, family moved from Indiana to Iowa, 1848), *Reminiscences of New Castle, Iowa: A History of the Founding of Webster City, Iowa* (Des Moines, IA: Historical Department of Iowa, 1921), foreword. See also Elizabeth H. Jones (b. 1823, family moved to Iowa, 1839), in George R. Carroll, *Pioneer Life in and around Cedar Rapids, Iowa, from 1839–1849* (Cedar Rapids, IA: Times Printing and Binding House, 1895), 238.

60. Tillson, *A Woman's Story*, 145, 22.

61. May, "The Story of Her Ancestry," 123.

62. See Rebecca Burlend (b. 1793, England, emigrated to Illinois, 1831), *A True Picture of Emigration, or 14 Years in the Interior of North America* (Chicago: Lakeside Press, 1936), 45, 46; Mary Luster, *Autobiography*, 48; Juliette Kinzie (b. 1806, traveled to Chicago, 1830), *Wau-Bun, The "Early Day" in the North-West* (New York: Derby and Jackson, 1856), 107.

63. Caroline Kirkland (b. 1801, moved to Michigan, 1837), *A New Home or Life in the Clearings* (New York: Charles Francis, 1839), 85, 73.

64. See Mrs. Ambrose Warner (b. 1842, traveled to Iowa, 1866), "Recollections of Farm Life," *Wisconsin Magazine of History* 14 (1930): 199.

65. Mary Bryam Wright (b. 1807, moved to Illinois, 1831), "Personal Recollections of the Early Settlement of Carlinville, Illinois," *Journal of the Illinois State Historical Society* 18 (1925): 674, 684.

66. Burlend, *A True Picture of Emigration*, 58.

67. Bonebright, *Reminiscences*, 226.

68. Tillson, *A Woman's Story*, 147–49.

69. See Kirkland, *A New Home*, 59; Farnham, *Life in Prairie Land*, 333.

10

Changing Times

Iowa Farm Women and Home Economics Cooperative Extension in the 1920s and 1950s

DOROTHY SCHWIEDER

FROM THE BEGINNING of the 1920s to the end of the 1950s, the lives of Iowa farm women underwent great change. During these years, technological, economic, and social change had a major effect on open-country residents. To examine more fully the lives of Iowa farm women, and in broad outline the lives of other midwestern farm women, this chapter will analyze two important decades, the 1920s and the 1950s, with respect to farm women's experiences. Iowa farm women's involvement in a major farm organization, Home Economics Cooperative Extension, will also be examined to help determine women's changing interests and social and educational needs. During every decade of its existence, Home Economics Extension has undergone change, typically in response to changing conditions within Iowa's rural society. The comparison of women's experiences in these two decades provides an opportunity to identify the types of change occurring, particularly with respect to women's social and educational activities, and the degree of women's involvement in rural society.[1]

While the lives of American farm women have been constantly affected by political and economic changes, two studies done early in the twentieth century are particularly important for framing the discussion of the social side of farm life and identifying the concerns of farm women. Studies of farm life in the first quarter of the century, especially those conducted by the United States Department of Agriculture (USDA) and the Country Life Commission, made clear that while farm men desired help with production problems, farm women could benefit from programs designed for the farm home.

The first of these studies, conducted by the Country Life Commission, concluded that farm women worked too hard, had too few social outlets,

and often received no assistance or even a sympathetic ear from family members. The Commission's Report recommended "a more helpful, cooperative spirit in the farm family," as well as more household conveniences. To relieve isolation, an ever-present condition on the nation's farms, the report recommended that farm women have more telephones and greater access to women's organizations.[2]

A few years later, the USDA took a closer look at farm women's lives. In 1913, anticipating the creation of an Extension Service, Secretary D. F. Houston sent letters to 55,000 farm women asking how the Department of Agriculture might better serve them. In approximately 2,200 replies, the women documented many concerns including heavy workloads, social isolation, lack of labor-saving devices, the absence of good schools for their children, and the lack of spending money. One Iowa woman wrote, "In my opinion, the worst feature of farm work is too much work and too little pleasure. No wonder young folks leave the farm. The main cause of the dissatisfaction of housewives is their isolation." Farm homes throughout the nation had few amenities such as electric lights, indoor water systems, or central heating. This meant women performed most of their work without the help of labor-saving appliances.[3]

In response to concerns about farm life and the needs of farm people, Congress passed the Smith-Lever Act in 1914, which created Cooperative Extension; the legislation included a provision for the creation of the Division of Home Economics. Two years later, Iowa counties began employing female college graduates, mostly from Iowa State College, as home demonstration agents to carry their expertise in domestic science to rural women around the state.

These earliest agents would find a female population that in some ways had changed little in the previous twenty or thirty years. While significant technological change had occurred in agriculture itself, particularly with developments in machinery enabling farmers to be more productive, not much had changed in the farm woman's world of work, in Iowa or elsewhere in the Midwest. Generally, farm women handled their daily domestic routines in much the same way as their mothers and, in some cases, even their grandmothers before them.

While social isolation was less pronounced in the 1920s than earlier, primarily due to the widespread ownership of automobiles, bad roads would often prevent families from leaving the farm. In effect, throughout the Midwest, weather determined farm residents' travel patterns. Helen Brainard, an Iowa teenager living near Casey, kept a diary of her family's activities in 1921. While Brainard wrote about many topics, weather dominated her entries. In the event of rain or snow, not only was the mail not delivered—which

Brainard often noted with displeasure—but the family typically had to cancel any travel plans, either to town or to the neighbors. Automobiles provided excellent transportation, but only if roads were passable.[4]

Iowa farm women, like their counterparts in other midwestern states, worked both inside and outside the home. Domestic tasks were always women's responsibilities, including meal preparation, child care, household cleaning, and laundry. At the same time, women typically had responsibility for planting and tending gardens (which also involved much canning of produce), and raising chickens and marketing eggs. In fact, such a strong identity existed between farm women and poultry raising that some women "frequently categorized chicken chores as housework." Many women also helped with milking, and usually had total responsibility for the separating process, including the washing of separator parts. Some women also helped with field work, but this practice apparently varied from farm to farm, depending on the family's income level and ethnic background.[5]

As part of their work, women often produced income that contributed significantly to the overall operation of the farmstead. As Deborah Fink points out, farm women's work tended to be subsistent in character, while farm men were viewed as producing the major or commercial crops. While that dual perception was deeply rooted, in reality, especially in times of economic difficulty, the money women earned from the sale of eggs, cream, chickens, and butter was sometimes the only income realized. Iowa farm women, moreover, were highly resourceful in earning additional dollars, particularly in the 1920s. Accounts in *Wallaces' Farmer* indicate that women, among other things, raised canaries, braided rugs, caned chairs, and prepared meals for townspeople, all in an effort to earn money. In every decade, farm women earned a few dollars by boarding country schoolteachers.[6]

In the 1920s, Iowa's rural neighborhoods played an important part in the lives of most farm women and their families. But at the same time, rural neighborhoods were beginning to lose their vitality. Farm life throughout the Midwest still revolved around the institutions of family, church, and school—all viewed as special preserves of women—but the sense of rural solidarity that emanated from these institutions was beginning to fray. The automobile had brought great freedom to farm families, but that freedom led to the decline of some rural instititutions. Rural churches, for example, began to fall on hard times in the 1920s. As some churches closed, farm people joined congregations in nearby towns, a change that resulted in fewer institutions to help sustain rural solidarity.[7]

Most open-country schools in Iowa, as in other parts of the region, would remain intact during the 1920s, but they were increasingly criticized by professional educators. For several decades, state officials had believed that country schools generally were inadequate, citing poor physical facilities

as well as poorly prepared teachers. In a more recent study, Richard Jensen and Mark Friedberger observed that, by the 1920s, Iowa "operated . . . two school systems . . . a modern one for towns, cities and the most progressive rural areas, and a traditional one [for] the majority of farmers." The latter employed less-qualified teachers than did urban schools; moreover, farm residents were often reluctant to support new programs such as school libraries because they feared change would result in higher costs and possible loss of local control.[8]

For Iowa farm women, as with women elsewhere in the Midwest, changes in the 1920s touched on areas most closely identified with female concerns. Mothers traditionally provided the physical care and nurturing of children, guided their moral and religious development, and supervised and assisted with their studies as well as encouraging them to continue their educations. With educational and religious change and instability, farm women must have felt some anxiety about their children's future. At the same time, as women viewed their own lives, particularly the social isolation and heavy workloads, relief did not seem forthcoming from within the family circle or the rural neighborhood.

These changes and concerns, moreover, took place during a time when Iowa farm women were also increasingly aware of the lack of modernity in their homes. Unlike town residents who at least had access to electricity, indoor plumbing, central heat, and modern appliances, farm families had few, if any, modern amenities. Town residents also had more social opportunities and better school facilities for their young. By the mid-1920s, these contrasts between town and country were starkly portrayed in popular farm publications, wherein farm life was viewed as less desirable than town life.[9]

While Iowans were aware of the decline of rural institutions and the corresponding decrease in rural cohesiveness, an insightful observer of rural life, *Wallaces' Farmer* editor Henry A. Wallace, wrote in 1925, "Too often folks in the country seem to think they can maintain no social and intellectual life of their own. They have the notion that the ideal is to dash off to the nearest small town as often as possible and to lose themselves in its activities." Wallace believed that farm people should develop a "distinctive culture" and "prevent the countryside being merely a field for the extension of town habits."[10]

The programs offered by Iowa State College Cooperative Extension would speak to the needs of farm women and their families in various ways, including the need to maintain a rural distinctiveness. Programs provided by home demonstration agents were focused directly at women's domestic work. Other Extension programs spoke to broader needs, such as recreation for the entire family. Iowa would be one of the first midwestern states to hire an Extension sociologist who created and promoted educational and

recreational programs for rural families. Moreover, in the 1920s, Extension landscape architects offered plans for the landscaping of farmyards to beautify the surroundings of rural families. In regard to women's work areas, Extension offered assistance through poultry specialists, even if the information was misguidedly directed at men rather than women.[11] While the work of Cooperative Extension focused primarily on the individual needs of farm men, women, and youth, collectively Extension programs strengthened rural life, enhancing the viability of rural neighborhoods. In effect, Cooperative Extension served as a facilitator for rural cohesion.

The programs offered by home demonstration agents dealt with four aspects of farm women's domestic roles: nutrition, clothing construction, home management, and child care. Once organized into township groups within each county, farm women selected an annual project from one of the four main areas. During the decade, clothing construction proved to be the most popular project, and women had their choice of three types of training: a five-month course, a two- or three-day training school; and a one-day training school. While rural women had traditionally sewn clothing for their families, Extension specialists presented advanced techniques that many women had not previously used, including pattern making, tailoring, and the construction of dress forms. Extension staff also presented information on fabric selection and color. For many women, taking part in a clothing program meant producing better-constructed and better-fitting garments as well as enjoying a creative experience.[12]

The popularity of sewing projects, no doubt, stemmed from women's desire to save money and to be better dressed. Throughout the 1920s, farm people continued to exhibit a sense of social inadequacy in relationship to town and city dwellers. By taking part in Extension's sewing projects, women were able to dress themselves and their children in more fashionable clothing and thus allay some of their concerns about appearing dowdy when going to town. Alice Ann Andrew of Jefferson expressed this feeling when she recalled her Extension activities in the 1920s. Mrs. Andrew remembered that Extension specialists came to Greene County with "all kinds of great inspirational things" for women to do. She explained, "I'll never forget one session with dress forms. It was a hot old August day, and they were pasting all this stuff over a so-called T-shirt. About half of [the women] fainted with the heat, but that was how eager women were to learn to create their own clothes. They were ALMOST AS SPIFFY as town ladies. . . . "[13]

In the 1920s, farm women also had the opportunity to select an annual minor Extension project, such as millinery or music. Hat making proved particularly popular, providing yet another way that women could dress more fashionably. In Adams County in 1925, women selected a millinery project that involved a five-month program. They learned about design, fabrics, and

color selection as well as the styles best suited to different facial shapes. In total, farm women attended 335 meetings for the hat project, and 230 women made hats.[14]

Early in the 1920s, Iowa's Home Economics Extension Director, Neale S. Knowles, faced a serious shortage of home demonstration agents (hereafter known as HDAs). While Extension believed every county needed a male agent, HDAs were not considered so indispensible. In fact, throughout the 1920s, only about 40 percent of Iowa's counties hired HDAs. As a result, Director Knowles embraced the concept of local leadership, whereby HDAs enlisted the aid of farm women, known as local leaders, to present Extension lessons. Working at the county level, HDAs or state specialists presented training sessions or lessons to local leaders, who in turn, presented the lessons numerous times within their townships. Some local leaders presented training sessions in townships other than their own, in effect, training additional farm women to give the lessons. Through this system, farm women received valuable training in leadership and in public speaking, training that would be utilized in serving as 4-H leaders and in various positions within the community.[15]

The second most popular annual Extension project was nutrition, with women in some parts of the state studying the subject for five years. One reason, no doubt, for the sustained popularity of this topic was its particular suitability to the local leader method. Iowans all over the state experienced benefits from nutritional projects: the initiation of hot lunches in rural schools, increased consumption of milk by Iowans of all ages, and the improvement of infant feeding including the encouragement of breast-feeding. Extension specialists also promoted better nutrition by urging Iowans to follow six basic rules including eating fruit daily and fresh vegetables and cooked cereal three times a week.[16]

Extension personnel sometimes included accounts of their experiences with rural people as well as correspondence from farm women in their annual reports, thus providing a more personal view of the effects of Extension work. Mrs. Warden Logan, a Scott County farm woman, wrote in 1926 that, when she first became involved in Extension work,

> we had a baby several months old who in spite of constant medical care was alarmingly underweight and a very unhappy baby. After a couple of months of nutrition work and the help of our efficient Home Demonstration Agent our baby was on the road to health, [and] at nine months of age took second prize at a baby health contest.

Also in Scott County, state specialist Florence A. Imlay wrote about young girls drinking coffee and tea: "One girl of seven has been drinking six cups of coffee daily. She is working to earn a new dress which will be hers when

she can report three weeks with no coffee." Rural teachers sometimes reported similar results to state specialists. As one teacher wrote, "All but one of my pupils bring milk to school. They have given up tea and coffee."[17]

In the 1920s, farm families everywhere experienced another aspect of open-country living: an economic downturn in the farm economy. Farm women had always had a mentality of "making do," but that view would become even more critical after 1920. In response to farm women's concerns about stretching their economic resources, Iowa HDAs prepared lessons dealing with cost-cutting measures. Lessons sometimes centered on ways farm women could repair or maintain household equipment, forestalling the need to purchase new items. One highly popular lesson was the cleaning and adjustment of sewing machines. Some lessons showed women how to make— rather than buy—sewing materials, such as bias tape. One lesson dealt with refinishing linoleum. Lessons occasionally helped women develop skills to earn money. In 1926, Madison County agent Opal Milligan reported that some women had learned how to cane chairs and "one woman, as a result of the project work, is able to make extra money for her home." HDAs also promoted home butchering to reduce food costs.[18]

As Iowa farm women gained more knowledge about subjects such as nutrition, that knowledge frequently served two age groups. During most of the twenties, major topics available for study by 4-H girls paralleled those available for farm women. Programs on nutrition, for example, while presented at different levels, informed both mothers and daughters. While HDAs were typically responsible for helping to organize girls' 4-H Clubs (earlier known as Girls Homemaking Clubs) and assisting with their programs and projects, mothers served as 4-H Club leaders; often the women with experience as township local leaders assumed the role of 4-H leaders. This experience had a direct benefit for daughters, as farm women were always more willing than their spouses (males served as leaders of boys' 4-H Clubs) to serve as club leaders. Male farmers, given the absence of the local leader method in agricultural Extension, did not have the same leadership and speaking experience as did their wives, and therefore were sometimes hesitant to take on leadership roles. The result was that the number of girls' 4-H Clubs greatly outnumbered the number of boys' 4-H Clubs during the 1920s and beyond.[19]

While farm women responded positively to formal Extension presentations, it was recognized from the time of the Country Life Commission that farm women needed more from Extension than educational lessons: they badly needed more socializing opportunities. In their annual reports, HDAs frequently alluded to the fact that Extension played a role in fulfilling that need. Extension meetings offered farm women the opportunity to get away from home for several hours at least once a month. Housework, chicken

chores, and laundry were left behind as women came together to visit with neighbors, frequently share a noon meal, and listen to an Extension lesson. While the educational content of the lessons was certainly significant, perhaps even more important was the social aspect of Extension gatherings, which helped to mitigate rural isolation. Moreover, in the process of visiting with neighbors and friends, farm women were strengthening rural ties and increasing their sense of rural solidarity.

By the 1950s, farm women's lives in Iowa had changed significantly. The institutions of family, church, and school were still vital considerations, but each institution had undergone important change since the 1920s. In effect, economic, technological, and social developments had all affected open-country residents throughout the Midwest.

Agricultural production itself, throughout the region, had undergone remarkable change. By the end of the decade, the traditional pursuits of maintaining a small milking herd, raising poultry, and practicing a diversified crop program had largely disappeared. In Iowa, specialization had become increasingly evident as farmers concentrated on the production of corn, soybeans, hogs, and cattle. For some time, Iowa Extension officials had been urging farmers to expand their land holdings, specialize for greater economic return, and incorporate better management practices. That advice produced results. In 1960, Cooperative Extension Director Floyd Andre announced that a new farmer, a "professionally oriented man who sees his farm as a business, rather than solely as a 'way of life,'" had appeared in Iowa.[20]

For farm women, a major shift had taken place with the elimination of milking and separating, and the production of poultry and eggs. Gone was the time-honored practice of taking eggs to town to exchange for groceries. One Iowa farmer declared that, while his parents had produced most of what they consumed, the farm family in the 1950s purchased what it consumed. Many farm women still raised large gardens, but families had ceased to be largely self-sufficient in terms of food needs. These developments greatly reduced the workload of farm women. At the same time, as elsewhere in the Midwest, fewer hired men worked on Iowa farms, a change that also lessened women's workload.[21]

By the 1950s, the farm home itself was undergoing considerable change. Farms everywhere in Iowa had electricity, thus making central heating possible as well as the use of a myriad of electrical appliances. Profits realized during World War II allowed farm families to modernize homes or construct new ones. By the 1950s, newly constructed ranch-style homes were becoming common, and most farmyards included grass, shrubs, and other landscaping. At midcentury, therefore, farm homes began to take on the look of town

homes, both inside and out. In effect, major physical disparities between town and country living had largely disappeared, not only in Iowa, but also in other parts of the Midwest.[22]

In Iowa, other differences between town and country living had also disappeared. Township boundaries, which often marked the general limits of rural neighborhoods, had less meaning. While Extension groups retained their township organizations, farm women's interests—as reflected through Extension programs—often transcended these boundaries, with some projects encompassing entire counties. In many ways, the interests of town and country women were one and the same with respect to public education, social activities, and church involvement. By the 1950s, most Iowa farm families lived along hard-surfaced roads, and weather presented them with little difficulty in getting to town. Farm youths could attend high school almost as easily as their town counterparts. Farm couples, therefore, frequently traveled to town to attend school functions such as sporting events, plays, and concerts. In Hamilton County, parent-teacher association meetings served as an important social activity for all rural residents; this situation was common throughout the state. While farm families still resided in open country, their social and educational interests were increasingly centered in nearby towns.[23]

Put another way, the institutions of the 1920s, which had provided some cohesiveness for rural neighborhoods, were becoming less and less obvious. The number of country schools in Iowa had declined dramatically by the 1950s, and continued declining during that decade. Shortly after the turn of the century, Iowa had over 12,000 one-teacher schools; by the end of the 1950s, that number had dropped to 354. Moreover, by that date, forty-three of the state's ninety-nine counties had closed all one-room schools. At the same time, rural churches were also continuing to decline. The total number of Iowa farms, moreover, was continually decreasing, thus lengthening the physical distance between farm families and reducing the number of farms in each township. By 1950, Iowa contained 203,159 farms, a decrease of 5,776 farms since 1945 alone.[24]

For farm women, many of the heavy physical tasks associated with farming in the 1920s were no longer necessary. In this area as well, farm women's lives and town women's lives had grown more similiar throughout the entire Midwest. The rituals of cleaning the chicken coop each spring, ordering baby chicks from a nearby hatchery, and carefully tending the chicks were no longer a part of most farm women's lives. Milking not only represented hard work, but also tied the family to the farm, as milking had to be done both morning and evening. Because of milking chores, it was difficult for farm people to take even short vacations.[25]

As Iowa farm women's lives changed in the 1950s, Extension programs reflected that change. While Iowa Cooperative Extension had input from both the federal and state levels, Extension has been described as an agency that operates "from the bottom up," indicating that participants at the county level have major input into program decisions. In effect, an important role of Home Economics Extension in the 1950s, as well as in the 1920s, was responding to the needs and interests of farm women. This responsiveness was even more apparent in the 1950s than earlier, given the increased number of Extension specialists on staff. Extension programs reflected farm women's interests and needs at the time.[26]

Extension home economists provided a wide array of programs, both old and new, with many of the latter related to new home appliances. Like other Iowans, farm women were purchasing home freezers, electric ranges, and smaller appliances such as electric skillets. Home economists and state specialists responded by offering lessons on electric skillet cookery, preparing food for freezing, and using the broilers in the new kitchen ranges.[27] At the same time, programs that had been the most popular in the 1920s carried over into the 1950s, particularly clothing construction.

While nutrition remained a popular topic among farm women, it sometimes took a different form in the 1950s; many counties, for instance, intiated programs for weight control. Three decades earlier, weight problems had generally been seen in terms of overweight or underweight children; in the 1950s, weight concerns were generalized to all Iowans, particularly adults. In 1954, the Boone County home economist wrote in her annual report that the weight control program had been an extremely popular project. She believed that "the masses" became interested because "not only [could] they look better and feel better but they learned that carrying this extra weight was a danger to them." In other counties, home economists put together packets of information including graph charts for weight loss, lists of low-calorie foods, and suggested menus and exercises. In a move that foreshadowed current weight-loss programs, participating women met every week or two for weighing and every four weeks for measuring.[28]

As routinely happened with women's Extension's programs, benefits quickly extended to teenage daughters. The Boone County agent noted that participating women had informed public school officials, including the school nurse, of the weight-control program. The result was that a class of teen-age girls met every Saturday morning to weigh in, and to hear a lesson concerning weight control.[29]

While Home Economics Extension continued to use townships as the basic form of organization, the number of committees established and the number of farm women assuming leadership roles within each township had

greatly expanded. Within each county, most townships had five standing committees: library, health, music, school, and international relations. Some townships also had citizenship, recreation, and publicity committees; a few had drama and rural-urban committees. In counties with a high level of participation, each committee might have both a chair and a co-chair.[30] The standing committees themselves indicate that farm women's interests had changed considerably since the 1920s, when most Extension activity centered around specific domestic projects presented in members' homes. The subjects of library, health, music, school, and international relations all created strong connections with institutions and groups beyond the rural neighborhood.

Throughout the decade, reading committees seemed to be particularly active and provide a good sense of women's interests as well as their involvement in the wider community. In Adams County in 1950, the home economist gave the following summary of the library committee's work: "Stressed reading program; cooperated with city library, school superintendent, and county superintendent of schools [in carrying out program]; seventy-three adults took part in reading program and forty-five completed reading and reporting on six books; a total of 467 books read by the group." In Carroll County, Extension staff promoted reading by keeping 125 books permanently in the Extension office; to make them even more accessible, the home economist took two books to every township meeting she attended. As with so many activities, reading programs adopted by rural women reached down to youngsters through 4-H Clubs.[31]

Health committees were also active in the 1950s and again illustrate farm women's identification with countywide interests. In Clay County, committee members discussed the advisability of a drive to raise funds for a community health center, but concluded there was little interest among county residents. In Buena Vista County, the health committee outlined four goals: obtain a county health nurse, promote the testing of local wells, encourage girls to go into nurses' training, and assist in organizing a county health council. While Buena Vista County residents obtained a county health nurse in one year, other counties fared less well. In Chickasaw County, efforts to obtain a county nurse led to concerns on the part of the county medical association that "this type of thing might lead toward socialized medicine." The women quickly responded that having a county health nurse "would help to prevent the development of thinking toward socialized medicine." Another proposal, the creation of a county health council, was rejected by the medical association as unnecessary.[32]

Health Committee work alone suggests that women spent extraordinary amounts of time on committee projects, thus indicating their deep commitment to such projects. In Chickasaw County, members of the Health Com-

mittee first contacted other interested groups that might take part in planning for health services, including the county superintendent of schools, the county board of education, and county physicians. The women then held a countywide meeting with a representative of the state health department discussing the development of a county health council. Several rural women also served on a subcommittee for the purpose of securing the cooperation of the local medical association for the proposed projects. After numerous contacts and meetings, the group decided they needed to do further study on the issues before proceeding.[33]

County Health Committee projects took many forms. In Buchanan County, which had a state mental health facility located in the county seat, the women sponsored one party each month for the patients. The women believed this activity helped "the patients' morale and at the same time [helped Extension members] to understand more about mental problems." In Cass County, Health and Safety Committee members helped sponsor and then assisted with both the county blood drive and the tuberculosis X-ray screenings for county residents.[34]

In the 1950s, Extension reports also covered the activities of citizenship committees. In 1954, in many counties, township vice-chairs—who served as chairs of the citizenship commitees—met to make plans for the "Get-Out-The Vote" campaign for the June primary election. In Bremer County, women distributed handbills and reminder cards in each township shortly before the election. Girls' 4-H Clubs assisted in distributing the materials. In contrast with the 1920s, when farm women were probably targeted as a major group to receive voting materials, by the 1950s, many farm women were involved in promoting higher voter turnout in their neighborhoods.[35]

The annual narrative reports also make clear that Home Economics Extension continued to speak to certain social needs of rural women. While farm women obviously attended many functions in town—some on a daily basis—they still felt a desire to maintain neighborhood contacts. Most townships still began the year's activities with a Homemaker Tea, to which all township women were invited. Counties also traditionally held an annual Rural Women's Day, during which participants enjoyed both entertainment and a preview of future Extension programs. In Benton County in 1954, Rural Women's Day included nine displays, two special speakers, and a style review. At times, social events included the entire family, as in Allamakee County in 1954, when 650 people attended the County Rural Family night. Women in Allamakee County also had the opportunity to take an annual out-of-state bus tour, a practice initiated in the 1940s. Some counties including Appanoose and Buchanan, continued the rural women's choruses started in the 1920s.[36]

During the 1950s, in addition to their increased involvement off the farm, women also had an opportunity to become more involved in decision making on the farm. During that decade, Extension officials created several programs that emphasized the involvement of both husbands and wives in planning long-term goals. The Farm and Home Development Program (FHDP), a part of every state's Extension agenda, called for a family planning process wherein husbands and wives sat down together with Extension staff (usually an agricultural economist and a county staff member) to discuss all aspects of the farming operation. One Extension official described FHDP as a program designed to help individual families determine what they hoped to accomplish in farming, homemaking, and family living. The result was that, on hundreds of farms throughout the state, men and women together discussed common problems with Extension personnel. According to a former Extension home economist, many farm couples for the first time had a clear understanding of each other's priorities.[37]

Farm women's involvement in shared or mutual activities was also evident at the county level through programs set up by county Extension staff. Home economists' annual reports in the 1950s indicate that, increasingly, Extension personnel viewed mutual programs as necessary and worthwhile. In 1954, the Franklin County home economist urged more "discussion dinner meetings" for men and women, where everyone focused on economic policy, legislative issues, and international concerns. A few years later, the Grundy County home economist wrote that, to improve the entire Family Living Program (as the home economics program was called), it should be "tied more closely to the overall Extension program—working in correlation with the men's progam and the youth's progam in the county."[38]

As a result of changes both in Extension programming and within the wider society, rural women in the 1950s increasingly focused their attention on national and international issues. By the late 1950s, many farm families were traveling outside the country and returning home to share their trips with family and friends. Moreover, in keeping with their standing committee on international relations, women's township groups were selecting foreign cultures as a topic for study. Foreign exchange programs were also becoming more visible as Iowa farm youths spent time overseas, and foreign students, in turn, traveled to Iowa to spend several months with farm families. These developments meant that all rural Iowans were broadening their outlook toward and knowledge of the world.[39]

By the end of the 1950s, rural life would be undergoing yet another major change, as more and more farm women went to work off the farm. According to the federal census, between 1950 and 1960, the number of rural women in Iowa listed as working increased by 25 percent. This change would

have major implications for Home Economics Extension. By the latter 1950s, home economists noted increasingly in their annual reports that it was becoming difficult to find women not only to attend Extension meetings but to accept leadership positions. The Green County home economist noted that "Quick Trick Cookery" was offered because women "are joining the ranks of the employed in ever increasing numbers." The Hamilton County home economist wrote,

> The number of working homemakers in Hamilton County remains very high. Community activities take a large share of time of the homemakers who are not working. This makes daytime meetings less effective and lower participation in meetings of some of the groups participating in the Extension Family Living program.[40]

For farm women themselves, life in the 1950s differed markedly from life in the 1920s. Rural solidarity, at least as reflected through farm residents' dependence on townships as the basic unit of social activity, was decreasing. Farm women's interests in the 1950s, although still centered domestically within the farm home, had in other ways become increasingly identified with nearby communities or with countywide interests. In other words, township boundaries, so vital to farm life in the 1920s, had become far less important. Also by midcentury, farm homes as well as farm women's day-to-day work routines, varied little from those of women in nearby towns. Thus, a distinctive rural lifestyle such as that proposed by Henry A. Wallace was no longer feasible.

Yet another view of the 1950s with respect to farm women's lives is in its relationship to the decades beyond. In this sense, the 1950s served as a transitional decade between a farm life characterized by a higher degree of isolation and a more rural-centered lifestyle, and the more business-oriented farming of the 1960s with its strong ties to entities outside the rural neighborhood. By the 1960s, with a greater degree of production specialization, continued school consolidation (as children were bused from smaller town schools to larger consolidated schools), and increased farm acreages, the rural neighborhoods of the 1940s and even the early 1950s had disappeared. For Iowa farm women, little remained of the old patterns of work or sociability, or almost any type of rural cohesion.[41]

While Extension offered many opportunities for rural women, it must also be recognized that Home Economics Extension was not for everyone. In every well-organized township in both the 1920s and the 1950s, there were dozens of women who had never attended an Extension meeting and had no desire to do so. Some women did not feel the need to take part; others did not have the time. Some farm women felt they could not take part be-

*other
factors?*

cause their husbands did not approve. In the 1920s, a few HDAs noted that foreign-born women often had no interest in Extension, perhaps because of their limited knowledge of English. For younger women with large families, there were the difficulties of time and finding someone to care for the children. For farm women who did take part in Extension, however, the rewards were many.[42]

While it is clear that the lives of Iowa farm women changed in major ways between the decades of the 1920s and 1950s, it is also known that similar change occurred throughout the Midwest. The degree and type of change, however, are not always clear. In the prairie states, particularly Minnesota, Illinois, and Missouri, social and economic developments probably approximated those in Iowa. On the other hand, the experiences of farm women in the plains states had always differed from those of other midwestern women. In the 1950s, plains farm women still experienced considerable social isolation, as farms were often located many miles apart. Country roads in states like South Dakota often remained unimproved, making travel difficult or impossible during wet weather. School consolidation proceeded at slower rates in the plains states; in the Dakotas and Nebraska, for example, country schools were common in the 1950s and beyond. Therefore, at least one major rural institution still existed to serve as a center for rural life. Also in the 1950s, American women everywhere were going to work in ever-larger numbers, especially during and after World War II. Presumably farm women in every midwestern state were a part of that movement, although for plains women, distance was sometimes an inhibiting factor.

What is known is that agriculture itself changed throughout the Midwest, especially during the 1940s and 1950s. It seems likely that in all midwestern states, therefore, farm women ceased milking cows and raising poultry and eggs. According to Kathleen Jellison, some midwestern farm women in the 1950s spent more time in the fields driving tractors and helping with the harvest. It is also clear from Jellison's work that throughout the Midwest, distinctions were often erased between town and country living, particularly in regard to domestic work and the availabiliy of modern conveniences.[43]

Given the many social, economic, and geographical variations among the twelve midwestern states, scholars will need to look more closely at the experiences of farm women in each state. Even though the Midwest is described in terms that suggest a homogeneous nature—such as the heartland and the nation's bread basket—these perceptions do not erase the many variations within the region. Only with closer study of each state can more meaningful observations be made about midwestern farm life that in turn can be used for comparative purposes with other regions of the country.

Notes

1. See R. Douglas Hurt, *American Agriculture: A Brief History* (Ames: Iowa State University Press, 1994), for a brief overview of the subject. In order to make comparisons between the 1920s and the 1950s, I have used some material from my book, *75 Years of Service: Cooperative Extension in Iowa* (Ames: Iowa State University Press, 1993), particularly from chapter 3. The present chapter affords an opportunity to examine certain Extension programs of the 1950s that were not covered in *75 Years of Service*.

2. William Bowers, *The Country Life Movement in America* (Port Washington, NY: Kennika Press, 1974), pp. 62–64. The Country Life Commission was established by President Theodore Roosevelt in 1907. The Commission was to study rural life and determine ways in which it could be improved.

3. "Social and Labor Needs of Farm Women," U.S. Department of Agriculture, Report No. 103 (Washington, DC: U.S. Government Printing Office, 1915), p. 13.

4. Helen Brainard Diary, 1921, Brainard Family Papers, Iowa State Historical Department, Des Moines.

5. Deborah Fink, *Open Country Iowa: Rural Women, Tradition and Change* (Albany: State University of New York Press, 1986), SUNY Series in the Anthropology of Work, June Nash, ed., p. 49. Also see Fink, and Katherine Jellison, *Entitled to Power: Farm Women and Technology, 1913–1963* (Chapel Hill: University of North Carolina Press, 1993), for general discussions of farm women's work during this time.

6. Fink, *Open Country Iowa*, pp. 46–57; and *Annual Narrative Reports of Iowa Home Demonstration Agents* (hereafter referred to as *ANR*), Madison County, vol. I, 1926, pp. 8–13.

7. Don Kirschner, *City and Country: Rural Responses to Urbanization in the 1920s* (Westport, CT: Greenwood Publishing Corporation, 1970), pp. 116–18. According to a Methodist Church publication, John Nye, *Between the Rivers*, p. 93, the Methodist Church in Iowa suffered membership losses in rural areas because of the farm depression of the early 1920s, with the number of churches diminishing every year. The experience of the Methodist Church is significant because it was the largest Protestant denomination in Iowa at the time.

8. Richard Jensen and Mark Friedberger, *Education and Social Structure: An Historical Study of Iowa, 1870–1930* (Chicago: Newberry Library, 1967), pp. 7.4–7.9. Earle Ross has also made this observation in *Iowa Agriculture* (Iowa City: State Historical Society of Iowa, 1942).

9. See Dorothy Schwieder, "Rural Iowa in the 1920s: Conflict and Continuity," *The Annals of Iowa* 47 (Fall 1983): 105–107. My research indicates, in contrast to Jellison in *Entitled to Power*, that farm women in Iowa and South Dakota eagerly accepted new technology that would lighten their workloads.

10. *Wallaces' Farmer*, May 1, 1925, 643.

11. C. H. Schopmeyer, "Extension Projects in Rural Community Organization," *Extension Service Circular* 43, (Office of Agricultural Instruction Extension Service, Washington, DC, May 1927), p. 3; and Ralph K. Bliss, *History of Cooperative Agriculture and Home Economics Extension in Iowa: The First Fifty Years* (Ames: Iowa State University, 1960), pp. 138, 140.

12. Cora Leiby, *Annual Report for Clothing Specialist*. Included in the *Annual Report for Home Economics*, Iowa Sate College, 1921–22, n.p.

13. Quoted in Thomas J. Morain, *Prairie Grass Roots: An Iowa Small Town in the Early Twentieth Century* (Ames: Iowa State University Press, 1988), pp. 106–107, italics added by author. Even in the 1950s some farm women did not want to take part in programs such as the Farm and Home Development Project because they felt they did not have proper clothing to wear to meetings.

14. ANR, Adams County, vol. I, 1925, pp. 14–15.

15. J. Brownlee Davidson, Herbert M. Hamlin, and Paul C. Taff, *A Study of the Extension Service in Agriculture and Home Economics in Iowa* (Ames: Collegiate Press, Inc., 1933), pp. 105–106, 178.

16. *Annual Report* for food and nutrition specialist, included in the *Annual Report for Home Economics*, 1921–33.

17. *ANR*, Scott County, vol. 2, 1926, p. 35; and Florence A. Imlay, *Annual Report* for Extension milk specialist. Included in the *Annual Report for Home Economics*, 1920, 1921, and 1922.

18. Louise Rosenfeld, Interview, Ames, Iowa, May 3, 1988, tape 2, p. 9; and *ANR*, Madison County, vol. I, 1926, pp. 8–13.

19. See Schwieder, *75 Years of Service*, pp. 58–59; county agents or state specialists who handled agricultural presentations did not use the local leader system, as they claimed the information they were dispensing was too technical for lay people to present.

20. Schwieder, *75 Years of Service*, p. 159.

21. Jellison, *Entitled to Power*, p. 156. Jellison shows that, by 1954, 50.8 percent of Iowa farms had hired labor.

22. Extension reports, including the director's report and the annual narrative reports, included countless references to the money Iowa farm families made during the war and the fact that after the war, those families were spending it on improved housing and new machinery; also see Chapter 6 of Jellison, *Entitled to Power*. Although farm families throughout the Midwest enjoyed a better standard of living than before the 1950s, from my personal experience in South Dakota, I know that farm homes in the western half of the state were much slower to modernize than those in eastern South Dakota.

23. Paul J. Jehlik and Ray E. Wakeley, *Rural Organization in Process: A Case Study of Hamilton County, Iowa* (Ames: Agricultural Experiment Station, Iowa State College of Agriculture and Mechanic Arts, Sociology Subsection, 1949), Research Bulletin 365, pp. 141–59. The authors write that about 97 percent of Hamilton County farms were located along good, all-weather roads. Hamilton County would have been typical of other rural counties in the state. See pp. 131–32. The authors emphasize that township boundaries had far less meaning even in the late 1940s than in the 1920s.

24. Jellison, *Entitled to Power*, p. 153; S. J. Knezevich, "The Changing Structure of Public Education in Iowa and Its Relation to the Educational Needs of Rural and Urban Areas," in *Urban Responses to Agricultural Change*, Clyde F. Kohn, ed. (Iowa City: State University of Iowa, 1961), pp. 174–75. It is extremely difficult to get a count of open-country churches in Iowa in the twentieth century. Hamilton County is one of the few counties for which these data are readily available. In the latter

1940s, Hamilton County had a total of forty-five churches, and twelve of these were located in open country. It is probable that a few of these churches had closed down by the end of the 1950s. Moreover, the Hamilton County churches were not distributed evenly throughout the county, as seven out of sixteen townships had no open-country churches.

25. Fink, *Open Country Iowa*, pp. 162–70.

26. Schwieder, *75 Years of Service*, p. 225; Elizabeth Elliott, former head of Home Economics Extension at Iowa State University, has stated that, even in the 1970s, field staff believed they should only offer programs that farm women had requested. See Elizabeth Elliott, interview, Ames, Iowa, May 10, 1990, pp. 3–4.

27. *ANR*, Adams County, vol. I, 1950, p. 9; Appanoose County, 1950, vol. I, p. 17; Cerro Gordo County, 1950, vol. I, pp. 117; Appanoose County, 1954, vol. I, p. 18.

28. *ANR*, Boone County, vol. II, 1954, p. 10; Grundy County, vol. 6, 1958, pp. 12–13; Allamakee County, vol. I, 1958, p. 5.

29. *ANR*, Boone Couny, vol. II, 1954, p. 10.

30. *ANR*, Adair County, vol. I, 1950, p. 8; Adams County, 1950, vol. I, p. 8; Carroll County, 1950, vol. I, p. 14; Buchanan County, vol. I, 1950, p. 13. In 1955, the Iowa Farm Bureau Federation and the Iowa Cooperative Extension Service severed their long-time affiliation. While it was anticipated that this disassociation would alter the nature of Home Economics Extension programs, that did not seem to be the case. In other words, county activities seemed the same in the later 1950s as in the early 1950s.

31. *ANR*, Adams County, 1950, vol. I, p. 8; Carroll County, 1950, vol. I, p. 14.

32. *ANR*, Clay County, vol. III, 1950, p. 9; Buena Vista County, 1950, vol. I, p. 9; Chickasaw County, vol. II, 1950, p. 16.

33. *ANR*, Chickasaw County, 1950, vol. II, p. 16.

34. *ANR*, Buchanan County, vol. II, 1954, p. 29; and Cass County, vol. II, 1954, p. 22.

35. *ANR*, Bremer County, vol. II, 1954, p. 14.

36. *ANR*, Benton County, vol. I, 1954, p. 12; Appanoose County, vol. I, 1954, p. 23; Allamakee County, vol. I, 1954, p. 18; and Buchanan County, vol. II, 1954, p. 29. The music instructor at Mystic High School directed the women's Extension chorus in Appanoose County.

37. *Iowa Yearbook of Agriculture, 1954–1955*, part B, pp. 344–45; Elsie Van Wert, interview, Garner, Iowa, February 11, 1988, p. 10. The FHDP continued into the 1960s, when it apparently was viewed as unnecessary.

38. *ANR*, Franklin County, vol. V, 1954, p. 26; Grundy County, vol. VI, 1958, p. 15.

39. *ANR*, Fremont County, vol. VI, 1958, p. 13. In her article, "Personal Perspectives on the 1950s: Iowa's Rural Women Newspaper Columnists," *The Annals of Iowa* 49 (Spring 1989), Gladys Rife writes of rural women's interest in the United Nations' organizations of the 1950s.

40. Deborah Fink, "Comment," *The Annals of Iowa* 49 (Spring 1989): 690; and *ANR*, Greene County, vol. V, 1958, p. 9; Hamilton Couny, vol. VI, 1958, p. 74. By the mid-1950s, Home Economics Extension was perhaps at its zenith in terms of township organization and the participation of rural women as local leaders and project chairs. At the same time, women's off-the-farm work was growing. By the

early 1960s, Extension home economists were reaching out to new constituents such as those in the inner city, and were offering programs such as the Expanded Food and Nutrition Education Program. See Schwieder, *75 Years of Service*, pp. 180–85.

41. Two recent studies of American women in the 1950s are Elaine Tyler May, *Homeward Bound: American Families in the Cold War Era* (New York: Basic Books, 1988), and Stephanie Coontz, *The Way We Never Were: American Families and the Nostalgia Trap* (New York: Basic Books, 1992). May argues that during the 1950s, given the unsettling conditions brought on by the presence of the Cold War, communism, and McCarthyism, Americans turned to their families as havens from the outside world. As a result, May writes, American women in the 1950s were marrying at a younger age and having larger families, thus embracing domesticity more totally than before. Coontz believes that the view should not be so sanguine, as women experienced many problems within their familiies and also experienced a high degree of discrimination in areas outside the home. Both studies, however, deal with urban and suburban women, and it is difficult to make connections with Iowa farm women in terms of their social and educational interests. With respect to May's thesis, however, farm women were perhaps moving slightly in the opposite direction as they engaged far more in interests outside the home.

42. For the experience of one Iowa farm woman, see Julie McDonald, *Ruth Buxton Sayre: First Lady of the Farm* (Ames: Iowa State University Press, 1980), pp. 40–45.

43. Jellison, *Entitled to Power*, pp. 162–66.

11

Women, Unions, and Debates over Work during World War II in Indiana

NANCY F. GABIN

WOMEN SHOULD HAVE the same rate when they perform men's jobs," stated Orville Passwater, financial secretary of Federal Labor Union (FLU) 18704 at Anaconda Wire and Cable in Anderson, Indiana, in May 1944. But, he confessed to a U.S. Women's Bureau investigator, women should not be regarded as equal to men. "Married women generally get too independent when they earn their own money," Passwater complained. "They won't do what you want them to do. They get too bossy." Passwater had personal experience with "bossy" women. His wife was employed elsewhere in Anderson, and he wanted her to quit her job after the war. And women in FLU 18704 were taking advantage of wartime circumstances to protest long-standing treatment they described as "unfair."

Contradicting Passwater, Gertrude Harris, a married woman who had served as recording secretary of the local, reported to the federal investigator that the union program was "to keep women on women's work with women's rates and the men keep their jobs with the higher rates." Women were willing to concede sex-differentiated jobs, even if it meant that men were "given preference in men's jobs regardless of seniority." But they "raised Cain"—as one woman put it—when the union negotiated a wage increase of seven cents per hour for men and a paltry two cents per hour for women. Women's jobs may not have been as heavy as men's jobs, union member Mame Jenkins explained, but women had to work seven days a week, sometimes nine hours per day. Women considered the two-cent wage increase insulting as well as unjust, and they complained to the National War Labor Board (NWLB), demanding an additional wage increase for women workers. Jenkins, who represented the women at a NWLB hearing in Chicago, earned the begrudging respect of male coworkers, who said that she and the other women had more "gumption" than the men had.[1]

The men and women employed at Anaconda Wire and Cable during World War II disagreed about many things, but they all had opinions about the definition and significance of gender equality. Their diverse views are

absent from standard treatments of Indiana during the 1930s and 1940s. Their disputes confound the conventional view of Hoosiers as homogeneous and complacent people with harmonious class and gender relations and universal antagonism toward federal interference. Like the historiography on the Midwest generally, that on Indiana is remarkably gender blind. Correcting the omission of women from the region's and the state's history, moreover, means not only adding women to the story but also altering the terms of the story itself.[2]

Just as Orville Passwater, Mame Jenkins, and Gertrude Harris change our view of midwestern history, their engagement with ideas of gender and equality at work also complicates our understanding of the significance of World War II for American women. Scholars have evaluated the short- and long-term impact of the war, debating the extent of change and continuity in social, political, and economic terms.[3] Many of the changes associated with World War II were only temporary, but their effect on the attitudes and behavior of women and men, unionists and employers, and policymakers and politicians has been hotly contested.

The extent to which women for the first time took male-defined jobs in basic industries and challenged assumptions about the "naturalness" of the gender division of labor has been a principal concern in the debate over the effect of the war. The scholarship on this issue generally divides between those who view the influx of women into the nation's factories as a historical "watershed" because it validated the labor force participation of women—especially married and middle-class women—and those who regard the circumstances of the war as reinforcing rather than subverting occupational segregation by sex.[4]

This chapter takes on that argument by examining debates over work and gender equality in unionized workplaces throughout Indiana during the war. In many respects, the conflict in FLU 18704 confirms both competing interpretations of the effect of World War II. Yet the debate was rehearsed all over the state in the 1940s. Its pervasiveness indicates that the greater absolute and relative number of women in factories during World War II compelled unionists and employers at least to confront their commitments to gender hierarchy. The greater presence of women in mass-production industries did not in and of itself serve as a leveler among women and men, erasing the boundaries between their work and fostering a new sense of equality. By no means did all involved reject or even seriously question inequality. But there is sufficient evidence of a high degree of circumspection among unionists and employers, evidence that indicates that the war years were more volatile on the question of gender equality than scholars generally have acknowledged. Neither industry-specific nor union-specific and not limited to major defense-impacted cities, the engagement with notions of gen-

der hierarchy, difference, and equality was more widespread in Indiana and the Midwest heartland and thus of greater consequence than any of the competing interpretations of the war have acknowledged.[5]

Indiana offers a rich field for an analysis of ideas about gender equality in the 1940s. The state received a much larger than average share of war contracts, ranking eighth in the nation, and its manufacturing industry grew more rapidly than that of most states. In 1944, payrolls of war industries accounted for nearly one-third of all Indiana income payments, ranking the state fourth nationally behind only Michigan, Connecticut, and Ohio in this regard. Women constituted a significant proportion of those payrolls. In 1940, women represented 18 percent of those employed in manufacturing in the state. At the peak of wartime employment in Indiana, in the fall of 1943, more than one-third of all factory workers in Indiana were women. The greatest increase in female employment in the state occurred in the defense industries, not only in machinery plants (mostly converted auto equipment and electrical goods plants) where women on average made up one-third of the labor force, but also in iron and steel mills where the number of women employed increased 260 percent by 1944. In some defense factories, such as a tank armor plant in Gary, an RCA factory in Bloomington, and most of the ordnance plants, women constituted the majority of workers.[6]

The state's diversified economy and the presence of a variety of defense industries, including aircraft parts and aircraft assembly, tank armor, ammunition and weapons, LSTs and other ships, and uniforms and parachutes, also meant that unions increased their membership in Indiana during the war. By 1945, membership in the state AFL organization far surpassed all previous figures, and the CIO's State Industrial Union Council claimed more than 200,000 dues-paying members, up from 64,000 in 1940. The United Auto Workers (UAW) and the United Steel Workers won near universal organization of the auto and steel industries; the United Electrical Workers (UE) had significant membership in the state, especially in Fort Wayne and Evansville. The AFL also extended its influence; the Indiana State Federation of Labor reported in 1944 alone the formation of 47 new locals. As a consequence of maintenance-of-membership agreements, the character of the industries in which unions operated, and the greater number of women employed during the war, women's share of union membership in Indiana also increased.[7]

Indiana also is an especially interesting site for analysis of debates over work during World War II because female labor laws were much less a factor there than in neighboring and other industrial states. In contrast to their peers in Illinois, Ohio, and Michigan, Indiana legislators paid little and late attention to the problems of women in industry. In the 1890s, the Indiana General Assembly passed laws requiring seats for women employed in stores

and factories and prohibiting their employment between the hours of 10:00 P.M. and 6:00 A.M. However, it never augmented these protective laws to include maximum hours, minimum wages, or weight-lifting limits. This did not mean that occupational segregation by sex did not exist in the state; nor did it mean that gender equality was somehow taken for granted. But it did mean that the idea of gender equality in the workplace was not ladened with the well-established rhetoric of gender difference and gender hierarchy that characterized similar discussions in other states. The debate over gender and jobs in the state during World War II, therefore, took place in a context unlike that in places that have received greater scholarly attention.[8]

The influx of women did appear to demolish some of the barriers to their greater integration into industry in Indiana. The trend was evident in the employment of women in industries and plants that, before the war, had employed men almost exclusively. Women employed in steel mills before World War II tended to work only on sorting and inspecting tinplate. The demand for labor expanded women's opportunities in the mills; women could be found in almost every department, working at the ore docks; in the storage yards handling raw materials; on the coal and ore trestles; in the coke plants; in the blast furnaces, the steel furnaces, the rolling mills; and in the finishing mills. Women held untraditional jobs ranging from bricklayer to furnace door operator to truck driver to crane operator. At the peak of wartime employment, women's share of the steel labor force averaged 20 percent, varying from a low of 6 percent to a high of 55 percent in the different divisions of the industry. Although the new presence of women in enormous plants such as U.S. Steel in Gary and Alcoa in Lafayette raised eyebrows, the labor forces of smaller factories throughout the state were similarly transformed. To cite just one example, before World War II, the Brown Rubber Company of Lafayette employed approximately 500 people, 75 percent of whom were male, in the production of rubber auto parts. In 1944, having secured defense contracts for the manufacture of self-sealing gasoline tanks for bombers and rubber fittings for Army Air Corps vehicles, the factory employed 400 people, 85 percent of whom were female.[9]

The employment of women in defense industries new to Indiana further highlighted the changes wrought by the war. At the inland shipyards at Evansville and Jeffersonville, women proved adept at burning, chipping, and welding. Nearly 3,000 women, making up one-sixth of the work force, were employed in production jobs at the peak of wartime employment at the Evansville shipyard alone. Like the shipyards that had no prewar history in Indiana, newly constructed ordnance factories transformed small rural villages into teeming cities almost overnight. The most notable examples were a powder plant at Charlestown, the Kingsbury Ordnance Works in La Porte County, and the Wabash River Ordnance Works in Vigo County, which to-

gether employed thousands of women. Although the work itself—dangerous and unusual—attracted attention and made ordnance plants and their employees novelties, the sudden appearance of the huge installations employing great numbers of women also made women workers visible to an unprecedented extent and reinforced the popular perception that they were inhabiting heretofore male public space.[10]

Even factory work that was regarded as traditionally women's was accorded greater respect and higher value during World War II, as Indiana cannery operatives discovered. In the 1930s, Indiana ranked second in the United States in terms of the number of wage earners in vegetable canneries and had the fourth-largest number of canning factories of any state in the nation. Because of the location of the canning plants near the fields, and the relatively brief but highly labor-intensive packing season, most Indiana canners relied on local women from the towns and surrounding farms. The annual stint in the canneries was a mainstay of the rural family economy in Indiana. Yet women cannery workers were largely invisible, regarded as members rather than heads of households, as insulated by their rural isolation from a restive urban working class, and as too dependent on the canneries for cash income to protest their exploitation. During World War II, if only for a brief moment, women cannery workers became highly and newly visible. Opportunities for higher-paid and less-seasonal jobs in defense plants attracted Indiana women and diminished the available supply of labor for the vegetable-packing season. "Older men, boys, and girls if properly trained can help in harvesting," advised an Indiana trade journal in March 1943. "Housewives and others not regularly employed may if enrolled and given some pre-season training," it lamely suggested to canners who had long depended on and exploited just such people as a source of labor, "provide enough labor in the canneries to get us through 1943." Growers and packers cooperated with the state office of the War Manpower Commission and the Indiana Employment Security Division to recruit still unemployed women. When demand continued to exceed supply, they turned to German prisoners of war, a practice that attracted a great deal of public attention and highlighted the importance of women as workers. Another indication of the new respect paid women's role in the industry was the introduction, at the annual state tomato festival in 1944, of a tomato-peeling contest. Noting the event's "enthusiastic" crowd of 3,500, industry coverage made clear that the champion tomato peelers—all women—were canning factory employees. These and other efforts publicly to esteem work that before the war was trivialized or invisible indicate the higher profile of women factory workers in Indiana during World War II.[11]

World War II and the increased employment of women, however, did not so much erase the boundaries separating women's and men's work as

much as reconfigure them. In Indiana as elsewhere, job segregation by sex persisted. Women still constituted the principal labor force in female-dominated industries. Although not considered by many a war industry, garment manufacture—whose Indiana labor force was 80 percent female before and during the war—acquired defense contracts for such items as uniforms, military bedding, and parachutes. Women often were unevenly distributed through the occupational structure of war plants, holding untraditional jobs in some plants but denied jobs defined as highly skilled in other plants. Many women, moreover, worked on operations that were the same as or similar to those performed by women in peacetime. Automotive parts and equipment factories and electrical goods plants had always hired women in production jobs. The conversion of these factories and plants to defense production often entailed few changes in the work process and might require simply the hiring of more women for jobs already labeled as "female." Where women did take men's jobs, the job sometimes had been altered in ways that seemed to justify and rationalize the hiring of women, and maintained the notion that gender distinctions were essential and fundamental. The use of hoists and conveyors or the modification of a press to accommodate the smaller stature of women or the use of a male helper was commonly cited as having transformed a male-defined job into a female-defined one. The preservation of the gender division of labor seemed to validate the continued use of separate and unequal wage rates and job classifications based on sex.

The shift in the composition of the labor force that attended conversion in industry, however, at least made the once-rigid boundaries separating women's and men's work ambiguous. As employers remapped the occupational structure, unionists challenged decisions about wage rates and job classifications. At issue were wage standards as well as jobs. Simply put, unions did not want defense jobs labeled as female because the label would justify lower wages and jeopardize employment for men. But the intents and purposes of unions were complicated in unpredictable ways.

The first response of unionists in plants in which men were dominant was generally to prevent the employment of women on defense production. To cite just one example, in the fall of 1941, conflict developed between the Bendix Corporation in South Bend, Indiana, and the union representing workers in the plant, UAW Local 9, over defense employment. The company had always employed women, but only in certain female-labeled jobs. On September 4, 1941, the local took a strike vote to protest the placement of women in aircraft parts inspection, a new defense operation similar, it claimed, to work long performed by higher-paid male auto parts inspectors in the plant. The union later concluded an agreement with Bendix that endorsed the customary practice of segregating women in particular departments, classifying jobs according to the sex of the operator, and paying

women an hourly rate twenty-five cents less than that paid men in the same or similar jobs. The contract, however, also contained a new feature that limited the future employment of women except in already demarcated "female" departments. Union leaders pressed for this provision because management refused to equalize the wages of women and men in defense jobs. Seeking to protect men's jobs and wage standards, Local 9 conceded women's lower rates but compelled management to obtain the local's permission before hiring more women.[12]

As the attempt to exclude women from defense jobs became an untenable strategy for maintaining wage standards, unions generally pressed for application of the principle of equal pay for equal work. There was, however, uncertainty in many minds about the correct application of the principle. The classification of newly created defense jobs that closely resembled prewar operations to which both sexes had been assigned, but for which sex-differentiated wage scales had been established, particularly confounded interpreters of the equal-pay principle. Unionists tended to argue that if a man ever had performed a job, it was ipso facto a "male" job, and women now employed in it should receive the higher "male" rate negotiated before conversion. Employers generally asserted that the process of conversion had changed or simplified the tasks once assigned to men, making them more like those done by women before the war and thereby justifying the lower "female" rate. Both sides were somewhat disingenuous, since neither would admit the flimsy and esoteric basis for many prewar differentials. It became, however, increasingly difficult to distinguish between operations performed by men and women. Operating a honing machine at General Motors' Delco-Remy plant in Anderson, Indiana, one woman, for example, found it easy and convenient to do her own set-up, the task that differentiated the work of women and men on the machine and justified a lower wage rate for women. When it was brought to his attention, the foreman was surprised that she could do the set-up but, rather than grant her the higher rate of pay and thereby acknowledge the arbitrary character of the sexual division of labor, he simply took her off the job. Another baffled foreman at the same plant referred an equal-pay grievance on an aircraft part assembly job to higher management because both sexes had performed and were performing the operations associated with the job. "I am unable to determine which is to be done by men and which to be done by women," he confessed. In this confused and confusing environment, disputes over job classification and wage determination proliferated.[13]

The endorsement by the National War Labor Board of the equal-pay-for-equal-work principle in the fall of 1942 promised to resolve the conflict between labor and industry over wartime wage policies. The decision of the NWLB in the landmark case brought by the UAW and the UE against Gen-

NWLB

eral Motors also disallowed slight disparities in job content as justification for wage differentials. Directing the company and the unions to include in their contracts a clause stating that "wage rates for women shall be the same as for men where they do work of comparable quantity and quality in comparable operations," the NWLB rejected GM's claim that the necessity of employing male helpers to assist women on certain operations warranted its paying women less than men and asserted that "wage-setting on such a basis is not compatible with the principle of equal pay for equal work." By ordering GM to establish wage rates for women and men on the basis of comparable quality and quantity of output rather than differences in the physical characteristics of the operations, the NWLB not only removed the opprobrium from the term "job dilution" but also called into question the legitimacy of sex-based job classifications and the pervasive devaluing of women's work.[14]

The NWLB intended its equal-pay policy to fulfill its mandate to settle labor disputes, but the ambiguous boundaries between women's and men's prewar and wartime work continued to make the determination of job classifications and wage rates difficult, and conflict persisted, as a NWLB case involving Bendix and UAW Local 9 demonstrates. As war production intensified in 1942, Bendix sought to revise the agreement that restricted both the hiring and the placement of women at its South Bend plant. The company now wanted the freedom to hire more women without the consent of the local, to place them in departments of the plant designated as for men only, and to pay them the lower rate accorded women in the same jobs in so-named "female departments." Fearing a wholesale reduction in wage rates, the local demanded that women placed in male departments in jobs also performed by men receive the higher male rate before it would agree to eliminate the contract clause restricting the employment of women. Bendix refused to equalize wages. Admitting that, "to the casual observer they may appear very similar," the company insisted that the jobs performed by the two sexes were different. Bendix also maintained that implicit in the prewar agreement to classify the work of women and men separately was the assumption that the two sexes performed different and unequal work. Now to pay some women higher wages simply because they would be performing jobs elsewhere in the plant, the company asserted, would violate not only the contract but long-standing principles of wage determination.[15]

Local 9 then placed itself in the unusual position of discrediting the gender division of labor in the plant. Arguing that there were no "female classifications" per se, the local insisted that wage rates should be determined on the basis of the content of the job not the sex of the operator, and that even women employed in so-called "female jobs" in "female departments" should receive the same pay as men and women similarly employed elsewhere

in the plant. Bendix rejected this demand, claiming that to raise so many women's wage rates would place the company at a competitive disadvantage in the industry. Management did call the union's bluff and proposed an independent plantwide evaluation of the disputed jobs to eliminate sex labels and differentials. Confronted with the prospect of wage increases for some women but wage reductions for many men, Local 9 balked, withdrew its demand for wage equalization, and called instead for a ten-cent differential between men and women in the same jobs. Bendix countered with an offer to increase the hourly rates of women in those jobs by eight cents.[16]

Unable to compromise, both sides invited NWLB arbitration of the dispute. In his decision, Harry Shulman, the board-appointed arbitrator, declared that "the differential between male and female rates was in origin and in its continuance based on nothing else but sex." Shulman agreed in principle with the company proposal for systematic job evaluation but rejected it as both impractical in wartime and offensive to the union. Stating that, "were this differential not agreed upon and were it not of long standing there would be little doubt that it should be completely eliminated," Shulman reduced but did not erase it. He granted the union's offer and pegged the hourly rate for women in the disputed classifications ten cents below that already negotiated for men. Shulman also removed the restriction on the company's freedom to employ women.[17]

The Bendix decision reflected the NWLB's retreat from the broadly defined position on equal pay that it had adopted in the fall of 1942. In May 1943, William Davis, chair of the NWLB, criticized unions' use of the equal-pay-for-equal-work policy promulgated by the board to increase wages in job classifications to which only women had been assigned in the past. In a decision on another case, Wayne Morse added that the equal-pay doctrine "is not to be invoked to abolish wage differences between jobs which have historically been performed by women almost entirely and jobs which have been recognized in the industry as jobs limited for the most part to men." In July 1943, the NWLB settled an ongoing dispute between GM and the UAW by eliminating sex-labels on jobs but substituting the terms "light" and "heavy" for the controversial "female" and "male" and establishing a ten-cent wage differential to reflect alleged job disparities. "Rates of each classification," Edwin Witte of the Regional War Labor Board later explained, "imply whether the employees are men or women." The board was not unmindful of the extent to which wages in women's jobs were artificially low. The slippery and inconsistent character of the gender division of labor continually undermined NWLB attempts to render clear and unambiguous decisions. The board, however, like other federal agencies during World War II, chose not to lead a revolt against long-standing and deeply rooted ideas about women's place and gender hierarchy in U.S. industry.[18]

But together with the process of conversion and the increased employment of women, NWLB rulings—despite their limitations—disturbed unions' equanimity with respect to the gender division of labor. In combination, they compelled some unions to make the case for higher wages for the growing share of their membership that was female by acknowledging the extent to which distinctions between women's and men's work had been and still were arbitrary and irrelevant. The UAW, for example, found itself in the novel position of proving that women's jobs were the same as men's jobs despite the prewar practice, in which the UAW had concurred, of distinguishing among jobs on the basis of sex. In its exception to the 1943 NWLB decision in the GM case, the UAW insisted that no discrimination should be made between "light" and "heavy" operations, disagreeing that the work performed by women and men in same-titled jobs was dissimilar enough to warrant wage differentials and noting that, within any job or rate classification, there were tasks that ranged in difficulty. This was a considerable advance over the UAW's position before and during the period of conversion, when it had sought to preserve wage standards by restricting women to a small number of jobs and excluding them from the larger number of male jobs.[19]

The UAW did not wholly endorse gender neutrality in this period. In other instances, auto unionists continued to think in customary ways and to describe the wage and occupational structure in the auto industry in gender-specific terms, even though doing so played into the hands of employers who also asserted the importance of difference in establishing lower rates for women regardless of occupation. Industry members of the Regional War Labor Board objected to the 1943 decision in the GM case because it used a standard of comparability in narrowing the differential between women and men in same-titled jobs. "There is different work being done by women than that being done by men," they insisted. The vice-chairman of the executive board of UAW Local 662 in Anderson, Indiana, simply confirmed the employers' position when he told a U.S. Women's Bureau investigator in 1944 that "women should return to women's jobs" after the war. By talking in terms of men's jobs that women could do and women's jobs that men did not do, the UAW confirmed rather than challenged management's position. The equivocal position held by the UAW would bedevil its efforts, late in the war and after the war, to challenge occupational segregation by sex and eliminate sexual discrimination. Other unions even more steadfastly maintained that men and women were unequal in all respects, did different and unequal work, and deserved different wages.[20]

But the significance of the reconsideration of gender and the work process in industry during World War II ought not be underestimated. The UAW at least began to rethink its approach to wage determination. The UE, which

represented tens of thousands of electrical goods workers throughout Indiana in the 1940s, went even further, guarding against wage cutting by exposing the historical and arbitrary basis for wage discrimination by sex.

In another landmark NWLB case, the UE charged General Electric—which operated a huge plant in Fort Wayne, Indiana—and Westinghouse with systematically undervaluing the work performed by women. Endorsed by the NWLB in a 1945 decision, the UE's position essentially advanced the same argument as our contemporary concept of equal pay for work of comparable worth. The union and the board assailed the practice of both firms of systematically and neutrally evaluating all jobs in their plants but arbitrarily reducing wage rates by as much as one-third if women performed them. On the basis of documented evidence as well as the personal observations of jobs made by NWLB members, the board concluded that Westinghouse and General Electric had deliberately paid women less than men for jobs involving equal or greater skill, effort, and responsibility. The board thus found, at least in the case of the two largest electrical goods manufacturers, that sex alone explained the low wages paid to women and that the companies had discriminated in setting lower rates for women. The board went out of existence before it could design and implement a remedy, however, and the UE's campaign failed in the short run. And like the NWLB and the UAW, the UE's own position on gender equality in industry was limited in certain respects. Although it did call for gender-neutral job evaluation, urging, as did the Women in Industry Committee of District 9, which included nearly all Indiana UE locals in the 1940s, "that all jobs be considered from the human aspect," the UE did not then advocate sex-blind job assignments. But even if World War II was not the time for permanent change in the status of women in the labor market and for gender equality in the workplace, it was important in establishing precedent for reconsideration of wage disparities, specifically, and occupational segregation by sex, generally.[21]

The response of women to the issues raised by the war emergency was varied and not easy or simple to interpret. There is abundant evidence that women in Indiana defense factories recognized the prospect for and actually fought hard to obtain equal opportunity and equal treatment in the workplace. The myriad complaints of Indiana garment manufacturers and tomato canners about the difficulty of recruiting and retaining women for still low-paid jobs in female-dominated occupations attest to the intent of women to take advantage of the demand for their labor and the higher wages in basic industry.

Moreover, women not only agreed that those who replaced men during the war should receive the same rate previously paid male employees but also were keen on capitalizing on the opportunity to challenge the separate and

unequal status of women in industry. Some volunteered for transfer to male-defined jobs to file equal-pay grievances. Other women sought NWLB arbitration on their own, charging that men did not press for equal pay because they wanted to preserve their gender's dominant position in the labor force. Women members of International Association of Machinists (IAM) Local 1449 in Indianapolis initiated a successful campaign for equal pay and, although the men were "not for it particularly," they accepted the women "more on an equal footing after it was won." A female member told a U.S. Women's Bureau investigator that, "now that women have equal pay, women interchange jobs with the men and are sent all over the plant." Half of the members of this IAM local were women, but even in plants where they were a small minority, women pressed for equity, if necessary to the point of threatening to strike.[22]

Even in plants and industries where they predominated, women sought versions of equal treatment. Belying the image of cannery workers as temporary, marginal, and passive, a variety of food-processing unions were organized by the AFL and the CIO in Indiana in the 1930s and 1940s. A principal complaint among cannery workers was the industry's well-documented and well-deserved reputation for underpaying its employees. Union leaders not only regularly sought rate increases and bonus pay for the overtime required of employees during the canning season but, during World War II, added a demand for equal pay with men in the canneries. When women workers at an RCA plant in Indianapolis unsuccessfully challenged the prewar policy of denying them access to the smaller number of higher-paid, male-defined jobs, they expressed their "dissatisfaction [in] voluntary quits." Asked to account for high turnover rates among women employed at Bridgeport Brass, another Indianapolis factory dependent on female labor, the woman president of United Mine, Mill, and Smelters Workers Local 607 cited women's lower and unequal pay as well as their harder work. "Men admit," she said, that "women work harder than they do and yet receive lower hour rates."[23]

Women, however, did not speak in one voice or act as a unified group. The goal of gender equality might have meant little to women who were new to basic industry and saw no reason to complain about unequal pay because their wages already were significantly higher than those they were accustomed to receiving in conventional women's jobs like waitressing, sales and clerical work, and garment manufacturing. Recounting how her local ratified Delco-Remy's offer to increase all women's hourly rates by ten cents rather than grant equal pay to women in those jobs also performed by men, one woman told a U.S. Women's Bureau investigator that "many were young girls, others did not expect to work after the war. All they could see," she complained bitterly, "was the ten cents right then." When a majority of the

women employed at the Chevrolet Commercial Body plant in Indianapolis similarly acceded to management's offer to raise their hourly rate of 82 cents to 96 cents rather than insist on the $1.09 rate paid to men in the same jobs, women who had worked in the plant before the war claimed that they were "out of heart." Distressed by the disinterest among younger women in the issue of equal pay for equal work, they were reluctant to continue pressing for equal pay.[24]

It is undeniable that there were many women who, like men, continued to think in terms of gender hierarchy when they contemplated the structure and organization of work. But, to be fair, there also is evidence that even women who recognized the larger, long-term implications of equal-pay disputes simply found the burden of protest too onerous. Seeking support or action from men who viewed them as temporary coworkers or, worse, as interlopers, and who dismissed them as "hotheads" or troublemakers was a challenge many women chose not to meet. Other women felt it simply was not worth the effort only to be cheated in pay. After the NWLB promoted light-heavy distinctions and sanctioned essentially sex-based wage differentials, women who may have wished to defy expectations and seek a man's job, particularly one that required some additional skill or training, saw no practical reason for doing so. "Women have not bid for men's jobs as they would just have to do harder work for less money than the men get and for the same as they get on the women's jobs," explained one woman. As another put it, "women feel proud of being able to do men's work, [but] after working awhile, they don't like it because of the unequal pay." Other women were willing to trade wage parity for job security. Women employed by a company producing aircraft bearings in South Bend "fuss and fume among themselves [about unequal pay]," a female officer of the UAW local complained, "but will not go to a meeting and do something." The women, however, countered that, because their plant had not expanded as much as others in the city, such as Bendix and Studebaker, their prospects for retaining their jobs when the war was over were better but only if they did not cause trouble. At another South Bend factory organized by the UE, union leaders acknowledged the persistence of unequal pay and sex-differentiated classifications on comparable jobs, but attributed these problems to employer resistance. A female union member admitted that "all of the women are in the low paid jobs," not because they were somehow more suitable for women, but because "the majority of the women are mature and live in the vicinity of the plant" and thus "the plant could secure women at 53 cents [per hour]." In other words, the absence of protest did not necessarily imply either agreement or even acquiescence on the part of women as union leaders or members in their own subordination.[25]

The attitudes of working women and men in this period and the effect

of World War II on those attitudes defy simple explanation. It is still a task of research to define the views on gender equality held by working-class women—those women who would have worked even had there been no war or who, because of the conditions of working-class life, were accustomed to a lifetime of employment. The extent of the evidence in Indiana of women's acceptance of and commitment to wage work and their recognition, even if unspoken, of the problem of gender inequality and hierarchy in the workplace reinforces the emerging interpretation of the middle third of this century as a critical period in the history of women, work, and unions. The Indiana case also indicates that union and working-class men's attitudes about women and work, and their ideas about gender equality and difference, merit greater attention.[26]

This examination of the debates over gender and work in unionized workplaces in Indiana during World War II suggests, too, that the state in particular and the Midwest in general require further study. By the 1940s, the entire region was both the industrial heartland of the United States and the heart of the U.S. labor movement. Although major cities such as Detroit and Chicago have received scholarly attention, the smaller cities and towns of the Midwest were affected as well by the expansion of basic industries, the growth of mass-production unionism, and the increased presence and influence of the federal government in the region's political economy. Consideration not only of the experiences of women but of gender as a category of analysis offers a fresh perspective on and new insight into these important aspects of the history of the Midwest in the twentieth century.

Notes

1. Contract reference notes, Anaconda Wire and Cable, May 27, 1944, Reel 3, U.S. Women's Bureau Papers Record Group 86, National Archives, microfilm edition, part 2, series A.

2. Examinations of Indiana in the World War II era include: Max Parvin Cavnes, *The Hoosier Community at War* (Bloomington: Indiana University Press, 1961); James H. Madison, *Indiana through Tradition and Change: A History of the Hoosier State and Its People, 1920–1945* (Indianapolis: Indiana Historical Society, 1982), pp. 370–407; and Hugh M. Ayer, "Hoosier Labor in the Second World War," Ph.D. dissertation, Indiana University, 1957. None of these offers any systematic or extended treatment of women in Indiana during World War II.

3. There is much grist for the mill. Nearly half of the eleven million women employed in the United States in 1940 worked in low-paid, low-status clerical, sales,

and service jobs. The 20 percent who worked in manufacturing were concentrated in a few low-paid industries, such as textiles and garments. World War II substantially improved the economic prospects of women, as the demand for labor to meet the nation's wartime needs exceeded the available supply of male labor and opened occupations formerly closed to them. Of the eighteen million women employed in 1944, 36 percent held clerical, sales, and service jobs, while the proportion employed in manufacturing had increased in relative terms to 34 percent. The entrance of over three million women into manufacturing represented a striking 140 percent increase over the figure for 1940, but the 460 percent increase in the number of women employed in male-dominated basic industries that converted to war production was even more dramatic. The war also offered many women upward occupational mobility. Although 49 percent of the women employed in defense industries in March 1944 had not worked before the war, 27 percent of those so employed, attracted by higher wages, better working conditions, and the opportunity to learn new skills, had shifted from other occupations. Mary Elizabeth Pidgeon, *Changes in Women's Employment during the War*, Special Bulletin No. 20, Women's Bureau (Washington: U.S. Government Printing Office, 1944), pp. 9, 12, 15.

4. The secondary literature on women and World War II is vast. For assessments of the effect of the war on women in the labor market and the workplace, see: William Chafe, *The American Woman: Her Changing Social, Economic, and Political Roles, 1920–1970* (London: Oxford University Press, 1972), pp. 135–95; Chafe, *The Paradox of Change: American Women in the 20th Century* (New York: Oxford University Press, 1991), pp. 121–72; Ruth Milkman, *Gender at Work: The Dynamics of Job Segregation by Sex during World War II* (Urbana: University of Illinois Press, 1987); Sherna Gluck, ed., *Rosie the Riveter Revisited: Women, the War, and Social Change* (Boston: Twayne Publishers, 1987); Susan Hartmann, *The Home Front and Beyond: American Women in the 1940s* (Boston: Twayne Publishers, 1982), pp. 53–99; Karen Anderson, *Wartime Women: Sex Roles, Family Relations and the Status of Women during World War II* (Westport, CT: Greenwood Press, 1981); Leila Rupp, *Mobilizing Women for War: German and American Propaganda, 1939–1945* (Princeton, NJ: Princeton University Press, 1978), pp. 167–81; Amy Kesselman, *Fleeting Opportunities: Women Shipyard Workers in Portland and Vancouver during World War II and Reconversion* (Albany: State University of New York Press, 1990); and D'Ann Campbell, *Women at War with America: Private Lives in a Patriotic Era* (Cambridge, MA: Harvard University Press, 1984), pp. 101–61.

5. Industry- and union-specific studies that consider but do not highlight midwestern women include Milkman, *Gender at Work*; and Nancy Gabin, *Feminism in the Labor Movement: Women and the United Auto Workers, 1935–1975* (Ithaca, NY: Cornell University Press, 1990). Karen Anderson compares gender roles and relations in three defense-impacted cities, one of which—Detroit—is in the Midwest, in *Wartime Women*, but she does not do a regional analysis. Relatively few works focus on women in the Midwest during the war. These few include: Katherine Jellison, *Entitled to Power: Farm Women and Technology, 1913–1963* (Chapel Hill: University of North Carolina Press, 1993), pp. 131–48; Elizabeth Faue, *Community of Suffering and Struggle: Women, Men, and the Labor Movement in Minneapolis, 1915–1945* (Chapel Hill: University of North Carolina Press, 1991), pp. 168–88; Alan Clive, "Women Workers in World War II: Michigan as a Test Case," *Labor History* 20 (Winter 1979): 44–72; and Richard Santillán, "Rosita the Riveter: Midwest Mexican American

Women during World War II, 1941–1945," *Perspectives in Mexican American Studies* 2 (1989): 115–46.

6. Indiana Economic Council, *Hoosiers at Work*, (Indianapolis: Indiana Economic Council, 1944) pp. 8, 22; *USES Labor Market Letter* 1 (November 1945); Hugh M. Ayer, "Hoosier Labor in the Second World War," *Indiana Magazine of History* 59 (June 1963): 97. At the Vigo County ordnance plant, 85 percent of the 5,000 employees were women; the labor force of the Chrysler ordnance plant in Evansville was 60 percent female. More than 50 percent of the workers at the Gary tank armor plate mill were women. Ayer, "Hoosier Labor in the Second World War," Ph.D. dissertation, p. 362.

7. Ayer, "Hoosier Labor in the Second World War," Ph.D. dissertation, pp. 469, 597.

8. Lisa Phillips, "Indiana's 'Female Breadwinners': The Politics of Protective Labor Legislation, 1913–1929," master's thesis, Purdue University, 1993; Nancy Gabin, "Gender and Power in Rural America: Women Factory Workers and Labor Activism in Indiana," paper presented at the Berkshire Conference on the History of Women, Vassar College, Poughkeepsie, NY, June 12, 1993.

9. Ethel Erickson, *Women's Employment in the Making of Steel, 1943*, Bulletin No. 192–5, Women's Bureau (Washington, DC: U.S. Government Printing Office, 1944), pp. 1–20; John K. Jennings, *The War Manpower Commission in Indiana, 1943–1945* (Indianapolis, IN: War Manpower Commission, 1946), pp. 89–90; Jim Rose, "'The Problem Every Supervisor Dreads': Women Workers at the U.S. Steel Duquesne Works during World War II," *Labor History* 36 (Winter 1995): 24–36; Donna Penning, "Iron Yard," *Steel Shavings* 7 (1981): 24; Joan Souther, "Dozen Different Jobs," *Steel Shavings* 7 (1981): 32–33; Brown Rubber Report, Indiana War History Commission Collection, Box 4, Folder L, Indiana Division, Indiana State Library, Indianapolis.

10. Evansville Report, Indiana War History Commission Collection, Box 3, Folder E; Ayer, "Hoosier Labor in the Second World War II," *Indiana Magazine of History*, pp. 117–19; Cavnes, *The Hoosier Community at War*, pp. 15–54, 79–107.

11. Lotys Benning, *The Vegetable Canning Industry* (Indianapolis: National Youth Administration of Indiana, 1938); Nancy Gabin, "Labor and Gender Relations in the Indiana Food Processing Industry: Women in Tomato Canning Factories, 1920–1950," paper presented at the North American Labor History Conference, Wayne State University, Detroit, MI, October 17, 1992; *The Canners' Wail* 10 (1943) and 11 (1944).

12. *United Auto Worker*, September 15, 1941; Decision of the National Board in the case of Bendix Aviation and UAW Local 9, July 26, 1943, *War Labor Reports* 10 (1944): 45–46.

13. Minutes of Management-Local 662 meeting, November 11, 1942, Neal Edwards Collection, Box 3, September–November Meetings Minutes Folder, Walter P. Reuther Library, Archives of Labor and Urban Affairs, Wayne State University, Detroit, MI (hereafter cited as ALUA).

14. Opinion of the Board in the GM case, *War Labor Reports* 3 (1943): 355–56.

15. Decision of the National Board in the Bendix case, September 20, 1943, *War Labor Reports* 11 (1944): 669–77.

16. *Ibid.*

17. *Ibid.*

18. National War Labor Board, *The Termination Report of the National War Labor Board*, vol. 1 (Washington, DC: U.S. Government Printing Office, 1947), pp. 293–96; Decision of the National Board in Rotary Cut Box case, *War Labor Reports* 12 (1944): 605–609; Arbitrator's decision on women's rates in the GM case, July 31, 1943, Walter P. Reuther Collection, Box 28, Folder 5, ALUA; Decision of Regional Board XI, October 9, 1943, *War Labor Reports* 11 (1944): 745; Eleanor Straub, "U.S. Government Policy toward Civilian Women during World War II," *Prologue* 5 (1973): 240–54.

19. UAW exception to arbitrator's decision in GM case, August 18, 1943, Walter P. Reuther Collection, Box 28, Folder 4. For the UAW's prewar record on gender issues, see Gabin, *Feminism in the Labor Movement*, pp. 8–46.

20. UAW exception, August 18, 1943, Walter P. Reuther Collection, Box 28, Folder 4; Decision of Regional Board, October 9, 1943, *War Labor Reports* 11 (1946): 746; Local 662 survey, n.d. [1944], U.S. Women's Bureau Papers, Record Group 86, Box 1703, Union Schedules Folder, National Archives and Records Administration, Washington, D.C. For other unions in Indiana, see Survey Schedules for Federal Labor Union 18704 (Anaconda Wire and Cable, Anderson), UAW Local 940 (Pierce Governor Co., Anderson), Federal Labor Union 22636 (Continental Roll and Steel Foundry Co., East Chicago), and Evansville Metal Trades Council (Missouri Valley Bridge and Iron Co., Evansville), all 1944, on Reel 4, Record Group 86, microfilm edition, part 2, series B.

21. Milkman, *Gender at Work*, pp. 80–83, 147–49; Winn Newman and Jeanne M. Vonhof, "'Separate But Equal'—Job Segregation and Pay Equity in the Wake of *Gunther*," *University of Illinois Law Review* (1981): 269–331; Minutes of District 9 meeting, October 7–8, 1944, UE District 9 Records, File Folder 17, UE Labor Archives, University of Pittsburgh, Pittsburgh, PA; Nancy Gabin, "The Issue of the Eighties: Comparable Worth and the Labor Movement," *Indiana Academy of the Social Sciences Proceedings, 1988* 23 (February 1989): 51–58; Linda M. Blum, *Between Feminism and Labor: The Significance of the Comparable Worth Movement* (Berkeley: University of California Press, 1991), pp. 1–53.

22. Survey Schedule IAM Local 1449, May 1944, Reel 4, Record Group 86 microfilm edition, part 2, series A; UAW Local 97 report, Record Group 86, Box 1703, Union Schedules Folder.

23. Gabin, "Gender and Power in Rural America"; *Report of the Indianapolis Area Director WMC Labor Market Analysis*, n.d. [December 1942], pp. x–4; Survey Schedule Mine, Mill Local 607, June 3, 1944, Reel 4, Record Group 86, microfilm edition, part 2, series A.

24. UAW Local 662 Schedule, May 1944, Record Group 86, Box 1703, Union Schedules Folder; May Bagwell to Mary Anderson, March 18, 1944, ibid.

25. UAW Local 590 Schedule, ibid; UAW Local 662 Schedule, May 1944, ibid; Contract Reference Chart for Singer Manufacturing Company and UE Local 917, February 12, 1944, Reel 3, Record Group 86, microfilm edition, part 2, series A.

26. Recent historical scholarship that is reshaping our thinking about women, work, and equality in the twentieth century includes: Eileen Boris, *Home to Work: Motherhood and the Politics of Industrial Homework in the United States* (New York: Cambridge University Press, 1994); Dorothy Sue Cobble, *Dishing It Out: Waitresses and Their Unions in the Twentieth Century* (Urbana: University of Illinois Press, 1991); Cobble, "Recapturing Working-Class Feminism: Union Women in the Post-

war Era," in Joanne Meyerowitz, ed., *Not June Cleaver: Women and Gender in Post-war America, 1945–1960* (Philadelphia, PA: Temple University Press, 1994), pp. 57–83; Faue, *Community of Suffering and Struggle*; Gabin, *Feminism in the Labor Movement*; and Alice Kessler-Harris, *A Woman's Wage: Historical Meanings and Social Consequences* (Lexington: University Press of Kentucky, 1990).

12

"Making Rate"

Mexicana Immigrant Workers in an Illinois Electronics Plant

IRENE CAMPOS CARR

THE MEXICAN POPULATION in the Midwest is relatively small and recent compared to the large and historic settlements of Mexicans in the Southwest and on the West Coast. This factor has much to do with the dearth of studies on Mexicans in the midwestern states and the virtual non-existence of research on Mexican American women in the labor force in the Midwest. However, the number of Mexicans immigrating to Illinois in the last twenty years, in particular to Chicago and northern (upstate) counties, has escalated and continues to rise. Yet, despite the increased population, most scholars have continued to ignore their presence. This lack of research moved me to begin a study of the immigrant Mexican women workers at an electronics factory where I had been directing an adult education project for the Spanish-speaking assembly-line workers. My status as an insider/outsider, familiar with the plant and its workers, prompted me to use an ethnographic approach to my research of the factory culture, with an emphasis on the dynamics of the workplace and the women workers, while focusing on issues of ethnicity, gender, and culture. This chapter, based on a segment of a larger unpublished study, looks at the role of the worker within the factory, explores the social interaction of the women with each other, and examines their feelings regarding their work.

Chicanas and Mexicanas in the Workforce

The history of Mexican American women in the labor force shows that women have been moved to seek employment by the prospect of improving their economic situation, that is, their material circumstances.[1] In the United States, working-class Mexican women and those from rural areas have usually worked outside the home. Only upper-class women in the Southwest stayed

at home and had domestic help to assist them. Thus, the idea that women from "good families" do not work outside the home and that men must be the sole support of their families became fixed, forming the stereotype of the traditional Mexican woman who stayed at home to care for her family.[2]

Records of the Chicana (a term used interchangeably with Mexican American woman) in the labor market show that the very difficult economic situation affecting Mexican American families in the Southwest in the late 1870s and 1880s led to the entry of women into the U.S. workforce. During those years, Chicanas began to work as domestics and to join their families in the seasonal migrant field work. By 1930, the U.S. Census showed that one-fifth of Chicana workers were employed as farm laborers. They also represented over 75 percent of the laundresses in El Paso in 1920. The majority of Chicanas, however, worked in the clothing and food industries, and as domestics.

Women were paid lower wages than men, and in the case of Mexican American women, the situation was even worse.[3] Historian Mario Barrera observes that "racial and sexual subordination combined to place Chicana and Mexicana at the bottom of the occupational hierarchy." He also notes that respective censuses demonstrate that in 1930 the proportion of Chicanas in the workforce reached 14.5 percent; in 1950 it had increased to 21.7 percent, and by 1970, 33.2 percent.[4] By 1985, the number of Hispanic[5] women in the workforce had jumped to 49.4 percent. More recently, the U.S. Bureau of the Census (Current Population Report, 1991) showed that 51 percent of Mexican-origin females were in the labor force compared to 57 percent of non-Hispanic women. However, a new demographic report on Latinos in the Midwest indicates that Hispanic women in this region have a higher labor participation rate than non-Hispanic white women. According to the authors of this report, Robert Aponte and Marcelo Siles, 59.8 percent of the Latinas in Illinois are in the workforce, compared to 57.5 percent of the white women.[6]

Nonetheless, the emerging body of work in the social sciences examining *mexicanas* (a term used to designate more recent immigrants from Mexico)[7] and Mexican American women in the labor force has been concentrated in the West and Southwest. Feminist Chicana scholars (native to the region) have analyzed the condition of Chicanas and immigrant *mexicanas* at work primarily in California and Texas,[8] states with the largest Mexican-origin populations. Studies to date have completely neglected the growing Mexican-origin population in the Midwest, over a million people in 1990 (1,153,296), an increase of 40 percent over the previous figures shown in the 1980 census (1980 and 1990 U.S. Census). The largest concentration of Mexicans in the Midwest, a total of 623,688, is in Illinois, the state with the fifth-largest Mexican-origin population in the nation. Mexican Americans make

up 64 percent of the total population of Latinos (Hispanics) in the Midwest, a group with a significant number of women in the workforce and its own regional characteristics.

Regional Characteristics of Mexican-Origin Population

The history of U.S. Mexicans has created important regional differences. There is, for instance, a marked contrast among Mexican Americans who have been native to the Southwest from the time of the Spanish conquest and those who migrated from Mexico to the Midwest at the turn of the century and subsequently. *Tejanos* (Texan Mexicans) are not allowed to forget that, after the bitter war fought in Texas (1835–36), Anglo-Americans declared the territory an independent republic, depriving the original settlers of their land and beginning the history of a brutal discrimination against Mexicans (unlike anything known in Michigan or Illinois). With the subsequent Mexican-American War (1846–48) and Mexico's loss of a million square miles of territory, Mexicans north of the Rio Grande, the new U.S.-made border, became foreigners in their own land, victims of racist practices that persist to this day.[9]

In New Mexico, natives proudly note that they are the descendants of the Spanish settlers who founded Santa Fe in the 1600s. Many of these early settlers oversaw large Spanish crown land grants taken from the communal lands of the indigenous people. The commingling of Indians and Spaniards in this land created different traditions than the ones developed by the *Californios*, those who settled California, for instance.[10]

Immigration to the Midwest

The immigration of Mexicans to the Midwest did not occur until the early years of the twentieth century. With the advent of the Mexican Revolution (1910), Mexicans escaping the political turmoil at home began to migrate north, eventually making their way to the Midwest. Industrial centers like Chicago offered jobs for unskilled labor in the meat-packing plants, the steel mills, and the railroads. The sugar beet producers in the upper Midwest, Michigan, Minnesota, Wisconsin, Ohio, and Indiana, recruited Mexicans as agricultural labor after the onset of World War I stopped the flow of immigrant workers from Europe. Midwest historian Dennis Valdez notes that by 1920 the sugar companies "had recruited more than five thousand Mexican workers, mostly single males, for the Michigan and Ohio beet fields."[11]

In Chicago, the first Mexican immigrants were also young unmarried males; however, women began to arrive in the 1920s. Driven by economic necessity, they began working in factories, laundries, restaurants, and in their

own homes by taking in boarders. A surprising 47 percent of the *mexicanas* were in the labor force, according to a 1925 Chicago Public Welfare study. By 1930, the growing Chicago population of Mexicans had reached nearly 20,000, yet three years later, the number had diminished to 14,000, forced by the U.S. government to return to Mexico during the Depression.[12]

Immigration to Aurora

In towns like Aurora (the site of my study), located in northern Illinois in the midst of the rich agricultural prairie by the Fox River, Mexicans began to arrive from Mexico and other areas of the United States in the early 1920s. The Fox River, new roads, a large railroad center, and the proximity to Chicago spurred the economic development and growth of the city and acted as a magnet for newly arrived immigrants to the United States.

The first group of Mexicans, immigrating to Aurora in the early 1920s, came after hearing of the opportunity to work for the Chicago, Burlington, and Quincy Railway. Soon after they were hired, their relatives and friends arrived to find jobs in the same railroad yard. These first workers, some thirty-five families housed in the railway's boxcar camp with their wives and children, formed the first generation of Mexicans in Aurora.[13]

Although halted by the Depression, Mexican immigration to Aurora started again in the 1950s and 1960s, attracted by a city that continued to expand its smokestack industry and offered plenty of entry-level work to newcomers. Many came with permits as *braceros*[14] to work as agricultural field labor and stayed, others came to work for the railroad, and many more sought work in the large factories dotting the city of Aurora.[15]

The most recent influx of Mexican immigrants, occurring from the 1970s through the 1980s, is also the largest. These newcomers are principally natives of Mexico who, like their predecessors, heard of work in Aurora from relatives residing in the city. Unlike the early immigrants, they arrived to find an established and thriving Mexican/Latino community. The newest immigrants form part of a small community within the larger Latino community and seem to be arriving from the same villages as the large number of Mexicans who arrived in the previous fifteen years.[16]

Many of the men returned to Mexico to find a bride and bring her to the United States. Not surprisingly, a number of the women working in Aurora factories came from Mexico as brides brought over by husbands already settled and working in the area. These men, sometimes the sons of *braceros*, often came to this country to join their fathers and, like their fathers, continued to travel back and forth between Mexico to the United States.[17]

Unfortunately, by the late 1970s, the city of Aurora had seen its heavy industries reduce their size and ultimately close their doors and head south. With the extinction of the smokestack industry, it became necessary for the city government to make a push for a new economic development that would bring light technology and service-oriented companies to Aurora. However, as a result of these changes, employment for the unskilled immigrant was sharply decreased.

Many of the *mexicanas* currently working in Aurora factories arrived in the Aurora area in the early to middle 1970s, when local industry still had the need for low-skilled factory labor. Their immigration from the rural sectors in northern or central Mexico was generally indicative of their low economic status and their expectation to seek work in their new home to contribute to the economic base of their households. Their arrival in this country, consequently, was marked by the immediate assumption of a factory job.

Some of the immigrant women arrived alone, armed with the ambition to contribute to the economic welfare of their parental family; they found jobs and sent money to Mexico. Contrary to studies showing that it is the young single males or heads of families that immigrate, these women demonstrated that, traditional gender roles notwithstanding, they chose to depart from the established norms to help their families.[18]

Another element common to these new immigrants was their lack of documents or entry permits to the United States. Many simply crossed the border, evading the border guards, or came as tourists and stayed. In many cases, these women obtained residency papers through their husbands or relatives, but some remained undocumented, afraid they would be caught and sent back. The Immigration Reform and Control Act passed by Congress in 1986 authorized the legalization of those who had resided in the United States for a predetermined number of years; this new law facilitated the legal residency of hundreds of Mexicans with jobs in the Aurora area.

Work at manufacturing plants that required no skills but paid more than the minimum scale was highly sought after by the *mexicanas*. Consumer electronics factories with labor-intensive production hiring females were one of the first stopping places for immigrant women looking for a job.

The Electronics Plant

The work site of many women was the manufacturer of residential electronic smoke detector alarms, a division of a multinational corporation. In the early 1980s, the company maintained 1,000 to 1,200 employees in its two divisions. When the assembly lines were in full production, there were 500

or more plant workers, some 95 percent to 97 percent of whom were female. Unionized by the International Brotherhood of Electrical Workers in 1981, the production-line workers received wages that were attractive to many of the immigrant women lacking English-speaking skills. Whenever there were factory job openings, a sign in English and Spanish was placed on the door of the employee entrance, and word of mouth spread the news around. It was usually Mexican women by the hundreds that applied, most of them relatives of workers. Men seldom applied for the light assembly-line work except to get their foot in the door while they waited for the higher paid jobs.[19]

Although preference could not be articulated verbally, the personnel department hired primarily women for the assembly of small components. Patience and strong hands with well-coordinated movements are required for the job—attributes that the multinational electronics industry has decided are innate to women, since these characteristics are presumably needed for household and child care tasks. Thus, the assembly of small electronic devices has become "women's work." Anthropologist Maria Patricia Fernandez-Kelly, leading authority on the *maquiladora* industry, quotes an electronics manager in the Mexican Border Industrial Zone who declares, "We hire mostly women because they are more reliable than men; they have finer, smaller muscles and unsurpassed manual dexterity. Also, women don't get tired of repeating the same operation nine hundred times a day."[20]

In 1984, 35 percent of the factory workers at the Aurora electronics factory were of Hispanic origin; African American workers were the second-largest minority group, followed by a small number of Laotians. By 1990, the proportion of Latinas in the plant work force had increased sharply to nearly 70 percent.[21] Although the Latinas included a large number of Mexican Americans and Puerto Ricans, the majority were Spanish-speaking immigrant *mexicanas*.

The *mexicana* majority is hardly surprising since management and personnel office staff had found from experience that *mexicanas* worked hard[22] and complained less about adverse circumstances in the workplace than the non-Hispanic employees. Department supervisors capitalized on the sociocultural traditions of the *mexicana* who was often less assertive than the other workers. Chicana sociologist Ruth Zambrana argues that

> our cultural values of respect and dignity negatively influence how we are perceived in the dominant culture. In other words, the majority of Latinos, both women and men, are perceived as "nice." However, Latina women are expected to remain that way and men are expected to assume more assertive characteristics. At this point, the interrelationship or linkage between personal, cultural and institutional dimensions becomes clearer.[23]

Thus, the stratification of labor on the production floor was based on the ethnocultural characteristics of the women workers; the *mexicanas* were usually relegated to the least desirable jobs with no hope for advancement.[24]

Mexicanas worked in the most tedious jobs and those most likely to cause injury to wrists, arms, and shoulders due to repetitive motions: manual insertion. This job required workers to manually insert minute electronic components onto a small plain printed circuit (PC) board at a rapid pace to keep up with the quickly moving conveyor belt line. The women sat and stood along the line, picked up small color-coded parts, up to twenty for each worker, and pressed them one by one on the boards. Other workers picked up the small PC board, held it tight between the thumb and little finger of the left hand, and, using the right hand with a small air gun snipper, cut small wires on the board to precisely the right length. Work well done and at the appropriate speed was difficult, since wires adjacent to a particular resistor can be snipped too long or too short and the circuit cut, rendering the board useless. The intermittent force exerted by the hands and fingers in a machinelike motion repeated thousands of times during the eight-hour working day eventually resulted in crippling injuries.

Esperancita, a Spanish-speaking *mexicana* who worked four years on the same exacting job on the line, suffered from a ganglion cyst on the wrist that had to be surgically removed. These large cysts are formed on the tendon of the wrist from repetitive motion and strain. Discussing her work, she said, "Do you know what causes the injuries? It's too much pressure and too much work. It's not so much the work itself. If we could work moderately, as it should be, people wouldn't suffer so much damage. But it's the pressure; we get pressured a lot, and it's just too much work." The unrelenting pressure resulted in the production of 50,000 units or more a day in her department. When the question of the predominance of *mexicanas* working on the manual insertion line was brought up, she exclaimed, "We are all Mexican! (*¡Todas somos mexicanas!*)" When asked why, she said, "I don't know. Sometimes there are a couple of Americans and blacks on the line, but they don't do the work like we do. We do better work and more of it. If they can't do the work, they let it go or put it aside. We *do* the job." What she did not mention was that Anglo-American and black women evaded the job and managed to be transferred to other work by not doing it properly, while the *mexicanas* felt they had no recourse.

When one of the production managers supervising a number of assembly lines was questioned regarding *mexicana* workers, he said simply that Mexican women were hard workers. "Women are used to working very hard in Mexico," he argued. "When a woman is used to washing clothes in the river, the assembly line is not such hard work," he added. He spoke as if his words indicated praise and an obvious appreciation of the Mexican workers.

Indeed, this man's comments showed that he thought the workers "had it good" at the factory.

The supervisor also explained that the Mexicans invariably improved their immediate work environment to ease their job task. "Other women," he commented, "don't bother to make these changes." He emphasized the *mexicanas'* resourceful nature with an example. He said that, a short time before, engineers and management had decided to make the manual-insertion line more efficient (read, faster), and at great expense placed on the assembly line worktables a linear, hooked-on receptacle to hold the components to be inserted on the PC boards. What the planning engineers did not foresee was that the women working on the line would have to stretch their hands out and reach across for the components, a movement that decreased their speed and increased their muscle strain. According to the supervisor, the *mexicanas* discarded the new device and created a new one placed between themselves and the PC board, one that circumvented the extra movement and made motion more efficient—and easier. "The women use tape, bits of card-board, and anything available in the shop, for these work-saving devices they make," he said. Somehow, however, the engineers and management failed to consult these "clever *mexicanas*" when they made their plans to improve job efficiency on the manual-insertion line.

In the factory packing department, the machines folded the flat cardboard boxes and dropped them onto the conveyor belt line, where the workers stuffed each one with a smoke detector. The units continued on the line as women using an air gun glued the box flaps down. Always moving very quickly, the belt could be speeded up or slowed down according to the production goals or perhaps, as Laura claims, according to the whims of the supervisor. Laura, who worked for almost ten years in the packing department, felt the strain of the physically taxing, fast-paced work that left her whole body worn out at the end of the day. She moved large boxes of the product to keep her supplied with the units; she lifted, pulled, pushed, and pressed. If she was not careful while gluing, the hot glue sometimes burned her hands or arms. Although incredibly fast in her movements, at times she could not keep up with the line. In one instance, she was fond of recalling, the line was going so fast that the units she was not able to process were piling up by her side. She yelled in frustration for someone to slow down the line. She even called over to the supervisor to tell him in her fragmented, broken English, that the line was too fast. All in vain. "Then," she recounted, "I called the supervisor to my side, and pointing in the direction of the bathroom, I told him, 'Now *you*,' and left him [surprised] standing in my place. When I came back, he had a huge pile of unfinished work he was pushing to his side and on the floor, and he was working like crazy." She laughed, "He admitted that he couldn't do it, and he slowed down the line."

After a while, she discovered the button under the machine that increased or decreased the speed of the conveyor, and she adjusted it herself. Her story illustrates the way some workers resisted the management's disregard for the line workers. Laura did not directly confront the supervisor but cleverly outwitted him.

For eight years, Laura stood and packed the units at a breakneck speed. However, the ache in her feet and the expanding varicose veins in her legs from years of standing became so intolerable that she approached the supervisor, through an interpreter, to ask him to transfer her to a sitting job in the department. Since supervisors were loath to move a worker who was experienced and fast (a slower substitute will lower production), he delayed the transfer by making excuses. At her repeated insistence, he took her off the machine permanently after she signed a voluntary downgrade, from Grade 2 (standing work on a machine) to Grade 1 (assembly line, sitting). A downgrade from Grade 2 to a 1 meant a loss of $.12 an hour, a loss that Laura considered inevitable. Subsequent to her downgrade, she began to be moved from one place to another, to whatever job the supervisor assigned her from day to day, jobs usually relegated to new employees. She felt that the supervisor was getting even with her for insisting on a transfer. When Laura finally asked the Spanish-speaking union steward to help her fight the supervisor's arbitrary assignments, she found no assistance. It was explained that the union contract stated that once a worker signed a voluntary downgrade and was transferred from a machine (or other job with a higher grade), she lost her job seniority and could be assigned to whatever job needed to be filled. This episode is typical of the reason why many of the line workers chose not to complain about the pain and hardship of a job. After years of hard and competent work, Laura felt that she was punished for her request to transfer. The continual moving and changing of tasks was something that Laura detested. Workers disliked the instability, the lack of opportunity to become a permanent part of a social group with coworkers, and the inability to stay on a job long enough to get a high production rate.

Life at the factory necessarily included discussions concerning the value of belonging to the union. The plant workers joined the International Brotherhood of Electrical Workers in 1981, the conclusion of a difficult struggle for those trying to convince their sister workers that it was important to join a labor union. Unfortunately, within a few years, the union was giving little attention to the more specific needs of the workers. Referring to the women workers as "my girls," the union business representative's attitude was not one of concern and advocacy for the women workers. On the contrary, at bargaining time he seemed to go along with the company's proposed contracts and did little to pressure the company to increase its share of the enormous cost of health insurance.

One large problem for the factory employees was their lack of under-
standing of what a union could and could not do for the workers. The bar-
gaining contract was seldom read and understood by those who could read
English and usually remained a mystery to the Spanish speaking (although
the 1989 contract was translated into Spanish for the first time).

There were times, of course, when workers used the union as the only
recourse to fight seemingly arbitrary rules by the company. In the case of
"the bathroom caper," as the union business man jokingly called the epi-
sode, the plant management decided the workers were using a trip to the
bathroom as an excuse to have a smoke or have an extra break. Their solution
was not to allow the factory workers the use of the bathroom except during
the two daily ten-minute breaks, the half-hour lunch period, plus two more
times. Pregnant women were exempted from the new rules. Women with
kidney or bladder problems had to bring a doctor's note to the supervisor.
Personnel passed on the dictum to the production supervisors, who spoke
to their departments about the new rule. The women protested, and com-
mented that only a male administrator could come up with such a stupid
idea. On the assembly lines, problems began to occur.

Fabiola, a manual-insertion worker, liked to relate how she called out to
the lead operator to take her place on the line because she needed to go to
the bathroom. In a reproving voice, with a hands-on-the-waist posture, ac-
cording to Fabiola, the lead operator asked her why she had to go to the
bathroom when they had had a break fifteen minutes before. Fabiola an-
swered her in her make-do English with a "Is my problem. So . . . ?" The
supervisor was called. He again asked her why she had to go to the bathroom
when she had had a ten-minute break moments before. A very angry Fabiola
grabbed her purse and pulled out a sanitary napkin. "For this," she re-
sponded. "He turned *red, red, red*" (*colorado, colorado, colorado*), she says,
relishing the part of a story she has told many times. "And I was dying of
fury (*me moría del corage*)," she would continue in a resentful voice; "be-
cause we never bother them [the supervisors] like all the others, the *gueras*
(Anglos) and blacks who go out and smoke and nothing [happens] . . . but
we *mexicanas* are always being checked."

Absolutely livid at the idea of something so personal being questioned,
especially by a male, she asked Rose, the Spanish-speaking union steward,
for a meeting with her supervisor, the lead operator, a union representative,
and personnel. Had she not been so indignant she would have never initiated
the complaint, for she is a very compliant worker. At the meeting, according
to Fabiola, they fought it out, and she told Rose to tell the supervisor, "You
Americans have a horrible habit. You think that with a little patting on the
shoulder and an 'I'm sorry,' everything is all right." After speaking her piece,
detailing her complaint and the discriminatory practices she felt prevailed in

the department, she heard the perfunctory "I'm sorry" from the supervisor, with an attempt to pat her shoulder. Fabiola said she rejected his gesture and turned away. It was obvious that she considered the pat on the back an extremely patronizing gesture. It should be noted that the bathroom rules did not last long; pressure from the union and the grievances filed by the employees persuaded the company management to drop the whole thing and forget about their ridiculous regulations.

The social hub for the factory workers was the cafeteria. Groups of well-established friends came together to socialize. At lunch time and rest breaks, *mexicanas* gathered together to gossip about the newest hot story at the factory, share their food, complain about the supervisor, discuss their families, and talk about the latest news from their *pueblo* (village). More often than not, the women in these groups had migrated from the same rural towns in the state of Durango and sometimes had known each other as children.

Personal events were marked with potlucks in the cafeteria and celebrated by coworkers in the same department. The women cooked their special dishes the night before, and two or three workers (with the supervisor's permission) would heat them in the cafeteria microwaves ten minutes before their lunch break and arrange the potluck serving tables. *Mexicanas* took enchiladas, guacamole, and burritos; Laotians prepared eggrolls and other more exotic recipes; Anglos contributed potato salads, ham, and other all-American favorites. The long line formed in front of the food tables, and the first people in line finished the ever-popular enchiladas.

Farewell parties (another frequent event) meant more potlucks. Wedding showers, promotions, and Christmas were all opportunities to celebrate and break the daily routine. For the *mexicana*, the factory was not only a workplace, but the center of social activities, a marketplace, and a community of relatives, friends, and neighbors where women worked and learned from each other.

Nevertheless, life at the electronics factory was ruled by the time clock and production schedules. *Mexicanas* learned to live on a regimented schedule where a single minute was considered important and could be counted against them. Their workday was controlled by the "rate card" and the necessity of "making rate." The factory was a world of its own where production (read, profits) was god, and the high priest proclaiming the word was the company president. However, although the company president might set the production goals necessary to make the greatest profit possible, it was the department supervisor who was responsible for setting his or her own department's work production rates for each line or machine and for pressuring the workers who ultimately must implement the production goals. He or she was the day-to-day authority that could make or break a worker. Supervisors had control over work assignments, demotions, and transfers.

They could choose to enforce the rules rigidly or more flexibly.[25] The lead operators, women promoted from the line, worked very closely with the workers and were the second bosses in the department. These second-in-command women were also the "relief operators," the stand-in for a line worker who needed to leave for a few minutes (usually to go to the bathroom), as the rapidly moving conveyor belt stopped only for the company's officially sanctioned breaks. Although most *mexicanas* felt that they were kept on the lowest grade level (the hourly wage increased as the worker's grade category moved up), Grade I (the assembly line), they seldom complained officially to either the union or management. The Mexican women did not like to complain for several reasons: those who were undocumented were afraid of being discovered as illegals, some viewed complaining on the job as unacceptable behavior, and others feared that complaining about a work situation would bring retribution from their immediate supervisors. Nonetheless, those *mexicanas* who learned to speak English, were vocal about their abilities, and consistently applied for the better-paid jobs of running machines, were often upgraded to these easier jobs.

Conclusions

The perspective in this narrative has been the subjective voices of the *mexicana* factory workers as they spoke of thoughts and feelings regarding their role in the workplace and their interaction with their supervisors and coworkers. Although their anecdotes and conversation did not necessarily point it out, it became clear that, for the women immigrating from rural Mexico to the urban Midwest, working in the factory became a way of life, an indispensable means of making her family's circumstances more comfortable. On their own or in the company of their husbands, they arrived in a city in Illinois where relatives had said they could find factory assembly work paying a living wage.

Working outside the home produced important changes in the lives of the *mexicanas*. Their job responsibilities taught them to take greater control of their lives, as shown in their resistance to the unbending rules at the factory; work pressures and problems allowed them (and sometimes pushed them) to learn to speak for themselves. Also, the ability to hold a job helped them to gain a sense of self-confidence, while their earning capacity gave them some financial independence.

On the other hand, the *mexicanas* countered the alienation of a foreign ambiance, the stress of the work environment, and the tediousness of their jobs by recreating a familiar social milieu with all the salient elements of their gender and ethnicity, infusing the factory with their culture and language. They developed a viable Mexican community in the workplace, replete

with their own social norms and friends from their native *pueblo*. It was this social time that gave importance to their day; it was the friendships formed, the *chismes* (gossip) whispered to the work partner, the camaraderie and the rivalries, and the constant networking[26] that made the worker look forward to the next day at the factory. "Making rate" was part of the job; making a community of the workplace made it worthwhile.

Notes

1. In her materialist perspective of Chicana historiography, Chicana scholar Rosaura Sanchez observes that socialist feminists have noted that women's oppression has a material base, thereby connecting women's subordination to the exploitation of the working class as well as to the patriarchal family. On the other hand, some Chicana materialists shift the emphasis from class and gender to ethnicity, and develop a materialist perspective of culture. This perspective proposes that a material reality influences attitudes and values. Sanchez proposes that, "as material conditions for [Mexican American] populations have changed, so have expectations for women on what is appropriate for women to do, say, and think." See Sanchez, "The History of Chicanas: A Proposal for a Materialist Perspective," in *Between Borders: Essays on Mexican/Chicana History*, ed. Adelaida R. Del Castillo (Encino, CA: Floricanto Press, 1990), pp. 1–29; also, Maria Linda Apodaca, "The Chicana Woman: An Historical Materialist Perspective," *Latin American Perspectives* 4, nos. 1 and 2 (Winter and Spring 1977); Annette Kuhn and Ann Marie Wolpe, "Feminism and Materialism," in *Feminism and Materialism: Women and Modes of Production*, edited by Kuhn and Wolpe (London: Routledge, 1978), pp. 1–10; Margarita B. Melville, "Mexican Women in the U.S. Wage Labor Force," in *Mexicanas at Work in the United States*, edited by Melville (Mexican American Studies Monograph No. 5, Mexican American Studies Program, University of Houston, 1988), pp. 1–11.

2. Melville, "Mexican Women in the U.S. Wage Labor Force," p. 3.

3. See Richard Griswold del Castillo, "Myth and Reality: Chicano Economic Mobility in Los Angeles, 1850–1880," *Aztlan: International Journal of Chicano Studies Research* 6 (Summer 1975): 151–71; and Albert Camarillo, *Chicanos in a Changing Society: From Mexican Pueblos to American Barrios in Santa Barbara and Southern California, 1848–1930* (Cambridge, MA: Harvard University Press, 1979).

4. Mario Barrera, *Race and Class in the Southwest: A Theory of Racial Inequality* (Notre Dame, IN: University of Notre Dame Press, 1979): 99, as cited by Irene Campos Carr in "A Survey of Selected Literature on La Chicana," *National Women's Studies Association Journal* 1, no. 2 (Winter 1988–89): 253–73.

5. The word Hispanic has been used by the United States Census since the 1980 Census, as a generic term to denote those of Latin American and Caribbean origin as well as individuals of Spanish ancestry. It has remained the government's

official identifier; however, many of us find ourselves uncomfortable with the name, because it emphasizes Spanish origin and seemingly eliminates indigenous ancestry present in most Latin Americans. The term Hispanic can be used interchangeably with Latino (masculine form) and Latina (feminine), a commonly used self-descriptor.

6. Robert Aponte and Marcelo E. Siles, *Latinos in the Heartland: The Browning of the Midwest*, Research Report 5, Julian Samora Institute, Michigan State University, East Lansing, November 1994.

7. I use the word *mexicana* for a woman born in Mexico who has lived in the United States for a few or many years. Also, Mexican American and Chicana are used to denote women of Mexican ancestry born in the United States, possibly descendant of several generations of Mexican Americans. The term Mexican American is more frequently used as a self-identifier in the Midwest, whereas in California, Texas, and some other Southwest states, Chicana(o) is often the term of choice. (New Mexicans have always referred to themselves as Hispanos.) It should be added that the word Chicano developed during the 1960s, a period of militant activism for Mexican Americans, and still retains this connotation for many.

8. Research on Chicanas and *mexicanas* as wage earners has usually focused on three areas: the history of Chicana activism in labor struggles, the racial/ethnic factors leading to occupational segregation, and the effect of cultural values and women's wage labor on family relationships. Other analyses center on the implications of a transnational labor force in the electronics industry that capitalizes on female workers.

For references on labor struggles see the following: Vicki L. Ruiz, *Cannery Women, Cannery Lives: Mexican Women, Unionization, and the California Food Processing Industry, 1930–1950* (Albuquerque: University of New Mexico Press, 1987); also Ruiz's "Obreras y Madres: Labor Activism among Mexican Women and Its Impact on the Family," *Renato Rosaldo Lecture Series Monograph*, vol. 1, series 1985, pp. 19–38; "A Promise Fulfilled: Mexican Cannery Workers in Southern California," *The Pacific Historian* 30, no. 2 (Summer 1986): 51–61; Dolores Delgado Campbell, "Shattering the Stereotype: Chicanas as Labor Organizers," *Berkeley Women of Color* 11 (Summer 1983): 20–23; and Magdalena Mora, "The Tolteca Strike: Mexican Women and the Struggle for Union Representation," *Mexican Immigrant Workers in the U.S.*, ed. Antonio Rios-Bustamante (Los Angeles: University of California, Chicano Studies Research Center Publications, 1981), pp. 111–18.

For occupational segregation of Chicanas see Mary Romero, *Maid in the U.S.A.* (New York: Routledge, 1992); Denise Segura, "Labor Market Stratification" and "Chicanas and Triple Oppression in the Labor Force," in *Chicana Voices: Intersections of Class, Race, and Gender*, Teresa Cordoba et al., eds., National Association for Chicano Studies (Austin: University of Texas, Center for Mexican American Studies, 1986), pp. 47–65; Rosaura Sanchez, "The Chicana Labor Force," in Rosaura Sanchez and Rosa Martinez Cruz, eds., *Essays on La Mujer* (Los Angeles: Chicano Studies Center Publications, University of California, 1970), pp. 3–15; Tatcho Mindiola, "The Cost of Being a Mexican Female Worker in the 1970 Houston Labor Market," *Aztlan: International Journal of Chicano Studies Research* 11 (Fall 1980): 231–47.

For further readings on the effect part-time, seasonal work has on Chicanas and their family relationships, see Patricia Zavella, *Women's Work & Chicano Families, Cannery Workers of the Santa Clara Valley* (Ithaca, NY: Cornell University Press,

1987); Maxine Baca Zinn, "Employment and Education of Mexican-American Women: The Interplay of Modernity and Ethnicity in Eight Families," *Harvard Educational Review* 50 (February 1980): 47–62; Lea Ibarra, "When Wives Work: The Impact on the Chicano Family," *Journal of Marriage and the Family* 44 (February 1982): 169–78.

For research on the *maquiladora* industry, see Maria Patricia Fernandez-Kelly, *For We Are Sold, I and My People, Women and Industry in Mexico's Frontier* (Albany: State University of New York Press, 1983); June Nash and M. P. Fernandez-Kelly, eds., *Women, Men and the International Division of Labor* (Albany: State University of New York Press, 1983); Devon Pena, "Between the Lines: A New Perspective on the Industrial Sociology of Women Workers in Transnational Labor Processes," in *Chicana Voices*, pp. 77–95.

9. James Diego Vigil, *From Indians to Chicanos, A Sociocultural History* (St. Louis, MO: C. V. Mosby Company, 1980), pp. 117–18. For a complete history of Chicanos, particularly in the Southwest and the West, see Rodolfo Acuna's *Occupied America: A History of Chicanos*, 2nd ed. (New York: Harper and Row, 1981).

10. Margarita B. Melville, ed., *Twice a Minority: Mexican American Women* (St. Louis, MO: C. V. Mosby Company, 1980), p. 6. The word *Californio* is used by California natives tracing their ancestry to the first Spanish settlers.

11. Dennis Nodin Valdes, *Al Norte Agricultural Workers in the Great Lakes Region, 1917–1970* (Austin: University of Texas Press, Center for Mexican American Studies, 1991), p. 9.

12. Louise Ano Nuevo Kerr, "Chicanas in the Great Depression," in Del Castillo, *Between Borders*, pp. 257–68.

13. Irene Campos Carr, "Mexican Workers in Aurora: The Oral History of Three Immigration Waves, 1924–1990," *Perspectives in Mexican American Studies* 3 (1992): 31–51.

14. Mexican immigration was again encouraged when World War II left the United States in need of laborers and agricultural workers. The *bracero* (a term deriving from the word *brazos*, arms) program, instituted in 1942 and based on a mutual agreement between the United States and Mexico, provided this country's growers with the extra arms needed to labor in the fields. Close to five million Mexicans came to the United States as *braceros* during a program that was to last over twenty years. The *bracero* agreement ended in 1964, when legislation limited the number of immigrants from the western hemisphere. See Leobardo F. Estrada, et al., "Chicanos in the United States: A History of Exploitation and Resistance," *Daedalus, Journal of the American Academy of Arts and Sciences* (Spring 1981): 103–131.

15. Campos Carr, "Mexican Workers in Aurora."

16. Ibid.

17. Ibid.

18. Ibid.

19. The research of the factory culture (and the narrative in this chapter) resulted from my work as director of an adult education project (a pilot program funded by a government grant) at the electronics factory from 1984 through 1989. The project included English as a Second Language, literacy tutoring, and GED classes, as well as direct services and counseling (there was a social worker on my staff). In 1987, I started taking notes of conversations with the *mexicana* workers, and, as I became more familiar with the factory floor, I added details of the plant

assembly line to my field notes. After leaving this work in June 1989, I returned to
the factory for several visits in July 1990 to gain a new perspective on what had
become routine for me. At this time, I interviewed the workers and supervisors
quoted in this essay (all of whose names have been changed to protect their privacy),
asked many questions regarding the assembly line, and began writing a detailed nar-
rative of the factory culture. At times, I taped the conversations. Nevertheless, many
of my observations emerged from the daily contact I enjoyed during my years of
interacting with the workers—and the notes I made at the time. It should be stressed
that I have translated into English the *mexicanas'* words quoted in the text. This
research forms the basis of my doctoral dissertation, "Mexican Women Workers at
an Electronics Factory in Illinois: Social Context for Adult Education," Northern
Illinois University, 1991.

20. Maria Patricia Fernandez Kelly, "Francisca Lucero: A Profile of Female Fac-
tory Work in Ciudad Juarez." Department of Anthropology, Rutgers University,
1979. As cited by Susan S. Green in "Silicon Valley's Women Workers: A Theoretical
Analysis of Sex-Segregation in the Electronics Industry Labor Market," in Nash and
Fernandez-Kelly, *Women, Men and the International Division of Labor*, 315.

21. Figures were requested and obtained by the author from the electronics
factory personnel office.

22. *A Portrait of the Nation's Latino Newcomers*, a brief demographic report
compiled by Hermandad Mexicana Nacional (Washington, DC: Youth Policy Insti-
tute, 1994).

23. Ruth E. Zambrana, "Toward Understanding the Educational Trajectory and
Socialization of Latina Women," in *The Broken Web: The Educational Experience of
Hispanic American Women*, edited by Teresa McKenna and Flora Ida Ortiz (Encino,
CA: Floricanto Press, 1988), p. 68.

24. I have found no research concerning the supra segmentation of *mexicana*
workers in an environment where they find themselves on the bottom of the pile
while other racial and ethnic minorities (blacks, Puerto Ricans, and Mexican Ameri-
cans) place themselves a notch above. Chicana research usually focuses on the stra-
tification of Chicanas in an Anglo working world.

25. In her research on cannery workers in California, Vicki Ruiz also found that
"the foremen and floor ladies exercised a great deal of autonomous authority over
workers. They assigned them positions on the line, punched their time cards and
even determined where they could buy lunch." Ruiz, "A Promise Fulfilled: Mexican
Cannery Workers in Southern California," in Del Castillo, *Between Borders*, p. 286.

26. Networking and social activities at the workplace have been discussed in
earlier research. See Patricia Zavella, *Women's Work & Chicano Families*; also Louise
Lamphere, Patricia Zavella, Felipe Gonzalez with Peter B. Evans, *Sunbelt Working
Mothers: Reconciling Family and Factory* (Ithaca, NY: Cornell University Press, 1993).

Bibliography

Addams, Jane. *Twenty Years at Hull-House*. Urbana: University of Illinois Press, [1910], 1990.

Anderson, Kathie Ryckman. "Eva Ball Thompson: A North Dakota Daughter," *North Dakota History* 49 (Fall 1982): 11–18.

Ankarloo, Bengt. "Agriculture and Women's Work: Directions of Change in the West, 1700–1900," *Journal of Family History* 4 (1979): 111–20.

Aponte, Robert, and Marcelo Siles. *Latinos in the Heartland: The Browning of the Midwest*. Research Report #5, The Julian Samora Institute, Michigan State University, East Lansing, November 1994.

Argersinger, Peter, and Jo Ann E. Argersinger. "The Machine Breakers: Farmworkers and Social Change in the Rural Midwest in the 1870s." *Agricultural History* 58 (July 1984): 393–410.

Armitage, Katie H. "Public and Private Lives: Fannie and James C. Horton, 1874." *Kansas History* 17 (Summer 1994): 124–39.

Armstrong, James Elder. *Life of a Woman Pioneer, As Illustrated in the Life of Elsie Strawn Armstrong 1789–1871*. Chicago, n.p., 1931.

Arnold, Eleanor, ed. *Memories of Hoosier Homemakers*. Bloomington: Indiana University Press, 1993.

Ashlee, Laura R. "Fadeless Immortality." *Michigan History* 77 (July-August 1993): 10–19. [Harriet Quimby, first U.S.-licensed female pilot to solo across the English Channel]

Assion, Peter. *Acht Jahre im Wilden Western: Erlebnisse einer Farmersfrau, 1882–1890* (Eight Years in the Wild West: Adventures of a Farm Woman). Marburg, 1983.

Axtell, James, ed. *The Indian Peoples of Eastern North America: A Documentary History of the Sexes*. New York: Oxford University Press, 1981.

Baird, Elizabeth Therese. "Reminiscences of Life in Territorial Wisconsin." *Collections of the State Historical Society of Wisconsin* 15 (1900): 205–63.

Bennett, Lyn Ellen. "Reassessing Western Liberality: Divorce in Douglas County, Kansas 1867–1876." *Kansas History* 17 (Winter 1994–95): 274–87.

Bern, Enid. "Memoirs of a Prairie Schoolteacher." *North Dakota History* 42 (Summer 1975): 5–16.

Bieder, Robert E. "Kinship as a Factor in Migration." *Journal of Marriage and the Family* 35 (1973): 429–39.

Bigham, Darrel E. "The Black Family in Evansville and Vanderburgh County, Indiana, in 1880." *Indiana Magazine of History* 75 (June 1979): 117–46.

Blatti, Jo, comp. *Women's History in Minnesota: A Survey of Published Sources and Dissertations*. St. Paul: Minnesota Historical Society Press, 1993.

Blee, Kathleen M. *Women of the Klan: Racism and Gender in the 1920s*. Berkeley: University of California Press, 1991.

Borst, Charlotte G. "Wisconsin's Midwives as Working Women: Immigrant Mid-

wives and the Limits of a Traditional Occupation, 1870–1920." *Journal of American Ethnic History* 8 (1989): 24–59.

Boter, Babs. "Women Helping Women: A Discussion of the Women's Association of Hmong and Lao." Minneapolis: University of Minnesota, 1988.

Boynton, Virginia R. "Contested Terrain: The Struggle over Gender Norms for Black Working-Class Women in Cleveland's Phillis Wheatley Association, 1920–1950." *Ohio History* 103 (Winter-Spring 1994): 5–22.

Brady, Marilyn Dell. "Kansas Federation of Colored Women's Clubs 1900–30." *Kansas History* 9 (Spring 1986): 19–30.

———. "Organizing Afro-American Girls' Clubs in Kansas in the 1920s." *Frontiers* 9 (1987): 69–72.

———. "Populism and Feminism in a Newspaper by and for Women of the Kansas Farmers' Alliance." *Kansas History* 7 (Winter 1984–85): 280–90.

Brewer, Eileen Mary. *Nuns and the Education of American Catholic Women, 1860–1920*. Chicago: Loyola University Press, 1987.

Broker, Ignatia. *Night Flying Woman: An Ojibway Narrative*. St. Paul: Minnesota Historical Society Press, 1983.

Brown, Jennifer S. H. "Woman as Centre and Symbol in the Emergence of Metis Communities." *Canadian Journal of Native Studies* 3 (1983): 39–46.

Brown, Victoria Bissell. *Uncommon Lives of Common Women*. Madison, WI: Wisconsin Feminists Project Fund, Inc., 1975.

Buechler, Steven M. *The Transformation of the Woman Suffrage Movement: The Case of Illinois, 1850–1920*. New Brunswick, NJ: Rutgers University Press, 1986.

Buffalohead, Priscilla. "Farmers, Warriors, Traders: A Fresh Look at Ojibway Women." *Minnesota History* 48 (Summer 1983): 236–44.

Burland, Rebecca. *A True Picture of Emigration*. London: G. Berger, 1848; rept., New York: Citadel Press, 1968.

Bus, Annette P. "Mathilde Anneke and the Suffrage Movement." In *The German Forty-Eighters in the United States,* ed. Charlotte L. Brancaforte. New York: Peter Lang, 1989.

Carr, Irene Campos. "Mexican Workers in Aurora: The Oral History of Three Immigration Waves, 1924–1990." *Perspectives in Mexican American Studies* 3 (1992): 31–51.

Carson, Mina J. "Agnes Hamilton of Fort Wayne: The Education of a Christian Settlement Worker." *Indiana Magazine of History* 80 (March 1984): 1–34.

Cartwright, Allison S. "Jessie P. Slaton, A Renaissance Woman." *Michigan History* 73, no. 5 (September-October 1989): 20–23. [an African American teacher, lawyer, activist]

Cary, Alice. *Clovernook or Recollections of Our Neighborhood in the West*. Clinton Hall, NY: Redfield, 1852.

Christie, Jean. "'An Earnest Enthusiasm for Education': Sarah Christie Stevens, Schoolwoman." *Minnesota History* 48 (Summer 1983): 245–54.

Cleary, Catherine B. "Lavinia Goodell, First Woman Lawyer in Wisconsin." *Wisconsin Magazine of History* 74 (Summer 1991): 243–71.

———. "Married Women's Property Rights in Wisconsin, 1846–1872." *Wisconsin Magazine of History* 78 (Winter 1994–95): 110–37.

Clive, Alan. "Women Workers in World War II: Michigan as a Test Case." *Labor History* 20 (Winter 1979): 44–72.

Coburn, Carol K. "Ethnicity, Religion and Gender: The Women of Block, Kansas, 1868–1940." *Great Plains Quarterly* 8 (Fall 1988): 222–32.

———. "Learning to Serve: Education and Change in the Lives of Rural Domestics in the Early Twentieth Century." *Journal of Social History* 25 (Fall 1991): 571–84.

———. *Life at Four Corners: Religion, Gender, and Education in a German-Lutheran Community, 1868–1945.* Lawrence: University Press of Kansas, 1992.

Conrad, Ethel, ed. "Touring Ohio in 1811: The Journal of Charity Rotch." *Ohio History* 99 (1990): 135–65.

Conzen, Kathleen. "Immigrants in Nineteenth-Century Agricultural History." In *Agriculture and National Development: Views on the Nineteenth Century,* ed. Lou Ferleger. Ames: Iowa State University Press, 1990.

Cordier, Mary Hurlbut. "Prairie Schoolwomen: Mid-1850s to 1920s, in Iowa, Kansas, and Nebraska." *Great Plains Quarterly* 8 (Spring 1988): 102–19.

———. *Schoolwomen of the Prairies and Plains: Personal Narratives from Iowa, Kansas, and Nebraska, 1860s to 1920s.* Albuquerque: University of New Mexico Press, 1992.

Craig, Lee A. "The Value of Household Labor in Antebellum Northern Agriculture." *Journal of Economic History* 51 (1991): 67–81.

Cramton, Willa G. *Women beyond the Frontier: A Distaff View of Life at Fort Wayne.* Fort Wayne: Lincoln Printing Corp. for Historic Fort Wayne, 1977.

Crocker, Ruth Hutchinson. *Social Work and Social Order: The Settlement Movement in Two Industrial Cities, 1889–1930.* Urbana: University of Illinois Press, 1992.

Crow Dog, Mary. *Lakota Woman.* New York: Grove Weidenfeld, 1990. [activist's autobiography]

Crump, Pat Kennedy. "Florence Nelson Kennedy, Fashion Illustrator." *Minnesota History* 53 (Fall 1992): 86–98.

Daily, Christie. "A Woman's Concern: Millinery in Central Iowa, 1870–1880." *Journal of the West* 21 (April 1982): 26–32.

Dains, Mary K., ed. *Show Me Missouri Women: Selected Biographies.* Philadelphia, PA: Thomas Jefferson University Press, 1989.

Darroch, A. Gordon. "Migrants in the Nineteenth Century: Fugitives or Families in Motion?" *Journal of Family History* 6 (1981): 257–77.

DeBlasio, Donna. "The Greatest Woman in the Reserve: Betsy Mix Cowles, Feminist, Abolitionist, Educator." *Old Northwest* 13 (Fall-Winter 1987): 223–36.

Deloria, Ella. *Waterlily.* Lincoln: University of Nebraska Press, 1989.

Devens, Carol. *Countering Colonization: Native American Women and Great Lakes Missions, 1630–1900.* Berkeley: University of California Press, 1992.

Eblen, Jack. "An Analysis of Nineteenth Century Frontier Populations." *Demography* 6 (1965): 399–413.

Edmunds, R. David. "Shells That Ring for Shadows on Her Face: Potawatomi Commerce in the Old Northwest." *Wisconsin Magazine of History* 76, no. 3 (Spring 1993): 163–79.

Ekberg, Carl J. "Marie Rouensa-8cate8a and the Foundations of French Illinois." *Illinois Historical Journal* 84 (Autumn 1991): 146–60.

Ellet, Elizabeth F. *Pioneer Women of the West.* New York: Charles Scribner, 1852.

Emmerich, Lisa E. "Marguerite La Flesche Diddock: Office of Indian Affairs Field Matron." *Great Plains Quarterly* 13 (Summer 1993): 162–71.

Fairbanks, Evelyn. *The Days of Rondo.* St. Paul: Minnesota Historical Society Press, 1990. [memoir of African American St. Paul in the 1930s and 1940s]

Faragher, John Mack. "History From the Inside-Out: Writing the History of Women in Rural America." *American Quarterly* 33 (1981): 537–57.

——. *Sugar Creek: Life on the Illinois Prairie.* New Haven, CT: Yale University Press, 1986.

——. *Women and Men on the Overland Trail.* New Haven, CT: Yale University Press, 1979.

Farnham, Eliza W. *Life in Prairie Land.* New York: Harper & Brothers, 1846; rept., New York: Arno Press, 1972.

Faue, Elizabeth. *Community of Suffering and Struggle: Women, Men, and the Labor Movement in Minneapolis, 1915–1945.* Chapel Hill: University of North Carolina Press, 1991.

Fehn, Bruce. "'Chickens Come Home to Roost': Industrial Reorganization, Seniority, and Gender Conflict in the United Packinghouse Workers of America, 1955–1966." *Labor History* 34 (Spring-Summer 1993): 324–41.

Ferguson, Earline Rae. "The Woman's Improvement Club of Indianapolis: Black Women Pioneers in Tuberculosis Work, 1903–1938." *Indiana Magazine of History* 84 (September 1988): 237–61.

Filler, Louis, ed. *An Ohio Schoolmistress: The Memoirs of Irene Hardy.* Kent, OH: Kent State University Press, 1980.

——. "Prevailing Manners and Customs on the Frontier: The Memoirs of Irene Hardy." *Ohio History* 86 (1977): 41–53.

Fine, Lisa. *The Souls of the Skyscraper: Female Clerical Workers in Chicago, 1870–1930.* Philadelphia: Temple University Press, 1990.

Fink, Deborah. *Agrarian Women: Wives and Mothers in Rural Nebraska, 1880–1940.* Chapel Hill: The University of North Carolina Press, 1992.

——. "Anna Oleson: Rural Family and Community in Iowa, 1880–1920." *The Annals of Iowa* 48 (Summer-Fall 1986): 251–63.

——. *Open Country Iowa: Rural Women, Tradition and Change.* Albany: State University of New York Press, 1986.

Fink, Deborah and Dorothy Schwieder. "Iowa Farm Women in the 1930s: A Reassessment." *The Annals of Iowa* 49 (Winter 1989): 570–90.

Folmar, John Kent, ed. *The State of Wonders: The Letters of an Iowa Frontier Family, 1858–1861.* Iowa City: University of Iowa Press, 1986.

Foreman, Carolyn Thomas. *Indian Women Chiefs.* Washington, DC: Zenger Publishing Co., 1976.

Foster, Martha. "Of Baggage and Bondage: Gender and Status among Hidatsa and Crow Women." *American Indian Research and Culture Journal* 17, no. 2 (1993): 121–52.

Fox-Genovese, Elizabeth. "Women in Agriculture during the Nineteenth Century." In *Agriculture and National Development: Views of the Nineteenth Century*, ed. Lou Ferleger, pp. 267–301. Ames: Iowa State University Press, 1990.

Friedberger, Mark. "Women Advocates in the Iowa Farm Crisis of the 1980s." *Agricultural History* 67 (Summer 1993): 224–34.

Fry, Mildred Covey. "Women on the Ohio Frontier: The Marietta Area." *Ohio History* 90 (1981): 55–73.

Fuller, Rosalie Trail, ed. "A Nebraska High School Teacher in the 1890s: The Letters of Sadie B. Smith." *Nebraska History* 58 (Fall 1977): 447–73.

Gabaccia, Donna R. *Immigrant Women in the United States: A Selectively Annotated Multidisciplinary Bibliography*. New York: Greenwood Press, 1989.

Gabin, Nancy F. *Feminism in the Labor Movement: Women and the United Auto Workers, 1935–1975*. Ithaca: Cornell University Press, 1990.

———. "'They Have Placed a Penalty on Womanhood': The Protest Actions of Women Auto Workers in Detroit-Area UAW Locals, 1945–1947." *Feminist Studies* 8 (Summer 1982): 373–97.

Gebby, Margaret Dow. *Farm Wife: A Self-Portrait, 1886–1896*, ed. Virginia E. McCormick. Ames: Iowa State University Press, 1990.

Ginzberg, Lori D. "Women in an Evangelical Community: Oberlin 1835–1850." *Ohio History* 89 (1980): 78–88.

Grant, Marilyn. "The 1912 Suffrage Referendum." *Wisconsin Magazine of History* 64 (Winter 1980–81): 107–18.

Gullet, Gayle. "'Our Great Opportunity': Organized Women Advance Women's Work at the World's Columbian Exposition of 1893." *Illinois Historical Journal* 87, no. 4 (Winter 1994): 259–76.

Gundersen, Joan R. "The Local Parish as a Female Institution: The Experience of All Saints Episcopal Church in Frontier Minnesota." *Church History* 55 (1986): 307–22.

Gunn, Virginia Railsback. "Industrialists Not Butterflies: Women's Higher Education at Kansas State Agricultural College, 1873–1882." *Kansas History* 18 (Spring 1995): 2–17.

Handy-Marchello, Barbara. "Independence and Interdependence on Midwestern Family Farms: A Review Essay." *The Annals of Iowa* 51 (Spring 1992): 390–96.

———. "Land, Liquor, and the Women of Hatton, North Dakota." *North Dakota History* 59 (Fall 1992): 22–39.

Haney, Wava G., and Jane B. Knowles, eds. *Women and Farming: Changing Roles, Changing Structures*. Boulder, CO: Westview Press, 1986.

Harris, Charles F. "Catalyst for Terror: The Collapse of the Women's Prison in Kansas City." *Missouri Historical Review* 89 (April 1995): 290–306.

Heller, Elizabeth Wright. "A Young Woman in Iowa." *Palimpsest* 54 (March-April 1973): 18–31.

Hine, Darlene Clark. *The Black Women in the Middle West Project: A Comprehensive Resource Guide, Illinois and Indiana*. West Lafayette, IN: Purdue Research Foundation, 1986.

———. "Rape and the Inner Lives of Black Women in the Middle West: Preliminary Thoughts on the Culture of Dissemblance." In *Unequal Sisters: A Multicultural Reader in U.S. Women's History*, ed. Ellen Carol DuBois and Vicki L. Ruiz, pp. 292–97. New York: Routledge, 1990.

———. *When the Truth is Told: A History of Black Women's Culture and Community in Indiana, 1875–1950*. Indianapolis: National Council of Negro Women, Indianapolis Section, 1981.

Holbert, Sue E. "Minnesota Historical Society Collections: Women's History Resources at the MHS." *Minnesota History* 52 (Fall 1990): 112–18.

Hoover, Dwight W. "Daisy Douglass Barr: From Quaker to Klan 'Kluckeress,'" *Indiana Magazine of History* 87 (June 1991): 171–95.

Hurley, Sr. Helen A. *On Good Ground: The Story of the Sisters of St. Joseph in St. Paul.* Minneapolis: University of Minnesota Press, 1951.

Jeffrey, Julie Roy. *Frontier Women: The Trans-Mississippi West, 1840–1880.* New York: Hill and Wang, 1979.

Jellison, Katherine. *Entitled to Power: Farm Women and Technology, 1913–1963.* Chapel Hill: University of North Carolina Press, 1993.

Jennings, Rosa Schreurs. "The Country Teacher." *Annals of Iowa* 31 (July 1951): 41–62.

Jensen, Joan M. "The Death of Rosa: Sexuality in Rural America." *Agricultural History* 67 (Fall 1993): 1–12.

——. "On Their Own: Women on the Wisconsin Frontier." In *Promise to the Land: Essays on Rural Women*, ed. Joan M. Jensen, pp. 210–19, 297–98. Albuquerque: University of New Mexico Press, 1991.

——. "'Tillie': German Farm Woman." In *Promise to the Land: Essays on Rural Women*, ed. Joan M. Jensen, pp. 38–49, 272. Albuquerque: University of New Mexico Press, 1991.

Johns, Jane Martin. *Personal Recollections of Early Decatur.* Decatur, IL: Daughters of the American Revolution, Decatur Chapter, 1912.

Johnson, Anna. "Recollections of a Country School Teacher." *The Annals of Iowa* 42 (Winter 1975): 485–505.

Johnson, Judith. "Uncle Sam Wanted Them Too!! Women Aircraft Workers in Wichita during World War II." *Kansas History* 17 (Spring 1994): 38–49.

Johnston, Patricia Condon. *Eastman Johnson's Lake Superior Indians.* Afton, MN: Johnston Publishing, 1983.

——. "Reflected Glory: The Story of Ellen Ireland." *Minnesota History* 48 (Spring 1982): 13–23.

Jones, Nancy Baker. "A Forgotten Feminist: The Early Writings of Ida Husted Harper, 1878–1894." *Indiana Magazine of History* 73 (June 1977): 79–101.

Kamphoefner, Walter, Wolfgang Helbich, and Ulrike Sommer. *News from the Land of Freedom: German Immigrants Write Home.* Ithaca, NY: Cornell University Press, 1991.

Kaufman, Polly Welts. *Women Teachers on the Frontier.* New Haven, CT: Yale University Press, 1984.

Kegg, Maude. *Portage Lake: Memories of an Ojibwa Childhood*, ed. and trans. John D. Nichols. Edmonton: University of Alberta Press, 1991.

Kennelly, Karen M. "Mary Molloy: Women's College Founder," in Mary Oates, ed., *Higher Education for Catholic Women: An Historical Anthology.* New York: Garland Press, 1987.

Kerr, Louise Ano Nuevo. "Chicanas in the Great Depression." In *Between Borders: Essays on Mexicana/Chicana History*, ed. Adelaida R. Del Castillo, pp. 257–68. Encino, CA: Floricanto Press, 1990.

Kirkland, Caroline M. *A New Home—Who'll Follow.* 1839; rept., *A New Home, or Life in the Clearing.* New York: G. P. Putnam's Sons, 1953.

Kohl, Johann Georg. *Kitchi-Gami; Life among the Lake Superior Ojibway* 1960; rept., St. Paul: Minnesota Historical Society Press, 1985.

Kolmerten, Carol A. *Women in Utopia: The Ideology of Gender in the American Owenite Communities.* Bloomington: Indiana University Press, 1990.

Kolodny, Annette. *The Land Before Her: Fantasy and Experience of the American Frontiers, 1630–1860.* Chapel Hill: University of North Carolina Press, 1984.

Kremer, Gary R., and Linda Rea Gibbens. "The Missouri Home for Negro Girls: The 1930s." *American Studies* 24, no. 2 (Fall 1983): 77–93.

Krynski, Elizabeth, and Kimberly Little, eds. "Hannah's Letters: The Story of a Wisconsin Pioneer Family, 1856–1864." *Wisconsin Magazine of History* 74 (Spring 1991): 163–95; 74 (Summer 1991): 272–96; 75 no. 1 (Autumn 1991): 39–62.

Landes, Ruth. *The Ojibwa Woman* 1938; rept., New York: W. W. Norton, 1971.

Lawrence, Alice Mooney. "A Pioneer School Teacher in Central Iowa." *Iowa Journal of History and Politics* 33 (October 1953): 376–95.

Lawson, Ellen N., and Marlene Morrell. "Antebellum Black Coeds at Oberlin College." *Oberlin Alumni* 60 (Winter 1980): 8–11.

Leacock, Eleanor Burke. "Women's Status in Egalitarian Society: Implications for Social Evolution." *Current Anthropology* 19 (1978): 247–75. [theoretical study applicable to Native societies of the Midwest]

Leashore, Bogart R. "Black Female Workers: Live-In Domestics in Detroit, Michigan, 1860–1880." *Phylon* 45 (June 1984): 111–20.

Leet, Don R. *Population Pressure and Human Fertility Response: 1810–1860.* New York: Arno Press, 1978.

Leiby, Maria Quinlan. "A Woman's Touch: Women on Michigan's Iron Ranges." *Michigan History* 78 (November-December 1994): 54–61.

Liberty, Margot. "Hell Came with Horses: Plains Indian Women in the Equestrian Era." *Montana Magazine of Western History* 32 (Summer 1982), pp. 10–19.

Lieber, Justin, James Pickering, and Flora Bronson White, eds. "'Mother by the Tens': Flora Adelaide Holcomb Bronson's Account of Her Life as an Illinois Schoolteacher, Poet, and Farm Wife, 1851–1927." *Journal of the Illinois State Historical Society* 76 (1983): 283–307.

Lindenmeyer, Kriste. "Saving Mothers and Babies: The Sheppard-Towner Act in Ohio 1921–29." *Ohio History* 99 (Summer-Autumn 1990): 105–34.

Linderman, Frank. *Pretty Shield: Medicine Woman of the Crows.* 1932 as *Red Mother*; rept. with current title, Lincoln: University of Nebraska Press, 1972.

Lindgren, H. Elaine. *Land in her Own Name: Women as Homesteaders in North Dakota.* Fargo: North Dakota Institute for Regional Studies, North Dakota State University, 1991.

Lintelman, Joy K. "'On my Own': Single, Swedish, and Female in Turn-of-the-Century Chicago." In *Swedish-American Life in Chicago: Cultural and Urban Aspects of an Immigrant People, 1850–1930,* ed. Philip J. Anderson and Dag Blanck, pp. 89–99. Chicago: University of Chicago Press, 1992.

Loupe, Diane E. "Storming and Defending the Color Barrier at the University of Missouri School of Journalism: The Lucile Bluford Case." *Journalism History* 16 (Spring-Summer 1989): 20–31.

Lurie, Nancy Oestreich, ed. *Mountain Wolf Woman, Sister of Crashing Thunder: The Autobiography of a Winnebago Indian.* Ann Arbor: University of Michigan Press, 1961.

Lyon-Jenness, Cheryl. "They Hoed the Corn." *Michigan History* 78 (July-August 1994): 34–40. [early twentieth-century clubwomen and municipal housekeeping]

MacDowell, Marsha, and Lynne Swanson. "Michigan's African-American Quilters." *Michigan History* 75 (July-August 1991): 20–23.

Marti, Donald B. *Women of the Grange: Mutuality and Sisterhood in Rural America, 1866–1920.* New York: Greenwood Press, 1991.

Mathes, Valerie Sherer. "Susan La Flesche Picotte, M.D.: Nineteenth-Century Physician and Reformer." *Great Plains Quarterly* 13 (Summer 1993): 172–86.

Mayberry, Virginia. "A Draftee's Wife: A Memoir of World War II." *Indiana Magazine of History* 79 (March 1983): 305–29.

McBride, Genevieve G. "Theodora Winton Youmans and the Wisconsin Woman Movement." *Wisconsin Magazine of History* 71 (Summer 1988): 243–75.

McCann, Barbara. "Women of Traunik: A Story of Slovenian Immigration." *Michigan History* 68 (1984): 41–45.

McCormack, Virginia E. "Butter and Egg Business: Implications from the Records of a Nineteenth-Century Farm Wife." *Ohio History* 100 (1991): 57–67.

McDonell, Katherine M. "Women and Medicine in Early Nineteenth Century Indiana." *Indiana Medical History Quarterly* 6 (June 1980).

McDowell, John E. "Therese Schindler of Mackinac: Upward Mobility in the Great Lakes Fur Trade." *Wisconsin Magazine of History* 61 (1977–78): 125–43.

McTighe, Michael J. "'True Philanthropy' and the Limits of the Female Sphere: Poor Relief and Labor Organizations in Ante-Bellum Cleveland." *Labor History* 27 (1986): 227–56.

Mead, Margaret. *The Changing Culture of an Indian Tribe*. New York: Columbia University Press, 1932.

Medicine, Beatrice, and Patricia Albers. *The Hidden Half: Studies of Plains Indian Women*. Lanham, MD: University Press of America, 1983.

Meyerowitz, Joanne J. *Women Adrift: Independent Wage Earners in Chicago, 1880–1930*. Chicago: University of Chicago Press, 1988.

Miller, Kristie. *Ruth Hanna McCormick: A Life in Politics, 1880–1944*. Albuquerque: University of New Mexico Press, 1992.

Miller, Sally M. *From Prairie to Prison: The Life of Social Activist Kate Richards O'Hare*. Columbia: University of Missouri Press, 1993.

———. "Kate Richards O'Hare: Progression toward Feminism." *Kansas History* 7 (Winter 1984–85): 263–79.

Modell, John. "Family and Fertility on the Indiana Frontier, 1820." *American Quarterly* 23 (1971): 615–34.

Mooney, Catherine. *Phillipine Duchesne: A Woman with the Poor*. New York: Paulist Press, 1990.

Moore, J. "Developmental Cycle of Cheyenne Polygyny." *American Indian Quarterly* 15, no. 3 (311–28).

Morton, Marian J. *And Sin No More: Social Policy and Unwed Mothers in Cleveland, 1855–1900*. Columbus: Ohio State University Press, 1993.

———. "'Go and Sin No More': Maternity Homes in Cleveland, 1869–1936." *Ohio History* 93 (Winter-Spring 1984): 117–46.

———. "Homes for Poverty's Children: Cleveland's Orphanages, 1851–1933." *Ohio History* 98 (Winter-Spring 1989): 5–22.

———. "Temperance, Benevolence, and the City: The Cleveland WCTU." *Ohio History* 91 (Annual 1982): 58–73.

Moss, Carolyn J. "Kate Field: The Story of a Once-Famous St. Louisan." *Missouri Historical Review* 88 (January 1994): 157–75.

Motz, Marilyn Ferris. *True Sisterhood: Michigan Women and Their Kin, 1820–1920*. Albany: State University of New York Press, 1983.

Muir, Karen L. S. *The Strongest Part of the Family: A Study of Lao Refugee Women in Columbus, Ohio.* New York: AMS Press, 1988.

Murphy, Lucy Eldersveld, "Autonomy and the Economic Roles of Indian Women of the Fox-Wisconsin Riverway Region, 1763–1832." In *Negotiators of Change: Historical Perspectives on Native American Women,* ed. Nancy Shoemaker. New York: Routledge, 1995.

———. "Business Ladies: Midwestern Women and Enterprise, 1850–1880." *Journal of Women's History* 3 (Spring 1991): 65–89.

———. "Her Own Boss: Businesswomen and Separate Spheres in the Midwest, 1850–1880." *Illinois Historical Journal* 80 (Autumn 1987): 155–76.

Myres, Sandra L. *Westering Women and the Frontier Experience, 1800–1915.* Albuquerque: University of New Mexico Press, 1982.

Namias, June, ed. *A Narrative of the Life of Mrs Mary Jemison* [1824]. Norman: University of Oklahoma Press, 1992. [Iroquois captive]

Nelson, Paula M., ed. "Memoir of a Country Schoolteacher: Dolly Holiday Meets the Ethnic West, 1919–1920." *North Dakota History* 59 (Winter 1992): 30–45, 59; (Spring 1992): 17–27.

Neth, Mary. "Leisure and Generational Change: Farm Youths in the Midwest, 1910–1940." *Agricultural History* 67 (Spring 1993): 163–84.

———. *Preserving the Family Farm: Women, Community, and the Foundations of Agribusiness in the Midwest, 1900–1940.* Baltimore: Johns Hopkins University Press, 1995.

O'Brien, Thomond R. "Alice M. O'Brien and the Women's City Club of St. Paul." *Minnesota History* 54 (Summer 1994): 54–68.

Obst, Janis. "Abigail Snelling: Military Wife, Military Widow." *Minnesota History* 54 (Fall 1994): 98–111.

Osterud, Nancy Grey. "Gender and the Transition to Capitalism in Rural America." *Agricultural History* 67 (Spring 1993): 14–29.

Paddon, Anna R., and Sally Turner. "African Americans and the World's Columbian Exposition." *Illinois Historical Journal* 88 (Spring 1995): 19–36.

Peavy, Linda and Ursula Smith. *The Gold Rush Widows of Little Falls: A Story Drawn from the Letters of James and Pamelia Fergus.* St. Paul: Minnesota Historical Society Press, 1990.

———. *Women in Waiting in the Westward Movement: Life on the Home Frontier.* Norman: University of Oklahoma Press, 1994.

Pederson, Jane Marie. *Between Memory and Reality: Family and Community in Rural Wisconsin.* Madison: University of Wisconsin Press, 1992.

———. "The Country Visitor: Patterns of Hospitality in Rural Wisconsin, 1880–1925." *Agricultural History* 58 (July 1984): 347–64.

———. "Gender, Justice, and a Wisconsin Lynching, 1889–1890." *Agricultural History* 67 (Spring 1993): 65–82.

Peebles, Robin S. "Detroit's Black Women's Clubs." *Michigan History* 70 (January-February 1986).

Peterson, Jacqueline. "Many Roads to Red River: Metis Genesis in the Great Lakes Region, 1680–1815." In *The New Peoples: Being and Becoming Metis in North America,* ed. Jacqueline Peterson and Jennifer S. H. Brown. Lincoln: University of Nebraska Press, 1985.

———. "Prelude to Red River: A Social Portrait of the Great Lakes Metis." *Ethnohistory* 25 (1978): 41–67.

Peterson, Susan C. "Challenging Stereotypes: The Adaptation of the Sisters of St. Francis to South Dakota Indian Missions, 1885–1910." *Upper Midwest History* 4 (1984): 1–10.

———. "Doing 'Women's Work': The Grey Nuns at Fort Totten Indian Reservation, 1874–1900." *North Dakota History* 52 (Spring 1985): 18–25.

———. "'Holy Women' and Housekeepers: Women Teachers on South Dakota Reservations, 1885–1910." *South Dakota History* 13 (Fall 1983): 245–60.

Plummer, Stephen, and Suzanne Julin. "Lucy Swan, Sioux Woman: An Oral History." *Frontiers* 6 (Fall 1981): 29–32.

Polacheck, Hilda Satt. *I Came a Stranger: The Story of a Hull-House Girl.* Chicago: University of Illinois Press, 1989.

Posadas, Barbara M. "Mestiza Girlhood: Interracial Families in Chicago's Filipino American Community since 1925." In *Making Waves: An Anthology of Writings by and about Asian American Women*, ed. Asian Women United of California, 273–82. Boston: Beacon Press, 1989.

Pratt, William C. "Women and the Farm Revolt of the 1930s." *Agricultural History* 67 (Spring 1993): 214–23.

Raftery, Judith. "Chicago Settlement Women in Fact and Fiction: Hobart Chatfield Chatfield-Taylor, Clara Elizabeth Laughlin, and Elia Wilkinson Peattie Portray the New Woman." *Illinois Historical Journal* 88 (Spring 1995): 37–58.

Riley, Glenda. *The Female Frontier: A Comparative View of Women on the Prairie and the Plains.* Lawrence: University Press of Kansas, 1988.

———. *Frontierswomen: The Iowa Experience.* Ames: The Iowa State University Press, 1981.

Riley, Glenda, and Carol Benning. "The 1836–1845 Diary of Sarah Browne Armstrong Adamson of Fayette County, Ohio." *The Old Northwest* 10 (1984): 285–306.

Riney-Kehrberg, Pamela. *Rooted in Dust: Surviving Drought and Depression in Southwestern Kansas.* Lawrence: University Press of Kansas, 1994.

———. "Separation and Sorrow: A Farm Woman's Life, 1935–1941." *Agricultural History* 67 (Spring 1993): 185–96.

Rokicky, Catherine M. "Lydia Finney and Evangelical Womanhood." *Ohio History* 103 (Summer-Autumn 1994): 170–89.

Ross, G. Alexander. "Fertility Change on the Michigan Frontier: Saginaw County, 1840–1850." *Michigan Historical Review* 12 (1986): 69–85.

Sannes, Erling N. "'Free Land for All': A Young Norwegian Woman Homesteader in North Dakota." *North Dakota History* 60 (Spring 1993): 24–32.

Santillan, Richard. "Rosita the Riveter: Midwest Mexican American Women during World War II, 1941–1945." *Perspectives in Mexican American Studies* 2 (1989): 115–46.

Satorius, Rolf. "An Evaluation of the American Refugee Committee's First Steps for Women Project." Minneapolis, MN: American Refugee Committee, 1989.

Scharf, Lois. "'I Would Go Wherever Fortune Would Direct': Hannah Huntington and the Frontier of the Western Reserve." *Ohio History* 97 (1988): 5–28.

Schenken, Suzanne O'Dea. "Immigrants' Advocate: Mary Treglia and the Sioux City Community House, 1921–1959." *The Annals of Iowa* 50 (Fall 1989): 181–213.

Schlissel, Lillian. *Far From Home: Families of the Westward Journey*. New York: Schocken Books, 1989.

——. *Women's Diaries on the Westward Journey*. New York: Schocken Books, 1982.

Schneider, Dorothee. "For Whom Are All the Good Things in Life?" In *German Workers in Industrial Chicago, 1850–1910: A Comparative Perspective*, ed. Hartmut Keil and John B. Jentz. DeKalb: Northern Illinois University Press, 1983.

Schob, David E. *Hired Hands and Plowboys: Farm Labor in the Midwest, 1815–60* Urbana: University of Illinois Press, 1975.

Schofield, Ann. "The Women's March: Miners, Family, and Community in Pittsburg, Kansas, 1921–22." *Kansas History* 7 (Summer 1984): 159–68.

Scholten, Pat Creech. "A Public 'Jollification': The 1859 Women's Rights Petition before the Indiana Legislature." *Indiana Magazine of History* 72 (1976): 347–59.

Schroeder, Adolph E. "Eden on the Missouri: Immigrant Women on the Western Frontier." *Yearbook of German-American Studies* 18 (1983): 197–215.

Schutter, Silke, Hg. *Ein Auswanderinnenschicksal in Briefen und Dokumenten. Ein Beitrag zur Geschichte der westfälischen Amerikaauswanderung im 19. Jahrhundert (1827–1899)*. unter Mitarbeit von Carla Schulz-Geisberg. Warendorf: Archives Kreises Warendorf, 1989. [destiny of an emigrant woman to Missouri in letters and documents: a contribution to the history of emigration to America from Westphalia in the 19th century]

Schwieder, Dorothy. "Rural Iowa in the 1920s: Conflict and Continuity." *The Annals of Iowa* 47 (Fall 1983): 104–15.

——. *75 Years of Service: Cooperative Extension in Iowa*. Ames: Iowa State University Press, 1993.

Schwieder, Dorothy, and Deborah Fink. "Plains Women: Rural Life in the 1930s." *Great Plains Quarterly* 8 (Spring 1988): 79–88.

Seifert, Ruth. "The Portrayal of Women in the German-American Labor Movement." In *German Workers' Culture in the United States, 1850–1920*, ed. Hartmut Keil. Washington, DC: Smithsonian Institution Press, 1988.

Siegel, Peggy Brase. "She Went to War: Indiana Women Nurses in the Civil War." *Indiana Magazine of History* 86 (March 1990): 1–27.

Sklar, Kathryn Kish. *Florence Kelley and the Nation's Work*. New Haven, CT: Yale University Press, 1995.

——. "Hull House in the 1890s: A Community of Women Reformers." *Signs: Journal of Women in Culture and Society* 19 (Summer 1985): 658–77.

Smithe-Bader, Robert. "Mrs. Nation," *Kansas History* 7 (Winter 1984–85): 246–62.

Spector, Janet. *What This Awl Means: Feminist Archaeology at a Wahpeton Dakota Village*. St. Paul: Minnesota Historical Society Press, 1993.

Spindler, George, and Louise Spindler. *Dreamers with Power*. 1971, as *Dreamers without Power*; rept., Prospect Heights, IL: Waveland Press, 1984.

——. "Male & Female Adaptations in Culture Change." *American Anthropologist* 60 (1958), 217–33.

Spindler, Louise. *Menominee Women and Culture Change*. American Anthropological Association Memoir 91. Menasha, WI: Banta & Sons, 1962.

Springer, Marlene, and Haskell Springer, eds. *Plains Woman: The Diary of Martha Farnsworth, 1882–1922*. Bloomington: Indiana University Press, 1986.

Steinson, Barbara J. "Memories of Hoosier Homemakers: A Review Essay." *Indiana Magazine of History* 86 (June 1990): 197–222.

Stepsis, Ursula, and Dolores Liptak, eds. *Pioneer Healers: The History of Women Religious in American Health Care*. New York: Crossroad Publishing Co., 1989.

Stetson, Erlene. "Black Feminism in Indiana, 1893-1933." *Phylon* 44 (December 1983): 292-98.

Stofer, Paula. "Angels of Mercy: Michigan's Midwives." *Michigan History* 73 (1989): 41-47.

Stratton, Joanna L., ed. *Pioneer Women: Voices from the Kansas Frontier*. New York: Simon and Schuster, 1981.

Sugar, Hermina. "The Role of Women in the Settlement of the Western Reserve, 1796-1815." *Ohio Archaeological and Historical Quarterly* 46 (1937): 51-67.

Tanner, Helen Hornbeck. "Coocoochee: Mohawk Medicine Woman." *American Indian Culture and Research Journal* 3 (1979): 23-41.

Thompson, Delores, and Lyle Koehler. "Educated Pioneers: Black Women at the University of Cincinnati, 1897-1940," *Queen City Heritage* 43 (Winter 1985): 21-28.

Thornbrough, Emma Lou. "The History of Black Women in Indiana: Part I." *Black History News and Notes* 13 (May 1983): 1, 4-8.

————. "The History of Black Women in Indiana: Part II." *Black History News and Notes* 14 (August 1983): 4-7.

Tillson, Christiana Holmes. *A Woman's Story of Pioneer Illinois*. Chicago: The Lakeside Press, R. R. Donnelley & Sons, 1919.

Treckel, Paula A. "An Historiographical Essay: Women on the American Frontier." *The Old Northwest* 1 (1975): 391-404.

Underwood, June. "Civilizing Kansas Woman's Organizations 1880-1920." *Kansas History* 7 (Winter-Spring 1984-85): 291-306.

Van Horn Dwight, Margaret. *A Journey to Ohio in 1810*. New Haven, CT: Yale University Press, 1914.

Walker, Janet R., and Richard W. Burkhardt. *Eliza Julia Flower: Letters of an English Gentlewoman: Life on the Illinois-Indiana Frontier, 1817-1861*. Muncie: Ball State University Press, 1991.

Weimann, Jeanne Madeline. *The Fair Women*. Chicago: Academy, 1981. [the story of the Woman's Building, World's Columbian Exposition]

Weisberger, Bernard A. "Changes and Choices: Two and a Half Generations of LaFollette Women." *Wisconsin Magazine of History* 76, no. 4 (Summer 1993): 248-70.

Weist, Katherine. "Plains Indian Women: An Assessment." In *Anthropology on the Great Plains*, ed. Raymond Wood and Margot Liberty, pp. 255-71. Lincoln: University of Nebraska Press, 1980.

Wertsch, Douglas. "Iowa's Daughters: The First Thirty Years of the Girls Reform School of Iowa, 1869-1899." *The Annals of Iowa* (Summer-Fall 1987).

Wheeler, Adade D., with Marlene Stein Wortman. *The Roads They Made: Women in Illinois History*. Chicago: Charles H. Kerr, 1977.

Wilson, Gilbert. *Waheenee: An Indian Girl's Story, Told by Herself*. 1927; rept., Lincoln: University of Nebraska Press, 1981.

Xan, Erna Oleson. *Wisconsin, My Home*. Madison: University of Wisconsin Press, 1950.

Yzenbaard, John H., and John Hoffmann, eds. "'Between Hope and Fear': The Life of Lettie Teeple." *Michigan History* 58 (Fall 1974): 219-78; (Winter 1974): 291-352.

Contributors

Irene Campos Carr recently retired as director of the Women's Studies Program at Northeastern Illinois University, Chicago. Born in Chicago of Nicaraguan parents, she grew up in Nicaragua and El Salvador. Her research has focused primarily on Chicanas and *mexicanas* in the Midwest, in particular blue-collar workers and Latin American feminism. She has published poetry, essays, and articles in a number of journals.

Earline Rae Ferguson teaches at Illinois State University. Her dissertation concerns black clubwomen's community work in Indianapolis, 1879–1917. In 1988, she published an article in the *Indiana Magazine of History* entitled "The Woman's Improvement Club of Indianapolis: Black Women Pioneers in Tuberculosis Work, 1903–1938."

Nancy F. Gabin is an associate professor in the Department of History at Purdue University, where she teaches U.S. women's and labor history and directs the graduate program. Her book *Feminism in the Labor Movement: Women and the United Auto Workers, 1935–1975* was published in 1990. She is working on a book-length history of women in Indiana and another project that focuses on women in mass-production industries in the Midwest since 1880.

Christiane Harzig is Assistant Professor of History at Bremen University, Germany, where she teaches American social history. A specialist in women's and migration history, she is the editor of *Peasant Maids–City Women: From the European Countryside to Urban America.*

Rebecca Kugel teaches Native American History at the University of California, Riverside. Her research involves the Minnesota Ojibwe in the nineteenth century, focusing on their political and social adaptations as they sought to retain their autonomy in the face of the growing presence of the United States.

Karen M. Mason is Curator of the Louise Noun–Mary Louise Smith Iowa Women's Archives at the University of Iowa Libraries. She is the author of "Feeling the Pinch: The Kalamazoo Corsetmakers' Strike of 1912," in *"To Toil the Livelong Day": America's Women at Work, 1780–1980* (1987), edited by Carol Groneman and Mary Beth Norton. She is coauthor of *Women's History Tour of the Twin Cities* (1982).

Sarah F. McMahon is Associate Professor of History at Bowdoin College and past Director of Women's Studies. Her articles on the history of diet and the culture of food in New England have been published in *Historical Methods, William and Mary Quarterly*, and *Agricultural History*, and most recently, as "Laying Foods By: Gender, Dietary Decisions, and the Technology of Food Preservation in New England Households, 1750–1850," in Judith A. McGaw, ed., *Early American Technology: Making & Doing Things from the Colonial Era to 1850* (1994). Currently she is working

on a comparative study of two intentional communities in the Maine hill country: the Shaker Village at Sabbathday Lake and Shiloh in Durham.

Tamara G. Miller is Assistant Editor of the Elizabeth Cady Stanton and Susan B. Anthony Papers at Rutgers University.

Lucy Eldersveld Murphy teaches at DePaul University in Chicago. She has published articles on Native American women's economic activities in the Midwest and on Illinois businesswomen in the nineteenth century. Her current research project is a study of the economies and communities of Native Americans, Métis, and Euro-Americans in early Wisconsin, Illinois, and Iowa.

Pamela Riney-Kehrberg is Associate Professor of History at Illinois State University. The author of *Rooted in Dust: Surviving Drought and Depression in Southwestern Kansas* (1994), she is interested in rural and agricultural history and especially the lives of rural women.

Dorothy Schwieder is Professor of History at Iowa State University, where she has been on the faculty for thirty years. She is a trustee of the State Historical Society of Iowa and has served on the Iowa Humanities Board. She has published widely in the areas of Iowa, midwestern, and women's history. Her most recent book is *Iowa: The Middle Land*.

Tanis C. Thorne teaches history and Native American Studies at the University of California, Irvine. Her book *Many Hands of My Relations: French and Indians on the Lower Missouri to the Removal Era* is forthcoming. She is researching Southern California's Mission Indian Federation and is writing a book on the "World's Richest Indian."

Wendy Hamand Venet teaches at Georgia State University. She is the author of *Neither Ballots nor Bullets: Women Abolitionists and the Civil War* (1991). Currently she is writing a biography of Civil War activist and late-nineteenth-century suffragist Mary Livermore.

Index